100 IDEAS THAT CHANGED ART

Michael Bird

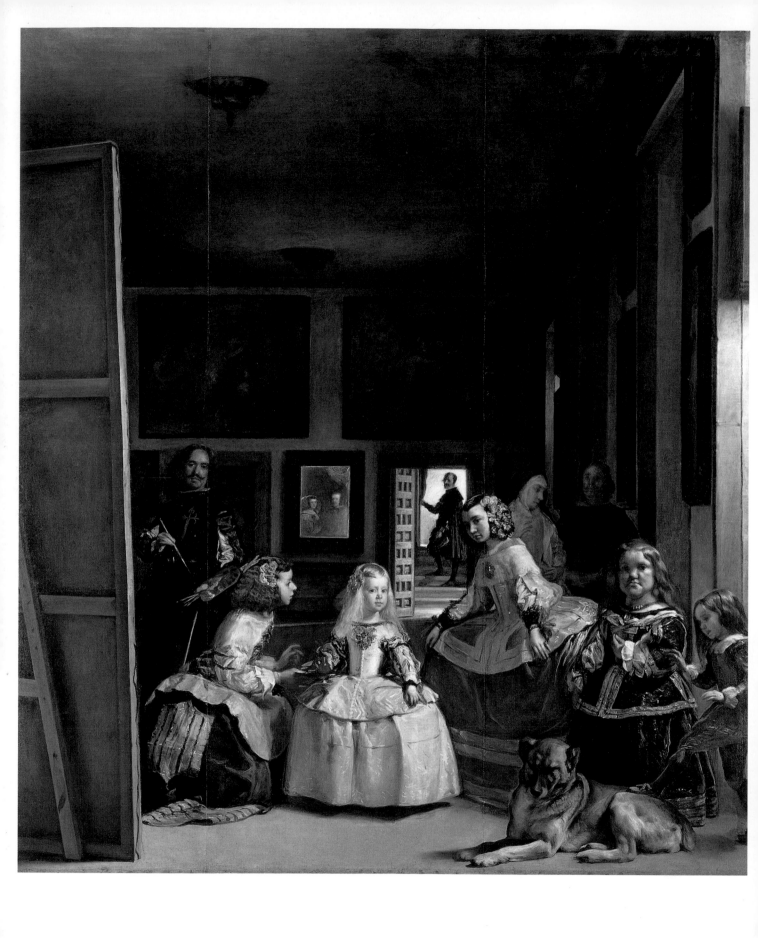

100 IDEAS THAT CHANGED ART

Michael Bird

Laurence King Publishing

Introduction 6

100 Ideas that Changed Art **8**

Glossary 208

Index 210

Picture credits 214

No.1	**CAVE AND ROCK ART**	*8*
No.2	**FIRED CLAY**	*10*
No.3	**LAND AS MATERIAL**	*12*
No.4	**STATUE**	*14*
No.5	**WALL PAINTING**	*16*
No.6	**SCALING UP**	*18*
No.7	**NARRATIVE**	*20*
No.8	**RELIEF CARVING**	*22*
No.9	**BODY AS SURFACE**	*24*
No.10	**THE NUDE**	*26*
No.11	**CONTRAPPOSTO**	*28*
No.12	**PROPAGANDA**	*30*
No.13	**LOST-WAX CASTING**	*32*
No.14	**PAPER**	*34*
No.15	**MEMORIAL**	*36*
No.16	**ARCHITECTURAL SCULPTURE**	*38*
No.17	**WORD AS IMAGE**	*40*
No.18	**COLOURED GLASS**	*42*
No.19	**FRAME**	*44*
No.20	**ICON**	*46*
No.21	**MAKING BOOKS**	*48*
No.22	**THE GROTESQUE**	*50*
No.23	**EROTIC ART**	*52*
No.24	**HANDWRITING**	*54*
No.25	**MOSAIC**	*56*
No.26	**MULTI-PANEL PAINTING**	*58*
No.27	**MINIATURES**	*60*
No.28	**OIL PAINT**	*62*
No.29	**WINDOW ON THE WORLD**	*64*
No.30	**MATHEMATICS**	*66*
No.31	**LINEAR PERSPECTIVE**	*68*
No.32	**TROMPE-L'OEIL**	*70*
No.33	**COLOUR CODES**	*72*
No.34	**ALLEGORY**	*74*
No.35	**PORTRAIT**	*76*
No.36	**THE SKETCH**	*78*
No.37	**MIRRORS**	*80*
No.38	**PRINTMAKING**	*82*
No.39	**CHIAROSCURO**	*84*
No.40	**ANATOMY**	*86*
No.41	**STILL LIFE**	*88*
No.42	**COPYING**	*90*
No.43	**CANVAS**	*92*
No.44	**CAMERA OBSCURA**	*94*
No.45	**REINVENTING GREEK ART**	*96*
No.46	**LANDSCAPE**	*98*
No.47	**SERIES**	*100*
No.48	**COLLECTIONS**	*102*
No.49	**HISTORY PAINTING**	*104*
No.50	**WHITENESS**	*106*
No.51	**ACADEMIES**	*108*
No.52	**ROMANTICISM**	*110*
No.53	**AUTHENTICITY**	*112*
No.54	**THE ARTIST**	*114*
No.55	**WATERCOLOUR**	*116*
No.56	**CONFRONTING REALITY**	*118*
No.57	**MEDIEVALISM**	*120*
No.58	**DEALING**	*122*
No.59	**CAPTURING THE INSTANT**	*124*
No.60	**ASSEMBLAGE**	*126*
No.61	**COMMERCIAL DESIGN**	*128*
No.62	**PAINT IN TUBES**	*130*
No.63	**PHOTOGRAPHY**	*132*
No.64	**ART COLONIES**	*134*
No.65	**ARTIFICIAL LIGHT**	*136*
No.66	**THE UNCONSCIOUS**	*138*
No.67	**THE PRIMITIVE**	*140*
No.68	**MULTIPLE VIEWPOINTS**	*142*
No.69	**COLLAGE**	*144*
No.70	**MACHINE FORMS**	*146*
No.71	**ABSTRACT ART**	*148*
No.72	**SATIRE**	*150*
No.73	**FOUND OBJECTS**	*152*
No.74	**KINETIC ART**	*154*
No.75	**SCENES OF DAILY LIFE**	*156*
No.76	**INSTALLATION**	*158*
No.77	**EXPRESSING INNER STATES**	*160*
No.78	**PLASTICS**	*162*
No.79	**PROTEST**	*164*
No.80	**DOCUMENTARY**	*166*
No.81	**CHANCE**	*168*
No.82	**SHOCK**	*170*
No.83	**WELDING**	*172*
No.84	**POP**	*174*
No.85	**LESS IS MORE**	*176*
No.86	**OPTICALITY**	*178*
No.87	**HALLUCINOGENS**	*180*
No.88	**PERFORMANCE ART**	*182*
No.89	**PERSONAL IS POLITICAL**	*184*
No.90	**MOVING IMAGES**	*186*
No.91	**CONCEPTUAL ART**	*188*
No.92	**TITLES**	*190*
No.93	**BODY AS MEDIUM**	*192*
No.94	**STREET ART**	*194*
No.95	**GLOBALISATION**	*196*
No.96	**DIGITAL TECHNOLOGY**	*198*
No.97	**MUSEUM**	*200*
No.98	**NEGATIVE SPACE**	*202*
No.99	**THE INTERNET**	*204*
No.100	**EPHEMERALITY**	*206*

Introduction

This book does not follow an academic conception of 'theory and practice'.
It reverses this order and places practice before theory, which, after all,
is the conclusion of practice.

Josef Albers, introduction to *Interaction of Colour* (1963)

What does it mean to 'change art'? Art, in any definition, is so much a business of transformation that change is always and everywhere part of its nature, whether you think of it in physical terms (stone into statue) or in intellectual or spiritual ones (giving form to invisible things). No sooner has an idea changed art than art reformulates that idea, allowing it to recognise itself. Around the early fifth century BC, for example, Greek sculptors changed the way they represented naked figures, probably under the influence of certain intellectual attitudes to the human body. At the same time, their nude statues endowed fifth-century Greek ideas about what it means to be human with an extraordinarily long and fertile posterity. As so often where art is concerned, the transformation works both ways, more on the analogy of a chemical reaction than the introduction of a new material in engineering or a new process in politics.

In this context, how should an idea be defined? Some are technical innovations: paper, glass mirrors, the camera obscura, plastics, the internet – none of these was developed specifically with art in mind, but each brought new possibilities that artists were ready to explore and exploit. Other ideas, such as using art to commemorate the dead or for propaganda purposes, formed artistic practice over millennia through changing social or political pressures. Maybe it's stretching a point to describe wall painting – or the portrait or the frame – as an idea. But in these cases, it's not so much a question of a roughly datable innovation as of a venerable tradition that has provided the focus for serial reinventions, as in early twentieth-century Paris, when Braque and Picasso reconceptualised the still life.

Sometimes an idea operates through a steady, not necessarily spectacular, series of adaptations.

The switch from making portable paintings on wooden panels to stretched canvases wasn't revolutionary, but in the 500 years since it took place, artists have done things on and with canvas that they couldn't otherwise have made. The idea of using canvas has changed art. At other times, whatever the idea – lost-wax bronzecasting, the Freudian unconscious, film – it's noticeable how quickly artists were on the scene, and how rapidly they pushed an innovation through almost the entire scale of its possibilities. Oil paint was a relatively untried medium when Jan van Eyck and Dieric Bouts took it up in the early fifteenth century, but within a short time they brought the technique of multiple oil paint glazes to a level of sophistication unrivalled since. Similarly, Perspex and nylon filament were barely on the market when Naum Gabo devised his *Linear Construction in Space No.1*, a strong contender for the world's most beautiful plastic object.

Visually this book pursues a familiar historical trajectory, from Palaeolithic art through the ancient world, the Middle Ages, the Renaissance, onwards into recent times. Within this movement, however, each entry forms a self-contained chronological arc. The practices of painting cave walls or firing clay have a continuous history reaching back through tens of thousands of years; with moving images or digital technology, the timeframe is tighter. But overall I have been struck by the sense of a cumulative continuum: in the twenty-first century artists are still using techniques and visual formulae introduced in the ancient world and every subsequent phase of art-making. Artists very often say that the ideas that have most influenced their work come from art – the art of contemporaries but even more so the art of the past, which continually renews itself through reinterpretation. A few ideas, such as hand-

illustrating bibles, painting allegories or dressing your subjects in medieval clothes, have apparently run out of steam, but a large proportion remain current in some area of present-day practice.

One hundred is an arbitrary number; there could as easily have been 73 ideas or 151. But what matters is that each idea has its own distinct history in art. Many of them have been the subject of books in their own right – which made the task of covering ideas such as narrative or landscape in 500 words a curious fusion of mural and miniature, wielding a broad brush with magnifying glass in hand. In terms of the artists illustrated, too, there are notable absences. Where are Cimabue and Duccio, El Greco, Munch, Mondrian or Ai Weiwei, to name a few? Artists have come and gone from successive drafts and shortlists, and in the end, everyone will have different examples they might have chosen. At least, I hope so, since my intention has been more to do with opening doors than fitting the furniture into the room.

I have kept in mind the precedence given by the artist and Bauhaus veteran Josef Albers to practice over theory in his introduction to *Interaction of Colour* (1963). Admittedly, his distinction becomes more equivocal the more you think about it – practice and theory are, as Albers himself was naturally aware, as mutually interactive as the juxtaposed and contrasted hues in his famous colour exercises. All the same, I have looked for ideas that shaped the ways in which artists worked, rather than those that determined how their work was (retrospectively) thought and written about. So, while it's impossible succinctly to discuss Western art without referring to the Renaissance, the Enlightenment, Realism or Cubism, these and other long-established categories were dropped at an early stage from the list, as were aesthetic terms including proportion, beauty, the

Sublime, and so on. At one point I tried – in a bid for what I hope will be a useful reframing and recasting of conventional art historical topography – to get rid of every single 'ism', although one or two resisted paraphrase to the bitter end.

As a word and a concept art has no precise equivalent in some of the cultures and time periods whose art is represented here. It could, in some ways, be defined most efficiently by exclusion: the Greek bronzesmiths pictured on a drinking cup in the process of casting and assembling statues, Velázquez staring out from *Las Meninas*, Courbet in his studio, Warhol in the Factory, Pollock frenetically drip painting, Nauman in a video walking contrapposto-style, or any of the other artists who turn up in the illustrations, are engaged in an activity for which there is no other useful term. Which brings me again to questions of practice and theory. Oil paint, printmaking, watercolour, collage, welding – all of these feature in the list of 'ideas'. What's more, it is their function as media for still other ideas that makes art histories different from technical manuals. But these words also have a thoroughly sensual, practical existence, steeped in smells, textures, visual sensation and the mess of making. Though ideas that change art arrive in many forms and from many sources, they flourish by breathing the atmosphere of the studio rather than the study.

Defining the function of art

IDEA Nº 1

CAVE AND ROCK ART

The oldest surviving paintings occur in caves in Europe. Produced across a timespan of more than 30 millennia, and including examples in Africa, Australia and the Americas, cave and rock art is by far the longest-lived form of artistic expression.

Rediscovered by a local landowner in 1879, the polychrome images that unfold across the cave walls of Altamira in northern Spain revealed the impressive skills and startling visual impact achieved by Palaeolithic painters. Here were life-size figures of bison, mammoth and other animals, rendered in precise, fluid lines and rich mineral pigments that remained astonishingly vivid after 14,000 years or more. Initially, the scholarly establishment simply didn't want to know. Art – like medicine or engineering – was supposed to progress through time, becoming ever more sophisticated as society advanced from its primitive state towards modern civilisation. How could early peoples have created art as powerful and subtle as this?

Opinion changed with new discoveries of Palaeolithic cave art in France. But, despite the wealth of visual and archaeological evidence at such French sites as Lascaux, Trois Frères and Chauvet (opposite top) and Kapova in Russia, many questions remain unanswered. What motivated people to decorate caverns too deep ever to have been habitable? Who did the painting? And how should the images be interpreted? The consensus now is that Palaeolithic art was at least as much about giving form to the invisible – to conveying ideas – as about capturing the real-life appearance of large quadrupeds. It was performing, in other words, one of the defining functions of art.

Caves could have been decorated because they were important for other reasons, or gained their significance from the paintings. Both possibilities are inherent in Altamira's sobriquet 'the Sistine Chapel of Cave Painting'. Either way, Palaeolithic painters creatively exploited every available surface. They used timber scaffolding to reach high ceilings and adapted natural rock formations in shaping their figures. Their limited palette, including red from iron oxide and black from manganese, was complemented by a range of techniques: spraying, stencilling, engraving, charcoal drawing, brushing and applying pigment by hand. This skilled work evidently also had a communal element. Sites were reworked over long periods, and handprints in painted caves occasionally include those of children.

Despite the tenuous parallels, it was once fashionable to interpret European cave art in the light of anthropological studies of present-day hunter-gather cultures, notably the cave and rock art of Aboriginal Australians (opposite bottom). The latter tends to be found in rock shelters and overhangs rather than deep caverns, and its subject matter often relates to surviving oral traditions. Paintings in the western Kimberley ranges represent Wandjina creator spirits and hero ancestors; their continuing spiritual importance means that they are carefully maintained.

Cave and rock art didn't entirely die out in Europe as settled farming communities replaced the hunter-gatherer way of life. Exposed rocks in western Sweden are animated with shallow carvings of schematic human figures (above), probably around 2,500–3,500 years old. Whereas Palaeolithic painting rarely shows human or humanoid figures, these carvings include what seem to be narrative episodes. ∎

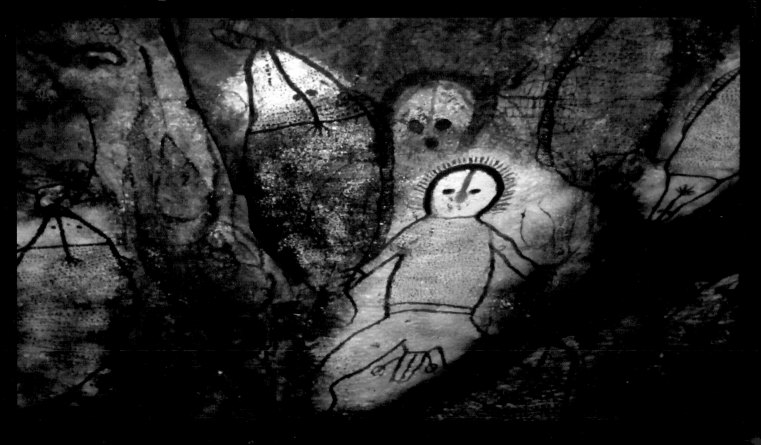

'Cave and rock art is by far the longest-lived form of artistic expression.'

Earthy cosmologies

BELOW: *Clay is the primal material of life itself in Antony Gormley's* Field for the British Isles *(1989–2003), which consists of thousands of rudimentary but individual humanoid figures, gathered in a crowd whose collective, atavistic gaze confronts the viewer.*

OPPOSITE: *Mesoamerican cultures used basic techniques to produce a wealth of decorated pottery and fired clay sculpture. This life-size Eagle Warrior is a rare example of large-scale Aztec clay sculpture that survived the Spanish conquest.*

IDEA Nº 2
FIRED CLAY

The basic technique of hardening clay objects in a fire has been practised for at least 30,000 years. To begin with, the firing process may have served a ritual purpose and was used only for clay figurines. Some 14,000 years passed before anyone thought of firing clay for the more practical business of holding food and drink.

A female form with stumpy head, blank face and heavy, elongated breasts is one of the oldest fired-clay sculptures. She was unearthed, along with thousands of other female and animal figurines, at Dolní Věstonice, a site in the Czech Republic once occupied by Palaeolithic mammoth-hunters. These objects might have been made as amulets or even toys

– the 'Venus of Dolní Věstonice' bears the thumbprint of a young child who held her while the clay was still wet.

Clay is easily modelled by hand, and the process gives great tactile pleasure, making this a natural medium for small sculptures. Fired clay, or ceramic, is a material with profound symbolic resonance in many cultures: a common

feature of cosmological myths is the creation of the first humans from soil or clay. The firing process itself relies on an interaction of the elements of earth, water, fire and air. Fired-clay figurines are often associated with sacred sites or religious rituals, such as the ancient Egyptian practice of placing *shawabti* figures in tombs to tend the dead person in the afterlife. An 8,000-year-old statuette from Çatal Hüyük in Turkey shows a female figure seated on a throne with leopard's-head arm rests, apparently in the act of giving birth. The clay was modelled and incised to achieve a fully realised sculpture whose generous

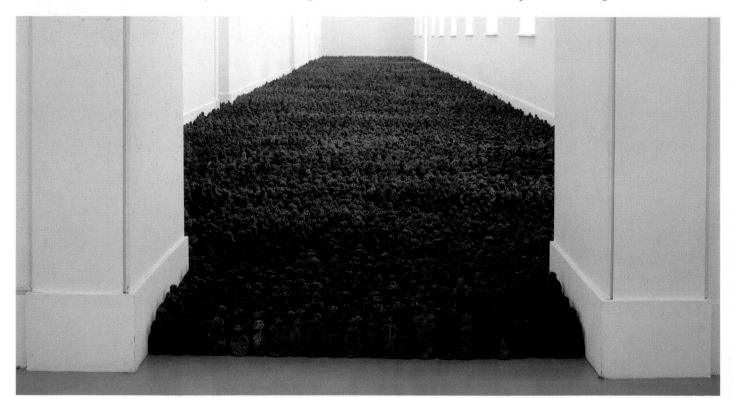

proportions belie its small size. In the region's later mythology, leopards were associated with the Mother Goddess.

Larger figures – such as the two fifteenth-century Eagle Warriors (right) discovered on the site of the Aztec capital Tenochtitlán (Mexico City) – were moulded or modelled from clay in several sections, and then joined by liquid clay, or slip, before firing. To prevent sculptures becoming too heavy or cracking in the heat, they were given hollow interiors, either by being assembled on an armature or scooped out when the clay had partly dried. The fact that clay is a cheap, everyday material, compared to marble or bronze, didn't prevent it being used in Renaissance Europe for high-status sculptures, as in Andrea del Verrocchio's terracotta portrait bust of Giuliano de' Medici (c.1475–78). It was also widely used for producing replicas of celebrated stone or bronze sculptures.

Sculptors continue to use clay for models of works intended for casting in bronze and for trying out ideas in small maquettes. In Antony Gormley's *Field* (opposite), clay's cultural associations with early societies and ritual are more important than its sculptural capabilities. This **installation** work has been re-created in numerous locations by amateur teams of makers assembled for the task. ∎

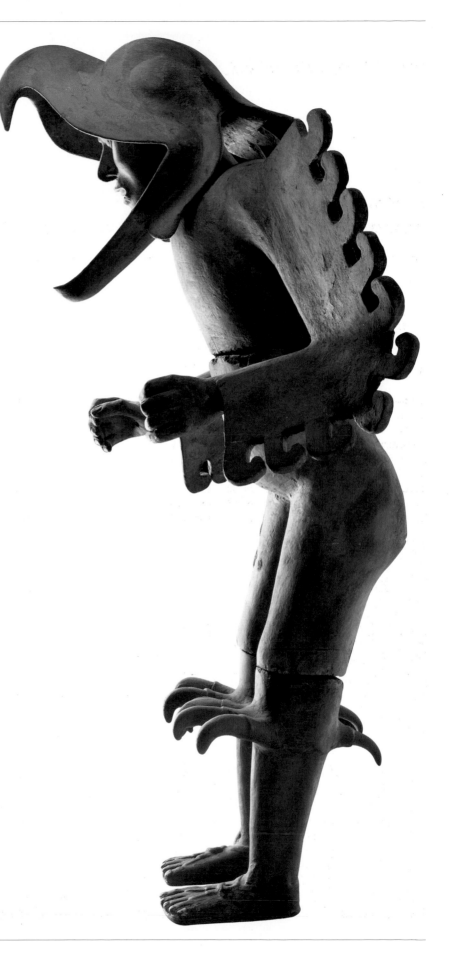

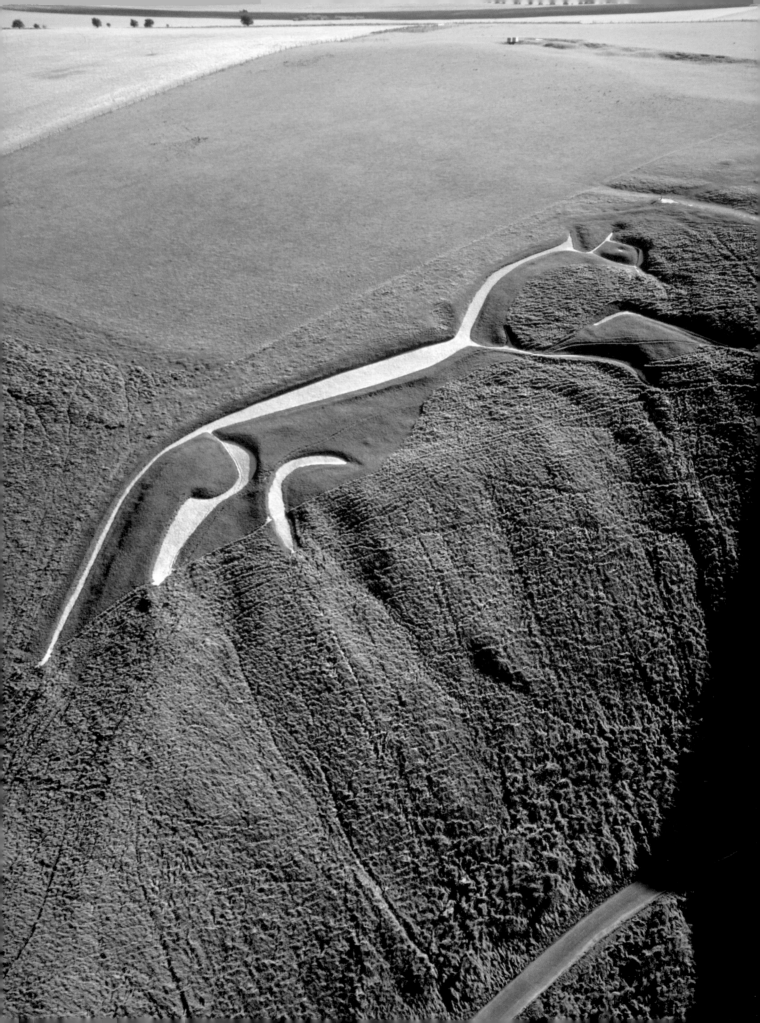

Symbolic shaping of the environment

IDEA Nº3
LAND AS MATERIAL

Early societies were capable of devoting vast collective resources to the symbolic shaping or marking of their environment. Modern artists have been no less ambitious, but whereas the earliest 'land art' attempted to tame its physical surroundings, the contemporary version addresses the fragility as well as the power of the natural world.

Using only basic technology, early societies quarried and transported enormous stones, shifted tonnes of earth and inscribed gigantic patterns in the land's surface. Monuments such as the alignments of single standing stones, or menhirs, erected around 5,000 years ago near Carnac in Brittany were clearly not designed for shelter, defence or agriculture. Their motivation may instead have been to render the environment intelligible – the form of the land and the changes in the sky and seasons – in the same way that a line immediately orients a blank page or a mariner takes bearings from a daymark (a structure on land such as a tower used to navigate by).

In some places people carved designs in the land's surface. The acts of cutting into the ground and visually comprehending the resulting shapes were completely separate, since the shapes only made sense when seen from a great distance. Whether intended to be viewed or experienced through walking, this early land art was essentially conceptual: putting the idea into practice was a matter of simple spadework.

The most striking example consists of linear patterns, geometric and animal forms etched across 450 square kilometres of pampa near Nazca in Peru. These 'Nazca Lines' are thought to be around 1,500 years old. They were rediscovered from the air in the 1930s and are only fully intelligible from a high altitude. On a more modest scale, English hill figures such as the 114-metre-long Uffington Horse in Oxfordshire (opposite) were created by digging trenches into the downland's chalky substrate. As with the Nazca Lines, it's hard to tell how this spare, calligraphic design was communicated to workers on the ground. Elsewhere, monumental forms were created by piling up earth. The largest such effigy mound is the Serpent Mound in Ohio, in the shape of a 430-metre-long snake with a tightly coiled tail.

European and American land art of the 1960s onwards referred both to the assumed spiritual associations of prehistoric structures and to contemporary concerns about our relationship with the environment. The terms were now reversed: where early societies may have aspired to tame or comprehend their environment's scale and power, the modern land artist aimed to restore a sense of physical humility and awe to the relationship. American artists such as Robert Smithson and James Turrell worked on a grand scale in which art either shaped or took its shape from landscape. At the more intimate end of the spectrum, British artists approached landscape more as a source of poetic metaphors, as in the transience and fragile beauty of Andy Goldsworthy's sculptures made from leaves, twigs or ice. ■

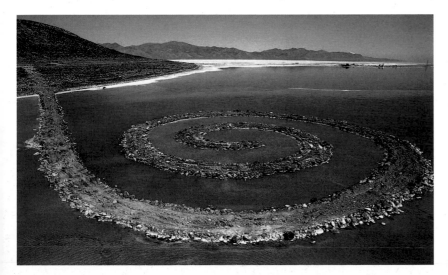

The embodiment of power

IDEA Nº 4
STATUE

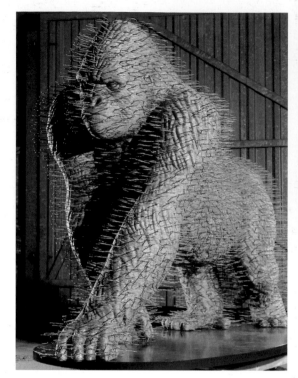

Statues are free-standing figure sculptures, typically of a single human form, sometimes a group. From the ancient world to the present day, publicly displayed bronze and stone statues have served complex social and political functions, providing a focus for both worshippers and the activities of revolutionary mobs.

The word statue comes from the Latin verb *stare*, to stand. Statues stood where they could be viewed or venerated, in sacred or civic spaces, conveying the influence of whoever commissioned them and the importance of the deity or individual they represented. The creation of a statue – usually a lengthy, expensive operation – gave sculptors scope to display and develop skills, and to participate indirectly in the mystique of spiritual and temporal power.

Statues played a potent role in ancient Mediterranean and Mesopota-

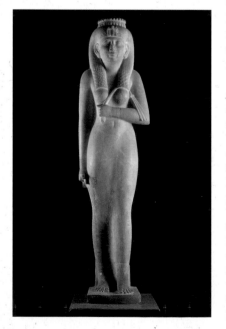

mian civilisations, as a form of alter ego wherever it was essential for a living ruler, dead ancestor or invisible god to assume manifest presence. Egyptian royal statues evolved a closely controlled repertory of poses, emphasising the pharaoh's suprahuman role beyond the individual characteristics of the man who fulfilled it. Greek sculptors of the fifth century BC were the first named artists whose fame in their own time was matched by their subsequent reputation. They owed their renown largely to statues commissioned as gifts or thank-offerings in temple precincts. Most statues made in the West from the fifteenth century onwards involved a formal dialogue with the types and techniques established by Greek sculptors.

Legends attributed miraculous or demonic abilities to speak and act to certain statues, like that of the Commendatore in Mozart's opera *Don Giovanni*. The frenzied destruction of statues, such as those of the KGB's founder Felix Dzerzhinsky in Moscow in 1991 and Saddam Hussein in Baghdad in 2003, reveals the passionate superstition that still attaches to statues and their symbolic possession of the ground on which they stand. During the twentieth century, outside culturally regressive totalitarian states, mass media overtook public statues as the chosen vehicle for omnipresence. Contemporary statues often critique or parody the statue's traditional roles.

BOTTOM LEFT: By giving his sister Amenirdis the position of wife of the god Amun, the eighth-century BC Kushite king Piye consolidated his power in Egypt. In the statue of Amenirdis, a foreign dynasty adopts the look of Egyptian sacred authority.

ABOVE: David Mach's Silver Back (2007–08), made not from bronze or stone but from metal coat-hangers, constructs a forceful individuality from throwaway, mass-produced materials.

Statues have an uncanny tendency to become more famous than their makers. Comparatively few people could name the sculptors responsible for the *Statue of Liberty* in New York harbour (Frédéric-Auguste Bartholdi), *Eros* in Piccadilly, London (Alfred Gilbert) or the *Bronze Horseman* in St Petersburg (Etienne-Maurice Falconet). Michelangelo's *David* (see p.97) is a rare exception. But is it possible to separate famous statues from their multifarious meanings, to view them primarily as works of art? *David*, for example, was originally installed in public view in the centre of Florence, as a muscular biblical symbol for the young Florentine Republic. The statue subsequently became a cipher for the idea of the Renaissance, a homoerotic icon and a logo for Italian tourism. ∎

Spatial transformations

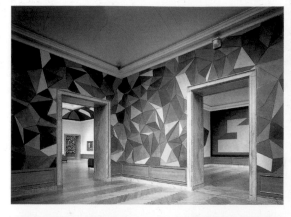

IDEA Nº 5
WALL PAINTING

While walls perform their function irrespective of decoration, wall paintings tend to make play with or even subvert functionality. Ceiling frescoes showing airborne dramas involving clouds and deities give the illusion that enclosed rooms are open to the heavens. Historical or mythological episodes turn blank surfaces into vehicles for fantasy or indoctrination.

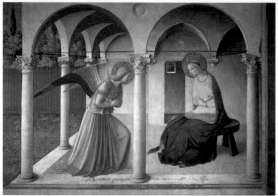

TOP: Sol LeWitt's 1993 wall installation in Andover, MA, recalls his earlier Minimalist sculptures based on serial configurations of geometrical units. Like mathematical diagrams, it is conceptual and can be recreated on different walls in other places.

ABOVE: On reaching the top of the stairs to their dormitory corridor, the friars of San Marco knelt before Fra Angelico's fresco of the Annunciation – the moment when the Virgin Mary learns that she is carrying God's child.

The decoration of rock-cut Egyptian and Etruscan tombs shows wall painting working hard to overcome the brute architectural fact of tomb burial: a dark, sealed space containing a corpse. Artists transformed such spaces into congenial habitations for the dead, equipped for sustenance and pleasure. In the fifth-century BC Tomb of the Triclinium at Tarquinia (opposite), figures of dancers, musicians and banqueters were painted on a plaster ground applied to the tomb wall. The dead seem to be enjoying an Etruscan feast of the kind described by the first-century BC Greek historian Diodorus Siculus, where 'tables groan under the weight of the luxurious fare ... shaded by canopies threaded with flowers'.

Wall painting techniques involve using either a binder, so that the paint sticks to the surface, or applying a smooth coating suitable for painting. In the fresco ('fresh') technique, the final layer of plaster (*intonaco*) is painted before it dries, so that pigment is incorporated into the surface. Fresco was practised in the ancient world, in China and elsewhere, and occasionally in modern revivals, but the technique is particularly associated with wall paintings in Italian religious buildings from the fourteenth to the seventeenth centuries. Whereas other types of wall painting decay over time and with expo-

sure to the atmosphere, frescoes are extremely durable. Giotto's great fresco cycles in churches in Padua and Florence survive substantially intact after almost 700 years.

Along with **architectural sculpture**, wall painting was a traditional medium for public art. Painters could make audacious use of the spaces they were commissioned to decorate. With Michelangelo's Sistine Chapel frescoes, and many lesser examples, the viewer's simple act of raising their eyes to the ceiling was intended to lift them imaginatively beyond the boundaries imposed by the architecture. Frescoes painted in the 1440s by the artist-cleric Fra Angelico in the dormitory areas of the monastery of San Marco, Florence (right above), function differently. Here they transform the inmates' simple living spaces into places of spiritual communion.

Investment in wall paintings generally assumes that people – the dead, for example, or members of a religious order – will be spending a lot of time in the decorated space or that they need to be impressed and persuaded by what they find there. The spatial transformations created by recent wall painting, like the painted rooms designed by Sol LeWitt (right top), have a more disruptive theme but are still essentially about entrance to a perceptual territory to which the wall itself provides no obstacle. ■

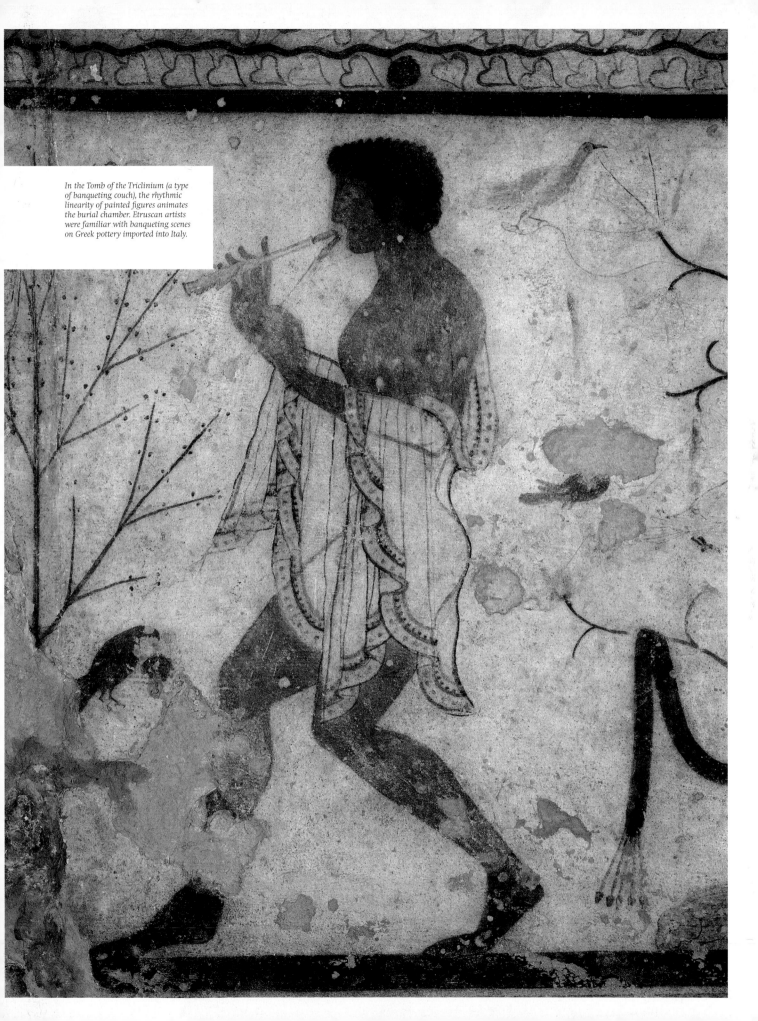

In the Tomb of the Triclinium (a type of banqueting couch), the rhythmic linearity of painted figures animates the burial chamber. Etruscan artists were familiar with banqueting scenes on Greek pottery imported into Italy.

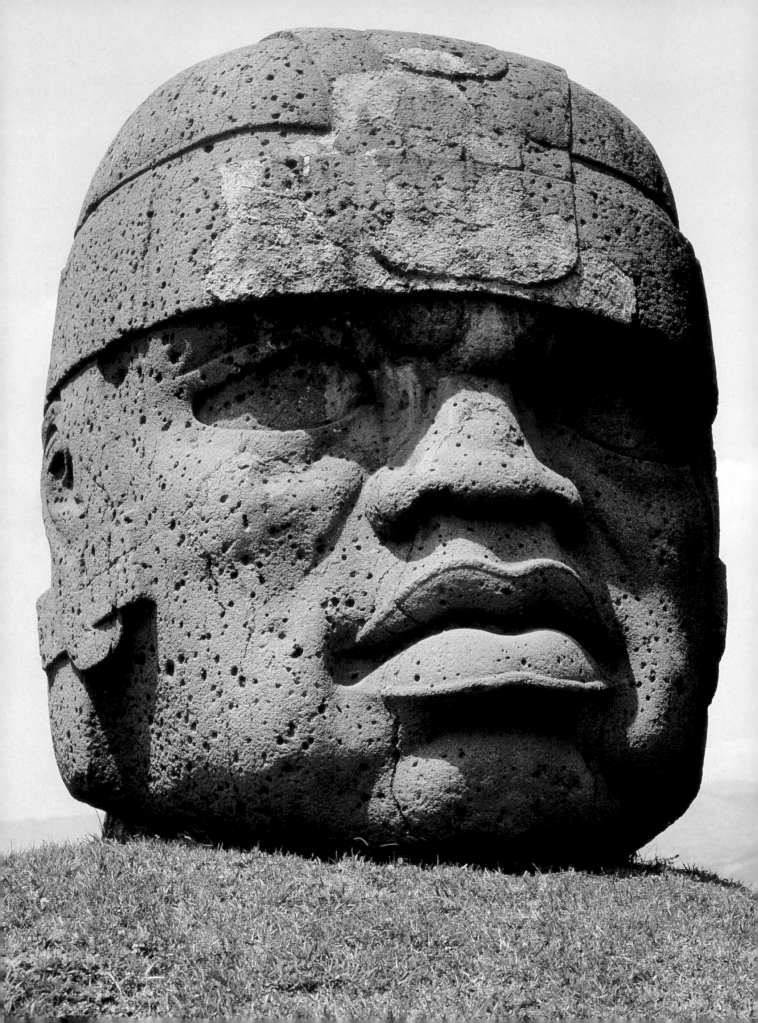

From bombast to irony

IDEA № 6
SCALING UP

Scale is a diluted concept in contemporary culture. We feel that much that can be communicated by a work of art comes across well enough at the uniform scale of a book page or laptop screen. Throughout history, however, outsize objects and images have been a powerful means of compelling attention and commanding awe.

Scaled-up sculpture before the mid-twentieth century has a history of association with the propagandistic bombast of despotic regimes. This is generally the case with ancient colossal art, most of which represents figures of deities or rulers. Whereas life-size images allow these beings to be present in different locations, colossal effigies –for example, the two monolithic statues of the Egyptian pharaoh Amenophis III near Thebes, known as the Colossi of Memnon, which stand 16 metres tall – magnify the impact of that presence by appearing to be the work of superhuman skills and strength. The same is probably true of the basalt heads found near San Lorenzo Tenochtitlán in Mexico (opposite), some measuring up to 3 metres high, which are thought to represent Olmec chiefs.

Gigantic statues are not usually the focus for technical experimentation – most are conventional figures in formal poses. Not all are designed to subdue the beholder. Buddhist sculpture has a tradition of colossal cult images carved directly into the rock at sacred sites. The earliest was a 38-metre-high rock-cut Buddha from about the second/third century AD that once stood in the cliff face at Bamayan in Afghanistan. Together with its later, taller (55-metre) twin, it was destroyed by the Taleban in 2001.

In most contemporary colossal sculptures scaling up has become a *jeu d'esprit* involving vertiginous, Alice-in-Wonderland reversals of proportion that could equally feel comic or threatening.

Well-known examples include Claes Oldenburg's and Coosje van Bruggen's monumental versions of such ordinary objects as a clothes peg or a spoon (left), Jeff Koons's monster-size inflatable toys, and Christo and Jeanne-Claude's wrapping of famous buildings to resemble ordinary postal packages. With its two-way action of uplift and bathos, this mode of scaling up could be called kitsch-sublime. Even in the absence of ironic intention, Antony Gormley's *Angel of the North* (1998), a gigantic mascot in the form of a human figure with outstretched aeroplane wings, fits this category.

Giancarlo Neri's *The Writer*, installed on London's Hampstead Heath in 2005, consisted of a 9-metre-high chair and table made of wood-veneered steel. The effect wasn't to glorify tables, chairs or writers, but to use scale to excite or entertain viewers. Contemporary scaling up doesn't always involve, as it did in the past, technological and physical challenges that stretch a society's resources to the limit, but it still gives the work of art the upper hand – there is no arguing with something that is several times life-size. ∎

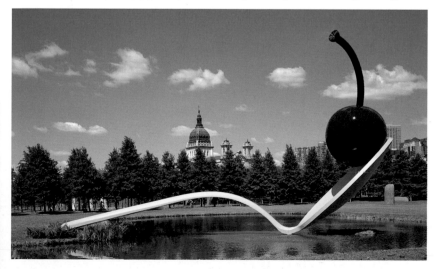

Ways of telling

IDEA № 7
NARRATIVE

Whereas stories are diachronic – they take time in the telling and involve the unfolding of events through time – visual images work synchronically, being interpreted almost instantaneously by the viewer. Visual artists have therefore developed a wide range of strategies for the task of storytelling.

Telling stories is a universal cultural activity. In education, religion, community life, politics, advertising and entertainment, stories are the means of communicating messages and inculcating values. As narrators, artists usually either present a new slant on a story already familiar to their viewers or employ well-established visual conventions to tell an unfamiliar story. Even simple narrative scenes and sequences require interpretation on the part of the viewer, and once their content or artistic conventions cease to be common currency, they can lose their power to communicate or, conversely, gain a completely unforeseen meaning.

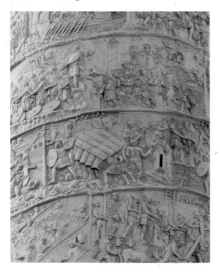

On Trajan's Column in Rome (bottom left), erected in 113 AD, visual narrative exploits the conventions of oral or written storytelling, such as the reappearance of the hero in a series of exploits. It also does something beyond the reach of literary art by allowing **multiple viewpoints** and keeping up a carefully orchestrated background theme of constant, purposeful military activity and ascent towards conquest. Told in a continuous low-relief scroll that spirals up the column – the work of teams of carvers – it represents scenes from two campaigns in Dacia (modern Romania) fought by Emperor Trajan. Although the detailed figures of around 2,500 Roman soldiers, together with equipment, buildings and landscape features, suggest scenes of reportage, the storytelling style is actually more like comic-strip frames, in which the figure of Trajan appears some 60 times in separate episodes.

Visual narrative can sidestep the storyteller's reliance on before and after by conflating time-sequenced events in a single scene. This is what happens in Masaccio's fresco *The Tribute Money* (c.1427, main image) in the Brancacci Chapel in Santa Maria del Carmine, Florence, which shows an episode from St Matthew's Gospel. Jesus instructs his disciple Peter to go fishing – the fish he catches will contain in its mouth the temple tribute money demanded by a tax collector. In the central

group, the tax collector confronts Jesus and his disciples; to the far left, Peter lands the fish and discovers the coin; and to the far right he pays the tribute money. The episodes are out of sequence but the story loses none of its integrity.

Moving-image media such as cinema and television, whose primary functions are to provide information and entertainment, usually employ conventional narrative styles in which actions follow in time sequence and images are explained. Video artists attempt to

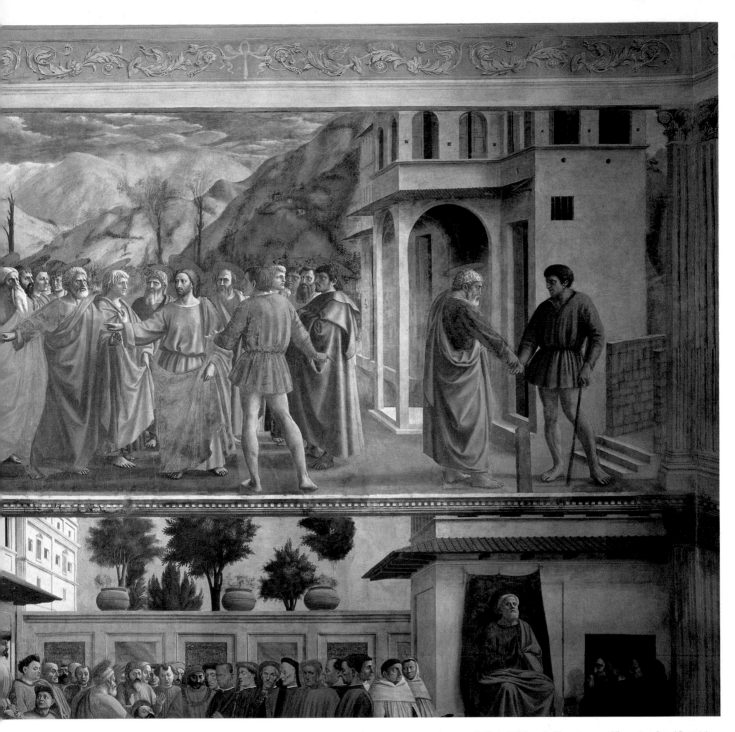

reclaim the moving image for art by disrupting such narrative expectations. Kerry Tribe, for example, has produced video works that mimic conventional television interviews but in which the narrative simultaneously moves forwards and loops back on itself as her subjects struggle with the scrambling of sequentiality created by memory loss or the dislocations of psychological trauma. ∎

OPPOSITE: *On Trajan's Column in Rome significant moments in the story of the emperor Trajan's Dacian campaign are grouped to align vertically, so that they make sense from several standpoints when viewed from the ground.*

ABOVE: *Like a mime show, Masaccio's* Tribute Money *fresco conveys the drama of emotionally charged confrontation and resolute action even to modern viewers unfamiliar with the biblical story.*

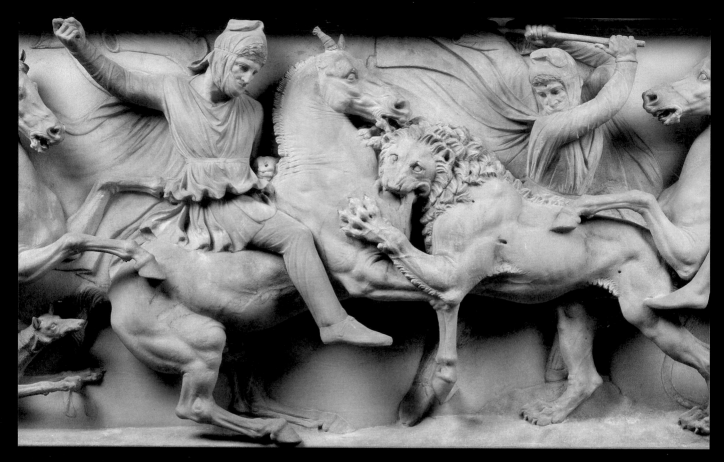

'Outstretched limbs of soldiers and horses are fully three-dimensional, as though surging towards the viewer.'

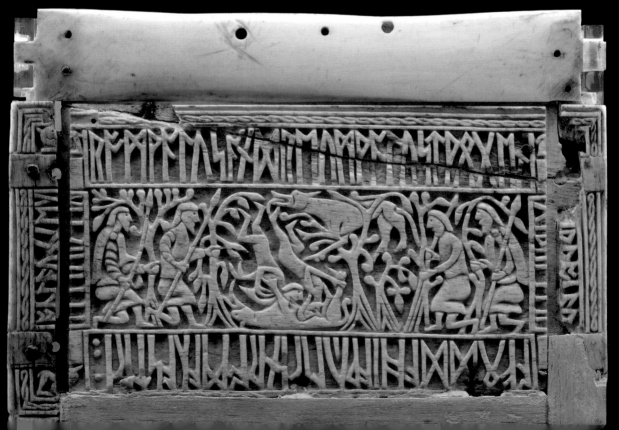

Sculpted surfaces

IDEA № 8
RELIEF CARVING

Relief carving – from the Italian *rilevare*, 'to lift' – creates forms that project from a surface but are not completely detached from it. Relief work is an integral part of the object or building it decorates and is especially effective for figurative groups and **narrative** sequences.

Relief sculptures are made by cutting away material from around shapes so that they stand out. They are classified as *basso* (low), *mezzo* (middle) or *alto* (high) *rilievo*, depending on what proportion of a figure's depth projects from the surface. Sculptors in ancient Mesopotamia, Egypt, Greece, Rome, Mesoamerica and India variously developed relief carving into a sophisticated, versatile art form, using the blank surfaces of stone buildings or tombs as vehicles for images. As exterior architectural decoration, reliefs are much more durable than paint, although ancient reliefs were often painted as well. Relief work on small artefacts, such as gems and caskets, provided scope for virtuoso exercises in microcarving.

Figures carved in relief have more freedom of movement than statues, which have to support their own weight. The fifth-century BC mythological reliefs of rearing centaurs and agile warriors from the Parthenon in Athens would have been impossible to realise as free-standing sculptures. Advances in ancient technology, such as the availability of iron tools and the use of drills for under-cutting enabled later Greek sculptors to exploit high relief to dramatic effect, as in the elaborate decoration of the fourth-century BC Alexander Sarcoph-agus (opposite top), discovered near Sidon in the Lebanon or the second-century BC Altar of Zeus at Pergamon. In a long panel on the sarcophagus showing Alexander the Great fighting Persian forces at the Battle of Issus, outstretched limbs of soldiers and horses are fully three-dimensional, as though surging towards the viewer in vivid counterpoint to the turbulent lateral rhythm.

Artists have often seen relief carving as a form of sculpture that relates to painting. Michelangelo thought that 'painting should be considered excellent in so far as it approaches the effect of relief, while relief should be considered bad in so far as it approaches the effect of painting'. Commenting on Andrea Mantegna's mock-relief painting *Cybele* (a tribute to Roman relief carving), Bridget Riley observed how 'the background is physically and perceptually integrated with the foreground'. Another feature of relief carving is its capacity to give equal weight to verbal and visual messages, as on the eighth-century whalebone box known as the Franks Casket (opposite bottom).

In twentieth-century Western art, relief carving – like stone carving in general – often carried overtones of ancient, medieval or '**primitive**' sculp-ture. Reliefs by the British sculptor Eric Gill (above), who also specialised in carved lettering, reveal his fascination with medieval sculpture and Indian **erotic art**. Gill's facility in combining images and lettering led to a series of commissions for reliefs between around 1910 and 1940. These played the tradi-tional architectural role of relief carving in sacred and public buildings, such as Westminster Cathedral and Broadcasting House, London (see pp.38–39), but Gill also wielded the medium on a smaller, illustrative scale to give a teasing gravitas to the fleetingly erotic. ∎

OPPOSITE TOP: *This detail from the Alexander Sarcophagus shows a lion hunt involving Macedonians and Persians. As in the battle scene on the opposite side, the carving is taken to the limits of high relief.*

OPPOSITE BOTTOM: *Relief work on the Franks Casket combines text in the form of Anglo-Saxon runes with scenes from Christian, Jewish and Roman stories – shown here are Romulus and Remus, twin founders of Rome, being suckled by a wolf.*

ABOVE: *Eric Gill's Dancing Couple (c.1928) formed the keystone to a bedroom balcony door at Shepherd's Hill House in Sussex. Gill described his carvings as 'not only born but conceived in stone ... in their innermost being'.*

Skin deep

BODY AS SURFACE

The practice of branding or tattooing has been used on slaves and prisoners since at least ancient Egyptian times. But in many cultures the human body is also seen as a surface to be marked and decorated using patterns and techniques that constitute an art form in their own right.

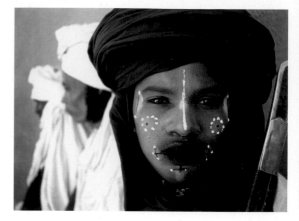

BOTTOM LEFT: *Body politics: in the 1970s Hannah Wilke created a series of 'performalist self-portraits'. In this 1974 image, the chewing-gum 'scars' transform a spat-out consumable into ritual cicatrices that both announce and disfigure the artist's sexual identity.*

ABOVE: *The Wodaabe are a nomadic people of the Sahara Desert. When competing for marriage to Wodaabe women from other clans, the men apply make-up to enhance desirable features such as white teeth or an elongated face.*

Permanent designs and inscriptions made on the skin are usually a means of announcing a person's identity as a member of a particular social group. Tattoos are made by injecting ink under the skin, while cicatrisation involves cutting the skin and inhibiting the healing process so that raised scars form. Impermanent methods, such as body painting, often have more to do with temporary roles assumed during ritual performances, as in the Nuba ceremonies photographed by Leni Riefenstahl in the Sudan in the 1960s

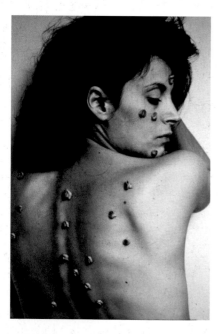

and 1970s or contemporary Wodaabe face painting (above).

Examples of tattooing as an art form dating from as early as the fifth century BC were discovered in a burial mound at Pazyryk on the borders of Russia, Mongolia and Kazakhstan, where the tattooed body of a chief was preserved in permafrost. From the sections that survive, it looks as though his whole body was decorated with stylised images of animals, fish and curving vegetal forms. From the seventeenth century onwards in Japan, the art of tattooing attained painterly finesse, and the most skilful practitioners were highly respected. Using multiple needles on bamboo shafts and several colours, they created subtle variations of light and shade as well as linear patterns and blocks of colour. A 1990 polyurethane body stocking by the fashion designer Issey Miyake incorporates traditional Japanese tattoo motifs combined with images from Western mass culture.

Whereas Japanese tattooing was largely a matter of personal taste, the Maori tattoo art of New Zealand expressed social status and group affiliation. The tightly packed swirling designs relate closely to the repertory of traditional motifs used in wood carving. They were produced in a similar way, in a painful procedure that involved gouging channels in the skin with a sharp tool, then filling the wounds with pigment.

Since the 1960s, in response to the ubiquitous manipulation of body images in mass media, the human body has become a highly politicised surface for art. In her S.O.S: Starification Object Series (1974–79, left), Hannah Wilke photographed her own naked torso in glamour-model poses, bearing what resembled tiny scars – in fact vulva-shaped lumps of masticated chewing gum. In *Snow White*, her 2001 video piece on the theme of skin colour, the black South African artist Berni Searle sat naked while slowly turning white in a cloudburst of flour. During the 1990s, the French performance artist Orlan literally intercut art history and body marking by undergoing a series of elective surgical operations to reshape her own features to resemble those in celebrated works of art, such as the forehead of the *Mona Lisa*. ∎

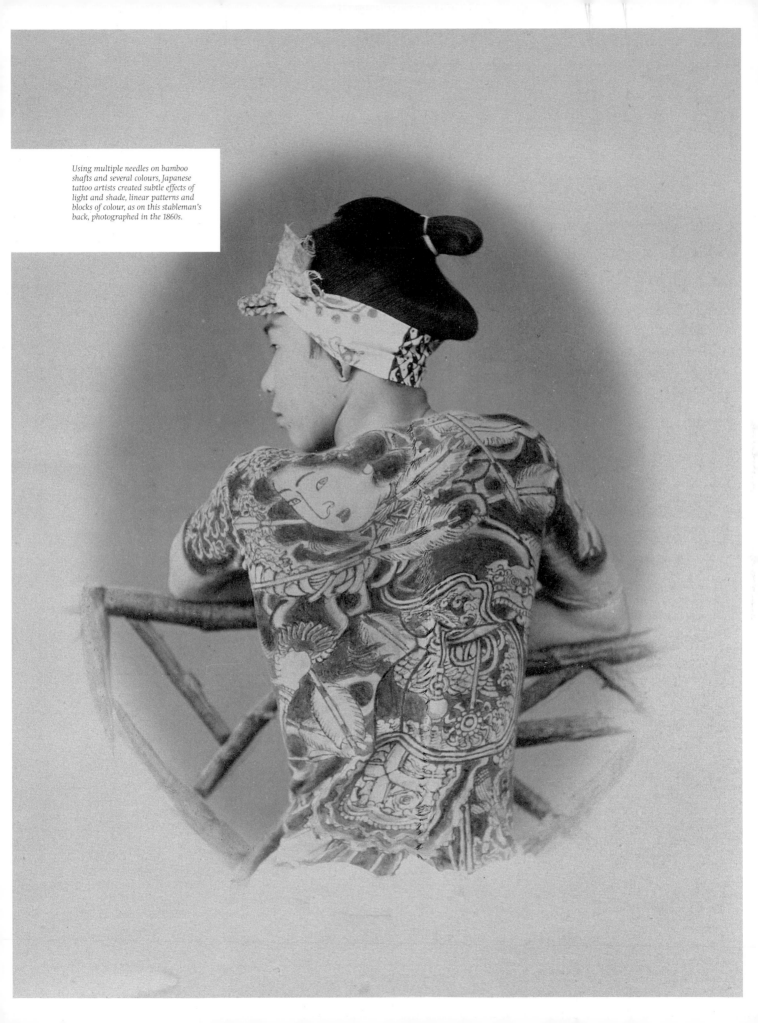

Using multiple needles on bamboo shafts and several colours, Japanese tattoo artists created subtle effects of light and shade, linear patterns and blocks of colour, as on this stableman's back, photographed in the 1860s.

Naked truth

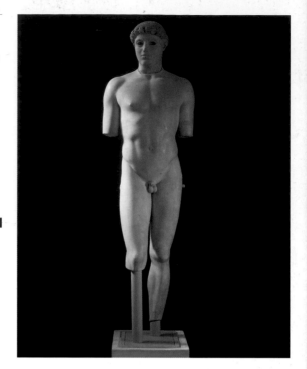

IDEA № 10
THE NUDE

Since the fifteenth century, the practice of life drawing has fostered the idea that the naked body is an unfailing test of an artist's skill and source of inspiration. Far from being a universal subject, however, the physical fact of nudity has tended to engage artists at times and in places where nakedness has carried particular ideological freight.

OPPOSITE TOP: In his Venus of Urbino *(1538), Titian provocatively conflated the ideal beauty of a Classical goddess and a contemporary interior. The clothed servants and the nude mistress seem to occupy parallel, barely connected worlds.*

OPPOSITE BOTTOM: For Matisse the female nude was an inexhaustible source of formal discovery and variation. Twenty-two successive stages of Large Reclining Nude *(1935) are documented in photographs. To fine-tune the pose, Matisse pinned cut-out paper shapes to the canvas.*

In contemporary visual culture, when the naked body is not being presented as an object of desire, often in order to arouse desire for commercial products, it frequently presents a meditation on the human condition, connoting the vulnerability of flesh. The hyperreal corpse in Ron Mueck's sculpture *Dead Dad* (1996–97) or Lucian Freud's unself-consciously obese *Benefits Supervisor Sleeping* (1995) echo Classical nude figures of fallen warriors or sleeping Venuses, but their nakedness also recalls medieval European art, in which it signifies the stripping bare of the soul, as in scenes of the Crucifixion or hell.

As an art-historical category, on the other hand, 'the nude' has more positive associations. It means the naked body as a focus for interest and skill in its own right – the embodiment of ideals of beauty and truth. And, although naked figures occur in other artistic traditions, such as Hindu temple sculpture, the nude as a subject for Western sculpture, painting and photography almost always refers in some way to the representation of the naked body pioneered by fifth-century BC Greek sculptors. While nakedness involves many registers of meaning, nudes are either Classical or otherwise.

Greek sculptors' preoccupation with the young male human form has shaped later Western concepts of the body, beauty and art. But why were Pheidias, Praxiteles and others so driven to get things right – to observe, in the absence of detailed anatomical knowledge, how skin, muscle and bone worked together, and to refine the formidable skills necessary to capture their interaction in sculpture? The fact that Greek gods were visualised in human form must be part of the explanation. Intellectual and ethical life had, moreover, a strong physical dimension: notions of proportion applied equally to the body, music, mathematics and architecture.

Female nude statues were a later development, connected to the cult of Aphrodite and, later still, to Roman habits of private worship and art collecting, which took sculpture out of the public, sacred realm and into patrician homes. In the fifteenth century, after a thousand years of clothed Christian propriety, Greek and Roman art re-entered European consciousness; by the early sixteenth century paintings of nude women purporting to be goddesses were becoming an art-market staple. The Classical mythological contexts of such Renaissance nudes as Giorgione's *Sleeping Venus* or Titian's *Venus of Urbino* (opposite top) released these figures from the Christian association of the body with sin and shame. Though their nudity was clearly sexual, it was also coloured by Classical-humanist thought, in which the viewer might hope to learn, via the enjoyment of beauty, the way to truth. As John Donne's seduction poem 'On His Mistress Going to Bed' runs: 'As souls unbodied, bodies uncloath'd must bee/ To taste true joies'. Henri Matisse was the last great painter of nudes in this European tradition. The sensuality of his female nudes (opposite bottom) is, as in Titian's, both intensely present and poetically abstracted, as though focused beyond the physical facts, on another form of truth – in his case, the truth of line and colour rather than humanist philosophy. ∎

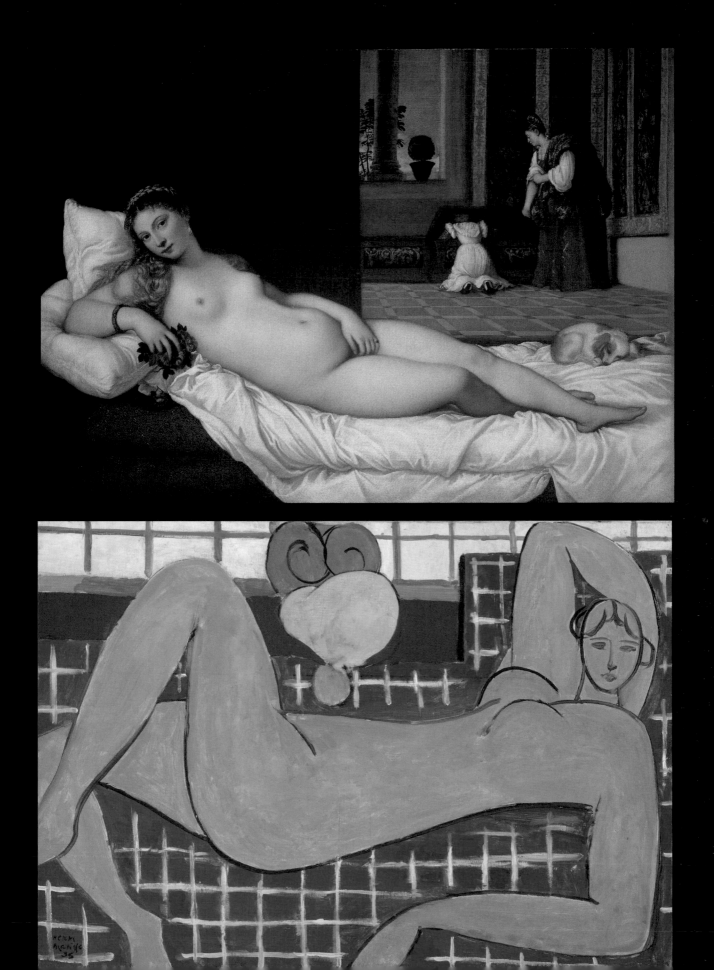

Making statues move

BOTTOM LEFT: *If* contrapposto *is all about movement, what happens when you put it into action? In 1968 performance artist Bruce Nauman spent an hour walking as the* Doryphoros *might have walked.*

OPPOSITE: *Polykleitos was credited with 'the idea that statues should stand firmly on one leg only'. Greek artists were said to derive the rules of art from his* Doryphoros *'as if from a law'.*

IDEA № 11
CONTRAPPOSTO

Greek sculptors in the fifth century BC found ways of endowing their statues with an unprecedented sense of vitality. *Contrapposto* was the name later given to poses that made it look as though a standing figure were in the act of moving.

The term *contrapposto* (Italian for opposite) implies balance or contrast – between, for example, stasis and movement. The development of classic *contrapposto* revolutionised the way sculptors could represent the human figure. Its effects can be clearly seen in the *Doryphoros*, or 'Spear-bearer', by the Greek sculptor Polykleitos (*fl. c.*450–*c.*415 BC), which is known from Roman marble copies (opposite) of the lost original bronze. Instead of showing the young athlete as a symmetrical figure staring straight ahead in the manner of earlier Egyptian or Greek statues, Polykleitos shifted his subject's weight onto the right leg, so that the right shoulder is slightly lower than the left, while his left leg, flexed at the knee, with the foot just lifted, creates a supple torsion. This movement flows up through the body, as it turns on the spine's vertical axis. Although none of Polykleitos' original sculptures and only fragments of his writings survive, both profoundly influenced the practice and theory of Greek sculpture.

Like other legacies of ancient Greek artists, mediated through their Roman successors, *contrapposto* was enthusiastically reinterpreted by Italian sculptors in the early fifteenth century. Whereas medieval statues tended to be stiffly posed and frontal, Donatello's *St Mark* combines traditional Christian iconography and Classical *contrapposto* in one of those innovatory fusions that define the Italian Renaissance. A century later, Michelangelo was testing *contrapposto* to its limits in marble figures whose limbs and torsos stretch and twist with strenuous restlessness, such as his *Rebellious Captive* (*c.*1513–16), carved for the tomb of Pope Julius II.

By the nineteenth century, *contrapposto* was a routine convention of figure sculpture, reiterated in public statues of national heroes the world over. Despite its weighty associations with the admired balance and serenity of Greek art and the controlled energy of Michelangelo's poses, however, there was still room for reinterpretation. The French sculptor Auguste Rodin – the Romantic era's nearest rival to Michelangelo – used *contrapposto* to strike a note of characteristically raw yet lyrical sensuality in his *Age of Bronze* (1876). The young male figure's torso turns with a fluid movement as, in contrast to Greek *contrapposto*, he raises his arms. In small-scale figure sculptures made by painters such as Edgar Degas or Henri Matisse, *contrapposto* loses some of its gravity and regains a sense of movement lightly caught rather than determinedly fixed. For late twentieth-century artists such as Bruce Nauman, who filmed himself walking *contrapposto*-wise (left), it was a formal cliché to be taken apart. ■

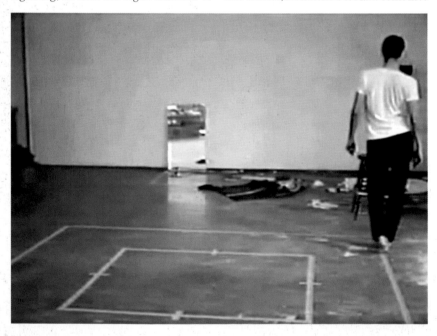

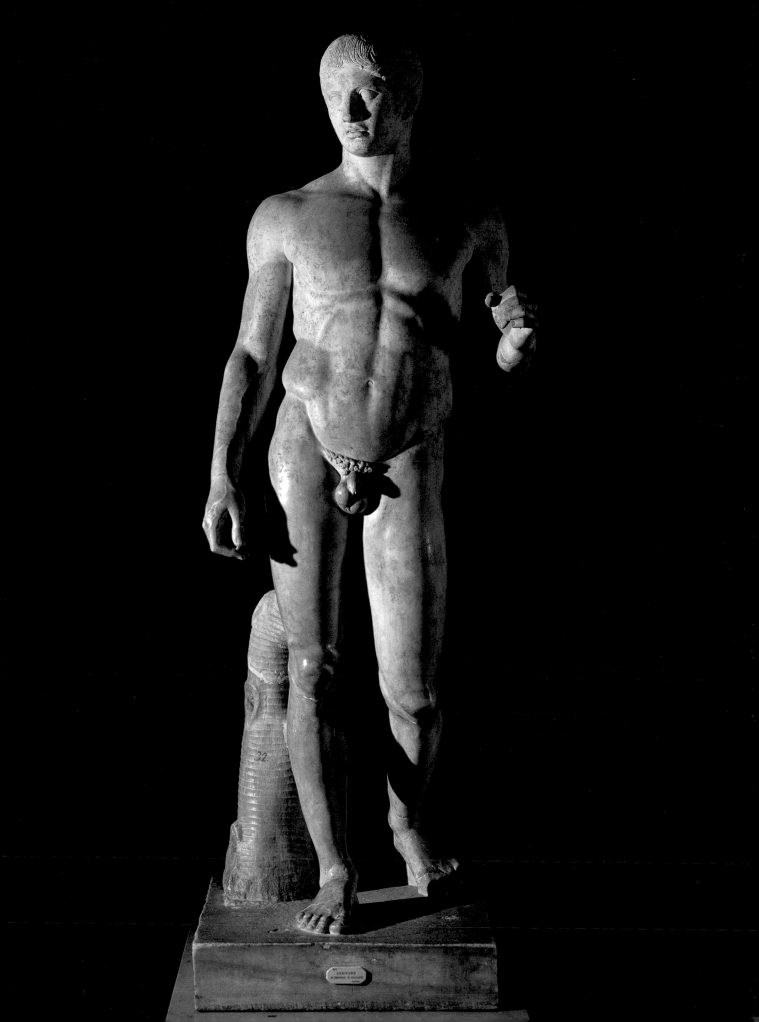

The art of persuasion

IDEA № 12
PROPAGANDA

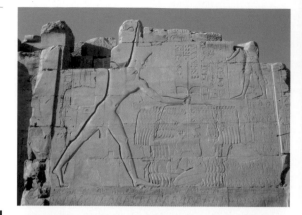

Though the word propaganda derives from the name of a council established by the Catholic Church in the seventeenth century to 'propagate the faith' overseas, the persuasive power of the visual arts has been enlisted by ruling elites and others throughout history, from Assyrian kings to modern totalitarian states.

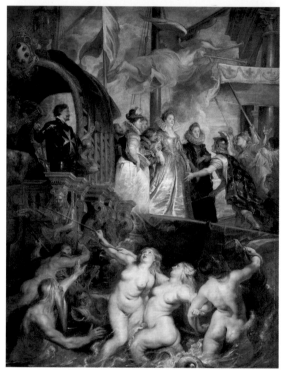

TOP: *The Egyptian artists who represented pharaohs smiting diminutive enemies, like Thutmose III on this temple wall at Karnak, may not have been expressing political support, but the conventions within which they worked had no language for dissent.*

ABOVE: *Rubens was a highly original artist, much of whose career was devoted to elaborating a sensuous mythology of power. Here Marie de' Medici, Queen of France, disembarks in Marseilles, attended by angels and water deities.*

RIGHT: *By placing Suprematism at the service of the new Soviet state, El Lissitzsky promoted the message that, under its leader Lenin, Communist society was determined to start from first principles, like progressive art.*

Since it is usually the dominant elites in any society who commission works of art intended for public view, these works often have propagandistic content. Far from corrupting or constraining artists, however, the demands of propaganda can elicit their best work – when viewed, that is, from a distant standpoint, either historically or geographically, where the messages the art contains are no longer backed by coercive force. In much state-sponsored and religious art from the ancient world to the present, almost the entire process of production is regulated by propagandistic requirements. Choice of imagery is controlled so that works are always 'on message'.

From the sixteenth to the nineteenth centuries, European artists found constant employment as makers of images that legitimated royal and aristocratic dynasties through Classical and mythological references or sheer visual splendour. Peter Paul Rubens's paintings of Spanish, French and English royalty (right below) in the seventeenth century performed much the same function as Joshua Reynolds's portraits of landowning oligarchs in the eighteenth and Jacques-Louis David's vision of Napoleon as a latter-day Roman emperor after the French Revolution. In practice, the display of artistic independence and the propagandistic requirements of patrons often worked in the same direction, since patrons might be paying for

a result that would astonish the audience by its audacity. Michelangelo's insistence on having complete independence in the design of the work commissioned from him by Pope Julius II – the Sistine Chapel ceiling and Julius' tomb – didn't stop the pope getting results that exceeded his expectations in terms of propaganda value.

The fact that artists have thrived on propagandistic commissions sits awkwardly with the modern view that progressive art should align with social radicalism against the establishment, but there are some notable twentieth-century examples. After the Russian Revolution of 1917, Suprematist artists found that the abstract visual language they had developed in the previous decade could be adapted for the new Soviet government's propaganda campaigns (opposite). El Lissitzsky's poster design *Beat the Whites with the Red Wedge* (1919–20) employs 'pure' geometric motifs of the kind earlier pioneered by Kazimir Malevich in order to exhort Communists (the Red Wedge) to pursue victory over the tsarist faction (Whites) in the civil war.

During the Cold War, abstract painting was again co-opted for state propaganda, this time by the US. The CIA funded the international promotion of Abstract Expressionism as a visual equivalent for the cherished American (that is, anti-Communist)

values of personal freedom and virile individualism. Artists didn't make their work in this propagandistic spirit, but their careers and those of their dealers benefited nonetheless. ■

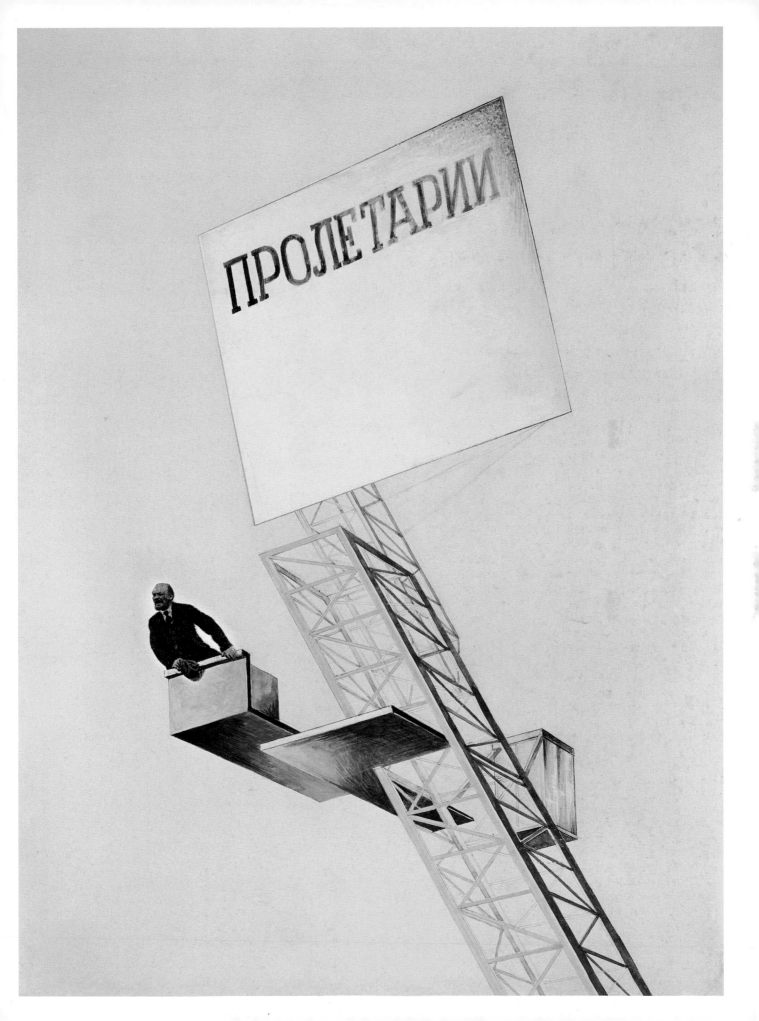

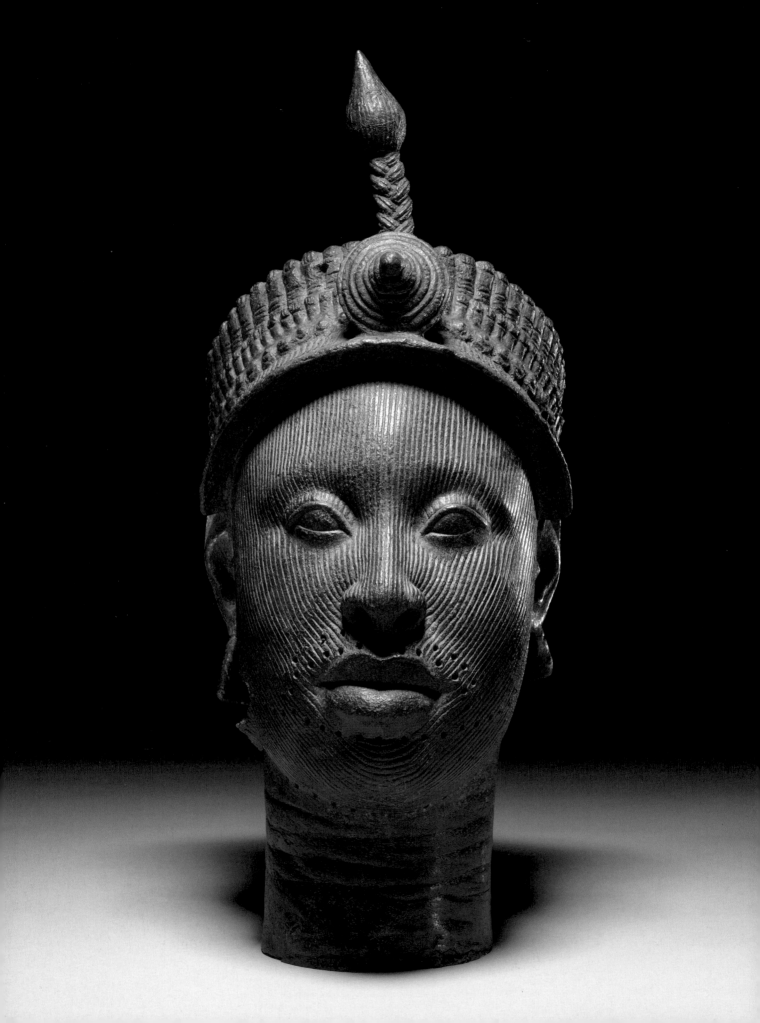

Breathing life into bronze

IDEA № 13

LOST-WAX CASTING

Learning to make tools and weapons by casting molten bronze in simple sand or clay moulds was a transformative prehistoric development. A later refinement of the technique known as the lost-wax method enabled bronzesmiths to cast large objects such as statues with fine detail and in startlingly lifelike poses.

The lost-wax (*cire perdue* in French) method was first practised by metal-workers in the Near East in the fourth millennium BC. Its most basic variant was direct lost-wax casting, in which a wax model was sheathed in clay, forming a mould. When molten metal was run into the mould, it melted the wax and took the form of the model. In the more complex indirect method, which by the sixth century BC was being used by Greek sculptors for life-size and larger statues, a mould was taken from a wax or clay model. This was then lined with a thin layer of wax and fitted with a clay core. Molten metal introduced through holes in the mould into the gap between it and the clay core melted the wax to create a hollow metal version of the original. Large objects such as statues were usually cast in sections, which were joined by soldering. In its essentials, this is the process still used today for casting sculpture in bronze (the collective term for alloys of copper).

Lost-wax casting greatly extended the range of poses available to sculptors. Bronze's high tensile strength enabled free-standing figures to stand or stride unsupported. The pose of the statue of Zeus or Poseidon from Cape Artemision, with his arms at full stretch as he aims a thunderbolt, would have been impossible to achieve in stone. Few ancient Greek bronzes survive, but they reveal a mastery of the medium for figure sculpture that has never been surpassed. The lifelike poses of two warriors known as the *Riace Bronzes* (c.450 BC) possibly made by Pheidias for the Sanctuary of Apollo at Delphi, show subtle differences in body tone and posture between the mature and youthful male physiques of the two figures. As the Roman poet Virgil observed in the first century BC, bronze statues sometimes 'seem to breathe'.

In West Africa, where metalworking has deep cultural associations with magic and the sacred, Yoruba sculptors of the eleventh to fifteenth centuries used the lost-wax process to produce royal effigies. Life-size bronze heads (opposite) unearthed at the sacred city of Ife in south-west Nigeria have a haunting naturalism that was beyond the reach of Western European bronze sculpture before Donatello (c.1386–1466).

Modern sculptors have used lost-wax bronze-casting to explore the interplay between mass and surface. Constantin Brancusi's *Bird in Space* (1932–40) is a burnished cipher, at once rooted and weightlessly aspiring. Balancing on the very tips of their sinewy legs, Louise Bourgeois' gargantuan bronze spiders (left) belie their own sheer weight, seeming to breathe with the disquieting alertness of alien life forms. ∎

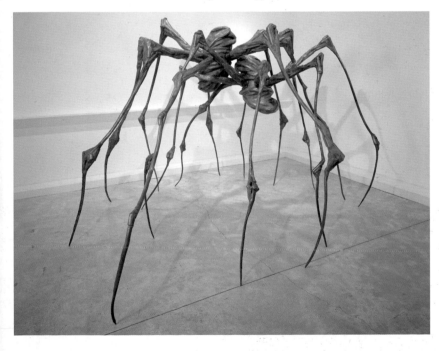

Light and cheap medium

IDEA № 14
PAPER

Invented in China more than 2,000 years ago, paper is one of the most versatile and widely used artistic materials. Artists have employed it for two-dimensional media such as painting, drawing, calligraphy, **printmaking** and **collage**, as well as in sculpture and conceptual art.

Paper has two great advantages as an art medium: it combines lightness with resilience, and it is cheap to make. Before the invention of paper, artists used vegetable-based supports such as papyrus and textiles including silk. Paper added greatly to the repertory since it could be made in sheets of almost any size and in a wide variety of textures, weights and colours.

The process of making paper by hand has changed little since it was first developed. It is made from vegetal fibres derived from such sources as wood pulp or textiles. The fibres are mixed with water and allowed to dry, forming flat sheets. The sheets may be coated with a sealant such as glue size.

The spread of papermaking technology from China is linked more closely to the history of writing and printing than that of visual art. It was first used for documents and Buddhist sacred texts, only later being adopted by artists, such as the Literati Painters of the Song Dynasty (960–1279). By the early eighth century, paper was being produced in Japan. Its durability (when kept dry) and the fact that it could be produced in very large sheets led to its adoption as an interior building material and for large pieces of decorative art such as folding screens, which could be painted with extended **landscape** or historical scenes.

By the eleventh century, paper had reached Europe along trade routes between East Asia and the Islamic world, which included Spain. In the late fourteenth century it was being manufactured in Italy, France and Germany. European scribes and artists were slow to take it up in preference to parchment. The growth of printmaking, the invention of moveable type and the spread of book production from the fifteenth century depended on paper. The vast quantities required led to a shift from small-scale to industrial manufacture.

Paper was crucial to the nineteenth-century development of **photography**, and played a prominent role in several twentieth-century Western art movements. In the *papiers collés* they began to produce around 1912 Georges Braque and Pablo Picasso placed **collage** at the

centre of modern artistic practice, relishing the distinctive qualities of a whole range of paper products, including wallpaper, commercial packaging and newspapers. Surrealists such as Max Ernst also used paper experimentally, for example in the technique termed decalcomania (pressing a sheet of paper on an inked or painted surface, pulling it away and using the resulting pattern as the basis for a painting). Conceptual artists made copious use of written and printed documents or, in

'The process of making paper by hand has changed little since it was first developed.'

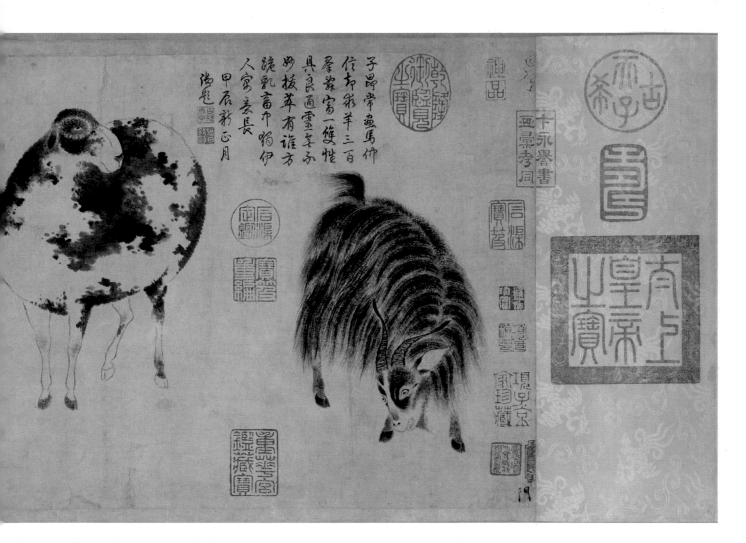

子昂常畫馬仰
信哉余羊三百
屠裳寫一雙惟
其良圖靈竿�
妙揆苹有誰方
疏乳富巾崎伊
人家玄長
甲辰新正月
漫書

the work of Joseph Beuys, paper stained with wax, grease and bodily fluids. In 1995, British artist and future Turner Prize winner Martin Creed exhibited *Work No. 88*: a sheet of A4 paper crumpled into a ball. ∎

OPPOSITE: *From 1958 the Bulgarian-born sculptor Christo developed his concept of empaquetage (packaging), altering the traditional continuity between sculptural mass and surface. From small works using paper, such as here* Surface d'empaquetage *(1959), Christo soon progressed to environmental-scale projects.*

ABOVE: *The Chinese scholar and administrator Zhao Mengfu (1254–1322) was also an eminent artist and calligrapher. Paper was the material he used for all these tasks, including this lively ink painting of a sheep and a goat.*

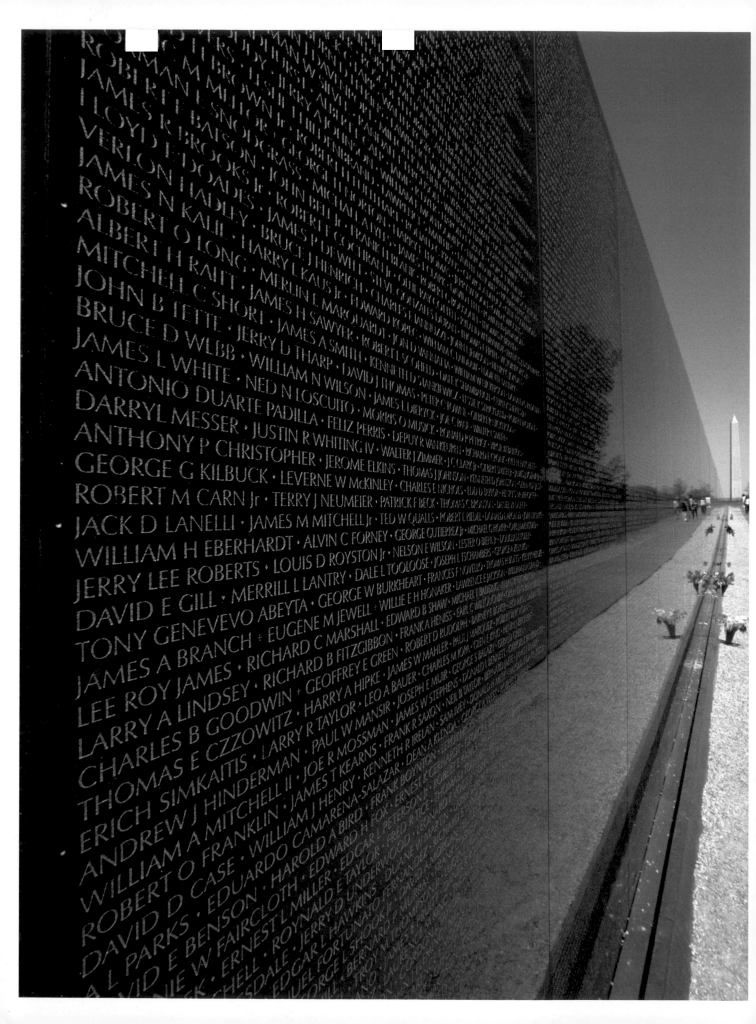

Talking to the dead

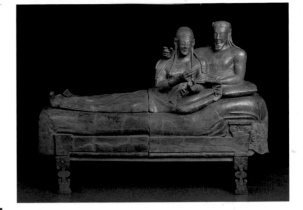

MEMORIAL

Mediation between the dead and the living is a function that art has fulfilled in one way or another in every society and every time period. Memorial art not only commemorates the dead but can endow them with a continued physical presence in the world of the living.

OPPOSITE: Maya Lin's Vietnam Veterans' Memorial *is inscribed with the names of all who died or went missing in the Vietnam War between 1956 and 1975. Those who read it see themselves reflected in the polished granite.*

BOTTOM LEFT: In the case of Asmat bis poles, art's memorial function relates to a particular time and ritual, rather than, as in European portraits and monuments, serving as a lasting aide-mémoire to future generations.

ABOVE: Of all types of memorial art, Etruscan tomb sculpture and painting best convey the pleasures of life. On this sixth-century BC terracotta sarcophagus from Cerveteri, near Rome, a couple relax in their enjoyment of good company and food.

The German artist Albrecht Dürer believed that art had two main purposes: to serve the Church and to preserve 'the likenesses of men after their death'. Art's capacity to transcend death was a theme of the Roman poet Horace, echoed in countless Renaissance poems. But the relationship between art and death extends beyond preserving the voice or appearance of the living. In Etruscan necropoleis, which consisted of tombs laid out in streets, like houses, the motive of art was to bring images of life into these 'cities of the dead'. A terracotta sarcophagus from Cerveteri (above right), constructed in the form of a life-size man and woman reclining on a banqueting couch, embracing and sharing food, seems to take it for granted

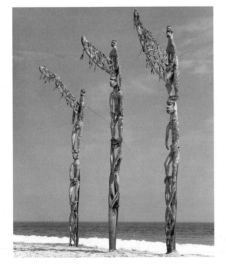

that the dead enjoy a parallel existence with the living and that art helps them to do this.

Memorial art can be a way of passing something, such as spiritual power, from one generation to another. The *bis* poles made by the Asmat people of western New Guinea (below left) are carved from inverted trees with figures representing the recently dead, for whom the pole stands in at a memorial feast. Once the feast is over, the pole is left to decay, so that the dead person's spirit fertilises the ground.

Most memorial art before the twentieth century is concerned with elite individuals and family groups. The ancient tomb art of Middle Eastern and Mediterranean civilisations, Chinese imperial burials, papal and aristocratic tombs of Renaissance Italy and innumerable nineteenth-century statues in European squares and cemeteries belong to this category. Art's capacity to enshrine collective memory is a more recent development, coexistent with the twentieth-century experience of mass warfare which involved entire civilian populations. The idea that a nation should acknowledge ordinary combatants who died in its service took root after World War I in the form of local and national war memorials, most of them examples of stolid official art commissioned by governments or institutions.

Western states have increasingly acknowledged their populations' ambivalent responses to war by commissioning memorials that are designed as a focus for grief or contemplation, rather than as an exhortation to honour the dead. Maya Lin's *Vietnam Veterans' Memorial* (1982, opposite) on the National Mall in Washington, DC, and Rachel Whiteread's Holocaust memorial (2000) in Vienna work on the scale of close-up, private reflection as well as constituting civic landmarks. In such memorials, art can briefly believe itself capable of making people more thoughtful, calmer and less violent – a late-capitalist version of the Asmat belief that the spiritual qualities implanted in the ground by the physical memorial will help to ensure the continued stability of the community. ∎

Add-on or essence?

ARCHITECTURAL SCULPTURE

Architectural sculpture – sculpture that is integral to a building – blurs the division between the building's solid, motionless mass and what's happening inside and around it. Telling stories or embodying symbols, such sculptures are features by which people remember and relate to the architecture itself.

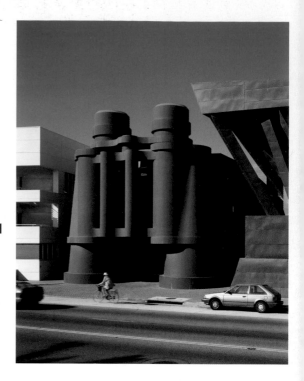

Oldenburg and van Bruggen proposed a gigantic pair of binoculars as a means of linking two very different structures in Frank Gehry's designs for the Chiat/Day Building in Los Angeles. Two tall rooms occupy the interior.

Different building types provide a range of framed surfaces that in some cases have led to the development of distinctive sculptural genres. In Greek temples, the frieze level of the entablature (the part above the columns) was often decorated with tableaux showing figures in relief (projecting out from a flat ground surface). The series of rectangular panels or metopes that subdivided the frieze proved a dramatic way of framing episodes from myth, such as the Labours of Herakles represented on the sixth-century BC Temple C at Selinus.

Filling the triangular space defined by the temple's gables or pediments presented a challenge that stimulated the most ambitious figure ensembles in Greek art. Sculptors had to create a single harmonious composition rising from two tight corners to the apex. Pheidias' design for the east pediment of the Parthenon represented the Birth of Athena, the temple's resident goddess. His solution to the corner problem drew a vast cosmic theme out of this restrictive architectural space: to the south, the horses of the sun god Helios rose from the sea; on the opposite side, the chariot of the moon goddess Selene descended.

Some Greek temples contained columns in the form of male figures (atlantids) which similarly turned the building into a cosmic metaphor, suggesting the god Atlas holding up the heavens. Female versions (caryatids) were used in Athens on the south porch of the Erechtheion (opposite bottom). There is an astonishingly subtle yet essential interaction between building and sculpture in the way these graceful figures perform a hefty load-bearing function, with the slenderest part of the neck taking the greatest stress.

Exterior sculpture brings visitors into a building's atmosphere long before they step through the door. Medieval cathedrals were highly theatrical buildings: their purpose was to house a stage where the drama of the Last Supper was regularly re-enacted. Sculpture was part of the drama, not just an illustration of its meaning. In the medieval Burgundian sculptor Gislebertus' scene of the Last Judgement on the tympanum above the west door of Autun Cathedral (opposite top), the saints and sinners massed around the figure of Christ leave no doubt that the stakes are high.

With the development of cast-iron construction in the nineteenth century and reinforced steel and plate glass in the twentieth, the use of carved architectural sculpture became a deliberate archaism. Eric Gill's relief above the entrance of Broadcasting House, London (1931), announces that the BBC's headquarters should be approached in sober spirit, as a cathedral of modern communication. For most of the twentieth century, Modernist architects banished any form of sculptural decoration, but during the 1970s the Postmodern reaction re-established the relationship on completely new terms. In Frank Gehry's Chiat/Day Building in Los Angeles (1985–91, above), which incorporates giant binoculars by Claes Oldenburg and Coosje van Bruggen, and his Guggenheim Bilbao (1997), the entire buildings are conceived as sculptures; their form is as much about meaning as function. ∎

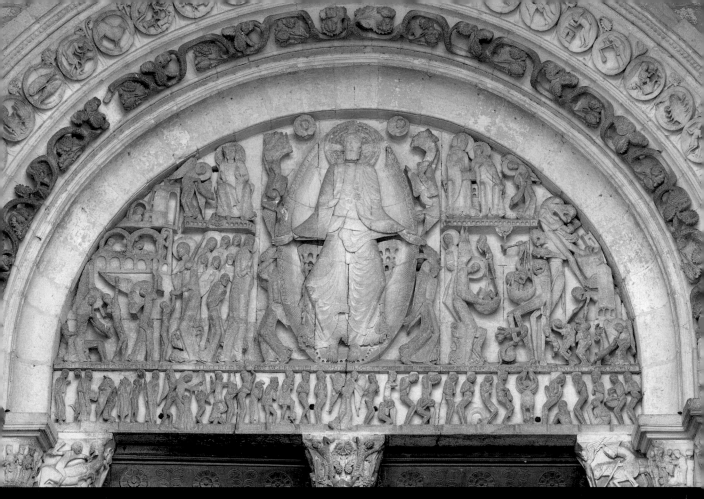

'There is an astonishingly subtle yet essential interaction between building and sculpture.'

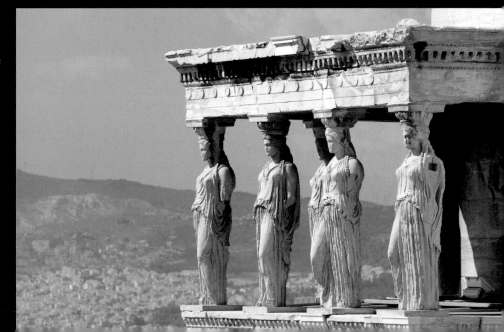

ABOVE: The sculptor Gislebertus probably spent ten years from about 1125 working on the Church of St Lazare (now Autun Cathedral). His Last Judgement is a magisterial and terrifying statement of the choices facing the Christian believer.

RIGHT: Graceful female figures replaced the usual cylindrical columns in the south porch of the Erechtheion (c.421–405 BC) in Athens, expressing this temple's feminine aspect as a house of the city's patron goddess, Athena.

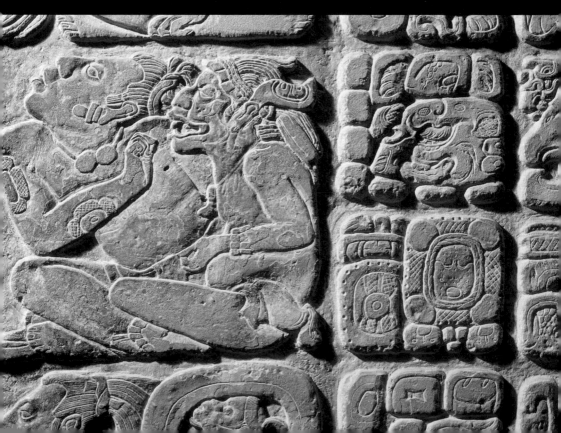

Ceci n'est pas une pipe.

Magritte

Reading the signs

IDEA № 17
WORD AS IMAGE

Written language began – probably in Mesopotamia more than 5,000 years ago – when images turned into words. Schematic visual representations of things and ideas were gradually adapted to create the abstract signs of early cuneiform script. In the reverse process, artists make images from written language, absorbing and transforming the meanings it communicates.

The borderline between word and image is far less clear than modern Western convention suggests, with its hierarchy of content-bearing text and illustrative visuals. At the same time, it has become commonplace to speak of 'reading' images – an implicit acceptance that visual images function like written language in their capacity to communicate meaning. Much depends on the viewer/reader's familiarity (or otherwise) with particular conventions. To non-readers of cuneiform (literally 'wedge-shaped') script, for example, the roughly triangular sign signifying 'cow', which evolved from crude drawings of cows' heads, just looks like an abstract symbol – a concise, elegant image that could mean anything. Mayan glyphs, on the other hand, retained their essentially pictorial quality through centuries of use as a phonetic writing system.

Most early Mayan glyphic material comes from religious sites such as the Temple of Inscriptions at Palenque, Mexico. There is, in fact, a wider connection between sacred texts and inscriptions, and the interpermeability of word and image. Nowhere has the argument between words and images as vehicles of spiritual truth been debated more fervently than in the Christian Iconoclastic Controversy of the eighth and ninth centuries (see pp.46–47). The Greek verb *graphein* means both 'to write' and 'to draw', and the iconophile Patriarch Nikefor argued that 'sacred books themselves are icons of speech of those who have written them'.

He could have been describing the transformation of words into icons, or images, in the contemporaneous illuminated manuscript the *Book of Kells*, whose initial page bears a fantastically elaborated version of the chi-rho monogram (the first two letters of the Greek name for Christ). The design transforms a simple abstract badge into a visual spectacle – yet one that, as the word *Christos* at its core insists, connotes spiritual, not worldly, superabundance. In Islamic sacred art and architecture, where representational images are prohibited, words became a primary decorative motif, as in the magnificent portal mosaics of the Shah Mosque, Isfahan (1611–*c*.1630). Taking the word into three dimensions, the contemporary Algerian artist Rachid Koraïchi has transformed Sufic texts and Arabic poetry into metal sculpture (right).

Twentieth-century Western intellectual culture was permeated by a secular preoccupation with the nature and limits of language. Surrealist artists based their practice on Freudian theory, in which words conceal meanings while dream images reveal the truth. The words *Ceci n'est pas une pipe* (This is not a pipe) in René Magritte's *Treachery of Images* (1929, opposite top) leaves the viewer uncertain what to believe – the words or the image – until the realisation dawns that images are not identical with the things they represent: this is a picture, not a pipe. ∎

Numerous modern artists in the Arab world have based their work on Arabic calligraphy. Rachid Koraïchi's series of steel sculptures Les Priants *(The Supplicants, 2008) suggests that words give shape to the people who use them.*

Spirit into substance

IDEA № 18

COLOURED GLASS

Unlike other two-dimensional art media, coloured (usually called stained) glass works through the effects of light shining through it rather than being reflected off its surface. In architectural settings, coloured glass responds to changing light conditions outdoors. The designs glow; interior spaces are suffused with colour.

ABOVE: *A window in Chartres Cathedral (c.1230), showing the story of Holy Roman Emperor Charlemagne. Abbot Suger described how 'delight in the House of God', including beautiful coloured glass, led his thoughts from material to spiritual things.*

OPPOSITE: *Matisse saw the coloured glass windows he designed for the Chapelle de la Rosaire at Vence (1948–51) as 'the culmination of a lifetime of work'. 'To me', he wrote, 'the spiritual expression of their colour is indisputable.'*

Glass coloured by metal oxides, introduced accidentally or deliberately into the molten mix, was produced by glassmakers in the ancient world. The development of chemically coloured, painted or stained glass as an artistic medium, however, took place in medieval Europe. Two factors were primarily responsible: the intense symbolic and mystical significance ascribed to light in Christian theology, and the Gothic pointed arch, which changed the engineering of religious buildings, freeing up large areas of non-load-bearing wall, which could be filled by windows.

In the early twelfth century, a craftsman-cleric named Theophilus (probably a pen name of the German goldsmith Roger of Helmarshausen) included instructions for making coloured-glass windows in his manual *De diversis artibus* (On Various Arts). Around the same time, Abbot Suger began a programme of works at Saint-Denis in Paris, through which he aimed to turn the abbey church into an environmental-scale prayer. The installation of coloured glazing at Saint-Denis and in many later Gothic churches and cathedrals was explicitly linked to the biblical symbolism of light, from God's cosmological pronouncement in Genesis, 'Let there be light', to the New Testament characterisation of Christ as 'the Light of the World'.

Images constructed from pieces of coloured glass could be used, like **wall paintings** and **mosaics**, to represent holy figures and stories. Many medieval coloured-glass windows have been destroyed by iconoclasm and war, but from the few surviving great ensembles, including the Sainte-Chapelle in Paris, Chartres Cathedral (above), Canterbury Cathedral and York Minster, it is clear how far their sensory impact surpassed painting and even gold and coloured-glass mosaic. As light passed through the windows, colours blended in the interior, tinting stonework, people's faces and bodies, and transforming the atmosphere inside the building. In turning spirit – in the form of light – into substance, coloured-glass images created a theological virtual reality.

The attempt to re-create the imagined spiritual integrity of medieval life within the context of nineteenth-century industrial modernity spurred a revival of coloured glasswork. Though production methods had changed little since Theophilus's treatise, there was now a much clearer distinction between the artist-designer and craftsman-fabricator. A.W.N. Pugin, William Morris and their contemporaries took every opportunity to incorporate coloured-glass windows into sacred and secular buildings, but these features – though sometimes magnificent – always bore the stamp of revivalism. They harked back to medieval antecendents rather than embracing modern forms and subjects.

It was the prominence given to glass in Modernist architecture that brought a new repertory to coloured glass through the involvement of artists such as Georges Braque, Georges Rouault and Marc Chagall in architectural projects. The greatest modern ensemble is the result of Henri Matisse's collaboration with the fabricator Paul Bony on the glazing of the Chapelle de la Rosaire in Vence (opposite). ∎

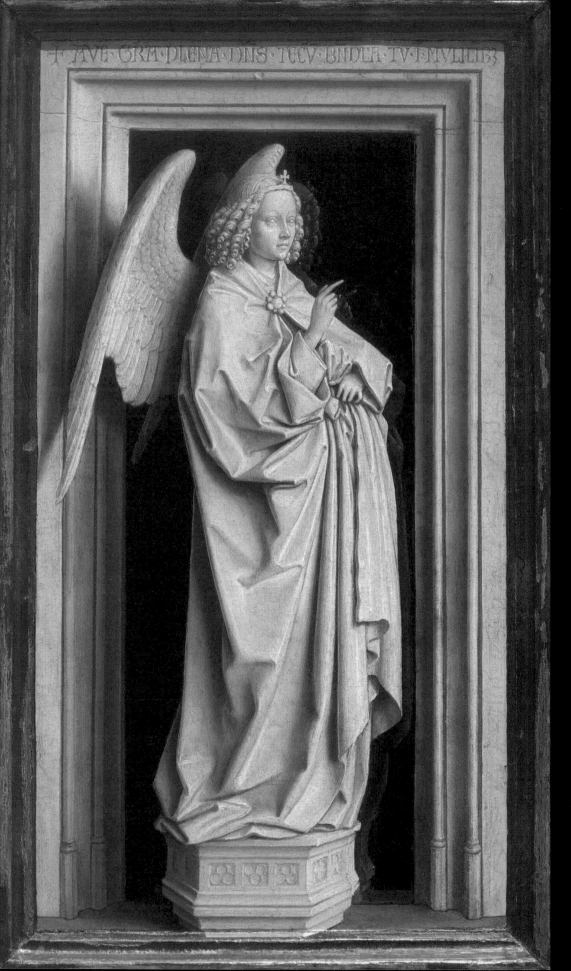

The lifted right wing of the trompe-l'oeil *carved angel in Jan van Eyck's* Annunciation *diptych (c.1435) casts a shadow against its painted frame, as though it is miraculously – but also playfully – about to take flight.*

Visible limits

IDEA № 19
FRAME

Frames separate art from what surrounds it. They mimic our experience of moving physically and mentally from one space to another, walking through a doorway, looking through a window or lifting the lid of a box. Frames announce that the art they circumscribe is something different, special, precious.

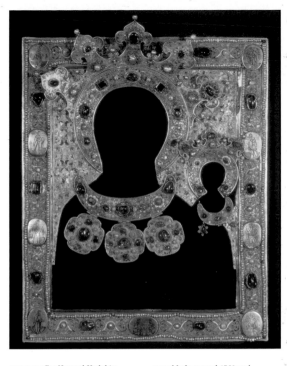

The frame is a familiar convention for presenting paintings and photographs as well as **relief** sculpture, gallery **installations** and other kinds of art displayed indoors. Art does not have to be framed, however. At one end of the temporal spectrum, **cave paintings** and prehistoric earthworks occupy spaces that are bounded only by natural features. At the other, late twentieth- and early twenty-first-century forms such as **land**, **performance** and **internet** art happen where they happen, defining actual or virtual spaces by their very existence.

Early framing devices related art to its architectural setting so that the two could interact. Greek temple sculptures were framed by architectural elements; Roman **wall paintings** and **mosaics** were framed with plain or decorative bands imitating mouldings or textile borders. Since the framing device is part of a fixed structure, art – whatever else it does – belongs in its place. There were portable paintings in the ancient world too, although it is not known how these were framed and displayed.

In medieval churches, paintings were framed in order to turn them into imposing pieces of furniture. Altarpieces were set in elaborate frames, echoing the forms and detailing of Gothic stone architecture. Standing at the building's focal point, these carved and gilded frames asserted their presence as precious objects. The framing of holy images also emphasised their inestimable spiritual value. Orthodox Christian **icons** are sometimes set in their frames like jewels or sacred objects in a reliquary.

With the development of **linear perspective** (see pp.68–69) in the fifteenth century, the frame became conceptually part of a painting. By outlining the plane through which viewers stared into illusory space, the frame made a clear distinction between art and life, which might otherwise appear disquietingly interchangeable. In dismantling the old conventions of illusory space, modern artists acquired an ambivalent relationship to frames. As the critic Clement Greenberg pointed out, Cubist **still lifes** seem to occupy a space in front of, not behind, the picture plane – which, of course, made the

conventional frame as indispensable for Cubists as it had been for Piero della Francesca. By the mid-twentieth century, a new awareness of the painting itself as an object in space – effectively a flat sculpture covered with shapes and colours – led to a certain impatience with frames and a habit of exhibiting large canvases unframed. In Howard Hodgkin's paintings (left), the frame both delineates and is an integral part of the picture. As the paint spills outwards across the frame, it is the surrounding wall space that seems to contain and intensify the image. ■

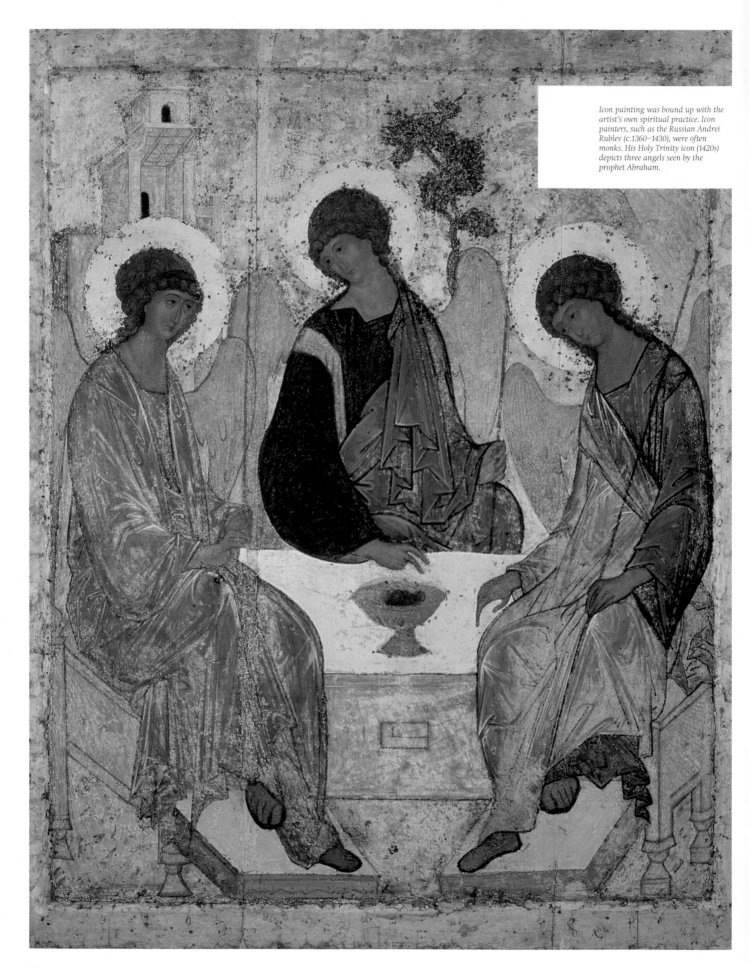

Icon painting was bound up with the
artist's own spiritual practice. Icon
painters, such as the Russian Andrei
Rublev (c.1360–1430), were often
monks. His Holy Trinity icon (1420s)
depicts three angels seen by the
prophet Abraham.

Sacred objects

IDEA Nº 20
ICON

Icons – a term derived from the Greek word *eikon*, meaning 'image' – are pictures of holy figures in Orthodox Christianity. Beyond providing a focus for worship, icons represent a wider conviction that spiritual truth can take physical form, giving the work of art itself a sacred aura.

BOTTOM LEFT: *This sixth-century icon of Christ Pantokrator (Christ the All-powerful) from St Catherine's Monastery in the Sinai Desert is the oldest known icon. The face of Christ makes direct eye contact with the viewer as his right hand gives blessing.*

ABOVE: *In Orthodox churches, like this one at Moldovita Monastery, Romania, the congregation is separated from the chancel (where the altar stands) by an iconostasis, a tall screen on which varying configurations of icons are installed throughout the liturgical year.*

Can, or should, God or holy figures be represented by images? In Jewish and Islamic tradition the answer is 'no' – for the reason that images are likely to end up becoming idols, objects of worship in their own right. This argument against figurative religious art was forcefully advanced in the Iconoclastic Controversy that divided the Christian Church of the eighth and ninth centuries. The eventual victory of the iconophile faction in 843 had far-reaching implications for

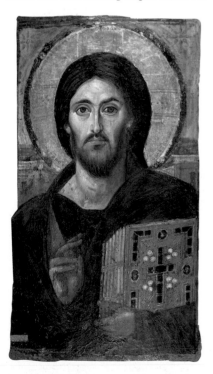

Western art. It ensured that, until the Protestant Reformation of the sixteenth century, churches continued to be filled with figure paintings that were informed by conventions inherited from Graeco-Roman art; and, since the Church was a major patron, it gave the visual arts a strong theological dimension.

'Theology in colour' was how the Russian thinker Eugene Trubetskoy characterised icons. God was never directly depicted but Christ (whom St Paul had called 'the icon of God'), the Virgin Mary, saints and other biblical figures were. The first icons were painted in early Christian times; the tradition continues in modern Greece and Russia. Christian faith and art were linked by a solemn parallel: as God was incarnate or 'made flesh' in Christ, so holy figures became physically present in icons. Since the distinction between incarnation-object and idol was in practice very blurred, however, icons were popularly believed capable of receiving prayers, performing miracles and winning battles. In order not to dilute or betray the presence of the holy figures in the paintings, icon painters studiously followed the form of existing icons. There was no attempt to make figures, actions or backgrounds realistic – the opposite, in fact. Icons portrayed an otherworldly reality clearly distinguished from ordinary appearances.

Whereas **mosaics**, **coloured glass windows** and **wall paintings** were fixtures in a church building, icons provided a moveable cast of holy presences. In one sense, icons can only be understood in the context of Orthodox Christian theology. In another, the icon's nature as a revered image that is constantly reproduced permeates modern art. **Pop** art took the fetishistic 'worship' of commercial products and celebrities as one of its primary themes – witness Andy Warhol's repeat images of Marilyn Monroe and Elvis Presley. However faithfully icons are copied, they mean different things and even look different, depending on time, place, artist and viewer. This was wittily critiqued by Francis Alÿs in his 2009 installation *Fabiola* at the National Portrait Gallery, London, which assembled a motley assortment of 300 painted copies of a popular, saccharine image of St Fabiola by the nineteenth-century French portraitist Jean-Jacques Henner. ∎

Moveable type

IDEA № 21
MAKING BOOKS

First developed in its familiar form in Roman times, the book has proved a highly durable medium for storing and communicating text and images. Since the invention of moveable type, artists' contributions as illustrators and designers have conferred cachet on a mass-produced product, which in turn has brought artists' works to new audiences and contexts.

Consisting of rectangular pages sewn together between protective covers so that they could be viewed singly or turned in sequence, books had distinct advantages over alternative ancient methods of information storage. They were robust, compact, easy to identify on shelves and less awkward to consult than rolled-up papyri, or stacks of clay or wax tablets. Books were equally well adapted for public reading or private study, and were central to the spread of Christianity, which was founded on a collection of disparate texts bound together to form the Bible, from the Greek word *biblos* or book.

Medieval bibles, psalters and other products of monastic scriptoria (rooms for copying manuscripts), where most European books were assembled before moveable type printing transformed the process, brought together the Word of God, the display of ecclesiastical resources and deep reservoirs of sensuous analogy on which Christian imagery drew. Such books were extremely costly to make, involving the slaughter of herds of livestock for hides, the preparation of colours from minerals such as lapis lazuli and gold, and months of collaborative effort by scribes and painters. An Anglo-Saxon riddle recounts this process from start to finish, envisaging the holy book as an object with almost supernatural powers in its own right.

In the fifteenth century, printed books changed all this. They were far cheaper than manuscripts to produce and many copies could be issued. But readers still expected pictures. Artists no longer worked directly on the page, filling the spaces left by the scribe and embellishing the text, and instead they supplied woodcuts and, later, copper engravings and other types of print to satisfy this demand. The artist-illustrator became separated from the production process, as specialist printmakers took over the task of **copying** original paintings for insertion in books. This was the reproductive medium in which artists and their works were encountered by a book-buying public who might never see the originals. Illustrated books were also a medium in which art was persuasively presented as history: reproductions of artworks from different sources could be organised within a book, so that they supported an interpretative narrative in a way that art seldom does in its actual surroundings, outside museum displays.

In the nineteenth century, publishers regularly commissioned artists to ensure cachet and a strong identity for their products. John Tenniel's illustrations for *Alice in Wonderland* helped turn Lewis Carroll's fantasy into a children's classic, while Aubrey Beardsley's art editorship and illustrations for *The Yellow Book* (opposite bottom) gave the journal a classy notoriety. In the twentieth century, artists, printmakers and publishers collaborated on limited-edition books, such as Matisse's print **series** *Jazz* (1947), of which just 250 copies were printed. More recently, Anselm Kiefer and others have set about reclaiming the artist's book as a multimedia fusion of two- and three-dimensional art intended, like medieval bibles, to give forceful materiality to messages (above). ∎

Wonders and horrors

IDEA № 22
THE GROTESQUE

The grotesque comes into play wherever art deliberately transgresses ideals of beauty and the rules associated with their representation. Through fantasy and exaggeration, it gives form to wonders and horrors that lie beyond the visible world, like the fabulous beasts of travellers' tales or the torments of the damned.

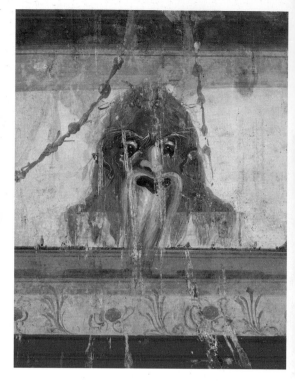

ABOVE: *Grotesque expressions: the rediscovery of wall paintings, such as this masked face from the House of Augustus (25 BC–AD 25) in Rome, revealed an unexpectedly weird and wild side to Classical art.*

The term grotesque was first used to describe Roman **wall paintings** rediscovered in the fifteenth century in the ruins of the Golden House, the former residence of the emperor Nero. These paintings contained a profusion of decorative motifs consisting of part-human, part-animal beings entwined with foliage. Since Nero's villa was at first mistaken for a cavern, or grotto, its weird decorations – so different from the familiar austere Classicism of Roman architecture and sculpture – were called *grotteschi*. This misapprehension lies at the heart of the idea of the grotesque, which associates images of fantastically misshapen or composite

beings with a shadowy netherworld in which socially repressed energies – sexuality, mockery, rebellion, fantasies of all kinds – have free rein.

In Freudian terms, the relationship between Classical art and the grotesque echoes the duality of ego and id. Freud's eclectic sculpture collection included a small Graeco-Roman female head with grotesquely exaggerated features (below). Through caricature and other distortions, the grotesque makes unpalatable truths as unpleasant as they actually are, rather than smoothing them into a more acceptable shape. In contrast to the ordered serenity that prevails in medieval scenes of heaven, hell is a swarming mêlée populated by grotesque demons and naked souls whose transgressions are reflected in their agonised contortions.

It is tempting to interpret Hieronymus Bosch's *Garden of Earthly Delights* triptych (1500–5) as a proto-Freudian fable in which the pleasures of the flesh (ego) are balanced by scenes of paradise (superego) and hell (id). In reality, Bosch's otherworldly landscapes contain a less neatly categorised orchestration of pain and pleasure; the artist needs grotesque forms as much as idealised ones in order to paint the wealth of God's creation. The grotesque exists everywhere in a similar binary relationship to the ideal. Where a Classicising artist such as Raphael claimed to

BOTTOM LEFT: In this terracotta grotesque head (100 BC–100 AD) from Sigmund Freud's collection, art says the socially unsayable, like the child who blurts out: 'I don't like you. You're ugly.'

combine the features of several beautiful women in an image of ideal beauty, the composite demons in Albrecht Dürer's print *Saint Michael Fighting the Dragon* (1498) represent ideal ugliness – the ugliness of sin.

Ideal forms, like the heads of Greek statues, persuade us that life could, or should, actually look that way. The grotesque provokes the more ambivalent responses of horrified fascination or unwilling belief. Whereas the ideal embodies rules and order, the grotesque breaks boundaries and confuses distinctions: the mermaid is woman and fish, warm and cold, desirable and deadly. In twenty-first-century visual culture, this ambivalence makes the grotesque far less amenable to commercial exploitation than conventions of ideal beauty, but it is a staple of the entertainment industry, where it flourishes in cartoons, animations, and horror and fantasy cinema. ■

Representing sex

IDEA № 23
EROTIC ART

The language of erotic experience permeates thinking about art in routine phrases like 'creative passion'. In the earliest artworks as in theorisations of 'desire' and 'the gaze' in modern critical theory, art reveals a primary engagement with sexuality.

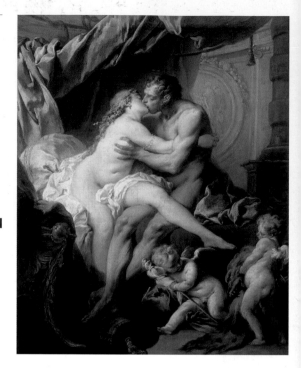

Modern (usually male) artists regularly claim that the creative process is like sex. The Impressionist painter Pierre-Auguste Renoir asserted: 'It is with my brush that I make love'; painting, said Francis Bacon, can be 'like an orgasm'. Such statements reprise the **Romantic** trope in which art-making is a creative rather than a mimetic or imitative act. They also reflect the pathways of displacement in Western art's handling of sexual representation. Owing to the transgressiveness attached to sexual pleasure by the Church, explicitly sexual imagery was generally suppressed until, in the secular twentieth century, it resurfaced as a visual arsenal primed for commercial exploitation.

Much early art, and the art of many cultures outside the West, draws form and content from human sexuality, often in an uninhibited manner that Western scholars sought to de-eroticise with such notions as 'fertility magic'. The epigrammatic voluptuousness of Palaeolithic 'Venus' figurines (see p.160) may have been intended to ensure community survival through childbearing and plentiful food sources, but it also shows art discovering its role as receptor and reflection of human desire. Art's earliest sex scene is a carved stone known as the Ain Sakhri Lovers (c.9000 BC), discovered near Bethlehem, which represents a couple squatting face to face with legs entwined. In giving lasting form to transient intimacy, it has been compared to 'the great kissing couples of Brancusi and Rodin'.

The sex lives of the gods provided a rich mythopoeic vein in ancient Greek and Egyptian art. The embracing couple (*mithuna*) theme runs deep in Hindu iconography. Sexually explicit scenes form a prominent part of the sculptural decoration on temples at Khajuraho (opposite top), Konarak and elsewhere. Some of these erotic ensembles are of a similar date to Gislebertus's great tympanum at Autun Cathedral (see p.39), in which the damned line up in trembling nakedness.

The fact that European artists were officially not permitted to represent sex gave its veiled or clandestine expressions a high erotic voltage. From the sixteenth century, mythological subjects involving Zeus' various paramours, Venus, Bacchus and a licentious line-up of nymphs and satyrs became an acceptable vehicle for erotic imagery. Unlike the Khajuraho sculptures, which feature both sexes almost equally, the erotic connection in European art typically ran between the nude female subject and the male beholder, as in the erotic scenes of François Boucher (above) commissioned by the French king Louis XV.

In Gustave Courbet's work and the mid-nineteenth-century emergence of avant-garde art, which aligned itself with social progress, sexual representation still had power to shock. Later, in the work of Gustav Klimt and Egon Schiele, it became more decorative and more clinical, reflecting Sigmund Freud's revelation that even polite social rituals are underpinned by repressed sexuality. For feminist artists, who confronted the exclusion of women's experience from Western art, sexual representation equally encompassed the political and the personal (see pp.184–85). There's no sense of Boucher's privileged voyeur in Nan Goldin's photographs (opposite bottom), which frame the alternately tense and tender spaces where sex as easily becomes what separates people as what draws them together. ■

ABOVE: *In Greek mythology Herakles (Latin Hercules) was punished for a murder by being enslaved to the Lydian queen Omphale. François Boucher's* Hercules and Omphale *(c.1730) employs classical allusion as a pretext for a contemporary bedroom scene.*

OPPOSITE TOP: *It's assumed that the sexually explicit sculptures on the tenth-century Lakshmana Temple at Khajuraho, Madhya Pradesh, India, carried a clear religious significance, possibly associated with Tantric beliefs about reaching the spiritual world through the physical.*

OPPOSITE BOTTOM: *The work of photographer Nan Goldin (b.1953), such as* The Ballad of Sexual Dependency *(1986) and* Valerie and Bruno: bodyforms, Paris *(2001, shown here), addresses sexuality in all its manifestations, from tenderness to loss and trauma.*

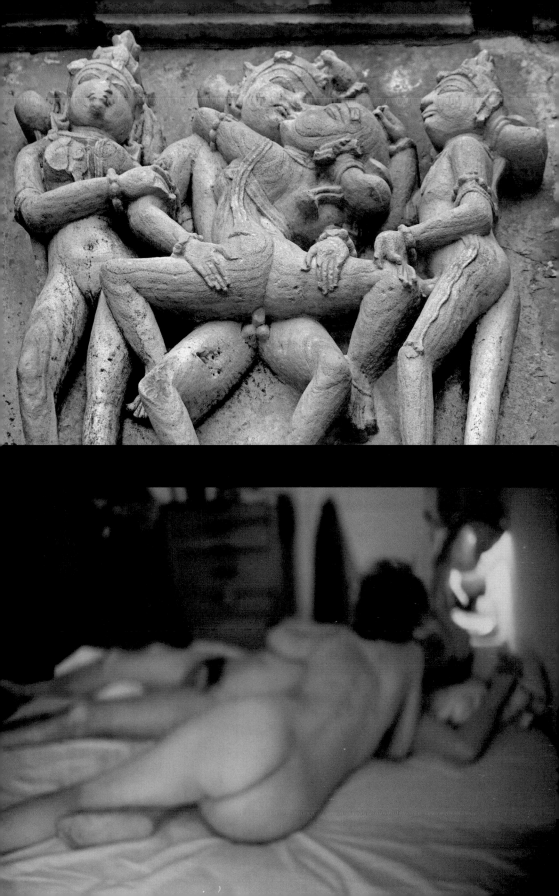

Making your mark

IDEA № 24
HANDWRITING

The conviction that a great artist can be recognized from a single drawn or painted line has been current since antiquity. Pliny the Elder recorded that a painting consisting of just a few coloured lines by the Greek masters Apelles and Protogenes was one of the most celebrated pieces in the emperor Augustus' collection.

OPPOSITE: Inscribed on a collage of coloured papers, an extract from the Ise shu (Poems of Lady Ise) shows the flowing kana or syllabic script associated with early twelfth-century Japanese women writers, whose male contemporaries were still using Chinese characters.

BOTTOM LEFT: A page from a tenth-century North African Qur'an, written on vellum in the Kufic script that was also used for architectural decoration. The calligrapher's craft entailed a long apprenticeship, and eminent practitioners were revered.

ABOVE: Cy Twombly's abstract paintings often resemble literary documents, incorporating words as well as pencilled or brushed marks that suggest handwriting. The words 'autunno' and 'your blood' occur in Four Seasons: Autumn (1993–95).

Two properties of handwriting – its capacity to communicate a message and to express the writer's identity – inform ideas about painting in several traditions. In China, where written characters consist of brushstrokes, poetry, calligraphy and painting are collectively known as the Three Perfections. In cursive scripts, a single brushstroke can simultaneously encompass all three arts, representing the 'mind print' of the poet-writer-artist. In Japan, the practice of calligraphy (*shodo*, 'the way of the brush') is traditionally considered a higher pursuit than painting, since the brushmark transcends literal representation to create a direct imprint of inner truth. In the inkbrush calligraphies of Zen monks, concise, energetic brushmarks convey a momentary yet serene completeness, as though things could not have been set down otherwise.

The more conventionally organised registers of Islamic calligraphies create an art of patient brilliance out of the copying of holy texts. Arabic owes its wide dissemination to the fact that it is the language of the Qur'an, in which God is said to have 'taught man by the pen'. The practice of writing therefore carries overtones of the sacred, even at a considerable remove. Since the traditional proscription of images of living things restricted the subjects available to Muslim painters, calligraphy became a focus for virtuoso artistic skill.

The connection between handwriting and image-making translates less easily to the West where, even before printed books arrived, images often functioned as illustrations – a pictorial accompaniment to texts. While **the artist's** signature became a mark of authentication from the seventeenth century onwards, it would not have occurred to contemporary critics to praise an artist for their handwriting as Asian and Islamic commentators did. In the twentieth century, avant-garde Western painters attached a new importance to brushwork as an expression of the artist's individuality. From the 1920s, Surrealists practised 'automatic' writing, in which the Freudian unconscious was believed to bypass conscious intention. Games, **performances** and **hallucinogens** were enlisted to liberate **the unconscious**, which inscribed its own strange realities through the artist's hand, as in André Masson's sand and glue paintings or Henri Michaux's drawings made under the influence of mescaline. Scribbled and scrawled marks seemed to want to communicate something – but what? Jackson Pollock's drip paintings (see p.168) resemble free-form Zen calligraphies, dissociated from all conventional signification. **Conceptual art**, on the other hand, from Joseph Beuys to Fiona Banner, often indicates its intentions through gnomic, handwritten words. ∎

A world in pieces

IDEA № 25

MOSAIC

Mosaics consist of thousands of tiny pieces of glass, pottery or stone known as tesserae. Their essential function is to be decorative and durable. More than any other art medium, wall and floor mosaics combine painstaking, repetitive craft skills with the creation of large-scale visual effects.

Mosaic has been exploited as a decorative medium since at least the fourth millennium BC, when the walls of Uruk in Mesopotamia – the world's first city – were covered with patterns made from red, black and white cones of clay and stone. These may have echoed textile designs, and ancient mosaics parallel the later role of tapestries in European interiors, combining practicality with ostentation. Greek and Roman floor mosaics (see p.70) were labour-intensive luxury features associated with high-status domestic interiors. The largest surviving example, the *Alexander Mosaic* (*c*.100 BC), from the House of the Faun at Pompeii, is probably a faithful translation, in the pixellated form of some four million stone tesserae, of a fourth-century BC **history painting** depicting a battle between Alexander the Great and the Persian king Darius.

It was the mosaicists employed to decorate Byzantine churches between the fifth and fourteenth centuries AD who developed mosaic into an environmental-scale artistic medium with a unique repertory of special effects. From around the third century AD, the introduction of reflective gold and silver tesserae, made from glass incorporating metal foil, transformed the possibilities for mosaic. Christian iconography before the Renaissance rejected anything suggestive of sensual pleasure, but colour and light held profound spiritual significance. Gold represented the glory of God, and mosaic became the decorative medium *par excellence* for Byzantine church interiors, creating full-toned yet shimmering effects of light and colour, richer and more mysterious than anything paint could achieve.

Byzantine master mosaicists were also painters. The images they constructed from tesserae were first rapidly painted on the top layer of plaster into which the mosaic was to be set. The preparation was similar to fresco, with a limit to the area workable in a single day before the plaster set. A skilled mosaicist might set about 2 square metres a day. The mosaics' glittering surfaces suggest gilded luxury, but the figures' magisterial stasis takes the visual experience into an altogether more contemplative register. With the exception of medieval **coloured glass**, no art form rivals Byzantine mosaics' lapidary fusion of the spiritual and the sensory. There was a parallel flourishing of mosaic in Islamic religious buildings of the seventh to eleventh centuries, on which Byzantine mosaicists were sometimes employed, as in the Great Mosque, Córdoba (965).

In modern mosaic, where the roles of artist-designer and skilled mosaicist are usually separate, the medium has been used to striking effect in public architectural projects, such as Antoni Gaudí's mosaics of glass tiles and ceramic fragments (left) in Parc Güell, Barcelona and Juan O'Gorman's mosaic cladding of the Central Library in Mexico City (1952). ∎

LEFT: *The Catalan architect Antoni Gaudí developed an idiosyncratic style of mosaic, applying glass and ceramic fragments to buildings and in his designs for the Parc Güell, Barcelona (1900–14), including this flamboyant reptile.*

OPPOSITE: *The centrepiece of mosaic decoration in the sixth-century basilica of Sant'Apollinare in Classe, Ravenna, is a jewel-like cross set in a celestial blue disc above the figure of the saint with the altar below.*

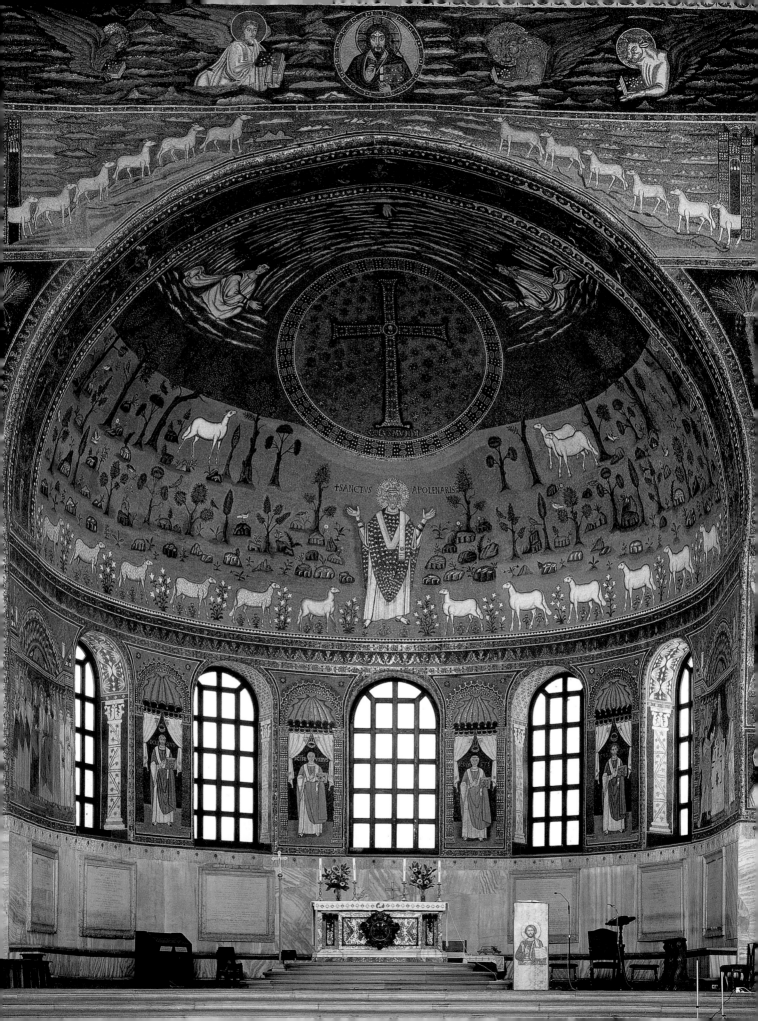

Doors of perception

IDEA № 26
MULTI-PANEL PAINTING

Multi-panel paintings are associated with religious art in the form of altarpieces in the West; in the East, they take the form of domestic folding screens. In both cases, the hinged painting is a moveable piece of furniture whose image content can be concealed or revealed as required.

ABOVE: Portable piety: in nineteenth-century Russian homes, miniature versions of the large iconostasis screens in Orthodox churches (see page 47) were used for private worship. This four-panel screen shows (top to bottom) patriarchs, prophets, New Testament scenes, and saints.

OPPOSITE TOP: The panels of Grünewald's Isenheim Altarpiece *can be opened or closed to produce three views: the Crucifixion (seen here); New Testament scenes and a Concert of Angels; and scenes flanking earlier carvings by Nikolaus Hagenauer.*

OPPOSITE BOTTOM: Otto Dix described his altarpiece-style War Triptych *as 'a site of silence and peace'. Commemorating the tenth anniversary of the end of World War I, it was intended as a secular memorial to 'the nameless martyr-soldier'.*

From around the thirteenth century, large paintings constructed from two or more hinged panels stood on the high altars of European churches, with smaller versions serving for private worship. These altarpieces probably evolved from reliquaries in which the plain lids opened to reveal sacred images inside. The technical terms for multi-panel paintings – diptych, triptych and polyptych (two, three and many panels respectively) – derive from *ptyche*, the Greek word for a folded object, and folding is an essential characteristic of altarpieces. It facilitates portability, protects the sacred content and, when the panels are opened out, enacts spiritual revelation.

In triptychs the central panel contains the main image, often a Crucifixion, Nativity or scene from the Virgin Mary's life, while the side panels, which close like doors over the central one, are decorated with subsidiary figures, as in Hugo van der Goes' altarpiece *The Adoration of the Shepherds*, where the Florentine patron Tommaso Portinari is shown with his family in the wings. Side panels were sometimes painted on the reverse, so that the open and closed altarpiece presented quite different scenes. The changeable appearance of altarpieces formed part of the dynamic character of church art, complementing the drama of the liturgy.

The huge altarpiece painted between 1512 and 1515 by Matthias Grünewald for the monastery of St Anthony at Isenheim (opposite top) is a physically and iconographically complex polyptych in which two sets of panels open and close to reveal three sets of images. This construction allowed Grünewald to create a layering of highly emotive biblical episodes and scenes of mystical intensity. In the altarpiece's 'first view', the scourged and crucified body of Christ defines the central panel with its taut Y-form, an apparition of suffering lurching into the viewer's own space.

The religious connotations of multi-panel painting, and a Grünewaldian sense of opening doors into otherwise unimaginable suffering, were adapted by Otto Dix for his *War Triptych* (1928–32, opposite bottom), in which biblical content is replaced by nightmare images of trench warfare, caught in gelid freeze-frame. The Y-form of a blasted tree is here displaced from the centre of the composition.

In China, Korea and Japan, there are long traditions of painting on multi-panel screens, which are hinged and covered with paper to provide a continuous visual field. Japanese painters of the Kanō school were celebrated for painted screens that exploited the multi-panel form to expansively lyrical or epic effect in landscape or battle scenes. The 3.5–metre-long eight-panel screen *Autumn Millet* by Kano Sanraku (1559–1635) creates a palpable autumnal warmth through the use of gilded paper as a support. Later makers of popular, cheap *ukiyo-e* woodblock prints occasionally alluded to aristocratic screen-painting in multi-panel works like Utagawa Toyokuni's triptych print *Inside a Kabuki Theatre* (c.1800). ∎

Noah's Ark rides the Flood in one of the miniatures from a manuscript of Beatus of Liébana's Commentary on the Apocalypse, *painted in Spain around 970–75 by the monk Emeterius and nun Ende, the latter*

'Likeness in little'

IDEA № 27
MINIATURES

Miniature painting evolved as a way of illustrating and organising sacred manuscripts. In the hands of later practitioners it began to inhabit more private spaces and started to be used for portraiture.

Minium is the Latin term for red lead, the pigment used by medieval scribes to emphasise important passages of text (or rubric). Another way to mark the start of a new section or paragraph in a manuscript was to insert decorated initials or small pictures, which became known as 'miniatures'. Confusion with another Latin term, *minimus*, led to miniature also coming to mean 'very small', which was frequently a characteristic of such work. Where other forms of medieval art were intended to be seen from a distance, miniatures could be appreciated only at close quarters, when a manuscript was being read. Medieval miniatures, executed in water-based pigment on vellum, contain subtler variations of tone and far more detail than the equivalent scenes in **wall paintings** and **coloured glass** windows.

The making of bound manuscripts was a costly collaborative process in which the master miniaturist was part of a production team that possessed many other skills. Medieval miniature painting provided artists with two distinct zones of operation: whereas images illustrating the text follow similar iconographic and stylistic conventions to other religious art forms, illustrations in the margins or at the foot of the page often show scenes from daily life or are populated by birds, animals and grotesques in a freer, more naturalistic style. Comparable sculptural figures appear at the margins of cathedrals – beneath seats, at the tops of pillars – but miniature painting brought the sacred and demotic together within the frame of a single folio or page.

The practice of private devotion involved hand-held prayer books in which miniatures addressed the experience of the solitary, contemplative reader. Lifelike figures appeared to step out from their frames, landscapes receded into dreamy atmospheric blues. This was still institutional art, but its relationship to the viewer was now direct and intimate. From the early sixteenth century, as printed texts superseded manuscripts, secular portrait miniatures began to be used as keepsakes, gifts or by marriage brokers. Once again, the miniature was both a social art, cementing relationships among the upper classes, and a private one, in which faces have a delicacy suggesting that the viewer cherished every feature and detail.

Throughout the seventeenth and eighteenth centuries, a small cadre of specialist miniaturists served the European aristocracy. There were technical innovations, like the use of ivory instead of vellum, and a diversification from portraiture into exquisite narrative scenes. In the nineteenth century **photography** put an end to the miniature's usefulness as a portable **portrait**. It also destroyed the essential privacy of the 'likeness in little'. Passport photos, ID cards, mugshots – with the demise of the miniature, small portraits came to represent its opposite: the invasion of the private by the public realm. ■

Hidden depths

IDEA № 28

OIL PAINT

After being taken up by Northern European artists in the early fifteenth century, oil-based paint became the most widespread medium for portable Western painting. It brought new possibilities in terms of the range of textures and effects that artists could achieve with paint.

ABOVE: *Oil paintings by the fifteenth-century Netherlandish painter Dieric Bouts are based on detailed underdrawings. Applying up to five successive glazes, Bouts achieved subtle colour effects, such as the softly glowing sky in this* Madonna and Child.

OPPOSITE: *In paintings such as* Head of E.O.W. I *(1960), Frank Auerbach's heavy impasto becomes almost sculptural. For Auerbach, the paint's 'massive substance' was an attempt 'to emphasise what was more permanent than a decorative or linear concoction'.*

Oil paint is a suspension of powdered pigment in vegetable oil – usually linseed but also sometimes walnut, poppy seed or other oils, which all have slightly different properties. It dries much more slowly than egg- or water-based paint, allowing artists to rework a painting almost indefinitely. The oil medium is usually thinned with a volatile solvent such as turpentine, which helps the paint flow more easily. Vegetable oil's refractive and reflective qualities, even when dry, give oil colours a translucency that artists learnt to exploit by building up series of thin layers or glazes. Dark grounds give depth to successive lighter glazes, while light grounds glow through darker colours laid on top.

Northern European painters such as Robert Campin, Jan van Eyck and Dieric Bouts (right above) didn't invent oil paint – the basic technique was described in a twelfth-century treatise. Within an astonishingly short time, however, they developed the use of multiple glazes to create effects of virtuoso naturalism, vividly imitating the reflective qualities of skin or cloth. Oil paint soon replaced egg-based tempera for panel painting and was almost universally adopted for work on **canvas**. Its viscosity meant that brushmarks could be precisely controlled, while simultaneously remaining fluid enough to allow tiny details like hair or blades of grass to be picked out with a fine brush.

Once it has dried, oil paint has a tough but flexible surface, which makes it particularly suitable for painting on canvas. It adheres well to the brush, so that a long stroke can be carried through without the brush running dry. During the sixteenth century, Venetian artists such as Titian evolved an active, bravura style of brush-work, very different from the sumptuous, static naturalism of fifteenth-century Northern artists. Rather than patiently applying paint to an under-drawing, Titian worked directly on canvas, as though making drawings in colour. He revised as he painted (almost impossible in fresco or tempera); his sometimes radical alterations are revealed by X-ray photography.

Renaissance artists or their assistants prepared oil paint themselves, grinding lumps of mineral pigment. As this skilled work was taken over by specialist suppliers, artists were tempted to experiment with new recipes, which could prove chemically unstable – many of Sir Joshua Reynolds's portraits survive only as jaundiced shades of their original brilliance. With the invention in 1841 of oil paint packaged in zinc tubes, ready for squeezing onto the palette (see pp.130–31), the practice of painting *en plein air* became widespread. It underpinned the Impressionist attempt to capture the most evanescent effects of light and atmosphere.

Oil's qualities as a binding medium led twentieth-century artists such as Pablo Picasso, Jean Dubuffet and Antoni Tapiès to experiment by incorporating sand, ash and other particles into the paint. The properties of impasto (built-up layers of opaque paint) had already been explored in the seventeenth century by Rembrandt who was said to have painted a **portrait** 'in which the colours were so heavily applied that you could lift it from the floor by the nose'. ∎

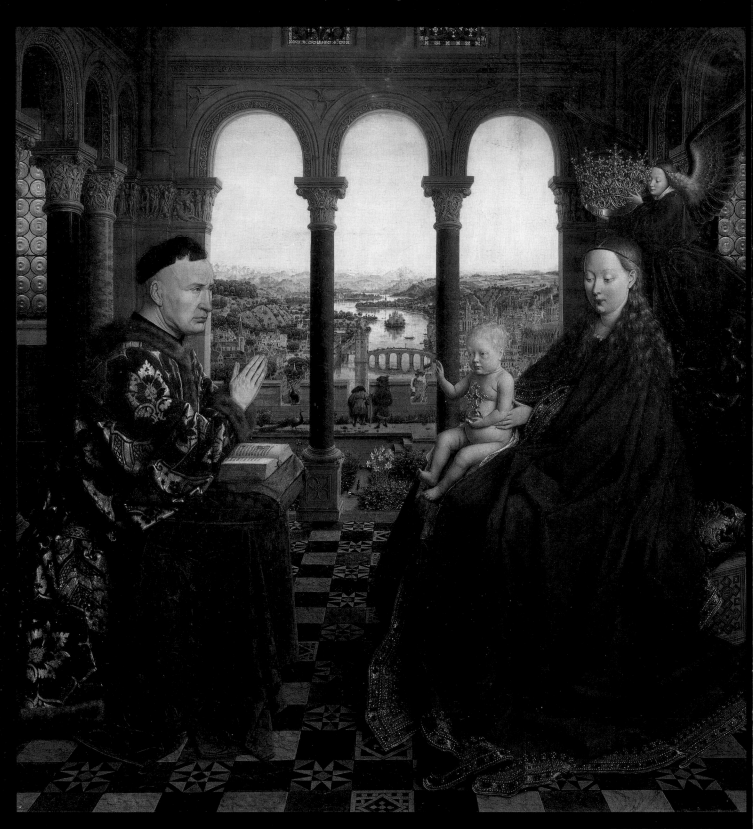

The view through the arcade in van Eyck's Virgin and Child with Chancellor Rolin *mediates between the here-and-now, in the figure of Chancellor Rolin, and the eternal and otherworldly. Both are equally convincing in their closely textured naturalism.*

Inside looking out

IDEA № 29
WINDOW ON THE WORLD

The idea of a painting as a window on the world goes back to ancient murals, which gave viewers the illusion of gazing into spaces on the other side of a wall. The window itself became a frequent motif in Western art in the Renaissance.

Windows are thresholds, allowing light and air into an enclosed space while letting anyone inside look out into their surroundings. Between the Renaissance and the twentieth century, paintings were often thought of as windows that magically dissolved the barrier between viewers' own space and that in which the objects of their contemplation seemed to exist.

The rules of perspective set out by Leon Battista Alberti in the early fifteenth century brought the general metaphorical sense of visual art as an opening or window into sharp focus. They placed viewer and object within a shared notional space. What caused the

BOTTOM LEFT: The cat in this print by Hiroshige (1856–58) is at once family pet and wild animal, serenely installed on the windowsill, which forms the boundary between secure, indoor contemplation and the unbounded landscape beyond.

world 'inside' the picture – or outside the window – to be organised in a particular way was the presence of an eye looking at it from the other side of the frame. The artist intent on pictorial illusion, said Alberti, should regard the quadrangular picture plane – the physical surface of the painting – 'as though it were glass'.

The Albertian comparison of the picture plane to a window coincides with the appearance of actual windows as a motif in art. Possibly because the Northern European climate made it more plausible to set religious scenes indoors rather than in open landscapes or architectural vistas, these windows are especially noticeable in the work of Alberti's Northern contemporaries, such as Jan van Eyck and Rogier van der Weyden. The riverine landscape beyond the open loggia in van Eyck's *The Virgin and Child with Chancellor Rolin* (c.1435, opposite) is much more than backdrop tapestry as it draws the gaze into deep perspectival space between the Virgin and the Burgundian chancellor. In the *Donne Triptych* (c.1478) by Hans Memling, one of the next generation of Northern painters, the contemporary rural landscape visible through the portico gives a comparable sense of mysterious yet everyday **authenticity**.

Windows in art often represent an interface between reverie and observation, inner and outer. Japanese *ukiyo-e* woodblock prints balance domestic detail with the vast or sensational, as in a print by Ando Hiroshige, showing a

ABOVE: Between 1948 and 1954 the American painter Ellsworth Kelly lived in Paris. Kelly's early abstract paintings echo the forms of modern Parisian architecture, such as the windows in the 1937 Museum of Modern Art after which this is named.

cat on a windowsill (left). But for its title, Ellsworth Kelly's painting *Window, Museum of Modern Art, 1949* (above) could be pure abstraction. Geometric shapes, as theorised in twentieth-century art, are themselves a window into the fourth dimension, the reality beyond representation. In contemporary culture, the window motif has become a universal portal in the form of computer screens, though conceptually it is much weakened by virtual reality's tendency to anaesthetise awareness of the frame or threshold. ∎

Harmony, proportion and the sublime

IDEA № 30
MATHEMATICS

It was through ancient Greek concepts such as harmony, symmetry and proportion that mathematics – the study of number and related concepts – and aesthetics became closely integrated in Western thought. Many artists have since based work on mathematical ideas.

Greek philosophers expressed the concept of beauty in mathematical terms. The circle, for example, was considered a perfect form both aesthetically and mathematically. For Aristotle in *The Poetics* (mid-fourth century BC), beauty resided in the harmonious relationship between 'properly ordered' parts and the whole. In their ambition to recover and transcend the achievements of Classical art, artists in fifteenth- and sixteenth-century Italy became similarly preoccupied with beauty's mathematical basis.

Piero della Francesca was, however, the only leading artist of his time who was also an accomplished mathematician. His treatise on **perspective** contains detailed diagrams showing how to project spatial configurations such as tiled floors and three-dimensional forms into two dimensions (right). Whereas Piero tackled problems of pure geometry, Leonardo da Vinci later sought to demonstrate how the human body (God's work of art) reflected the rules of proportion. Echoing Aristotle, he asserted that 'harmonious proportion' in painting and music has the power to hold the viewer or listener 'spellbound with admiration'. His *Vitruvian Man* (1485–90) illustrates rules of proportion derived from

the Roman architect Vitruvius, which state that, if you stand with feet apart and arms outstretched, your navel will be the centre of a circle of which your hands and feet touch the circumference.

Whereas Renaissance artists were primarily concerned with harmony and proportion, the mathematical concept that permeated **Romantic** art was infinity, which was important for the German philosopher Immanuel Kant's formulation of the Sublime – the feelings of awe stimulated by vastness. Nineteenth-century **landscapes** such as Caspar David Friedrich's *Morning in the Riesengebirge* or J.M.W. Turner's *Snowstorm: Hannibal and*

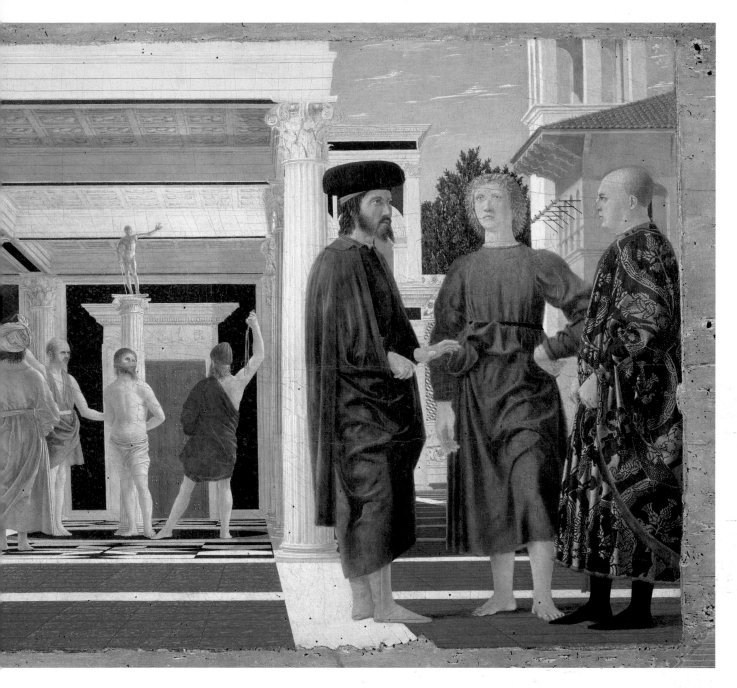

Army Crossing the Alps (1812) have no fixed perspectival viewpoint or clearly defined horizon but offer instead a spatial vision of potentially infinite extent. We desire to experience such scenes, the Romantic poet Percy Bysshe Shelley thought, because they are 'boundless/ As we wish our souls to be'. The aesthetic beauty of mathematics was now associated with its ability to express concepts that visual imagination could never fully grasp, as in William Blake's injunction to 'Hold infinity in the palm of your hand'.

Mathematical thinking informs much twentieth-century art. It is there in the geometric concept of a fourth dimen-sion, which supported the endeavours of Suprematist, Cubist and Surrealist artists to describe a reality beyond conventional three-dimensional representation. For Kenneth Martin in the 1950s, classical mathematics of a kind familiar to Piero or Leonardo brought a scientific pragma-tism to the utopian, spiritual associa-tions that had characterised European geometric **abstract art** in the 1930s. Mario Merz based many of his works on the Fibonacci sequence (opposite). Chaos theory, fractal geometry and other devel-opments in modern mathematics all fed a late twentieth-century artistic interest in random series and pattern-making. ∎

The rules of illusion

IDEA Nº 31
LINEAR PERSPECTIVE

Linear perspective is a system for translating the optical effect of spatial depth from three dimensions into two. First expounded in Renaissance Italy and used today in computer-based design, it is an artistic discovery that has become a deeply ingrained visual convention.

Artists have always found ways of suggesting spatial depth on a flat surface. Palaeolithic cave painters made the off-side limbs of animals look farther away than the near-side ones. Rule-of-thumb perspective, based on the perception that parallel lines converge with distance, was probably practised in ancient Greece. Medieval European painters and their Chinese and Japanese contemporaries suggested depth and atmosphere using various means. What is called linear or scientific perspective, which made optics and **mathematics** an essential part of the painter's craft, was first formulated by Leon Battista Alberti in his treatise *De Pictura* (*On Painting*, 1435). He described a perspectival pyramid whose base was

the picture plane, with its apex forming the vanishing point 'inside' the picture.

Linear perspective combines technical drawing, where measurements matter, with spatial illusionism, which denies the truth of measurement (a tiny distant tree might actually be taller than an apparently larger tree in the foreground). It was developed in the context of architecture and **wall painting** which provided so much employment for artists in fifteenth-century Florence, where trade and banking profits fuelled a remodelling of the urban fabric and of Church and civic visual culture. According to Giorgio Vasari, it was the sculptor and architect Filippo Brunelleschi who devised a technique for rendering perspective 'truthfully and accurately … by tracing it with the ground plan and profile and by using intersecting lines'. Brunelleschi passed on this method to his painter protégé Masaccio, who used it to unnervingly convincing effect in his *Trinity* (c.1425–27) in Santa Maria Novella, Florence where the holy figures occupy a factitious architectural space in the style of Brunelleschi.

The practice of linear perspective made the illusory space in a painting dependent on the viewer's own position; it made painted objects and people seem three-dimensional. The second effect is the one Vasari mentions most enthusiastically. To him, spatial depth seemed less wonderful in itself than the foreshortening that brought individual

BOTTOM LEFT: As developed by Giorgio de Chirico, Pittura Metafisica (Metaphysical Painting) used perspective to evoke convincing spaces that were suffused with an atmosphere of claustrophobic unease, as in The Mystery and Melancholy of a Street (1914).

ABOVE: Attributed to Piero della Francesca, with underdrawing by Leon Battista Alberti, Ideal City (c.1470) demonstrates the ordered, rational nature of the illusory space that artists could create through the rigorous application of linear perspective.

objects and figures to life, for example by making the parts nearer to the viewer seem larger than those farther away. By the end of the fifteenth century, the initial excitement about creating geometric perspectival spaces had waned. Leonardo saw that this approach worked well enough for unified architectural settings but was less effective for wide-angle landscapes.

Linear perspective remained a core element of the **academic** art curriculum from the seventeenth to the twentieth centuries, but it never again enthralled a generation of artists as it had in fifteenth-century Italy. Its ability to confer an absolute command of illusory space was employed to vivid effect in the interiors of seventeenth-century Dutch artists such as Pieter de Hooch. Twentieth-century artists such as Giorgio de Chirico (left) and René Magritte (see p.70) adapted Albertian perspective to heighten the strangeness of the dreamworld. ∎

*Linear perspective allowed
Renaissance artists to create realistic
settings for imaginary events.
Leonardo's drawing* Architectural
Perspective, for the Adoration of
the Magi *(c.1481) resembles a stage
set under construction for an as yet
unfinished play.*

Tricks of the eye

RIGHT: *Of the Surrealists, the Belgian painter René Magritte was the most fascinated by illusionism's mind-bending properties. In L'Appel des cimes (1943), as in much of his work, he disrupted familiar artistic conventions for making objects seem real.*

BOTTOM LEFT: *Shadows subtly crafted from tesserae (the tiny cubes of marble, glass or other material from which mosaics are composed) tempt the viewer to reach down and tidy up the dining-table detritus in this Roman floor mosaic.*

IDEA № 32
TROMPE-L'OEIL

The ability to give two-dimensional images the appearance of objects in three-dimensional space has been a measure of artistic skill since antiquity. The force of *trompe-l'oeil* (French for 'trick of the eye') lies in the uncertainty it creates: which is more real – the object we can touch or the image it creates in our minds?

The Roman writer Pliny the Elder recounted a competition between the celebrated fifth-century BC Greek painters Zeuxis and Parrhasios. Zeuxis' work seemed a sure winner: it contained a bunch of grapes so realistically painted that it enticed birds to swoop down and peck at it. But when Zeuxis reached out to lift a curtain seemingly obscuring Parrhasios' painting, he found that the veil was part of the painting itself. Nothing survives of the two artists' work, and Pliny's story, recorded five centuries after the event, may be fictitious. It does, however, show the value placed on virtuoso illusionism: it was variously the mark of a great artist, a spirited game that mesmerised spectators (including birds) and a subject for philosophical reflection.

By confusing the senses of touch and sight, *trompe-l'oeil* adds a particular piquancy to visual art. Another example associated with eating concerns a second-century mosaic pavement from the Aventine Hill in Rome known as the *Unswept Floor* (below). A bird's claw, shells and leaves lie apparently scattered across the floor. Like the fashionable illusionistic **wall paintings** in Roman villas, the *Unswept Floor* addresses a patron's gourmet tastes: it is art to stimulate the appetite and amuse the guests.

Trompe-l'oeil's sensory confusion gained an extra dimension in fifteenth-century Europe in two kinds of art that invited the viewer not just to reach out for illusory objects but imaginatively to enter the picture. In Northern Europe, Jan van Eyck's meticulous rendering of surface textures, made possible by **oil paint**'s slow-drying glazes, produced paintings as uncannily lifelike as those described by Pliny. In Italy, the development of perspectival space in painting opened illusory architectural and landscape vistas that seemed as real as the space in which the viewer stood. In different ways, the august *trompe-l'oeil* apse behind the figures in Masaccio's *Trinity* fresco in Santa Maria Novella (*c*.1425–27) and Mantegna's cherub-crowded ceiling oculus in the Ducal Palace in Mantua (1465–74, opposite) deliberately take illusionism on to a metaphysical plane, defining a world beyond the reach of the senses.

Artists' technical ability to produce illusionistic images lost much of its cachet with the emergence of **photography** as a cheap, popular medium in the nineteenth century, although *trompe-l'oeil* continued to be practised as an impressive party piece by a few artists such as the American John F. Peto. From the 1890s onwards, a defining characteristic of European modern art was its rejection of illusionism as an end in itself; an admiration for 'realistic' painting became a sign of uneducated or (worse) bourgeois taste. Some Surrealist artists specialised in *trompe-l'oeil* practical jokes that invite the viewer imaginatively into a picture in order to disturb and disorient them. René Magritte's *L'Appel des cimes* (*The Call of the Summits,* above) presents a *trompe-l'oeil* mountain within a *trompe-l'oeil* image of a painting. ■

Stimulating both eye and mind

BOTTOM LEFT: *Describing his idea for the painting that became* The Bedroom *(1888), Van Gogh told his brother Theo, 'Colour is to do everything ... looking at the picture should rest the brain or rather the imagination'.*

OPPOSITE TOP: *The luminous, saturated blue of the Virgin's mantle in Giovanni Bellini's* Madonna of the Meadow *(c.1500), echoed by the paler blues of calm sky and distant mountains, is simultaneously sensuous and otherworldly, like the young woman herself.*

OPPOSITE BOTTOM: *Despite its apparent rationality, Josef Albers'* Variation in Red and Orange around Pink, Ochre, Plus Two Reds *(1948) creates strangely ethereal effects. Albers' influential book* Interaction of Colour *(1963) recorded his experiments in studying and teaching colour.*

IDEA № 33

COLOUR CODES

Artists' use of colour often derives from ideas about its nature and the meaning of specific colours. For Wassily Kandinsky, for instance, colour was a 'spiritual vibration' rather than an effect of reflected light. Colour has regularly served as a pictorial element that simultaneously conveys meaning and stimulates the eye.

Egyptian, Greek and other ancient sacred art and buildings were painted in polychrome, as were the interiors of medieval churches. **Icons**, altarpieces and **coloured-glass** windows embodied the 'spiritual vibration' of colour that accompanied Christian worship before the Protestant Reformation. The Church colour-coded its liturgical year (blue or green for Sundays, purple for Ash Wednesday, and so on) and spiritual values – deep blue connoted contemplation and modesty, exemplified in the Virgin Mary (opposite top).

Leonardo da Vinci investigated light as a physical phenomenon but retained a semantic role for colour: the four elements, for example, were represented by 'yellow for the Earth, green for the Water, blue for the Air, red for Fire'. He noted how colours interacted and gave practical tips for painters: 'Black garments make the flesh tints ... whiter than they are ... while red garments make them pale.'

In the 1670s the English mathematician Isaac Newton's experiments with prisms revealed that white light contained the entire colour spectrum. His presentation of colour as a circular chart, showing how each colour had its complementary (the colour that produces grey when mixed with it), introduced the idea that colour could be deployed rationally to achieve premeditated effects. In the nineteenth century, the German polymath Johann Wolfgang von Goethe took issue with Newton, insisting that colour was not an objective property but a matter of perception, existing in the eye – or mind – of the viewer. The idea that seeing is 'coloured' by feeling informs much later European painting. The French chemist Michel-Eugène Chevreul analysed the changes in perception of a colour when it was placed next to other colours, an effect he called 'simultaneous contrast'. In varied ways, artists in late nineteenth-century France shared a preoccupation with achieving psychological effects from the 'scientific' manipulation of colour. Searching for a way to communicate the sun-struck brilliance of the Provençal landscape, Vincent van Gogh (left) opined 'There is no blue without yellow and without orange'.

Van Gogh's assertion 'I have tried to express the terrible passions of the human heart by means of red and green' provided one of the cues for twentieth-century artists' attempts to enlist colour's capacity both to express and to signify – to create a 'chromatic language'. This effort made common cause between the fuzzy grandeur of Mark Rothko's Colour Field paintings – apparently all 'spiritual vibration' – and Joseph Albers' geometrical exercises in simultaneous contrast (opposite bottom). ■

In devising his great allegory
Primavera *(Spring, c.1478), Sandro Botticelli followed Alberti's advice to painters, to take their themes from literary sources. In the centre Venus and Cupid represent love, while Flora*

Abstract ideas get personal

IDEA № 34
ALLEGORY

Allegory is based on the personification of abstract concepts, such as time, beauty or freedom. It allows ideas to assume visible form and dramatises the relationship between them. Allegory's didactic qualities have been consistently exploited for political ends from ancient Greece down to the Statue of Liberty in New York harbour.

Allegorical art originated in ancient Greece, where a system of thought based on personified abstractions developed around the pantheon of anthropomorphic deities. The Greek word *allegoria* means 'speaking otherwise', or describing something in terms of something else. In contrast to symbol and metaphor, to which it is closely related, allegory involves personification. Its force as a vehicle for political statement can be seen in the *Nike of Samothrace* (*c.*200 BC). Bearing forwards with wings outstretched and wind-blown robes, the statue – which, as its title suggests, personifies *nike* (victory) – was probably a thank-offering commemorating a naval

battle. In its more lyrical aspect, allegory was a link between visual and literary art. The graceful figure of Flora, personification of spring, in a Roman wall painting from Stabiae (below left), echoes a near-contemporary poetic allegory by the first-century BC poet Lucretius.

Medieval art adopted allegory as a didactic, moralising mode, using Christian rather than pagan iconography. Giotto's statuesque *Seven Vices* and *Seven Virtues* frescoes in the Scrovegni Chapel, Padua (1303–06) present a visual sermon in which abstractions such as Lust and Avarice confront the viewer like real people. From the Renaissance onwards, allegory's Greek origins reasserted themselves; its use became, like **nudes** or Ionic columns, a Classical allusion. The winged infant Cupid (Romanised version of the Greek Eros) personifies sexual love in a long series of **erotic** allegories including Botticelli's *Primavera* (*c.*1478, opposite), Titian's *Sacred and Profane Love* (*c.*1514), Caravaggio's *Concert of Youth* (*c.*1595) and Velázquez' *Toilet of Venus* (*c.*1651). In later art, from Antonio Canova's statue *Cupid Awakening Psyche* (1783–93) to Anna Lea Merritt's painting *Love Locked Out* (1889), allegory is often little more than a Classicising pretext for nudity. But still, for all the young flesh frankly displayed, the presence of allegory tries to persuade us that there's also a lesson to be learnt.

The twentieth-century philosopher and critic Walter Benjamin observed that an allegorical object relies on the meaning ascribed to it by its maker, becoming 'incapable of emanating any meaning … on its own'. This doesn't necessarily deplete its power: there is something of the *Nike of Samothrace*'s impact in the best-known modern allegory, the *Statue of Liberty* (more accurately *Liberty Enlightening the World*, 1886). This colossal draped female figure, a gift from the French state to the US, represents the Roman goddess Libertas. In true allegorical manner, the statue's function is didactic, announcing to all arrivals in New York harbour the principles on which the state they are about to enter is founded. She also embodies (though this is largely forgotten) the French claim to have given revolutionary birth to these ideals, dynamically evoked in Eugène Delacroix's great allegory *Liberty Leading the People* (above). ∎

The essence of biography

RIGHT: *With the Protestant Reformation's assault on 'idolatrous' religious images, portraiture gained new prominence. The closely observed economy of Hans Holbein the Younger's drawings of early sixteenth-century English courtiers, such as this portait of George Nevill, has never been surpassed.*

BOTTOM LEFT: *Who does a face belong to? John Deakin was a photographer on whose portraits Francis Bacon based several paintings. In Deakin's portrait by Lucian Freud (1963–64), the sitter proffers his sagging face as material for the artist.*

IDEA № 35
PORTRAIT

Portraiture establishes a unique bond between the sitter and the artist, who is entrusted with both recording and creating the face their subject turns to the world. Painted or sculpted portraits were the only way of preserving the likeness of an individual until the advent of **photography**.

Humanoid forms occasionally appear in Palaeolithic **cave painting**, and human figures in identifiable roles – kings, soldiers or stand-ins for anthropomorphic deities – constitute the most frequent subject of ancient art. But where faces occur, they are usually generic, not (as far as we can tell) true portraits. The distinctively pear-shaped, jug-eared face of the fourteenth-century BC pharaoh Akhenaten seems highly individual compared with earlier royal images, but there's no way of knowing whether he actually looked like this, or whether his queen, Nefertiti, was as beautiful as the elegant limestone bust now preserved in the Neues Museum, Berlin, suggests.

Portraits that survive from the Hellenistic Mediterranean world of the fourth–first centuries and the Roman Empire suggest that this was an age when art discovered a new role: it seized the essence of biography, literally 'life drawing'. In the multicultural, mobile ancient Mediterranean, the human face was, perhaps, the only book whose language everyone could read. A small fourth-century BC ivory head of Philip II of Macedon, Alexander the Great's father, shows a facial wound consistent with that found on the king's skull in his tomb at Vergina. The faces in coffin portraits from first-century AD Egypt are as lively and sharply defined as modern photographic head-shots, as though the subjects wanted to be recognised after death for who they were, not simply for their generic social roles – 'a young man', 'a merchant's wife'. Again, we can't compare portrait with sitter, although the sensitive young face of Artemidorus on a mummy case in the British Museum seems to correspond in age (18–21) with the bones inside.

The Renaissance gave birth to the modern idea of 'the individual', the single and unique person. Whereas Greek heroes had proved their worth by accomplishing the impossible and enduring the unbearable, the Renaissance heroic ideal had more to do with the fulfilment of great ambitions. In Andrea del Verrocchio's bust of the Florentine grandee Lorenzo de' Medici (1480), it is clear that character, as expressed in the face, with its deep thought lines and determined mouth, is the key to destiny. The face tells all; as far as his clothes go, this is just another rich Florentine.

From the mid-nineteenth century on, photography quickly overtook painting as the medium of choice for ordinary portraits, as well as robbing portraiture of its earlier exclusivity – everyone could have their portrait done now. In the photographer's studio, working-class sitters posed in their best clothes against a patrician backdrop of velvet curtains and marble columns. While conventional painted portraits are still commissioned as a traditional mark of social status, a few modern artists, such as Lucian Freud, have reversed portraiture's terms of reference. In Freud's portraits it is as though the sitter's very identity resides in the artist's transformation of flesh into paint: they become more fully themselves by being turned into 'Freuds' (left). ■

OPPOSITE: *Agnolo Bronzino was court painter to Cosimo I de' Medici, ruler of Florence. In this portrait of Cosimo's wife, Eleonora of Toledo, and son Giovanni (1545), the sumptuous fabric seems more expressive than the mask-like faces.*

Rapid fluency

IDEA № 36
THE SKETCH

So much art involves patience. The sketch, on the other hand, is a form of drawing characterised by rapid fluency. Sketches are about seizing images and ideas quickly. They can be made as doodles or *aides-mémoire*, for learning or demonstration purposes, or as a private visual diary for the artist.

Art destined for public display tends to reflect the conventions of its day, but sketches are impromptu and typically less constrained by conventional models. The cartoon-like drawings made by ancient Egyptian artists on potsherds, or *ostraca*, seem timeless; they lack the hieratic formality of the finished works such artists would have been required to produce (below). These sketches attest to a fundamental constancy in the impulse to translate things seen or thought into visual form – an impulse that precedes attention to achieving particular effects.

Artists have always made rough, throwaway drawings – even prehistoric **cave art** contains what seem to be sketches. Basic drawings have also been used for practical instruction, as in medieval books of regulations for masons. But the systematic practice of sketching as a means of note-taking came in with the Renaissance reinvention of **the artist** as a well-educated, literate, scientific spirit. From the fifteenth century onwards, artists sketched in order to understand; it became accepted wisdom that Nature was more various and unfathomable than anything that could be imagined or invented, and therefore provided a limitless source of visual material and ideas for the artist. The sketch was an instrument of this quest. It represented the artist's commitment to direct observation, which, since people and animals move and light changes constantly, has to be recorded rapidly, on the spot. Claude Lorrain's summary ink drawings, made in the Roman Campagna, were a means of gathering material for paintings, but also of capturing an atmosphere – a time of day or air temperature – of which the sketch would serve as an *aide-mémoire*.

From the sixteenth century, sketches in **oil paint** were used by artists in negotiations with patrons over the final appearance of commissioned works. Peter Paul Rubens, who worked for royal and aristocratic patrons throughout Europe, developed the oil sketch as a persuasive medium for communicating his ideas both to patrons and pupils. In the **Romantic** era, sketching became something different again. With the high value placed on feeling and emotional response, the sketch could be seen as possessing greater integrity than a fully worked-up painting based on it.

And, as the mystique of genius increasingly attached itself to artists and every mark they made, the sketch gained a certain glamour. Impetuous, more about process than finish, in the hands of J.M.W. Turner and Eugène Delacroix it was an art form in its own right. Later still, the whole enterprise of Impressionist painting existed on the boundary between sketch and finished work (see pp.124–25). In modern art education, filling a sketchbook remained a standard student discipline, although in the later twentieth century this was widely discontinued as the orthodoxies of **conceptual art** undercut the old reverence for the skilled co-ordination of hand and eye. ∎

BOTTOM LEFT: Ancient Egyptian artists practised their graphic and narrative skills by making informal drawings on fragments of stone or pottery. In this scene (c.1120 BC), a cat guards six geese and a nest of eggs.

ABOVE: In 1877 Claude Monet produced numerous paintings of Saint-Lazare railway station in Paris. At this date, photographic exposure times were too slow to capture movement; sketches were the only way to record activity inside the station.

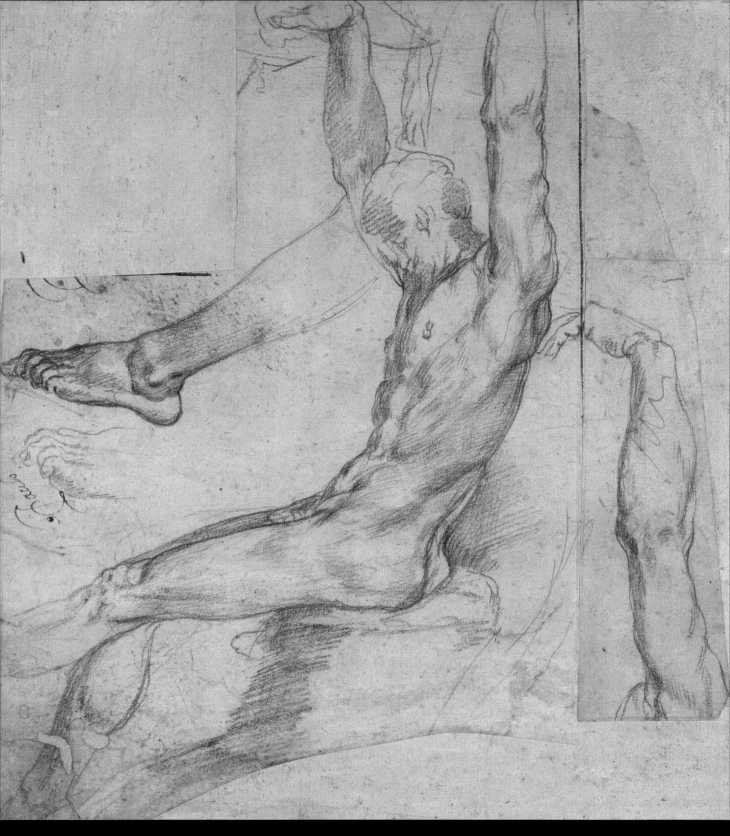

It may have been in preparation for painting a martyrdom scene that Polidoro da Caravaggio made this drawing of a nude male figure around 1535. His sketch pays close attention to the dynamic rhythms of musculature.

From the sixteenth century on,
mirrors became a standard item
in a painter's studio equipment.
Though earlier artists had
occasionally produced self-portraits,
for Parmigianino and future
generations, mirrors turned
self-scrutiny into an art form.

Reflection or reality?

IDEA Nº 37
MIRRORS

Leonardo da Vinci advised that 'The mind of a painter should be like a mirror'. From the Renaissance onwards, mirrors as metaphors, images, tools and media occur throughout Western art practice and theory to the extent that the idea of the mirror has come to seem integral to the idea of art itself.

Although polished metal mirrors were made in the ancient Near East about 5,000 years ago and were in common use in the Roman Empire, they provided only a small, cloudy reflection – enough to apply make-up, though not to mirror the wider world. Even after fifteenth-century Venetian glassmakers created clear glass sheets that could be backed with foil to produce a sharp reflection on larger surfaces, mirrors remained a luxury item, an idea rather than a daily reality for most people.

Renaissance artists were intrigued equally by what glass mirrors could do and what they represented. In Jan van Eyck's *Arnolfini Marriage* (c.1434), a convex mirror in the background reflects the scene in reverse and includes the figure of the artist, like a circular seal of **authenticity**. In his notebooks, Leonardo repeatedly counselled painters to 'act as a mirror', to keep their minds 'clear as the surface of a mirror', and to set up a flat mirror in the studio as a tool for critiquing their own work-in-progress with fresh eyes. The glass mirror turned the artist self-portrait into a form of detailed self-examination and self-presentation by these new members of the Renaissance intelligentsia. Parmigianino's 1524 *Self-Portrait in a Convex Mirror* (opposite) is a Mannerist conundrum: if mirrors both reflect and distort reality, then reality can only be mirrored – that is, represented – through distortion.

The characteristic self-contemplating gaze of the self-portraitist – the penetrating but wary look of a spy whose disguise is about to be found out – suggests that mirrors pose more questions than they answer. Where mirrors occur in paintings, the reflections they contain are often puzzling, as though the mirror-image were less a reflection of reality than proof that appearances are not as they seem. In Edouard Manet's *Bar at the Folies-Bergère* (1882), an otherwise invisible male customer is speaking to the dreamy, and apparently solitary, young bartender's more businesslike reflection.

BOTTOM LEFT: *Colour, weightlessness, reflection and transformation are elements in much work by British sculptor Anish Kapoor. All are combined in his mirror sculptures, such as the 10-metre stainless steel Sky Mirror, installed at New York's Rockefeller Center in 2006.*

ABOVE: *Pierre Bonnard's* Mirror in the Bathroom *(1908) evokes a world of ordinary domestic intimacies, but the mirror also makes us aware of distance, drawing the attention to the reflection instead of the female subjects themselves.*

In the highly metaphorical mirror sculptures of Anish Kapoor, spectators confront their own distorted reflections. Since looking in the mirror is an action usually performed indoors, the effect of dislocation is strangest, and strongest, in Kapoor's large outdoor mirror pieces, curved and angled to reflect wide landscapes or bring the sky down to earth (left). The Chinese artist Song Dong's 1999 video *Broken Mirror* reveals the fragility of all of art's attempts to reflect reality, as a single hammer stroke destroys an entire street. ∎

The possibility of multiples

IDEA № 38
PRINTMAKING

Printmaking allows a single design to be reproduced in multiple copies. For centuries, it was the only way to reproduce works of two-dimensional art, allowing images to circulate in a manner analogous to written texts. In the digital era, printmaking has developed new and distinct aesthetic possibilities of its own.

Prints are made by pressing an image made on one surface onto another, where it appears reversed. Some prints, known as monotypes, are produced in only a single copy, but most are intended as multiples. The number of copies that can be made, or 'pulled', from the original design depends on how quickly it wears out in the course of the printing process. Designs cut into wooden blocks or planks lose definition much more rapidly than those incised in metal plates.

In China and Japan, the development of printmaking was linked to papermaking technology and connected initially to the distribution of sacred texts rather than images. Colours and designs were printed on textiles for clothing and ornament; printmaking tended to be an everyday, **ephemeral** art form rather than an elite medium.

In fifteenth-century Europe, images took on a new importance in social and cultural life. Prints accompanied text as book illustrations and were distributed as copies of artworks and as media of **propaganda** in the fierce religious and political controversies that raged in one place or another from the early sixteenth century for more than 200 years. Albrecht Dürer's large print *Knight, Death and the Devil* (1513, opposite) is a moral **allegory**, a story designed to instruct through visual means. The Christian knight makes his way stead-fastly through horrors and temptations personified by the ugly figures of Death and the Devil. In previous eras, such an allegory might have addressed the circumstances of a private patron or a particular congregation in a church. Being produced as a print allowed it to enter the new social and intellectual sphere – part-private, part-public – created by the Protestant Reformation, in which freedom of individual conscience was seen as entirely compatible with social duty.

With the development of photomechanical printing technology in the late nineteenth century, it became possible to reproduce images in indefinite numbers of copies. Artists responded by turning traditional printmaking into a more exclusive practice, engaging in it as a medium with its own distinctive effects. Images could be made larger, lines sharper and darker, and colours more heavily saturated than in photoreproductive processes, which as yet produced mainly black-and-white images. Artist-printmakers such as Stanley Hayter had close personal collaborations with artists, bringing their technical and aesthetic skills to the task of realising another artist's images. In recent decades, **digital technology** and the inkjet print have taken printmaking into new territory. Anyone with a desktop set-up of computer, digital camera and printer can produce inkjet

TOP: Katsushika Hokusai's woodblock print Great Wave at Kanagawa, *from his series* Thirty-six Views of Mount Fuji *(c.1831–33), exemplifies the achievements of nineteenth-century Japanese printmakers. It is now widely reproduced in other media, from posters to tattoos.*

ABOVE: Joan Miró's prints brought his private, Surrealist vision into the public sphere, whether helping to raise funds for the Republican cause in the Spanish Civil War or, as in this 1961 poster, advertising an exhibition.

OPPOSITE: Dürer's Knight, Death and the Devil *(1513) shows the subtle gradation of tones that can be created in copperplate engraving with different tools and cutting strokes. Dürer's prints proved that masterpieces could be made as multiples.*

prints; artists have looked for different ways of using this medium, making enormous or highly idiosyncratic prints that are capable of enticing an audience sated with visual culture of all kinds to stop and look. ■

The startling effect of daylight shafting into a dark interior in Caravaggio's Calling of St. Matthew *(1599–1600), executed for the Roman church of San Luigi dei Francesi, helped to make the young artist's reputation overnight.*

Drama of light and shade

IDEA Nº 39
CHIAROSCURO

Chiaroscuro describes the contrast between lit surfaces and shadowed areas by which painters model the illusion of three-dimensionality, adjust the overall tonal balance of a painting or create dramatic impact. Bearing a name derived from the Italian words for light (*chiaro*) and dark (*scuro*), the effect has strong metaphorical associations.

Unless painters want shapes to appear flat, they use various techniques for suggesting the lit and shaded areas that reveal an object's presence in real space. The Renaissance interest in optics – the behaviour of light – combined with the universal resonance of light and dark to make chiaroscuro much more than a trick of the painter's trade. Light and dark were the most fundamental of the ten qualities perceived by the eye, according to Leonardo da Vinci, who imagined their action almost as a moral allegory: 'Light is the chaser away of darkness. Shade is the obstruction of light.' The adoption of **oil paint** by European artists in the fifteenth and sixteenth centuries made possible subtle blending and gradation of tones – the so-called *sfumato* or 'smoky' effect. In

Leonardo's *Portrait of a Lady with an Ermine (Cecilia Gallerani)* (*c.*1489–90), a young woman turns towards the light as though in response to a greeting. The smoky chiaroscuro registers the play of facial musculature beneath the softly lit skin, while the deep shadow that surrounds her is distilled in the black gems of her necklace and pupils.

A century later, Caravaggio transformed chiaroscuro into a vehicle for sensational theatricality in which light and dark don't so much balance each other as battle for supremacy (opposite). In his *Supper at Emmaus* (1601) and *Entombment* (1603–04), the heightened chiaroscuro created by a strong, localised light source turns familiar biblical scenes into tense dramas. This high-contrast formula, known as tenebrism, was taken up by numerous other artists, including Georges de La Tour (see p.137) and Artemisia Gentileschi.

In seventeenth-century Europe, such dramatic chiaroscuro effects marked painting as an art form determined to transcend the merely representational or decorative. It became common practice for painters to start with a dark ground on which lighter tones and finally highlights were built up. In this way the artist appears to conjure an image out of darkness, holding it steady for the viewer in the light. Diego Velázquez and Francisco de Zurbarán in Spain and Rembrandt and his followers

BOTTOM LEFT: The strong chiaroscuro effects employed by the American photographer Robert Mapplethorpe, as in his 1983 portrait Desmond, give his human subjects the poised, sharply modelled quality of statues, emphasising anatomical form and skin texture.

ABOVE: Rembrandt's emotive chiaroscuro was much imitated. The shadowed face of an old man wearing a turban was once thought to be the work of his pupil Jacques des Rousseaux (1600–38) but is now attributed to the master himself.

in the Netherlands developed chiaroscuro's expressive, if sometimes stagey, repertoire. The subdued or fading indoor light in the work of Rembrandt (above) has a persuasive honesty, as it slants across the furrows in ageing skin or seems frankly mesmerised by glowing embroideries.

In the mid-nineteenth century, photographers quickly discovered how to manipulate exposure and development times to create contrasts. Chiaroscuro's special effects, which had been exhaustively explored by painters, were revitalised as part of **photography's** stock-in-trade. Strong, carefully constructed chiaroscuro, as in Robert Mapplethorpe's work (left), often distinguishes the art photograph from other genres. ■

Getting under the skin

IDEA Nº 40
ANATOMY

Since antiquity, anatomical knowledge has enabled artists to create convincing representations of the human figure. The idea that the painted or sculpted figure should reveal complexities within – truths beyond the reach of superficial observation – reflected the scientific ambitions of Renaissance art. Viewers today are still mesmerised or shocked by art that looks beneath the skin.

BOTTOM LEFT: *The self-taught artist George Stubbs was an unrivalled painter of horses. The engravings in* The Anatomy of the Horse *(1766) are based on drawings he made during 18 months spent dissecting horse cadavers from a tannery.*

ABOVE: *In 1935 the Spanish painter Remedios Varo became involved with the Surrealists in Paris. Her collage* The Anatomy Lesson *(1935) exposes the hidden contents of both the mind (dreams and fantasies) and the body (X-rays).*

OPPOSITE: *As Rembrandt's sprightly Dr Tulp demonstrates, the action of muscle and tendon in the forearm, his raised left hand, balanced by the corpse's prostrate right one, creates an unsettling kinship between living and dead.*

At least 3,600 years ago, and probably earlier, Egyptian physicians were basing diagnoses on accurate observation of body parts and tissue revealed by wounds. Greek sculptors of the fifth and fourth centuries BC had detailed knowledge of muscular-skeletal structures,

but seem to have learnt from observation rather than dissection. The latter (the literal meaning of the Greek term *anatomē*) was practised on cadavers by Arab physicians from the twelfth century and, via contact with the Muslim world during the Crusades, had been adopted in medical training at Bologna by the following century.

In the fifteenth century, knowledge of anatomy, along with **mathematics** and other disciplines, became part of the new intellectual foundations of artistic practice. 'I have dissected more than ten human bodies,' wrote Leonardo da Vinci in relation to his exceptionally thorough anatomical studies, while conceding that not every artist might feel equal to 'passing the night hours in the company of corpses, quartered and flayed and horrible to behold'. It would be worth it, however: 'The painter who has a knowledge of the sinews, muscles and tendons' could capture their subtle interplay rather than showing figures in improbable, rigid attitudes. The expressive musculature of Michelangelo's **nudes** owes much to his study of anatomy.

From 1543, anatomical illustrations became widely accessible to artists through the publication of the young Dutch physician Vesalius's *De humani corporis fabrica* (On the Structure of the Human Body). Showing flayed figures statuesquely posed in landscapes, the engravings in his book provided a model for anatomical illustrations for three centuries or more. They became familiar to the generations of artists through the adoption of anatomy as part of **academic** art education. As a pedagogic requirement, however, anatomy lost its aura of investigation and discovery, and artists were simply trained to reproduce anatomical features competently. The most famous image of anatomy in art, Rembrandt's *Dr Tulp's Anatomy Lesson* (1632, opposite), shows a prosection – a dissection performed for an audience, in this case Amsterdam's Guild of Surgeons.

There nevertheless remains a frisson of the obscene or the occult about looking under the skin. Gunter von Hagens' egregious series of 'Plastinations' (1990s–) – real donated cadavers, chemically transformed into plastic sculptures – create a modern re-enactment of Vesalius's illustrations. In Mona Hatoum's *Corps étranger* (Foreign Body, 1994), an endoscopic camera films the pulsing, roseate tubes and cavities inside the artist's own body. ■

'Passing the night hours in the company of corpses, quartered and flayed and horrible to behold.'

Like gold and glassware, the lobster and lemon in Willem Claesz. Heda's still life (1650–59) were expensive goods. Their precise detailing reminds us that this was an age of scientific advances based on measurement and observation.

All is vanitas

IDEA № 41
STILL LIFE

Still life was a name given in the seventeenth century to an already long-established artistic subject involving arrangements of everyday objects such as fruit, flowers, dishes and vases. If earlier still life had provided an opportunity for brilliant displays of illusionism, it now became a focus for meditation on transience and mortality.

BOTTOM LEFT: Judging from the profusion of trompe-l'oeil food and drink in Roman wall paintings, still life was part of hospitality, providing an inexhaustible cornucopia, as in this detail from the House of Stags, Herculaneum (AD 45–79).

ABOVE: In Sam Taylor-Wood's video Still Life (2001), there's nothing new in the message that everything decays – except, of course, for the non-biodegradable plastic pen, which will last for ever.

Still or 'silent' or 'dead' subjects – numerous terms have been used in different times and languages – are by their nature contemplative. The distraction of human activity is kept out of the frame; instead, everyday objects are offered, often literally, as food for thought. The act of offering is there in the earliest still-life images: the meals piled up in Egyptian tomb decorations, which provide a self-replenishing banquet for the dead. In his hierarchy of artistic subjects, the Roman author Pliny the Elder placed paintings of flowers, food and ordinary objects at the lowest level – though this suggests that there was already a popular taste for still lifes (below).

Pliny's story of Zeuxis' illusionistic painting of grapes (see p.70) indicates that still-life subjects were respected enough to be a pretext for virtuoso

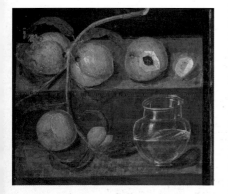

artistic display in ancient Greece. They resumed this role in European art with Caravaggio's *Basket of Fruit* (c.1598–1601), in which the teasing lusciousness of the fruit is tempered by signs of decay – the shadowed puncture wound of the apple's maggot hole, the vine and fig leaves curling as they dry. Food could be watched, as the human body generally could not, in the actual process of disintegration, prompting reflection on the dark side of ripeness, its moral **chiaroscuro**.

Where earlier still lifes with their hourglasses and skulls had a sermonising gloom (they are termed *vanitas* paintings alluding to the 'vanity' or futility of worldly goods) seventeenth-century Dutch painters lavished attention on petals, butterflies, creatures killed for the table, silver and glassware (opposite). These things spoke of wealth and pleasure as well as of their inevitable passing. Artists who specialised in such work addressed early capitalist tastes for moral edification combined with conspicuous display.

In the early twentieth century, still-life painting again proved its uncanny capacity to reflect the tenor of the times. All the intellectual and artistic developments that fed into Cubism were concentrated in still life. Georges Braque's and Pablo Picasso's fractured still lifes of wine bottles and guitars definitively challenged the nineteenth-century fashion for **narrative** figure paintings and **landscape** views. In the 1960s, in such forms as Andy Warhol's Brillo boxes or David Hockney's *Tea Painting in an Illusionistic Style*, still life led the **Pop** assault on the highbrow distinction between artwork and mere product. Sam Taylor-Wood's *Still Life* (2001, above) revisits the *vanitas* theme through video. ∎

ABOVE: *Gustave Courbet always admired Rembrandt. Like him, the earlier artist painted people as they were, without idealisation. In his copy (1869) of a Rembrandt self-portrait (1655), Courbet attempted to penetrate the secret of his realism.*

Learning by example

COPYING

The making of copies has defined many aspects of the artist's job across the millennia. Traditionally apprentices copied their master's work; masters in turn copied their admired predecessors or contemporaries, or attempted faithfully to transcribe the forms of Nature. More recently, although the practice of copying was disparaged in the Romantic era, it remains a springboard for personal creativity.

BOTTOM LEFT: *Private Roman art collections were filled with large- and small-scale copies of earlier Greek sculpture, like this Head of Athena Lemnia, copied from an original by the great Greek sculptor Pheidias.*

ABOVE: *In the 1950s the septuagenarian Pablo Picasso returned compulsively to works by great artists of the past, producing series of adaptations of Edouard Manet's* Déjeuner sur l'herbe *(see p.170) and Diego Velázquez'* Las Meninas *(above, see p.92 for Velázquez' original) in a style unmistakably his own.*

Wherever art is seen as a trade or profession, copying has formed part of the training. Most student copies are considered valueless and destroyed, but a very few examples survive. **Sketches** of human and owl heads on a fifteenth-century BC *ostracon* (inscribed pottery fragment) from Deir el Bahri appear to be the work of a trainee ancient Egyptian artist copying the correct way to represent these subjects. Since Egyptian art constituted an elaborate semantic system, incorporating images and hieroglyphs, the accurate copying of conventional forms was essential for communicating meaning. The same is true for Eastern Orthodox **icon** painting and the Christian art of pre-literate medieval Europe. The icon draws its power as an image from the belief that it is a faithful copy of an original. The appearance and attributes of biblical figures and saints had to be unambiguously copied from models, while the training standards imposed by the craft guilds – the organisations that controlled all artisanal production in medieval Europe – rested on respect for accurate copying.

Copying as a means of wholesale cultural assimilation had been pioneered by the Romans, who developed a technique for accurately copying Greek bronze statues in stone (left). There was no sense that a work of art was devalued by existing in many copies. Successful portraitists kept copies of their works for reference and to show potential clients.

The idea of the artist as originator rather than copyist or translator, which had taken deep root in Italy by the time the Renaissance polymath Giorgio Vasari published his *Lives* in 1550, changed the idea of copying. E. H. Gombrich observed that Donatello's statue of St George in Orsanmichele (*c*.1414) rejects the solemn stasis of earlier medieval statues of the saint while emulating (not copying) the spirit of Greek and Roman art and observing (not transcribing) Nature.

Copying became part of **academic** art training from the seventeenth century onwards, but the **Romantic** emphasis on originality and authenticity decisively relegated the mere copyist to a role far subordinate to that of the creative genius.

'No painter who is worth a straw will ever copy,' insisted the Victorian critic and artist John Ruskin, although he also praised Charles Fairfax Murray, whom he dispatched to Italy to copy Old Master drawings, as 'a heaven-born copyist'. Gustave Courbet, followed by many nineteenth- and twentieth-century avant-garde artists, produced copies of historical masterpieces in which the act of copying was a means of assimilating the original in order to go beyond it, to do something radically different (opposite). In Pablo Picasso's adaptations of Velázquez (above) or Francis Bacon's of Van Gogh and (again) Velázquez, copying effectively constitutes a quasi-cannibalistic act of possession. ■

The canvas on wooden stretchers in
Las Meninas *(1656) seems destined
for a royal portrait. Reflected in the
mirror at the back of the room,
Philip IV of Spain and his wife
Mariana appear to be sitting for
Velázquez and observing the scene.*

Essential support

IDEA № 43
CANVAS

Canvas is only one of many possible supports (or surfaces) for painting, but its particular qualities – from its portability to its flatness – have given it a special place in Western art, and this traditional material remained an essential tool in the arsenal of twentieth-century avant-garde artists.

BOTTOM LEFT: *Frank Stella's* Lunna Wola II *is made from coloured canvas, felt and other materials. It belongs to his* Polish Village Series *of the 1970s, in which shaped canvases echo the vanished architecture of Polish wooden synagogues.*

ABOVE: *'I have constructed, not destroyed,' said Lucio Fontana of his cut canvases. In* Spatial Concept `Waiting' *(1960) we look directly (and rather differently than in Velázquez'* Las Meninas*) into the space behind the picture plane.*

Few early paintings on cloth survive, but they were certainly made in the ancient world, in medieval Europe and in other contexts before stretched canvas – which includes textiles such as hemp (*Cannabis sativa*, from which the word comes), linen, jute and cotton – became a preferred support for **oil paintings** in sixteenth-century Europe. For paintings that needed to be moved, canvas had advantages over alternatives such as wooden panels: it was cheap and light, and it could be cut and joined to make work of almost any size. It was perfect for paintings designed for temporary spectacle, such as stage scenery and wall hangings. Pliny the Elder records a 36.5-metre-high portrait on linen of Nero displayed in the emperor's garden (where it was destroyed by lightning).

In Northern Europe, where the climate made fresco (see pp.16–17) a less suitable medium than in the warmer, drier atmosphere of Italy, artists used canvas for wall-hung paintings, sometimes as a cheaper alternative to tapestry. For the purposes of painting, cloth has to be stretched taut and sealed to prevent oil- or water-based paint from seeping into the fibres and depositing a dry, dull layer of pigment on the surface. It became standard practice to stretch canvases on a wooden frame and to coat them with diluted animal glue, or size, followed by a chalky ground to which paint was applied.

Even the largest paintings constructed in this way are portable and can be removed from their stretchers or frames and rolled for transportation and storage, making it possible for artists to produce work for distant patrons and locations. As Church and aristocratic patronage of wall paintings and altarpieces was superseded from the sixteenth century onwards, especially in the Protestant North, by private portrait commissions and a market for smaller paintings, canvas became the favoured support. The assertive, often life-size dynastic portraits that populated European elite residences would have been difficult to produce without canvas. Each time marriage alliances were formed and new heirs born, the family of portraits grew and changed. As court painter to the Habsburg kings of Spain, Diego Velázquez was required to produce many such works, like the huge canvas on which he is engaged in *Las Meninas* (The Maids of Honour, opposite).

With modern art's questioning of perspectival illusionism, it was another quality of canvas – its flatness – that came to the fore. In the influential critic Clement Greenberg's description of Cubism, which sought new ways of expressing three dimensions in two, 'Painting had to spell out, rather than pretend to deny, the physical fact that it was flat'. Later twentieth-century artists co-opted the physical qualities of canvas as part of the work, as in Frank Stella's polygonal paintings (left) and in Lucio Fontana's slashed or punctured canvases (above). ∎

Box of tricks

CAMERA OBSCURA

The camera obscura is a device that enables an image to be projected onto a flat surface inside a light-sealed chamber and then be traced. Enjoying its heyday in the seventeenth century and still used by artists today, it led to the development of **photography** in the nineteenth century.

BOTTOM LEFT: *One of the first published illustrations of a camera obscura appeared in 1561. It shows an inverted image of the total solar eclipse of January 1544 being projected through a small hole into a darkened room.*

ABOVE: *British artist Chris Drury's beehive-shaped Sky Mountain Chamber functions as a camera obscura. An image of the Italian mountain landscape outside, shown in the top photograph, is projected through an aperture in the chamber's southern wall onto the floor inside.*

The principle of the camera obscura (Latin for 'dark room') was noted by Aristotle, who observed how an image of the sun was projected through wickerwork. In its simplest form it consists of a box into which bright light reflected from external objects enters through a tiny hole, creating an inverted image on the surface opposite the hole. In later, more sophisticated versions of the device, the use of convex lenses and mirrors enabled the projected image to be flipped the right way round and projected onto a sheet of paper for tracing.

A basic camera obscura was used by medieval astronomers for observing eclipses (below). As a tool for connecting external reality with its convincing representation in art, it came into its own in the sixteenth century, when such questions were of pressing concern for painters. Leonardo da Vinci realised that the eye functions like a camera obscura, receiving inverted images on the retina. In 1558, a treatise by the Neapolitan physician Giambattista della Porta gave practical advice to artists about making drawings with a camera obscura, and by the early seventeenth century it was being widely used for this purpose.

With its shallow depth of field (the distance between the closest and farthest objects that are sharply defined), the camera obscura was of limited relevance for the Renaissance pursuit of perspectival illusion – the organisation of objects in deep pictorial space. It was, however, perfectly equipped to render the close-focus **still lifes** and domestic scenes that became popular in seventeenth-century Northern Europe. The eerily vivid still lifes of the Dutch painter Johannes Torrentius, almost certainly painted with the aid of a camera obscura, were so admired by Charles I that the English king pressured to have the artist released from prison in his homeland, where he was being held on charges of witchcraft. Johannes Vermeer was fascinated by the camera obscura's tendency to distort the forms that, at first sight, it seemed to reproduce so faithfully. In the bowed perspective and faintly glowing halation of his *Officer and Laughing Girl* (opposite), you sense the artist behind the lens, noting the differences between projected image and actuality.

Thereafter, however, there is little such frisson of the 'real seen differently' about the camera obscura's use by artists. Canaletto probably enlisted it to make drawings, though not for his finished paintings of Venetian scenes, in which he altered topographical facts to enhance the illusion of high-resolution verisimilitude. In effect, the camera obscura was no longer a magic box for capturing the world but a copying device whose effects were familiar to all. Out of this conventional piece of machinery in the early nineteenth century, however, came a new art form, photography – which means, literally, 'writing with light'. In 1827, by placing a plate coated with light-sensitive bitumen of Judaea inside a camera obscura, the French scientist Nicéphore Niépce captured the view from his window. Its grainy geometry of roofs and walls is the earliest known photograph. ∎

ABOVE: *Whereas other artists usually*
corrected the visual distortions
created by the camera obscura,
Vermeer carefully reproduced them.
In Officer and Laughing Girl
(c.1657) the nearer figure is out
of scale with the farther one.

Ancient but modern

IDEA № 45

REINVENTING GREEK ART

The ancient Greeks had no word for art and perhaps no concept of art as a category of object or activity distinct from the beautiful, the sacred or the skilfully made. But this didn't prevent later cultures seeing Greek art as the touchstone for everything art could aspire to.

OPPOSITE: The German art historian Winckelmann praised the 'noble simplicity and quiet grandeur' of Greek art. Ingres's Jupiter and Thetis (1811) presents a bizarre conjunction of noble Grecian grandeur and the fancy-dress eroticism of academic art.

ABOVE: The Belvedere Muses by Scottish artist and poet Ian Hamilton Finlay (1925–2006). He created a rural sculpture garden named Little Sparta, populated by Neoclassical sculptures and monuments intended to evoke poetic and philosophical reflection.

BOTTOM LEFT: Michelangelo's heroic nude statue David (1501–4) drew on his study of ancient sculpture in Rome. His biographer Vasari claimed: 'This figure has put in the shade every other statue, ancient or modern, Greek or Roman.'

What Greek art of the fifth and fourth centuries BC, known as the Classical period, provided most persuasively was a vision of the human form that constituted an astonishingly subtle interplay of observation and idealisation, together with the technical skills needed to realise it. Equally important was the wider religious and cultural legacy of ancient Greece – philosophy, **mathematics**, the wealth of mythological **narrative** with its cast of gods and humans.

Already by the fourth century BC, modes of representation developed for Greek sacred art were being adapted for political ends by Alexander the Great. In

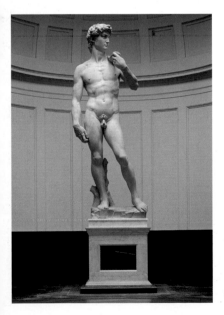

northern India, the farthest eastward expansion of Alexander's empire, Greek art was reinvented four centuries later for a Buddhist society. Sacred figures in the Gandhara style (see p.197) acquired the unmistakably vital presence of Classical statues. Almost from the first, Roman art constituted a wholesale reinvention of Greek antecedents, often with a personal or propagandistic slant. Imperial statues of Augustus assumed the heroic aura of Greek figure sculpture. It was to Graeco-Roman art that Christianity looked in its first attempts at an iconography. Carved on a third-century sarcophagus, the prophet Jonah lies outstretched, naked and sleeping like a Greek youth. Even after centuries during which pagan forms were stiffened and stylised to serve Christianity's requirements, the figural conventions of Greek art remained recognisable.

The next great reinvention of Greek idioms came in fifteenth-century Florence, when artists began consciously recovering what they saw as the achievements of 'the ancients'. Paradoxically, this legacy had been almost extinguished by Christianity, which, according to the Renaissance biographer Giorgio Vasari, had 'inflicted incomparably greater damage and loss on the arts' than the sack of Rome by barbarian tribes. For Renaissance artists, 'the ancients' provided the standard against which artistic endeavour measured itself; in Vasari's account it was Michelangelo who

finally, heroically established even higher aspirations for art (left).

By the seventeenth century, the influence of Greek thought and art could be felt in the preoccupation with precedents that characterised the newly formed **academies** (named for Plato's school in Athens), where art was taught according to a formal programme. **Academic** obedience to (sometimes imaginary) Greek 'rules' was revitalised in the 1760s by the German art historian Johann Joachim Winckelmann, who saw Greek art's 'purity' as springing from a whole political and intellectual outlook, introducing the idea of art as an expression of the zeitgeist. Jean-Auguste-Dominique Ingres (opposite) absorbed Winckelmann's ideas while studying with Jacques-Louis David, the leading exponent of **Romantic** Neoclassicism.

In contrast to the previous two millennia, Greek motifs resurface only fitfully in twentieth-century art – in Picasso's occasional vein of pastoral eroticism, in the debased distortions of fascist Classicism or as a form of concrete poetry in the sculptural installations of Ian Hamilton Finlay (above). ∎

Nature, domesticated or sublime

IDEA Nº 46
LANDSCAPE

Emerging first in China, landscape painting gives meaning to raw facts of nature such as mountains and rivers through formal organisation and distance. In late eighteenth-century Europe, as Enlightenment rationality was superseded by the **Romantic** primacy of feeling, landscape painting provided a visual equivalent for 'almost inexpressible experience'.

Landscape has a particularly long history in Chinese painting. The equivalent Chinese term, *shanshui*, means 'mountain and stream', suggesting the transcendent scale and experiential vividness that artists evoked in images of wild terrain. In Buddhism, mountains were sites of retreat and enlightenment; 'My heart is one with the late autumn trees', wrote the fifth-century Buddhist poet and mountaineer Xie Lingyun. The Lilliputian insignificance of the human presence in such works as *Travellers among Mountains and Streams* (left) by the great eleventh-century painter Fan Kuan underlined the sheer otherness of Nature. Cliff-faces tower like an ungraspable truth but also as vast physical objects, whose surfaces Fan Kuan mimicked using the 'raindrop-texture brushstroke' developed for this purpose. Such effects were based on direct observation; the artist confronted nature and relayed the experience so that busy patrons could contemplate it, as though they too had left the world of affairs to climb the mountain. Landscape, in this sense, became a religious art form.

As a subject, landscape was slower to emerge from the background in European art. It was, wrote the great central European poet Rainer Maria Rilke with the *Mona Lisa*'s landscape in mind, Leonardo da Vinci who first 'felt landscape to be a medium of expression of almost inexpressible experience'. Rilke saw landscape as an artistic means of addressing 'the Other', or everything in the world that is 'indifferent towards men'. In the seventeenth-century landscapes of Claude Lorrain (main image), this 'Other' comprises an Arcadian world that we can never enter but whose air we seem to breathe in the atmospheric transitions between the shade of trees and the warm summer air. The Victorian artist and critic John Ruskin observed that Claude was the first painter to represent the sun directly, as an object, believing this to be 'a revolution in art'. The landscapes of Claude's Dutch contemporaries show everyday farmland or coast. Whereas Claude makes poetic distances feel close to the viewer, landscape works the opposite way in Aelbert Cuyp's scenes of cattle in muddy fields under cloud-heaped

skies, allowing the viewer some contemplative distance from local life.

Though dismissed in 1771 by the *Encyclopaedia Britannica* as 'one of the lowest branches of painting', landscape exerted a formative agency throughout the eighteenth and nineteenth centuries. British oligarchs poeticised their power by physically remodelling their estates to resemble Claude's landscapes. In J.M.W. Turner's wide-angle seascapes, rainbow-tinted mountains and misty atmospherics, landscape attains – as it did in Chinese art – a visionary, transcendental quality that was theorised by philosophers as the Sublime. Ideas of landscape haunted artists throughout the urban twentieth century, in their rhetoric and practice equally. 'I the sculptor am the landscape,' said Barbara Hepworth, who thought of the way a sculptor carves and abrades a stone or piece of wood as analogous to the natural weathering processes that shape the landscape. ■

The many and the one

IDEA № 47

SERIES

In a group of works presented as a 'series', each work has its own identity while being explicitly linked to other works by the same artist, usually produced around the same time. Since individual works are situated within a larger conception, their full meaning derives from the relationship between the parts and the whole.

Series consist of individual works that can be, and often are, viewed in isolation. So although the separate episodes in Piero della Francesca's fresco cycle *The Legend of the True Cross* in the church of San Francesco, Arezzo (*c*.1447–65), effectively become a series when reproduced in books or as postcards, the original work constitutes a single, indivisible ensemble. By contrast, the episodes in William Hogarth's series of paintings *A Rake's Progress* (*c*.1733) and the prints (below) based on them can function as

self-contained satirical scenes; but, assembled in a series, they gain a further level of meaning as a moral **narrative** charting a young man's descent into destitution through his own extravagance. The series format gave the artist a controlling hand in the interpretation of his work: discovering the connections between images, and the sequence in which they should be viewed, means accepting the story he intended to tell.

In a series, it is the unifying concept or **narrative** that binds the individual

works together. For European artists, thinking in series is linked to the development of printing, which brought the possibility of producing multiples (see pp.82–83) and a close connection between image-making and the dissemination of printed texts (see pp.48–49). The simultaneous growth of a market for art beyond the closed networks of Church and elite patronage meant that an artist's identity began to assume the nature of a brand. Albrecht Dürer's *Apocalypse* print series (1498) belongs to this

RIGHT: *Elisabeth Frink described her* Four Heads *(1975) as 'a tribute to all people who have died or suffered for their beliefs'. Heads typically express individuality; the serial format emphasises the theme that connects these hero victims.*

BELOW: *Four of the eight engravings from Hogarth's series* A Rake's Progress *(c.1733): a young man comes into his inheritance but spends everything on drink and prostitutes; he is arrested for debt and ends up in a madhouse.*

moment in the late fifteenth century. Each of the 15 powerful images can stand alone; but once you ask what it is that connects them, you're faced with questions of the artist's personal interpretation of his theme. The series functions more like a set of essays on related ideas than as episodes in a well-known story.

In some ways, the series is a practical artistic response to market conditions for artists. It gives collectors an incentive to purchase more than one work and, when works are bought by different collectors, it asserts the artist's ownership of a connecting concept bigger than any individual work. In series, the viewer has constantly to defer to the artist's supposed intentions. Barnett Newman's series *Stations of the Cross* (1958–66), for example, prompts the question of how these large, minimal **abstract** canvases relate to each other and to the series title, with its freight of Christian sacred drama. Whether as personal crucifixion story (Newman was recovering from a heart attack at this time) or elegy for the World War II dead, the serial identity of the 14 *Stations of the Cross* paintings asserts that the whole is greater than the sum of the parts. As Newman said of his lithograph series *18 Cantos* (1963–64), 'Each can stand by itself. But its fullest meaning, it seems to me, is when it is seen together with the others.' ∎

Golden hoards

IDEA № 48
COLLECTIONS

Collecting is an almost universal practice. People collect objects as talismans, mementos and sources of scientific reference, among numerous motives utilitarian and otherwise. In certain times and places, collections have had a formative influence on art.

RIGHT: *Grigory Mikhailov was a serf's son who became an eminent and wealthy Russian academician. In* The Antiquities Gallery of the Academy of Fine Arts *(1836), casts of famous ancient statues line the route to artistic success.*

Roman collections of paintings and sculptures from subject territories – particularly from Greece – provided the sourcebook for Roman art. Pliny the Elder refers to a collection of 'outstanding masterpieces' in Augustus' palace. He repeatedly invokes the Greek artworks represented in such collections on which Roman artists based their work.

From the fifteenth century, as the treasury-type collections of medieval monarchs were succeeded by the Renaissance prestige collection, which expressed the learning as well as the wealth and power of the collector, artists gained access, through their patrons' eclectic possessions, to vital source material. Lorenzo de' Medici intended the collection of ancient sculpture in his palace garden to inspire an ambitious new generation of Florentine sculptors. It was here, according to Giorgio Vasari, that Michelangelo carved his first sculpture, a marble copy of a faun's head. Lorenzo also had a *studiolo*, a private room to which the collector could retire to enjoy his most precious and interesting objects.

Both treasure-house and study, in which paintings and sculptures joined geological and natural history specimens and exotica brought back from voyages of exploration, the *studiolo*, *Kunstkammer* or Cabinet of Curiosities became a feature of the European princely lifestyle. New art installed in these private rooms tended to be more literary, learned or erotic than the general run of commissions. With its allusions to poetry, mythology and Classical art, Titian's *Bacchus and Ariadne*, painted for Alfonso d'Este's *studiolo*, reinforced the collector's intellectual credentials while becoming part of the collection itself. As collecting was taken up by the bourgeoisie as well as the elite, artists were called on to paint cabinet pictures representing the contents of the collections amidst which they hung.

During the Enlightenment, collections increasingly provided libraries of specimens for scientific classification as well as models for artists. European **academies** were filled with casts of ancient sculptures, of which the originals were to be found in royal and aristocratic collections or the newly formed national museums. An artist's training now involved much time spent **copying** and learning from the objects in collections; in a 1781 painting by Hubert Robert, a draughtsman crouches submissively before a spoil-heap of ancient statuary in the Louvre.

Less comprehensive or objectively useful, though more personally revealing, are artists' own collections. Matisse affectionately labelled a photograph of some 40 ordinary objects that feature in many of his paintings 'Objects that have been of use to me all my life'. Picasso was a compulsive hoarder whose collection provided material from which he made art. Some **installation** art, such as Louise Bourgeois' rooms, mimics the ambience of a *Kunstkammer* or eclectic personal collection. In his 2001 performance *Break Down* (2001), British sculptor Michael Landy destroyed all 7,227 of his personal possessions in a public act of anti-collecting. ∎

OPPOSITE LEFT: *A print of 1655 shows the natural history collection of the physician Olaf Worm, which became part of the Danish royal Kunstkammer or Cabinet of Curiosities. Such collections combined material of cultural and scientific interest.*

OPPOSITE RIGHT: *Picasso and his dealer Daniel-Henry Kahnweiler at Villa La Californie, near Cannes, in 1957. From African carvings to the found objects he transformed into sculptures, Picasso's vast collection of art and junk constantly fed his work.*

ABOVE: *The three brothers in* The Oath of the Horatii *are swearing to defend Rome, where the artist Jacques-Louis David spent 11 months preparing for this commission. The theme of self-sacrifice in a noble cause was resonant in pre-Revolutionary France.*

BELOW: *Paolo Uccello's* Battle of San Romano *is a patriotic take on history – the forces of his native Florence are putting the enemy Siena to flight. The crowded battlefield gave Uccello scope for exploring his passion for linear perspective (see pp.68–69).*

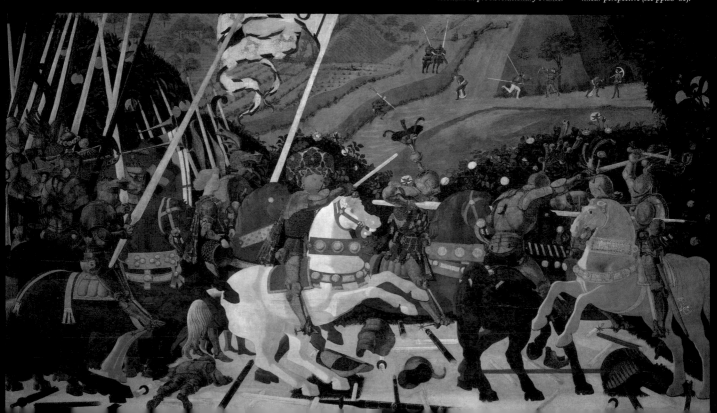

A canvas for great events

IDEA Nº 49
HISTORY PAINTING

The idea of history painting, or *istoria*, was formulated in the early fifteenth century by the Italian polymath Leon Battista Alberti as the supreme ambition of the painter's art. More recently, history painting has become a mode for self-questioning rather than national glorification.

Modern history painting began as pure idea. Ancient writers such as Pliny the Elder had described paintings of great events by celebrated Greek artists, but none of these works survived to the Renaissance. If Alberti and his contemporaries were to rival the ancients and give new dignity to the painter's vocation, history painting would have to be reinvented. In his treatise *On Painting* (1435), Alberti outlined the rules. An *istoria* should contain several figures of different types and ages, and evince 'copiousness and variety'. Though based on a Classical or biblical episode that might be suggested by a scholar or poet friend, it would 'capture the eye of whatever learned or unlearned person is looking at it and will move his soul'.

Alberti's concept of *istoria* didn't catch on immediately – it was to be 70 years before Mantegna, Raphael and other Italian artists were regularly producing compositions of this kind. An exception is Paolo Uccello's group of panels, *The Battle of San Romano* (mid-1438–40, opposite bottom), which depicts a battle between Florence and Siena in 1432. The painting does not entirely conform to Alberti's precepts: it portrays a recent event, and the multi-figure composition is very crowded. But in the central figure of the Florentine commander Niccolò da Tolentino, which echoes the ancient Roman equestrian statue of Marcus Aurelius (see p.15), *istoria* gives art a new confidence to cast

contemporary life in the heroic mould of ancient history.

In the **academic** system of the seventeenth and eighteenth centuries (see pp.108–09), history painting headed the hierarchy of subject matter. It became a test artists had to pass, resulting in a steady output of overblown, inert history paintings. Jacques-Louis David's hostility to the French Académie informed his redefinition of history painting in *The Oath of the Horatii* (1784, opposite top). In the austere glamour of its Classicism – utterly different from the poetic Renaissance kind – David's episode from Roman history projects a version of the past that's strong enough to hold the present in its spell. In the Napoleonic era, this vision helped to shape a wholesale reinvention of French visual culture.

History painting in the twentieth century was more a question of the age taking its own pulse, rather than wanting to find itself gloriously reflected in images from ancient history. In place of the set-piece episodes that had preoccupied history painters from the sixteenth through the nineteenth centuries, there was a focus on individual experience. In the work of post-World War II German artists such as Anselm Kiefer and Gerhard Richter, history is staged through the presence of single figures or even empty places. History painting adapts the convention of the family snapshot in Richter's *Uncle Rudi*

Of his portrait of 'the Nazi in the family', Gerhard Richter said: 'Uncle Rudi represented a generation of Germans who willingly participated in its own destruction and the destructions of the millions it tried to dominate.'

(above), where the innocuous title 'uncle' carries the weight of national self-questioning about the Holocaust and the war. This painting is just as crowded as Uccello's battle scene, though with ghosts rather than armour-clad warriors. ∎

All or nothing

IDEA № 50
WHITENESS

Purity and possibility, emptiness or plenitude, space or flatness – whiteness in art comes replete with meanings. White is usually much more than a colour, or absence of colour, deployed by artists for particular local effects. In Neoclassical art, Constructivism and other types of art, it connotes positive values amounting to an aesthetic philosophy.

ABOVE: *Antonio Canova's white marble sculptures, such as* The Three Graces *(1814–17), set the fashionable tone for early nineteenth-century Neoclassicism. In place of ancient marble's weathered pallor, they offered smooth surfaces and clean, flowing contours.*

OPPOSITE TOP: *In 1934 Ben Nicholson made several white-painted abstract reliefs; here,* 1934 *(relief - version 1). Their whiteness emphasised the organisation of forms as a totality, refusing to highlight details. It was also the mark of a dedicated Modernist, an admirer of Mondrian and Brancusi.*

OPPOSITE BOTTOM: *'As music is the poetry of sound, so painting is the poetry of sight,' wrote Whistler. His titles, such as* Symphony in White No. III *(1865–67), often combine music with colour. Here, white creates a whole 'symphony' of associations.*

Objects fashioned from ivory, silver or other 'white' materials may be imbued with spiritual potency, like the white crown of the Egyptian god Osiris or the ivory regalia from the African kingdom of Benin, associated with the ruler of the waters, Olokun. The pale tonal subtleties in Pieter Saenredam's paintings of seventeenth-century Dutch church interiors express the Protestant aversion to the 'superstitious' Catholic **wall paintings** that had recently been whitewashed over, replaced by the new faith's emphasis on unmediated contemplation of the Word of God. The Catholic answer to sober Protestant whiteness is the sensual agitation of Baroque marble sculpture. In Gianlorenzo Bernini's *Ecstasy of St Theresa* (1645–52), where an angel plays Cupid to the swooning saint, the stone's pallor puts a certain distance between the viewer and the sculpture's quasi-erotic charge. This is, on the whole, how whiteness worked for succeeding generations of European sculptors, culminating in the frankly erotic but coolly Classicising work of Antonio Canova (above right) around the turn of the nineteenth century – it announced that, however skilfully marble imitated the texture of youthful skin, a statue was a frigid, respectable object that could be publicly stared at.

By Canova's time, whiteness had acquired a dignified association with ancient Greek art. Although Greek temples and carvings had originally been painted in vivid polychrome, the reinvention of Classical art, led by the pioneering eighteenth-century Hellenist Johann Joachim Winckelmann, saw whiteness as a distinctive characteristic of Greek sculpture, expressing purity and idealism. The enthusiastic adoption of Neoclassical styles in architecture, fashion and decorative arts helped to implant the nineteenth-century equation of the sculptor's art with white marble figures. It took Auguste Rodin, whose marble *The Kiss* (1889) is assertively sexual, to tear down the veil drawn by Neoclassical whiteness between high-minded art and plain voyeurism. James Abbott McNeill Whistler's *Symphony in White* (opposite bottom) carries Symbolist overtones of the poetic value of colour: here it is the girls' clothes that are white, not their flesh, suggesting innocence but also possibility.

The resurgence of colour in progressive European art, from Eugène Delacroix onwards, was part of the avant-garde response to the perceived hypocrisies of **academic** art in which Neoclassical flesh had become the official language of soft porn. In the 1920s and 1930s, however, whiteness took philosophical centre stage again in the form of geometric **abstract art** and architecture. Visitors to Piet Mondrian's Paris studio were struck by the emphatic whiteness of his surroundings. Ben Nicholson's **series** of white reliefs (opposite top) express similar principles: art should clear the clutter from our lives so that we can see what's really important; it should change our relationship to the spaces we inhabit, so that we live in a more harmonious, purposeful way. Minimalist art of the 1960s and 1970s (see pp.176–77) represented a revival of these ideals in such works as Sol LeWitt's *Two Open Modular Cubes/Half-Off* (1972) or Robert Morris' *Slab* (1973). ∎

The professional programme

This engraving of 1531 shows the self-styled academy that the sculptor and painter Baccio Bandinelli established in his studio in Rome. A studious reverence for the Classical past became the foundation of later academic art.

IDEA Nº 51

ACADEMIES

The concept of the academy was founded on a belief that art was an intellectual as well as a practical pursuit, and that both aspects could be taught according to a prescribed system. In the seventeenth and eighteenth centuries, academies transformed art training from a craft apprenticeship into a professional programme – with mixed results.

Academia was the name of the olive grove outside Athens where the philosopher Plato taught in the early fourth century BC. In homage to the achievements of Greek culture, the term was adopted in fifteenth- and sixteenth-century Italy in various contexts involving study and teaching. In Lorenzo de' Medici's academy for artists in Florence founded in the 1490s, or the Accademia di San Luca in Rome, founded in the 1590s, and other formal or informal academies, a teaching system evolved that was to shape European art education for the next 350 years.

Copying ancient sculptures (making drawings or plaster casts of them), life drawing, correction of students' work by staff and visiting artists, lectures on subjects such as **mathematics** and **anatomy**, public exhibitions of members' work were features of academic practice enshrined in the programme of the French Académie Royale de Peinture et Sculpture (opposite bottom), established in Paris in 1648. The Académie Royale became a much-imitated model for state-sponsored academies elsewhere. By 1800 there were institutions in Berlin, Brussels, Copenhagen, St Petersburg, Vienna and many other cities. Official support for art academies stemmed from a belief that they enhanced national prestige and encouraged skills required by expanding mercantile and, later, industrial economies.

Sir Joshua Reynolds, first president of the Royal Academy in London (founded 1768, opposite top), exhorted young artists to aspire to 'that grand style of painting, which improves partial representation by the general and invariable ideas of nature'. Students could acquire this 'grand style' by studying the best art of the past. 'The principal advantage of an academy', Reynolds announced, 'is, that, besides furnishing able men to direct the student, it will be a repository for the great examples of the art.' What academic training might mean in practice can be seen in Joseph Wright of Derby's *An Academy by Lamplight*, painted the year the Royal Academy was founded. Strong **chiaroscuro** emphasises the face, shoulders and breasts of the Classical statue at its centre. But what, exactly, are students to learn from her? They copy diligently, stare with rapt attention or gaze into the distance. Wright captures both the sincere idealism and underlying sense of pointlessness associated with the academic milieu.

With a few exceptions, Reynolds's stirring words were not matched by the work actually produced by Royal Academicians. By the mid-nineteenth century the term academy became a byword for a professional closed shop controlled by pretentious mediocrities. Indeed, William Blake, who studied briefly under Reynolds at the Royal Academy but had no interest in the grand style, protested: 'This man was hired to depress art.' On the other hand, by according **the artist** professional and, to a degree, social status, academies assisted in the creation of a modern audience for art. The regular exhibitions of members' work staged by academies became social events, gaining art a public beyond the limited circles of royal and aristocratic patrons and collectors. Just as importantly, the academic teaching programme provided a set of rules to be broken. Artists of the nineteenth-century avant-garde defined their progressiveness in terms of their rejection of academic standards and practices. In the twentieth century, although Classically based academic training no longer seemed relevant, the idea of art education as a formal programme combining practice and theory was revitalised by such institutions as the Bauhaus and Black Mountain College. ■

LEFT: *In 1648 Mathieu Le Nain became a founding member of the Académie Royale. This earlier portrait attributed to him captures the academic spirit, in its combination of serious artistic interests with social status and male camaraderie.*

ABOVE: *In 1793 the Royal Academy commissioned Henry Singleton, a former student there, to paint* The Royal Academicians in General Assembly. *The admired first century BC sculpture Laocoön rears in agonised struggle above this gentlemanly gathering.*

A thirst for the infinite

BOTTOM LEFT: *An illustration from William Blake's poetry collection* Songs of Innocence and of Experience *represents 'the Two Contrary States of the Human Soul'. Unlike his academic contemporaries, Blake's work gave primacy to visions and fantasies.*

OPPOSITE TOP: *In Caspar David Friedrich's* Moonrise Over the Sea *(1820–26), three townspeople sit by an empty shore, watching two ghostly ships approach through the twilight. The landscape seems intended to evoke a mood rather than represent a specific location.*

OPPOSITE BOTTOM: *The withered, wintry trees in Mariele Neudecker's* I Don't Know How I Resisted the Urge to Run *(1998) echo those in Friedrich's landscapes. Yet the trees in the tank reverse the way that Romantic landscapes tend to dwarf the human figure.*

IDEA Nº 52
ROMANTICISM

Romantic art was described by the German writer Friedrich Schlegel as 'a perpetual becoming', an art that 'knows no law'. It was greeted in the 1790s as a radical new creative vision that pitted liberty against authority, and inspiration against reason. Its legacy still informs artistic practice and responses to art.

'Romanticism' became an effective, though practically indefinable, umbrella term for a complex set of interrelated factors that not only reshaped the way Western artists, writers and musicians understood their role but also, it was widely believed, had transformed people's very sense of what it meant to be human. The root meaning of Romanticism, from the medieval narrative poems known as 'romances', associated the phenomenon with legend, fantasy, violence, passion and the isolated figure of the suffering young hero, traversing

wild landscapes in pursuit of an ideal. This vision is mirrored in the new self-image of **the artist** that emerges around the 1790s: the lonely, heroic figure whose genius is its own law and whose imagination gives privileged access to truths that cannot be reached by reason (the core value of the foregoing Enlightenment period).

Revolution in America, then in France, followed from 1800 to 1815 by the Napoleonic Wars, brought extremes of dislocation and uncertainty for which **academic art** had no response. With the scornful impatience typical of Romantic artists in the face of officialdom, William Blake (left) derided the president of the Royal Academy, Sir Joshua Reynolds, for his 'Opinion that Genius May be Taught'.

Early nineteenth-century artists related the term Romanticism to their own aspirations. Eugène Delacroix, whom the French poet and critic Charles Baudelaire saw as the archetypal Romantic, resisted the label but affirmed: 'If by Romanticism one understands the free manifestation of my personal impressions, my aversion to the models copied in the schools, and my loathing for academic formulas, I must confess that not only am I Romantic, but I was so at the age of fifteen.' *His Liberty Leading the People* (see p.75) expresses the great Romantic theme of suppressed energies surging to the surface.

Writing in 1846, Baudelaire described Romanticism as a 'way of feeling', which can only be discovered by looking within. 'Whoever talks about Romanticism,' he stated, 'is talking about modern art – in other words intimacy, spirituality, colour, a thirst for the infinite, expressed by every means of which the arts are capable.' This reads as a manifesto for the robust subjectivity shared by later movements in art: by Baudelaire's definition Fauvist colour, Expressionist distortion and gestural Abstract Expressionist painting all equate to Romanticism. Postmodern art has attempted to set Romanticism in quotation marks, as in Mariele Neudecker's vitrine (opposite bottom) containing models evoking the Romantic landscapes of Caspar David Friedrich (opposite top). In other ways the Romantic legacy survives unreconstructed in the still current valuation of individual creativity and artistic freedom. Joseph Beuys's dictum 'Everyone is an artist' shares its democratic impetus with the crowd on Delacroix's barricade. ∎

*There is no question that Snow
Storm – Steam Boat Off
a Harbour's Mouth is a genuine
Turner painting, but his account
of being lashed to the mast in order
to paint it may have been invented
to add an 'authentic' touch.*

For real?

AUTHENTICITY

Art deals with illusion and imagination to such an extent that questions of authenticity – distinguishing between what is genuine and what is not – are never straightforward. Nevertheless, the faith or trust commanded by the idea of authenticity influences our response to art – a fact that artists have in turn exploited in their work.

Questions of authenticity arouse bitter opposition between believers and sceptics. For Protestant reformers in sixteenth-century Northern Europe, the myriad ordinary splinters claimed as fragments of the True Cross or Noah's Ark were just inert pieces of wood. If, however, you believed them to be authentic, their sacred aura and faith-healing powers might remain intact. This psychological mechanism comes into play with art too. Belief that an artwork is authentic in some way – genuinely produced by a particular artist or originating from a certain place or historical period, or the record of an actual experience – is central to the viewer's act of imaginative engagement with it. Hence the feeling of diminution and betrayal when an admired artwork turns out not to be what it seemed.

The Romantic insistence on the artist's personal (and preferably extreme) experience as a touchstone of truth can be heard in J.M.W. Turner's assertion about his turbulent seascape *Snow Storm – Steam Boat off a Harbour's Mouth* (1842, opposite): 'I got the sailors to lash me to the mast to observe it ... I did not expect to escape.' As time passes, audiences care less about the authenticity or otherwise of Turner's experience – the power of his storm doesn't lie in its accuracy as reportage. Yet the Romantic notion of art as an authentic record of experience persists down to the present day. For instance, Richard Long's text pieces document long-distance walks undertaken by the artist. Without faith in their documentary authenticity – the acceptance that Long actually walked all those miles rather than imagining the trip at his desk – these works would lose considerable impact.

A number of the roles self-consciously adopted by artists in the twentieth century – revolutionary, *enfant terrible*, showman, shaman – involve a compact with the viewer: what the authentic artist touches or makes becomes authentic art. The classic example is Piero Manzoni's set of 90 tin cans (1961, left) labelled (in Italian, German and English) 'Artist's Shit', which he successfully offered for sale for the equivalent of their weight in gold. According to his collaborator Agostino Bonalumi, the tins

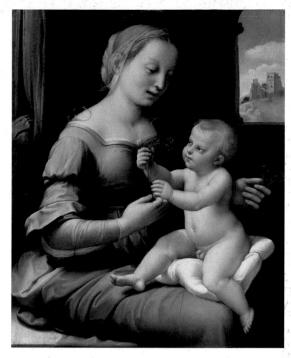

BOTTOM LEFT: *Conceptual art or confidence trick? A few years before purportedly packaging his own excrement in tin cans, Manzoni had passionately asserted that artists must look deep inside themselves to discover 'the authentic zone of values'.*

ABOVE: *In 1991 a small devotional painting, previously considered a copy of Raphael's* Madonna of the Pinks *(c.1506–07), was identified as the original. It was bought in 2004 for thousands of times more than its value as a copy.*

were actually filled with plaster, turning the work from a quasi-sacred relic into an artistic *jeu d'esprit* whose material was not excrement but the idea of authenticity itself.

Notions of authenticity and value – both often based on intangible properties – are closely connected in the art market. When a small Renaissance painting of the Madonna and Child was ascribed to Raphael, its value soared. *The Madonna of the Pinks* (above) became famous as much for the £22 million its hotly debated authenticity cost the National Gallery, London, as for its aesthetic qualities. ∎

Skilled artisan or creative genius?

IDEA № 54
THE ARTIST

In its original sense 'artist' meant a skilled practitioner, whether in the arts, sciences or some other discipline. In modern usage the term encompasses genius, originality, an ability to transform ideas into objects and images or simply to make attractive or interesting things that have no use value.

ABOVE: From 1962 Andy Warhol made most of his paintings by screen-printing photographs onto painted backgrounds. In successive New York studios known as The Factory, such works were made in a production-line process involving numerous 'art-assistants'.

BOTTOM LEFT: In a scene on the outside of a fifth-century BC red-figure kylix (drinking cup), Greek bronzesmiths are working on various statues, including what appears to be an athlete whose head is yet to be soldered in place.

OPPOSITE: A detail from Courbet's The Studio of the Painter (1855) shows the artist painting a landscape, observed by a nude female model and, to the right, people he called 'shareholders' – friends and supporters from the art world.

The idea of the artist combines traditional mystique with constant slippage in definition. The ancient Greek notion of *techne* or skill (Latin *ars*) seems straightforward: sculptors, painters and architects were, like metalworkers or potters, employed to practise their craft. At the same time, Greek sculptors such as Pheidias and Polykleitos (see pp.28–29) became famous for pushing technical boundaries and giving form to ideals. The concept of the artist as innovator, seeing and representing the world anew, begins here.

Essentially, though, however much their skills were valued, artists continued to be regarded almost everywhere as manual workers. The hierarchical distinction between art as practical labour and mental work such as philosophy was challenged in fifteenth-century Italy. Leon Battista Alberti, Leonardo da Vinci and other artist-theorists advised that painters should study mathematics, literature and optics. By the early sixteenth century, in Giorgione's mysterious landscapes and Titian's mythological paintings, the shift in the artist's self-image feels complete: the artisan has become a thinker-poet.

The high aspirations embraced by Renaissance artists, partly to raise their professional standing, were enshrined in academic training (see pp.108–09) from the sixteenth century on. In this system, however, experimental curiosity was subordinated to obedient copying. Such deference to the past accorded with the artist's role in eighteenth-century Europe as manufacturer of the elite's self-image. From the late eighteenth century, however, the **Romantic** idea of genius transformed the socially useful artist into a force of nature – a poet in a more turbulent, heroic sense than the Renaissance painter. Artists were felt to have a surer grasp of such absolutes as truth or beauty than could be gained through reason. Yet while artists became preoccupied with awe-inspiring natural phenomena such as mountains and stormy seas, the theorisation of this subject matter as 'the Sublime' was largely taken over by philosophers.

In the mid-nineteenth century, European artists reinforced their intellectual credentials as progressive social commentators and even activists. Gustave Courbet described his self-portrait tableau *The Studio of the Painter* (opposite) as 'my way of seeing society ... the world come to be painted at my place'. Whereas the socially radical Courbet painted himself at the centre of society, during the twentieth century the artist was typically a professional outsider, adopting the role of social critic or offbeat maverick. 'Artist' is now a protean category: whether shaman/teacher (Joseph Beuys) or thinking person's entertainer (Damien Hirst), defining the artist's personal role becomes part of the artwork itself. ∎

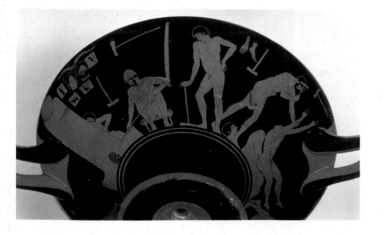

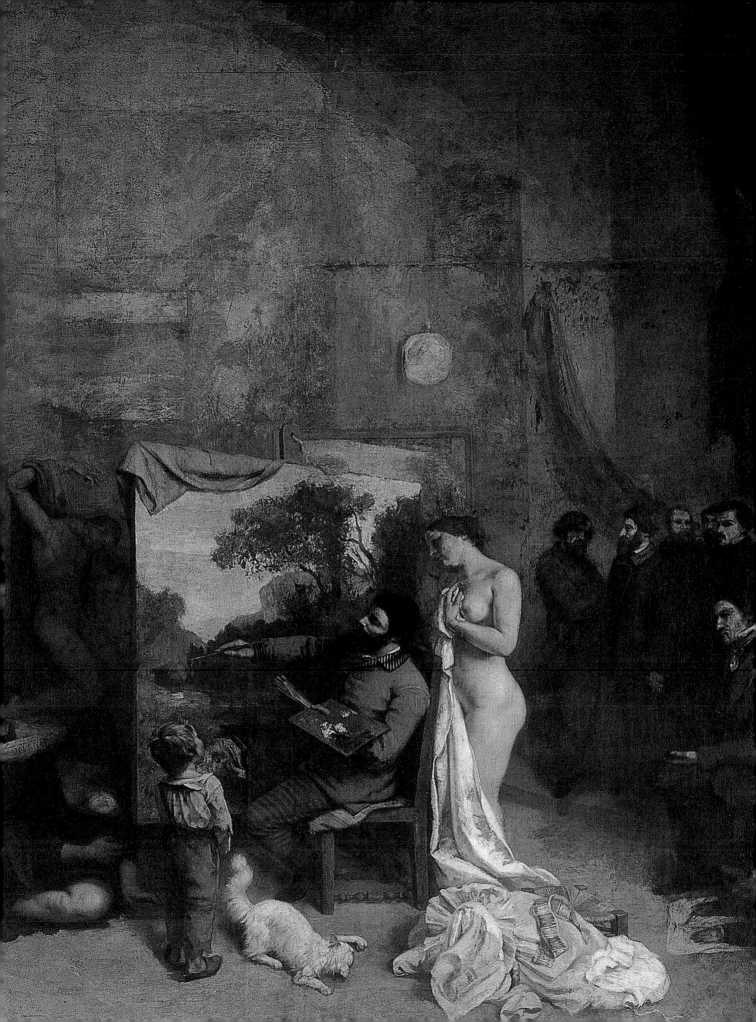

Medium of spontaneous experimentation

IDEA № 55
WATERCOLOUR

Unlike **oil paint**, it is possible to achieve beautiful effects with water-soluble paint with comparatively little practice. From the eighteenth century onwards this made watercolour a favoured medium for the growing numbers of amateur painters – a fact that played against its recognition as a major artistic medium, although the historical record tells otherwise.

Watercolour paint is made by mixing pigment with water and a binding agent, such as gum arabic or egg yolk, that enables the colour to adhere to a surface. The paint is thinned for application with more water to give it the degree of opacity or translucency the artist wants. Whereas oil paint dries slowly by evaporation, watercolour is usually applied to an absorbent surface such as **paper**, to which the pigment fixes rapidly, so that washes can be superimposed in quick succession without muddying the paint. The properties of water-soluble paint thus make it particularly effective for certain types of painting. Different strengths of dilution give a wide range of colour densities, from translucent washes to opaque blocks, while its fluidity lends itself to rapid drawing.

Artists used watercolour as their primary paint medium in ancient Egypt, China and many other countries. In Europe, water-based paints were employed for wall, panel and manuscript painting, but it wasn't until the late fifteenth century that artists began fully to exploit watercolour's particular qualities. European artists had been slow to adopt paper in preference to vellum, but its lightness and versatility were ideal for those who, like Albrecht Dürer, had to travel and to keep distant patrons informed. Dürer's closely observed watercolours of plants render leaves and petals in vivid colour but with an almost weightless delicacy, quite different to the jewel-like itemisation of early fifteenth-century naturalistic oil painting.

Before the invention of **oil paint in tubes** in 1841, watercolour was the only practical colour medium for outdoor or *plein-air* painting. In the seventeenth century, Claude Lorrain had made rapid ink-and-wash drawings in the Roman Campagna, which informed his studio paintings of mythological **landscapes** (see pp.98–99). In the hands of Romantic

landscape painters from the late eighteenth century onwards, however, the watercolour sketch became a recognised art form. Artists in late eighteenth- and early nineteenth-century Britain in particular, such as John Cozens and Francis Danby, used watercolour washes and subtle, misty tints to convey a landscape's atmosphere. In J.M.W. Turner's watercolours, atmospheric effects are far more important than actual topographical features. By the early nineteenth century watercolour paintings were being exhibited as finished works in their own right.

While oil paint stays where it's put, watercolour spreads and stains. It allows artists to strike a fine balance between control and **chance**: for example, in painting with watercolour on wet paper. Artists have turned to watercolour as a medium that is more responsive to the quicksilver play of ideas and fantasies than opaque, authoritative oil paint. William Blake's visionary scenes from the 1790s share with Paul Klee's talkative dreamscapes or Helen Frankenthaler's modern lyrical abstractions a use of watercolour that combines colour intensity with an aura of transience and reverie. ■

OPPOSITE: *John Constable exhibited this watercolour of Stonehenge, which he described as 'the mysterious monument ... on a bare and boundless heath', at the Royal Academy in 1836. It was based on a watercolour sketch made 16 years earlier.*

ABOVE: *Paul Klee was exceptional among early twentieth-century avant-garde artists in the extent to which he experimented with watercolour. The Fish in the Harbour (1916) plays on the contrast between expressionistic colour washes and deceptively whimsical line drawing.*

'Democracy in art'

BOTTOM LEFT: Colombian artist Doris Salcedo used human bones, a child's seat and domestic doors to make La Casa Viuda VI *(1995). The title means 'the widow's house', referring to homes where people had 'disappeared' in acts of political violence.*

OPPOSITE: Ernest Meissonier painted The Barricade, Rue de la Mortellerie, June 1848 *from a watercolour made on the scene after the suppression of workers' riots in Paris. Théophile Gautier called it 'a truth no one wants to tell'.*

IDEA № 56

CONFRONTING REALITY

A widely, often imprecisely, used term in art history, 'Realism' was originally the name for a new vision of the artist's role that took root in mid-nineteenth-century France. It involved the rejection of idealisation and academic convention in pursuit of an accurate, unflinching representation of contemporary social reality.

The down-at-heel inhabitants of Caravaggio's taverns or Diego Velázquez' street corners belong to the day-to-day reality of their times, but these artists would not have described their task in the terms of Gustave Courbet's 1855 'Realist Manifesto'. Courbet's enormous group scenes *A Burial at Ornans* and *Peasants at Flagey Returning from the Fair*, in which provincial events acquire the grandeur and gravitas of **history painting**, had already gained him the epithet 'Realist'. His aims, he said, were 'to translate the customs, the ideas, the appearance of my epoch ... to create a living art'.

Realism here meant more than representing appearances – something art had been doing since Palaeolithic times. For the writer Fernand Desnoyers, in 1855, it signified the vision of a 'sincere and clairvoyant artist' as opposed to one who 'continues to see through tinted glasses'. It was simply, said Courbet, 'democracy in art'. For socially progressive thinkers, the idea that painters should confront contemporary life, without idealisation or illusions, placed art in the vanguard, or avant-garde, of progress. In the socialist future that had been dreamed of in the French Revolution but had yet to come to pass, 'Every worker,' wrote the philosopher Pierre-Joseph Proud'hon in 1846, 'must become an artist in his chosen speciality.'

The belief that art had a socially progressive function persisted long after the debate about Realism had been superseded by fresh controversies surrounding avant-garde art. Neue Sachlichkeit (New Objectivity) was the label given to painters such as George Grosz (see p.151), Max Beckmann and Otto Dix (see p.59), who exposed the politically fragile society of 1920s Germany to a gaze of brutal disillusionment laced with satire. In *People of the Twentieth Century*, a vast documentary project by their contemporary August Sander, Realism in Courbet's sense ('the appearance of my epoch') found its natural medium in **photography**. Sander set out to photograph Germans of all types, ages and occupations – until his gallery of myriad non-Aryan faces fell foul of Nazi racist propaganda. It was photographers rather than painters who, in an age of interventionist social policy, had the official task of confronting reality, as in Dorothea Lange's almost biblical images of rural workers in the US in the 1930s Depression era.

The nature of the 'reality' that any art confronts or portrays is contentious, and such ambiguities of definition are the natural domain of art. Chuck Close's portraits itemise every skin blemish and wrinkle on their subjects' faces, recalling Proud'hon's democratic dictum that 'any figure, beautiful or ugly, could serve as a subject for art'. ■

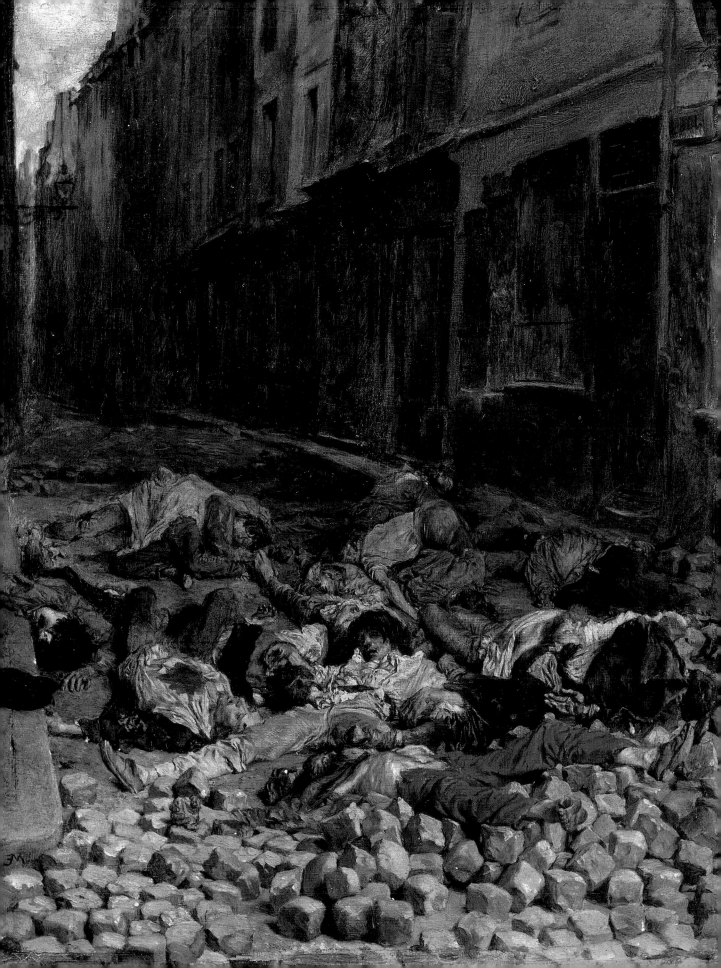

Our noble ancestors

MEDIEVALISM

In the late eighteenth century, a new current entered European art as artists turned to Gothic architecture and medieval art for forms and themes that would evoke the imagined strength and purity of the pre-industrial Christian world. For a century or more thereafter, medievalism was an almost ubiquitous feature of Western visual culture.

BOTTOM LEFT: *Whereas earlier paintings of ideal landscapes typically featured Classical ruins, Schinkel's places a storm-lit medieval cathedral centre stage. The Gothic building embodies the resurgent Prussian state – a vision of the future projected on to the past.*

ABOVE: *King Ludwig II of Bavaria was obsessed by medieval German legends and Wagner's music. Ludwig identified with the Swan Knight in Wagner's opera* Lohengrin, *who appears in August von Heckel's mural (1882–83) in Neuschwanstein Castle.*

OPPOSITE: *Based on a poem by Alfred Tennyson, Millais' Mariana despairs of seeing her lover and longs for death. Her body's sinuous, stretching form might have struck Victorian viewers as improper in a modern, rather than medieval, setting.*

The reinvention of medieval art from around 1780 went hand in hand with **Romanticism's** stress on feeling and imagination, contrasted with the rational idealism of Classical art. With rampant industrialisation, the Middle Ages also came to represent a lost world of stability, community and faith, as expressed by the anonymous artist-craftsmen whose work was preserved in Gothic cathedrals.

As a response to industrial modernity, medievalism reprised the old Arcadian idyll, with a cast of knights and damsels in place of shepherds and nymphs. In 1848, a group of young English painters founded the Pre-Raphaelite Brotherhood with the aim of returning to 'nature', while rejecting what they saw as the moribund academic tradition stemming from Raphael and Renaissance Classicism. In John Everett

Millais' *Mariana* (opposite) stained glass and velvet strike a note of upholstered comfort in a scene of sexual yearning. Medievalism, like Neoclassical sculpture, allowed art to lift sexuality just out of reach of the frankly voyeuristic.

Politically, medievalism came to be associated with Northern European national and civic pride. The fantasy cathedral in the architect Karl Friedrich Schinkel's *A Medieval City on a River* (1815, below), painted in the year of the Battle of Waterloo, is pure political theatre, its unfinished spire symbolising aspiration towards a unified Germany. Throughout a century during which artists, novelists and photographers were coming to terms with industrial capitalism, medievalism remained current as an iconography in which big moral and political statements could be historically sanctioned by medieval fancy dress. Notable

examples include the architect A.W.N. Pugin's designs for the Houses of Parliament in London and, at the escapist end of the spectrum, King Ludwig II's fairytale castle of Neuschwanstein in Bavaria (above).

From the Houses of Parliament to schools, museums, chapels, libraries and the **coloured-glass** windows in suburban homes, throughout Europe, North America and in colonial enclaves across the world, by the early twentieth century medievalism spoke variously of power, pretension, hypocrisy and everything old-fashioned. Its legacy was conclusively rejected after World War I by the Modernist drive for geometry and plain, unornamented surfaces in buildings and art. ∎

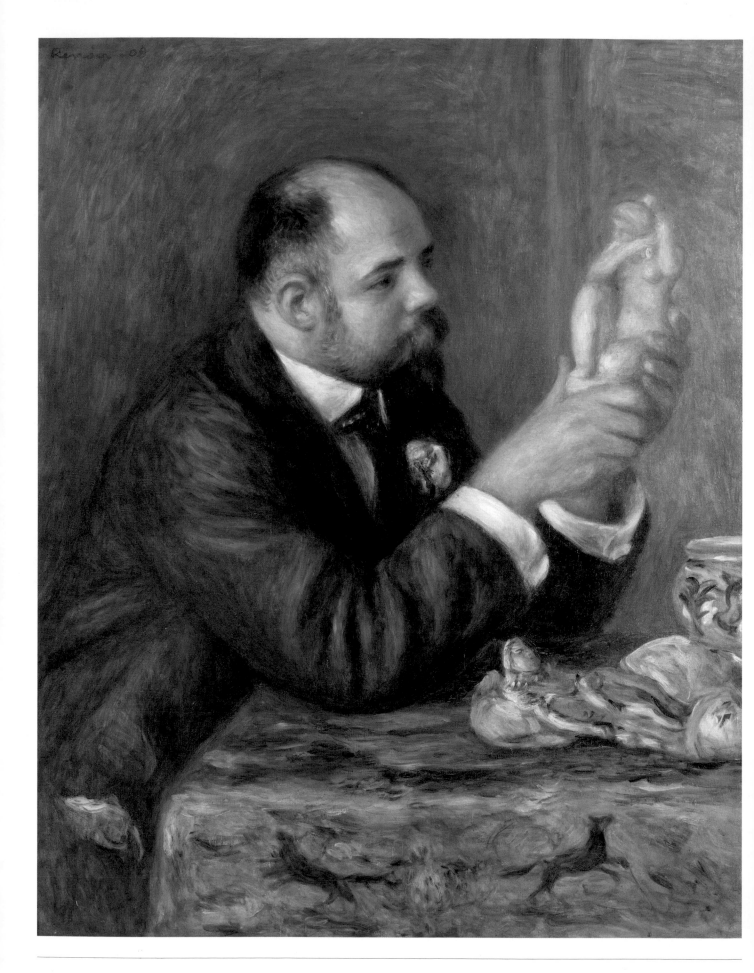

Shopkeepers or kingmakers?

IDEA № 58

DEALING

Since the art market is based on a commodity with no practical use value, dealers – middlemen between artists and the buying public – play a crucial role in setting prices. In the past two centuries, the way dealers operate has had a significant influence on artists' reputations and fashions in art.

The champagne-fuelled atmosphere captured by Martin Parr at Basel Art Fair in 1997 recalls Octave Mirabeau's description of a Parisian exhibition a century earlier: 'piles of gold, eyes gleaming covetously and spines bent in respect'.

When the Roman emperor Hadrian was assembling his art collection in the second century AD, dealers were already involved in an international trade in coveted objects. The Roman trade in Greek art not only involved specialist middlemen but provided work for living artists through a demand for copies of desirable pieces.

From the sixteenth century in Europe, the direct relationship between artist and patron was superseded by an art market of a type familiar today, in which vendors were not necessarily the artists themselves. Prints, in particular, were sold through dealers' shops, with works by celebrated artists such as Albrecht Dürer or Rembrandt commanding high prices. Some artists had a sideline dealing in other artists' work: in the early seventeenth century, for instance, Rubens's travels between different European courts to execute commissions for royal patrons facilitated his services as an art dealer for these same clients.

Before the nineteenth century a dealer's stock typically consisted of antiquities, originals or copies of paintings by great artists of the fifteenth to seventeenth centuries, and prints. Parisian dealers such as Paul Durand-Ruel initiated the now familiar practice of controlling the price and availability of work by living artists, with whom they often maintained personal ties. Auctions became a feature of the scene, with dealers bidding strategically to keep prices high. Durand-Ruel bought artists' work in bulk for exhibition and for sale to collectors who relied on his judgement. He helped to turn Impressionism into a marketable movement, buying work from Degas, Manet, Renoir and others. 'Without him,' Camille Pissarro said, 'we should have died of hunger.'

OPPOSITE: *Artists represented by Parisian art dealer and publisher Ambroise Vollard included Cézanne, van Gogh, Renoir (who painted this portrait of him in 1908), Rouault, Picasso and Matisse. Vollard sometimes bought their entire studio contents for later sale.*

LEFT: *Henri Matisse (left) with Étienne Bignou at the Galerie Georges Petit, Paris, in 1931. Bignou had recently acquired a share in the gallery and was giving Matisse his largest exhibition to date in France.*

In the 1930s and 1940s the American heiress Peggy Guggenheim personified a new breed of collector-dealer who was also effectively a curator. Guggenheim's New York gallery, Art of This Century, with its Surrealist installation-style displays, promoted a vision of what modern art should be. When Guggenheim later opened her Venetian palazzo to the public, her collection of work by artists such as Jackson Pollock, whose careers she had promoted as a dealer, became a museum – a culturally sanctioned version of twentieth-century art history.

The contemporary art market, in which a few artists make fortunes based on hugely inflated prices, functions in a way analogous to the financial sector, with a comparable scope for lucrative manipulation. Consortia of dealers stoke up the bidding at auction so that money circulates through the system. The headlines generated by high prices keep artists' names in the public eye. Most artists, however, see this kind of activity – like the financial practices that triggered the recession of the late 2000s – as ultimately toxic for the future of art. ∎

Fleeting impressions

IDEA № 59
CAPTURING THE INSTANT

In 1874, the critic Ernest Chesneau praised a painting by Claude Monet for its unprecedented sense of 'the ungraspable, the fleeting, the instant of movement'. The idea that such qualities should be a primary subject of painting was a new development and soon came to be named – from another work of Monet's – Impressionism.

Painters who are said to work from the motif – that is, to paint what is actually in front of them – have a particular awareness of transience. Even a **still life** changes continually as the light alters through the day. Artists know (as viewers sometimes prefer not to) that the fleeting instant captured by a painting like Chardin's image of a boy's wobbling soap bubble at the point of drifting away (below) is the work of many hours.

Before about 1800, the idea that art, with its patient exercise of observation and skill, should keep pace with the moment would have seemed absurd. A defining preoccupation of **Romanticism**, however, involved process and transformation; the originating impulse often seemed more interesting, the rapid outdoor **sketch** more truthful,

The passing moment tells a moral tale. Jean-Siméon Chardin borrowed his theme in Soap Bubbles *(1734), of which he painted several versions, from earlier Dutch* vanitas still lifes, *which invited the viewer to reflect on life's transience.*

than the painting carefully worked up in the studio.

Half a century later, when the Romantic cult of individual sensibility was being modified by a more Realist spirit, Chesneau made the observation quoted above in response to Monet's *Boulevard des Capucines* (opposite), a view into a modern city street from an upstairs window – possibly in the Parisian gallery where the First Impressionist Exhibition was staged. Monet made no attempt to itemise the urban scene, as he scornfully described Victorian British artists doing, 'brick by brick'. Instead, the summarily painted trees lining the boulevard appear to be 'swaying in the light and dust'. Taking his cue from Monet's harbour scene *Impression, Sunrise* (1872), the critic Jules-

Antoine Castagnary called this new approach 'Impressionist'. Its aim was not to portray the precise details of a **landscape** but to evoke 'the sensation produced by a landscape'.

The paintings of Monet and his associates, including Camille Pissarro, Alfred Sisley, Pierre-Auguste Renoir, Edgar Degas and Berthe Morisot, actively captured the *impression*, in the French sense of 'imprint', of the instant, much as a photographic plate passively received it. The relationship between the subjective (Impressionist) *impression* and the objectively recorded (photographic) one preoccupied artists and writers. It lies at the heart of Marcel Proust's great novel *A la recherche du temps perdu* (In Search of Lost Time), in which perceptual impressions are painstakingly assimilated to the fabric of memory. The notion of capturing the instant in art outlasted Impressionism, of course. Cubism distilled the ungraspable element in perception while discarding fleetingness. Futurism's painterly evocations of speed and movement, on the other hand, were dismissively characterised by Marcel Duchamp as 'impressionism of the mechanical world'. ∎

The realistic appearance of Degas'
Little Dancer of Fourteen Years
(cast in bronze after his death) was
too much for visitors to the 1881
Impressionist exhibition. Her tired,
obedient face was said to express
'a particularly vicious character'.

Found inspiration

IDEA № 60
ASSEMBLAGE

Assemblage is a sculptural version of **collage** in which an artwork is constructed from objects or fragments found, but not usually shaped, by the artist. The term was first used by Jean Dubuffet in the 1950s to describe collages he made with butterfly wings, but the practice itself began with earlier challenges to the distinction between 'art' and 'non-art' materials

ABOVE: *According to Raoul Hausmann, 'the average German has no more capabilities than those which chance has glued onto his skull'. His* Spirit of Our Time (Mechanical Head) *(1919) consists of a hatter's dummy and other found objects.*

Since the Western distinction between fine-art materials (e.g. paint, canvas), decorative arts (pottery, jewellery) and non-art objects (bicycle wheels, matchboxes, etc.) is alien to many cultures, globally assemblage is often just part of the way sculpture is made. Religious statues that survive as stone, metal or wooden figures in museums once – when they were serving their original function – incorporated real clothes, jewellery or weapons. But when, in 1881, Edgar Degas broke with convention by using a horsehair wig, gauze tutu and silk shoes in a wax statuette of a young

BOTTOM LEFT: *In 1913, Marcel Duchamp's* Bicycle Wheel – *a wheel slotted into the seat of a stool – transformed assemblage into a new Classical idiom in which everyday objects acted out the laws of aesthetics.*

ballerina (opposite), the Parisian public found this unaccustomed conjunction of art object and ordinary things incomprehensible.

Assemblage of Degas' kind, like the Impressionist painting (see pp.124–25) with which he was associated and the Realist movement that preceded it (see pp.118–19), attempted to abolish the **academic** segregation of fine art from everyday life. The use of ordinary materials, extended later to *objets trouvés* (**found objects**), was also a means of counteracting the taint of political servility that clung to academic art, whose aim in the late nineteenth century seemed primarily to be to ingratiate itself with the elite.

The Surrealist obsession with revelatory incongruity – in the Comte de Lautréamont's influential poetic image 'a chance encounter between a sewing machine and an umbrella on a dissecting table' – translated as well into assemblage as into its more familiar incarnation in photographic **collage**. Kurt Schwitters, who with fellow Dada artists Raoul Hausmann (above) and Hannah Höch sharpened photomontage into a key modern medium for protest and **satire**, invented a form of assemblage he termed *Merzbilder*. These were literally 'pictures made from *Merz*', a nonsense word Schwitters defined as 'the combination, for artistic purposes, of all conceiv-

able materials ... a pram wheel, wire netting, string and cotton-wool: *Merz* stands for freedom from all fetters, for the sake of artistic creation.' The culmination of Schwitters' project was the *Merzbau* (*Merz* Building, see p.158), an architectonic assemblage that eventually filled his Hanover studio but was destroyed during World War II.

Two strands of assemblage exemplified by Duchamp (left) and Schwitters – respectively, its conceptual wit and its magpie delight in material properties and textures – recur throughout later twentieth- and twenty-first-century sculpture. Louise Nevelson assembled her *Sky Cathedral* (1958) from wooden crates and offcuts painted a uniform black to suggest an ancient wall relief. In such works as *Car Door, Ironing Board and Twin-Tub with North American Indian Head-Dress* (1981, see p.202), Bill Woodrow created a consumer-age variant of Surrealism from garnerings of household junk. ∎

Into production

COMMERCIAL DESIGN

As product design became an important element in the competitive dynamic of industrial capitalism, the 'handmade' aesthetic of artistic production found a role in the industrial process. With the growth of advertising and packaging in the twentieth century, artists reversed this process by borrowing images from mass-produced consumer goods.

BOTTOM LEFT: Gerrit Rietveld believed that 'our chairs, tables, cupboards ... are the (abstract-real) images in our interior of the future'. His 'Red–Blue' chair (c.1923) is based on an unpainted prototype he designed in 1918.

OPPOSITE: Toulouse-Lautrec had already exhibited at the Moulin Rouge cabaret when he designed his first poster for the venue in 1891, advertising the dancer La Goulue. The poster made him one of the most famous artists in Paris.

ABOVE: Peter Blake and Jann Howarth's cover design for the Beatles' Sgt. Peppers Lonely Hearts Club Band album drew on Blake's passion for historical and contemporary popular culture. This defining image of 1960s psychedelic rock music became his best-known work.

In the 1860s William Morris attempted to bring together artist-designers and craft practitioners in a cottage-industry model of production. Morris's Arts and Crafts movement, and parallel movements elsewhere, influenced domestic architecture and design for 70 years or more, but Morris was forced to accept that, for all the wholesome integrity of his firm's products, it was 'ministering to the swinish luxury of the rich'.

Industrial competition between Britain, France and Germany drove a series of initiatives in the arts. The foundation of the South Kensington Museum (now the Victoria and Albert Museum) in 1857 was intended to provide trainee artists with a reference bank of histor-

ical models that would give British industry a leading edge. **Academic** art education, with its intellectual dimension, now had a more utilitarian counterpart dedicated to the service of industry and commerce. Walter Gropius's 1919 manifesto for the multidisciplinary college known as the Bauhaus drew on Arts and Crafts idealism but embraced a Modernist aesthetic: 'Architects, sculptors, painters, we must all get back to craft! ... Let us together create the new building of the future.'

Mass-produced objects could not have the unique aura of the traditional artwork. If art were to find a role in modern mass production, the alienation of artists from their own handiwork was apparently a price that must be paid. The nineteenth-century French artist Henri de Toulouse-Lautrec's colour lithograph posters (opposite) took their cue from Japanese woodblock prints, many of which arrived in France as disposable packaging on trade goods. Even the most esoteric art theories found their way into product design. For Piet Mondrian, art was 'a pure representation of the human mind' expressed in **abstract** paintings. Mondrian influenced Theo van Doesburg, whose journal *De Stijl* carried the motto 'The object of man is style'. One of its contributors, the architect Gerrit Rietveld, designed a chair that is effectively a utilitarian

parallel to Mondrian's abstract mysticism (left).

Commercial design in 1960s America and Britain reached the youth market through an iconography of creative individuality that artists were well placed to provide. Peter Blake's and Jann Haworth's sleeve design for the Beatles' 1967 album *Sgt. Peppers Lonely Hearts Club Band* (above) fused Surrealistic photomontage with retro typography and flower motifs, suggesting both civic and hippie culture. In a reversal of the movement from unique artwork to massmarket product, original *Sgt. Pepper* album covers are now traded like fineart prints. Fashion designers such as Issey Miyake, whose first show was titled *A Poem of Cloth and Stone*, have developed the concept of clothes as wearable works of art. Young British Artists (YBAs) of the 1990s, meanwhile, turned the **Romantic** notion of **the artist** as isolated misfit and rebel into a highly marketable form of personal branding. ∎

Immortality at a squeeze

IDEA № 62
PAINT IN TUBES

In 1841, the American portraitist John G. Rand invented a method of packaging **oil paint** in flexible zinc tubes, ready-mixed for squeezing straight onto the palette. Tubes of paint made it possible for artists to carry around a wide range of colours for use outdoors or wherever they wanted to work.

OPPOSITE: *Studio without walls: Claude Monet's 1891 series of paintings of poplar trees on the banks of the River Epte records the same scene under changing light conditions at different times of day.*

ABOVE: *British abstract artist Patrick Heron occasionally dispensed with brushes and drew with lines of oil paint or gouache squeezed directly from the tube, as in 2 July: 1995 (gouache on paper).*

BOTTOM LEFT: *Carl Larsson took up plein-air painting while living in a Scandinavian art colony near Paris during 1882–85. His Open-Air Painter (1886) expresses a determination to pursue this approach in the colder climate of his native Sweden.*

Even before Rand's invention, the handling of oil paint had changed significantly since the medium's first flowering in Northern Europe in the fifteenth century. Most artists no longer made their own paints by grinding pigments but instead bought them from specialist suppliers. Chemical processes had also greatly added to the range of available colours. Cadmium, discovered in 1817, yielded compounds that produced vibrant yellows and reds.

Artists such as Albrecht Dürer had worked in the open air before the mid-nineteenth century, producing studies of actual, rather than imaginary, landscapes. For Romantic **landscape** painters, **watercolour** provided the perfect medium for painting outdoors, or *en plein air*. The desire to paint directly from nature, rather than using watercolour **sketches** made on the spot as the basis for a later studio oil painting, was stimulated by the taste for landscape subjects and by the Realist stress on the artist's duty to represent the actual appearance of things. Handling oil paint in the field would never be as easy as using watercolour, but paint in tubes at least made it practical. Tube-packaged paint was quickly taken up by commercial suppliers, who developed a range of portable kit to go with it, such as ready-stretched and primed canvases and folding easels that could be set down in front of the motif like a photographer's tripod. Artists were now able to work *en plein air* on canvases destined (as watercolour sketches often were not) for public exhibition and sale.

Impressionist practice, which focused on transient open-air light effects in the changeable weather of northern France (see pp.124–25),

depended on tube-packaged paint. Like the peasant field workers in paintings by Jean François Millet and Jules Bastien-Lepage, *plein-air* artists and their portable kit became a subject in their own right for landscape art.

Paint in tubes had a sticky consistency that led to the use of stiff hogshair brushes, which left clearly defined, textured brushmarks on the canvas. Impressionist technique was based on small dabs of strong colour. When paint was applied rapidly and spontaneously in this way, rather than being patiently built up in dilute glazes, the visible brushmarks remained as an imprint of the passing moment and as a record of the artist's response – two qualities that were to have particular resonance in the twentieth century. Although acrylic paints (see pp.162–63), combining the fluidity of watercolour with the colour strength of oils, became the favoured medium for postwar **abstract** painting, artists continued to experiment with tube-packaged oils (above). ∎

Drawing with light

PHOTOGRAPHY

In the 1840s, photography seized the public imagination as an almost magical new technology that would supersede representational art, although it took another century for photography to win acceptance as an art form. The history of photography has been one of creative reciprocity between mechanical and manual image-making.

The term photography, meaning 'drawing with light', was coined by the British scientist John Herschel in 1839. Photography took the technology of the **camera obscura** a definitive step further by introducing a light-sensitive medium on which the projected image of reflected light could be captured and extracted from the device to produce a photograph. Photographs could be hung on the wall like paintings or bound in albums like prints. Like drawings, they provided a portable visual record of observations. However, photography did not rely on **the artist's** skill to **copy** the projected image inside the camera: mechanical and chemical processes did it all.

In photography's early years, what the camera 'saw' nonetheless often resembled a painting. Portraits, still lifes, landscapes, street scenes – photographs seemed to confirm that the visual world really was organised and framed like art. In this two-way relationship, artists welcomed photographs as a useful source of reference material. An allegory from the 1850s by Oscar Rejlander shows 'Infant photography' offering the artist 'an additional brush' (below) – an offer that was readily accepted by artists such as Gustave Courbet, who painted the nude in *The Studio of the Painter* (1855, see p.115) from a photograph rather than a live model.

Artists also responded to photography by concentrating on what couldn't be captured by a camera – such as the play of light on water or through leaves, to which Impressionist brushwork lent an illusion of ungraspable movement and evocative colour as yet beyond the photograph's scope. At the same time, they mimicked photography's emerging conventions, as in the cropped compositions favoured by Edgar Degas, which appear as though momentarily caught in the **frame** rather than posed squarely within it. On the whole, however, painting and photography followed parallel courses until the beginning of the twentieth century, when the avant-garde revaluation of art's role widened from subject matter and interpretation to embrace media and context. Dada and Surrealist artists used photo-

montage, a form of **collage** in which photographs from different sources were cut and pasted to form an image. In this process, the photograph's suave verisimilitude was sliced up and reordered to reveal dreamlike disjunctions. From this point onwards, a firm distinction between art and photography (as in Rejlander's photograph) became increasingly untenable.

There are many ways in which artists register a dialogue between the mechanical image and the handmade artwork. In the 1960s Gerhard Richter (see p.105) observed, 'I use photography to make a painting, just as Rembrandt uses drawing.' For him the difference between photograph and painting becomes a subject in its own right: 'The photograph makes a statement about real space, but as a picture it has no space of its own', yet 'A painting of a murder is of no interest whatever; but a photograph of a murder fascinates everyone.' Andreas Gursky's enormous photographic inkjet prints (above) overturn the convention of the easily 'readable' page-size photograph. ∎

OPPOSITE: *Early in his career the British portraitist Oscar Rejlander gave up painting and turned to photography. His photograph inscribed 'Infant photography gives the painter an additional brush' (c.1856) suggests that the future lies with the younger art.*

ABOVE: *The sheer scale and detail of Andreas Gursky's photographic prints, such as 99 Cent (1999), which measures 2 x 3.3 metres (81½ x 132½ in), create ersatz environments too vast to be intelligible from a single viewpoint.*

The simple life

IDEA № 64
ART COLONIES

Art colonies were a feature of late nineteenth- and early twentieth-century Northern Europe, in which the age-old desire to escape the city for a simpler rural existence combined with a utopian belief that artists themselves could establish a better way of life than was available in the modern industrial society around them.

ABOVE: *Artists in rural art colonies took the surrounding landscape and working-class population as their subjects, producing paintings of back-breaking but honest toil, earthy agrarian landscapes and picturesque fishing ports, as in Stanhope Forbes'* Newlyn *(1906).*

OPPOSITE: Bonjour Monsieur Gauguin *(1889) expresses Gauguin's fascination with Brittany: 'I find the wild and primitive here. When my clogs resonate on the granite ground I hear the muffled and powerful thud I'm searching for in painting.'*

BOTTOM LEFT: *Stanhope Forbes was one of the first 'gentlemen artists' to settle in the Cornish fishing village of Newlyn in the mid-1880s. In a 1906 photograph, local people seem amused to find themselves turning into art.*

Art colonies were a peaceful parallel to the rampant geopolitical colonialism in which imperial Britain, France and Germany engaged. At Worpswede near Bremen, Pont-Aven and Concarneau on the Breton coast, Newlyn and St Ives in Cornwall, Abramtsevo in Russia and other locations far beyond the metropolitan cultural orbit, the pattern repeated itself. Groups of city-trained painters visited regularly or settled long term, sometimes using redundant industrial or agricultural buildings as studios and often painting *en plein air*. The colonists liked to participate in the host community and paint its distinctive moments – the evening return from the fields or fishing grounds, the locals in traditional dress.

By the 1880s, art had yet to catalyse the fairer society of which Gustave Courbet and his avant-garde contemporaries had dreamed 30 years earlier (see pp.118–119). Art colonies were alternative communities, in which artists could – in theory – enjoy professional camaraderie while living in harmony with people who remained uncorrupted by industrial modernity. The promise of making contact with a more vital, '**primitive**' way of life held a powerful appeal for self-styled outsiders such as Paul Gauguin, who made several visits to Brittany (opposite). In autumn 1888 he joined Vincent van Gogh in a short-lived colony of two in the Provençal town of Arles. As so often in art-colonial history, the creative stimulus (their discussions, enthused Van Gogh, were 'terribly electric') was outweighed by what Gauguin euphemistically called their 'incompatibility of temper'. In 1891 Gauguin left Europe for Tahiti, in search of an exotic Arcadia where he vainly hoped to find 'happy inhabitants' enjoying 'the sweetness of life'.

The ideal of an artistic community in which ideas and ambitions could be shared had an urban version too. In 1902, the fireman-sculptor Alfred Boucher set up a studio complex outside

Paris known, from the building's distinctive shape, as La Ruche (The Hive). This collective model, in which individual artists lived and worked in close proximity, though not as members of a single atelier, repeatedly re-established itself in low-rent city districts with vacant workspace, frequently to be followed by property developers arriving in the artists' wake and putting studio space beyond the financial reach of the very people whose presence had made the place fashionable. ∎

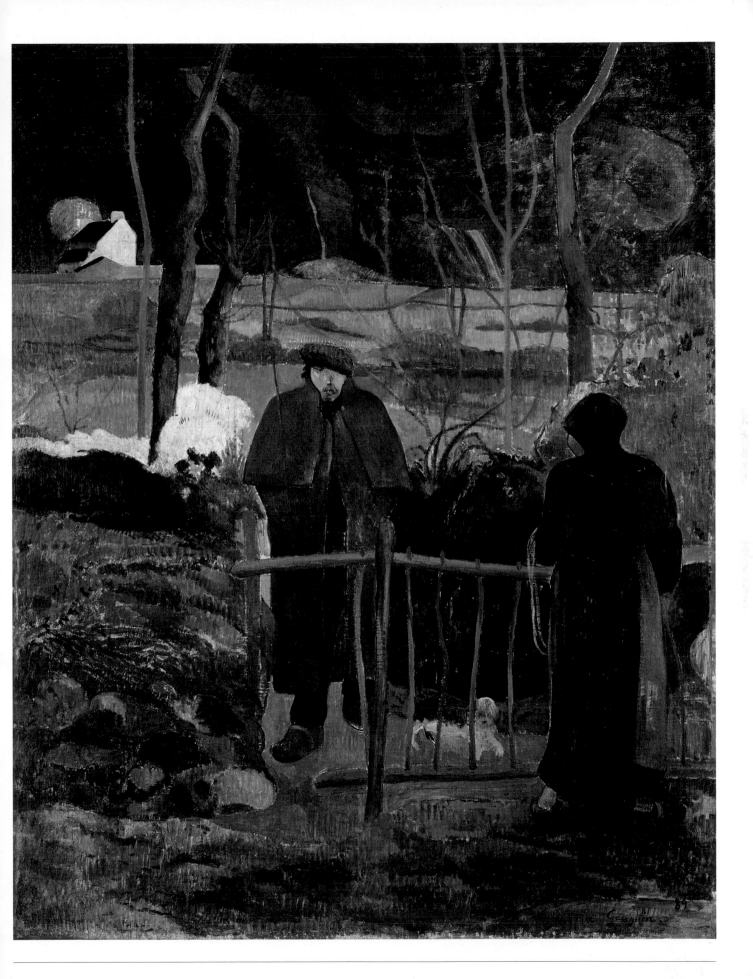

Seeing in the dark

IDEA № 65
ARTIFICIAL LIGHT

Art and artificial light are closely linked. Palaeolithic cave artists worked by the light of fires or simple lamps in the total absence of daylight; modern artists such as Francis Bacon have preferred electric light to daylight, while some have used artificial light as a medium in its own right.

BOTTOM LEFT: *Photographs give little impression of the environmental, mood-altering qualities of the light installations Dan Flavin created between the 1960s and 1990s.* Untitled *(1970), shown here, consists of a single blue and red fluorescent tube.*

ABOVE: *In Georges de La Tour's* Saint Joseph Carpenter *(c.1640), the young Jesus holds a candle while his father drills a wooden beam, foreshadowing the Crucifixion. Candlelight intensifies the spiritual drama of this apparently everyday scene.*

OPPOSITE: *'Energy' was one of the watchwords of Filippo Tommaso Marinetti's 1909 Futurist Manifesto. In Giacomo Balla's* Street Light *(1909), the modern energy of electricity pulses into the night, overwhelming the moon as both light source and poetic symbol.*

In art theory, light usually means daylight. In practice, however, artificial light is often an essential feature of the artist's method, the viewer's experience or both. Before the development of gas lighting, then electricity, during the nineteenth century, artificial light meant the dim glow of animal-fat lamps or tapers or the brighter but more expensive flame of beeswax candles. It is thought that the juddering flames by which Palaeolithic painters worked and which allowed their work to be seen may have been part of an intended effect, giving the animal forms on cave walls the mysterious illusion of movement.

On the whole, artists in the pre-modern world worked by daylight, like everyone else. Teaching, however, could evidently go on after-hours: an engraving by Enea Vico shows students of Baccio Bandinelli in Rome in the 1530s seated

around a table, copying a Classical statuette by candlelight (see p.108). They needed artificial light because they were no longer merely manual workers, but scholars too, burning the midnight oil like poets and philosophers. Doing anything by expensive candlelight could, in fact, be a sign of social status. When Goya included his self-portrait painting by candlelight in a family portrait of his patron Don Luis de Bourbon, he was making a social statement as much as a record of his working practice.

As artistic subject matter, the light of taper or candle flames produced a wealth of interpretations. Candles frequently featured in **still lifes** as symbols of the transience of human existence. From the late sixteenth century, the vogue for dramatic **chiaroscuro** gave rise to innumerable night scenes, from Luca Cambiaso's *Holy Family with St John the Baptist* (*c.*1578), where Mary reads by a single candle, through Caravaggio and Rembrandt. The French painter Georges de La Tour specialised in candlelit night-time subjects (above).

Electric light liberated artists once and for all from practical reliance on daylight, if they chose. Its widespread introduction coincided with the end of the single light-source as a noticeable presence in European painting. From the Renaissance down to the Impressionists, painters responded in one way or another to the quality of reflected or refracted daylight. But from Van Gogh and Gauguin onwards, concerns with colour, shape, different kinds of spatial illusionism or anti-illusionism, and the nature of objects irrespective of illumination, replaced the old primary relationship with light. Though electricity seemed a modern subject, light retained its ancient poetic associations. For all its apparent contemporaneity, Giacomo Balla's buzzing orange-yellow streetlamp from 1909 (opposite) recalls Marcel Duchamp's sideswipe at Futurism: 'an impressionism of the mechanical world'. As a medium, artificial light has been widely exploited by late-twentieth-century artists, such as Dan Flavin (left) and James Turrell, with effects ranging from the lyrical to the sublime or the clinical. ∎

Dreamers awake

IDEA Nº 66
THE UNCONSCIOUS

At the end of the nineteenth century the unconscious was proposed by Sigmund Freud as the source of psychological symptoms for which there was no evident cause in the subject's conscious experience. The awareness of a hidden region of the mind was not new, but Freud's idea that dreams are truthful manifestations of unconscious desires had profound implications for art.

The association between creativity and 'dark' aspects of the mind goes back to ancient times. For Aristotle, melancholy – a notion that included what we would call depression – was the natural temperament of philosophers and poets. Their ideas might be divinely inspired, but to ordinary mortals they could seem mad. Later **Romantic** art is bathed in a conviction that genius has hidden psychological wellsprings, often connected to extremes of mental anguish or exaltation. In the German philosopher G.W.F. Hegel's memorable image, the owl of Minerva, goddess of wisdom, takes wing as darkness falls. In Goya's print **series** Los Caprichos and contemporary paintings by the Swiss-born English artist Henry Fuseli (opposite), dreams are – as Freud was to see them – the place where repressed desires surface and fantasies are acted out.

The unconscious, described by Freud as 'a special region of the mind, shut off from the rest', had a central place in his mapping, or topography, of the mind. Freud thought that many actions and experiences were shaped by desires that, since they infringed social taboos, could not be acknowledged and were therefore repressed and remained unconscious. Access to the unconscious – denied to the waking mind – could be gained via the 'royal road' of dream

analysis. During World War I, when Freud's ideas were becoming widely known, it seemed to many that, if there was hope for a better future, it lay in confronting the unconscious desires that were driving nations into acts of mass psychosis.

As a medical auxiliary, the French writer André Breton practised Freudian analysis on shell-shock victims. His 1924 Surrealist Manifesto insists on 'the omnipotence of the dream' as a means of addressing 'the principal problems of life'. To Breton and his Surrealist circle in the 1920s and 1930s, Freudian psychology and Marxist economics were the twin foundations of social regeneration, in which artists could lead the way. Surrealist art's fantastical distortions and dream imagery (right top) are founded on these two articles of faith. Their most powerful public expression was Pablo Picasso's 1937 mural Guernica (see pp.164–65), an anti-fascist protest that, in its nocturnal setting, wide-eyed horse and writhing human forms, offers a political echo of the private Romantic nightmare visions conjured by Fuseli.

With World War II, the Surrealist project faltered. It had not, in the end, led to the 'solution' for which Breton hoped. In the postwar West, while Freud was highly influential in the formulation of critical theory, artistic practice

TOP: Salvador Dalí described his 'paranoiac-critical' method as a simulation of paranoia to circumvent the rational mind. In this state, 'one can see ... all sorts of shapes' in familiar objects. The Great Paranoiac (1936) exemplifies this approach.

ABOVE: Arshile Gorky's Garden of Wish Fulfilment (1944) relates to a memory of his Armenian childhood: 'My father had a little garden with a few apple trees ... This garden was identified as the Garden of Wish Fulfilment.'

OPPOSITE: In The Nightmare (1790), Henry Fuseli reworked the erotically charged painting that made his reputation in London nine years earlier. He drew on nightmare's original meaning – a creature that settles on sleeping people.

became more concerned with practical social agency. Artists such as Anselm Kiefer were interested in collective memory rather than the individual unconscious. Much of Kiefer's work addresses the repressed memory of his native Germany's Nazi past. Advertising, meanwhile, learnt to employ the mechanisms of subliminal suggestion developed by the Surrealists in order to sell products rather than bring about a more enlightened society. ∎

Savage and innocent

THE PRIMITIVE

Ideas associated with the term primitive have been as influential for Western artists as they are ethically contentious. From the Renaissance, nostalgia for the imagined innocence of early or distant societies haunted European art. Concurrent with the worst abuses of the colonial era, artists sought to harness a 'primitive' vitality that the West had lost.

BOTTOM LEFT: Brancusi's Danaïde *(c.1918) is a portrait of the young student Margit Pogany. Its highly simplified features and title from Greek mythology allude to ancient marble figures from the Cycladic islands, which Brancusi greatly admired.*

ABOVE: Natal'ya Goncharova was one of the early twentieth-century Russian artists known as Neoprimitivists, who believed that modern art should look to earlier vernacular arts. Her Peasants *(c.1911) is based on the lubok, a type of popular Russian print.*

In the Preface to his *Lives*, the Renaissance polymath Giorgio Vasari noted how 'children, brought up roughly in primitive surroundings, have started to draw instinctively'. This, he thought, was how 'the first men' began to make art. Primitive (i.e. the earliest) humans, he wrote, were more perfect than later people since 'they lived nearer the time of Creation'. Western art's conception of the primitive has always contrived to face two ways, both towards origins and towards the future: Michelangelo's nudes – Vasari's proof that modern artists could outdo the ancients – were also a living link to that primitive time when men were as God had made them.

As the idea of progress – the belief that human knowledge and capabilities were steadily improving – took hold of European thought from the eighteenth century onwards, however, the corresponding idea of the primitive became increasingly ethnographic. Educated Europeans deemed 'primitive' cultures – which included rural 'folk' cultures in their own countries as well as the societies of colonised territories – to represent an earlier stage of human development. Such cultures were seen as both 'savage' (requiring subjugation) and 'unspoiled' (an inspiring example for jaded Westerners). This paradoxical notion of the primitive held a peculiar excitement for early twentieth-century progressive artists.

It might seem 'unfair', opined the English artist and critic Roger Fry in 1920, that African wood carvers 'possessed this power [to create expressive plastic form] not only in a higher degree than we at this moment, but than we as a nation have ever possessed it'. By this date European artists had been striving for some years to harness the power of African masks or Pacific woodcarving. Pablo Picasso's *Demoiselles d'Avignon* (1907, opposite) contains a lexicon of 'primitive' ethnographic features, while Constantin Brancusi's simplified heads and bird forms allude to ancient and vernacular sculpture (left). There were parallels in every industrialised nation: in Britain, Ben Nicholson was enthralled by the work of the elderly fisherman and self-taught artist Alfred Wallis; in France, Picasso hosted a banquet for Henri 'Le Douanier' (customs official) Rousseau, master of exotic jungle scenes.

Fascination with the primitive shifted to new ground after World War II, when Jean Dubuffet used the term Art Informel to describe the creations of children, mental patients and other self-taught artists. In his own work and that of his contemporaries in the CoBrA group, misproportioned figures and intentionally awkward brushwork replicate the truth-telling vision of the 'unformed' artist. The analysis of power relationships in late twentieth-century theory – colonist/colonised, adult/child, master/servant – has discredited the term primitive, with its judgemental or sentimental overtones, although Western elite nostalgia for the primitive home-grown persists in fashions for raw or liminal genres such as **street art** (see pp.194–95). ∎

Watching Picasso at work on Les Demoiselles d'Avignon *(1907), the poet André Salmon observed that 'Polynesian or Dahomeian images always appeared "rational" to him', and that the artist 'always consulted the Oceanic and African enchanters'.*

Every possible angle

MULTIPLE VIEWPOINTS

ABOVE: *In landscapes such as Montagne Sainte-Victoire (1904–06), Cézanne used small patches of hatched colour to create strongly spatial effects, while leaving the precise relationship between objects in space open to interpretation.*

OPPOSITE: *David Hockney's Celia's Children, Albert & George Clark, Los Angeles April 7th 1982 (1982) is a 'joiner', assembled from multiple Polaroids. Hockney explained that his joiners 'were based on Cubism in the way that it filters things down to an essence'.*

In the first decade of the twentieth century, two young artists in Paris, Georges Braque and Pablo Picasso, set about dismantling the conventions of single-viewpoint **linear perspective** to which European easel painting had subscribed more or less consistently for almost 500 years. 'Cubist' was the word used to describe their multiple-viewpoint paintings.

BOTTOM LEFT: *Juan Gris' Breakfast (1914) shows how Cubist still life developed following Braque and Picasso's experiments. Cubism, said Gris, was 'a state of mind', in which the painter's intellectual analysis of objects was more important than appearances.*

The rules of single-viewpoint perspective developed in the fifteenth century depended on fixed spatial relationships between the viewer and the painting and between elements of the image arranged in illusory space. This, it was broadly accepted, was how a painting should work: like a **window on the world** before which the observing eye did not move. Centuries passed before anyone argued that this convention failed to reflect the way visual impressions actually shift and reconfigure as you walk down a street or glance repeatedly at a small area such as a tabletop.

By 1900, **photography** had changed the traditional 'window' relationship between object and picture. Trick photography, such as double exposures, and scientific or forensic photography, showing different aspects of an object or stages of a process, brought the realisation that seeing isn't usually accomplished by a fixed stare but by multiple takes of the same scene, often from different angles. Around this time, too, avant-garde artists were altering expectations about the way painting worked. Painters such as Paul Cézanne (above) became more interested in the capacity of brushmark, colour and line to evoke atmosphere and sensation than in mimicking three-dimensional forms.

Braque and Picasso's innovations constituted a form of obsessive but well-educated game-playing with representational conventions. 'We have kept our eyes open to our surroundings and also our brains,' wrote Picasso. They replaced perspectival depth behind the picture plane with the illusion of volume in front of it, comprising ambiguously interlocked and superimposed shapes, defined and fragmented by concise lines and crescent curves, as though reflected in a broken mirror. In Braque's *Le Portugais* (1911), disconnected clues such as vestigial guitar strings, a moustache and a rope apparently slung around a cylindrical form prompt the viewer to piece together a subject. This was effectively a conceptual version of Seurat's Divisionist approach to colour – an analytical method of image-making. The term Cubism suggested geometrical rigour, but the surface–depth interplay in Braque and Picasso's puzzling new **still lifes** and figure paintings was as mobile and indefinable as in Cézanne's landscapes. The Cubist effect, Picasso observed, was not scientifically rational but 'like a perfume – in front of you, behind you, to the side. The scent's all around but you can't quite tell where it comes from.'

The way Cubist painting adopted simultaneous multiple viewpoints was one of its most radical characteristics and influential legacies, but few later artists recaptured the irreverent wit of the original enterprise with such clarity as David Hockney, whose 'joiners' of the 1980s (opposite) are assembled from multiple photographs of the same subject taken from slightly different angles. ∎

Celia's children Albert + george Clark Los Angeles April 7ᵗʰ 1982

Newspaper mastheads and wallpaper were favoured components of Cubist collages, as in Georges Braque's Le Courrier (1913), where he combined found materials with charcoal drawing. Braque had learned to paint imitation wood grain as a trainee painter-decorator.

'Braque and Picasso transformed collage from parlour game to avant-garde medium.'

Cut and paste

IDEA № 69
COLLAGE

The technique of collage (from the French verb *coller*, 'to glue') involves selecting fragments of extraneous material such as newspaper cuttings and bits of textured paper which are then stuck down on a flat surface and incorporated into an image. In this way the artist forms a picture by organising ready-made materials.

BOTTOM LEFT: Although computer-generated cut-and-paste images mimic the technique of collage, they cannot reproduce the physical textures created by the layering and juxtaposition of material from different sources, as in Alex Daw's Pamela *(2008).*

ABOVE: Joseph Beuys's Bathroom of Circe *(1954–58) refers to Homer's* Odyssey *and James Joyce's novel* Ulysses, *both of which feature the enchantress Circe, who transformed men into animals. Collage expresses the layering and adaptation of 'found' narratives.*

Before its adoption by Cubist artists, the cut-and-paste picture was a familiar amateur pastime in which journal, souvenir, artwork and photographs could be combined on the pages of an album. In 1912, Picasso and Braque transformed collage from parlour game to avant-garde medium. Their experiments that year led to the rapid establishment of collage, then photomontage, in European avant-garde practice, and to the evolution of a new form of sculpture, the Cubist construction.

In line with Braque and Picasso's earlier reformulation of painting, collage was essentially a *jeu d'esprit*

carried to its logical conclusion. As the painter and theorist Maurice Denis observed in 1890, painting was not primarily a representation of reality but an object made of paint. Collage went one step further, assembling images not from paint but from actual pieces of the reality that paint had for centuries been co-opted to represent. Why paint a newspaper, as Degas had done in his *Cotton Market at New Orleans* (1873), when you could import it straight into your work?

Picasso's *Still Life with Chair Caning* (1912) is thought to be the first work in which the humble medium of collage announced itself as equal to painting. The collaged piece of oilcloth printed with *trompe-l'oeil* chair caning is a piece of the material actually used in café interiors of the kind to which the painted objects in the picture, including a newspaper, clay pipe and lemon slice, allude. Around the oval canvas Picasso wound a thick rope, mimicking the wooden imitations of rope-twists used in conventional frame-making. The previous year, Braque had already introduced imitation wood grain into painting, which he was soon to exploit in the collages he termed *papiers peints* (painted papers).

Whereas Cubist collage abjured strong colour, preferring the muted café tones of newsprint, tobacco and dirty glass, Henri Matisse turned collage into a medium concerned with the interaction between colour and shape. The cut-paper works he produced towards the end of his career, at first as a less strenuous alternative to painting, became a means of manipulating high colour in formal, semi-abstract configurations. For later artists such as Sandra Blow, for whom abstract painting was exclusively a matter of visual balance without any figure references, collage was a practical method for keeping an image clear and fluid until, when every part had fallen into place, the pieces could be finally glued down.

In the later twentieth century, much work in collage seemed more concerned with matter and texture than design. In Alberto Burri's sackcloth collages, a rough, ordinary material is used to impart humanity to austerely abstract images. On the other hand, Robert Rauschenberg, who had visited Burri in Italy, employed collage to suggest the complex layering and interpenetration of urban visual culture. ∎

Industrial beauty

MACHINE FORMS

Industrial mass production radically altered the relationship between people and the objects they made and used. To some artists industrial machinery appeared demonic and inhuman. Others – including the Italian Futurists, who made art that celebrated the aesthetics of the Machine Age – found the power of machines and their sleekly engineered forms compelling.

BOTTOM LEFT: *Bernd and Hilla Becher's photographic series document Europe's heavy industrial sites and machinery. Their multiple images of different building types, such as Gas Tanks (Round) (2000), seem like monuments of a lost age.*

ABOVE: *In Jacob Epstein's early version of* The Rock Drill, *shown in 1915 (reconstructed by Ken Cook and Ann Christopher), the figure straddling a real miner's drill is part-machine, part-human (an embryo curls inside his ribcage).*

OPPOSITE: Propellers *(1918) exemplifies Fernand Léger's 'machine aesthetic' of semi-abstract angular and cylindrical forms. Léger believed that art could reach out to working people only by reflecting the role of machines in their lives.*

Artists often had an ambivalent relation to industrial production. In his writings, the great Victorian critic John Ruskin promoted the spiritually uplifting qualities of Gothic art and the observation of nature but nonetheless confessed to 'the crushed humility with which I sometimes watch a locomotive take its breath at a railway station'. He compared the 'infinitely complex anatomy of active steel' and 'its polished calm of power' with 'this weak hand of mine, timidly leading a little stain of water-colour ... into an imperfect shadow of something else'. Steam power, he concluded, was a force in art, a 'Tenth Muse'.

Artists from Alberti onwards had insisted that art was different from craft skills like sign painting because it involved intellectual labour. Factory production altered this distinction. In the 1840s, Friedrich Engels observed 'the degradation to which the application of steam-power, machinery, and the division of labour reduce the working-man'. Artists, by contrast, continued to produce unique hand-crafted goods, which could be made, and bought, only by a select few.

For its part, mass-produced decorative art, from brass door handles to Art Nouveau posters, continued to rely on a repertory of 'natural' forms, which concealed its industrial origins. A reaction to this – a machine aesthetic in which handmade art would celebrate machine forms – emerged in Italy shortly before World War I. Filippo Tommaso Marinetti's 1909 Futurist Manifesto announced that 'the supine admiration of old canvases, old statues and old objects' must be swept away by an art attuned to 'the beauty of speed'. Serving as an engineer on the Western Front a few years later, Fernand Léger thought machine guns 'more worth painting than four apples on a table'. For Hannah Höch, the whole purpose of Dada photomontage was 'to integrate objects from the world of machines and industry in the world of art'.

By the mid-twentieth century, machine forms had become culturally pervasive and semantically complex. Tanks and planes stood for the mechanised killing fields of World War II, but cars and consumer goods represented freedom and prosperity. Space exploration and other technological advances foreshadowed a world where machines might equally solve problems or bring alien invaders from distant planets. Sculptors such as David Smith in the USA and Eduardo Paolozzi in Britain cast work from tools and machine parts. By the end of the century, however, across much of the Western world heavy industry and the machine aesthetic were becoming history. ∎

Beyond representation

IDEA № 71
ABSTRACT ART

'Abstract art' is a term loosely applied to any kind of work that doesn't seem to represent observable reality. Modern practitioners have made more positive claims for the practice, proposing that abstraction liberates the artist from the constraints of mimetic representation and gives form to deeper realities than can be expressed by imitating appearances.

As the opposite of the term representational, abstract includes all kinds of patterns and shapes. Even geometric shapes, however, have strong associations, leading many artists to insist that no valid distinction can be made between abstract and representational art. The influential American critic Clement Greenberg wearily observed: 'The presence or absence of a recognisable image has no more to do with value in painting or sculpture than the presence or absence of a libretto has to do with value in music.' He related the early twentieth-century flourishing of abstract art to the replacement of perspectival illusionism by a growing awareness of a painting as primarily a flat, decorated surface.

Whether geometric, biomorphic, monochrome or highly coloured, early twentieth-century abstract painting was never purely decorative. Artists shared a conviction that abstract art had a philosophical or quasi-mystical foundation, that it was capable (in contrast to representational painting) of communicating essences rather than mere appearances. The Russian painter Kazimir Malevich wrote of the 'blissful sense of liberating nonobjectivity' that attended his 'rediscovery of a pure art', in which the essence of modern urban life – the sensation of speed, the flight paths of planes – could be rendered in the geometric idiom he named Suprematist. Malevich's *Black Square* (1913) was unprecedented in its pure 'nonobjectivity' – no suns, moons or even flight paths could be discerned in its uniform black surface.

For Malevich's older contemporary Wassily Kandinsky, abstract painting was a new language capable of expressing otherwise inexpressible ideas and experiences. Piet Mondrian believed that abstract art was the form most appropriate to the 'changed consciousness' of modern people. 'As a pure representation of the human mind,' he wrote, 'art will express itself in an aesthetically purified, that is to say, abstract form.' Neoplasticism was Mondrian's term for his abstract painting, in which rectangles of strong colour set in black-on-white grids create spatial effects of extraordinary amplitude and calm.

Writing in 1954, Greenberg was convinced that the best abstract art was also 'the best art of our time'. He was thinking of Abstract Expressionists such

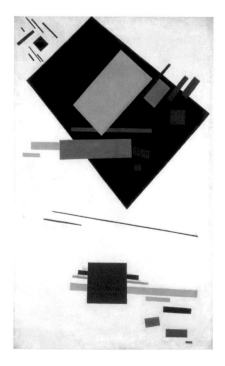

as Jackson Pollock and Franz Kline (the term had first been applied to Kandinsky) in whose large-scale paintings the artist's psyche was thought to express itself, in the manner of Surrealist automatism, through unpremeditated calligraphic abstract marks. Later artists tended to play down abstract art's spiritual claims while in many cases maintaining Kandinsky's philosophy of paint as a medium of pure expressive and communicative power. ∎

OPPOSITE: Suprematist Composition, Black Trapezium and Red Square *(after 1915) is an early example of Malevich's Suprematism, which he defined as 'a new culture ... produced by the latest achievements of technology, and especially of aviation'.*

ABOVE: Kandinsky believed that colour could be orchestrated to communicate like music. Composition No. 7 *(1913) bears out his theories, with its cumulative, symphonic intensity and bursts of colour in different parts of the painting.*

Savagely funny

IDEA № 72

SATIRE

In satirical art recognisable figures are distorted as a means of criticising certain aspects of society or individuals. The most striking visual satire is emotive and savagely observant, evoking both laughter and condemnation.

Historically, art has generally been constrained to provide those who commission or consume it with an acceptable reflection of themselves and the values with which they identify. In satire, however, the artist becomes, or poses as, a moral agent, registering the gap between appearances and underlying reality. The bigger and more iniquitous that gap is felt to be, the more intense the satirical energy released. At the same time, satire tends to be conventional in formal terms; its meaning needs to be unequivocally clear to its audience. William Hogarth's incisive critiques of eighteenth-century English society (see pp.100–01) use **narrative** and representational conventions that most viewers can understand. In this way, satire persuades us to accept startling subversions of the customary messages conveyed by art.

As animals are assumed to be incapable of hypocrisy, artists since the ancient world have used animal imagery to satirise human failings. Although the topical references of Egyptian satirical drawings (below) can only be guessed at, their motivations feel familiar – the social pressures that result in the normalisation of pretentious behaviour, not to mention injustice, brutality and oppression, have always needed a safety valve.

Satire can place the artist in the firing line: the painter and caricaturist Honoré Daumier was jailed for six months for creating a satirical image of Louis-Philippe in which the French king nourishes sycophantic supporters on his own faeces. Visualising the unmentionable is a potent satirical weapon that often draws power from metaphorical verbal invective, as in Georg Grosz's *Pillars of Society* (opposite), where the hollow heads of interwar Germany's fleshy profiteers and plutocrats are literally full of rubbish. Like the plays of Bertolt Brecht, Grosz's satire is both topically specific and universal,

ABOVE: *In Duane Hanson's life-size photorealist sculptures, such as* Supermarket Shopper *(1970), which he cast in polyester resin and fibreglass from real people, everyday American life seems to have become so grotesque that it satirizes itself.*

OPPOSITE: *George Grosz's satire is rooted in his loathing for the militarism he experienced while serving in the German army in World War I.* Pillars of Society *(1926) satirises the social groups who took control after the war.*

BOTTOM LEFT: *Humans become animals, and the predator enjoys a board game with his prey in a scene painted on papyrus around 1100 BC. As in ancient Egypt, satirical art today is often based on such reversals.*

depicting the corruption beneath the surface of social respectability.

Satire is often both reactive and constructive, implying a better alternative to the state of affairs it represents. Goya's print **series** *Los Caprichos* (1799) combines phantasmagoria, caricature and quasi-reportage in its exposure of the dark side of late eighteenth-century Spanish society. Satirical 'truth' is partisan rather than absolute, relating closely to the views of its intended audience. Satire therefore has an inbuilt capacity to offend. The greed satirised by Nazi propagandists, for example, was not universal but invariably expressed as Jewish. The international controversy in 2005 over Danish cartoons of the Prophet Mohammed showed the strength of the reaction satire remains capable of provoking. ∎

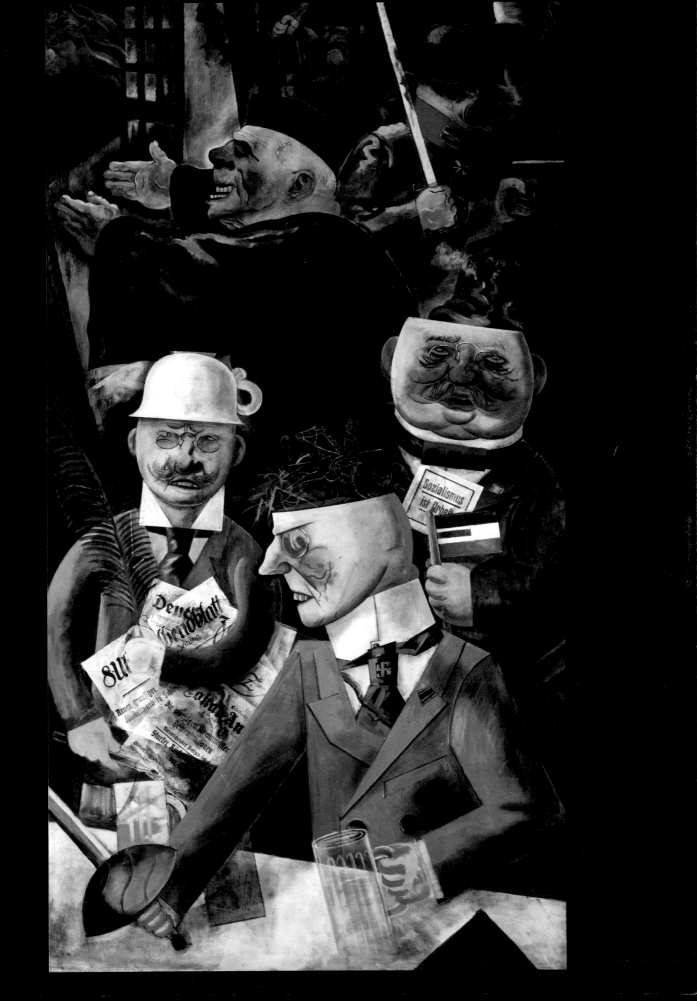

Putting things differently

IDEA № 73
FOUND OBJECTS

Found objects, or *objets trouvés*, are a focus for art's capacity to give meaning to ordinary things. Such everyday items – from litter to bicycle seats and even guns – are used by artists with little or no modification, sometimes on their own and sometimes incorporated into works consisting of several such objects or other, deliberately shaped or coloured elements.

More than a quarter of a million years ago, hominids picked up bones and stones that resembled figures and emphasised this chance resemblance by making rudimentary incisions. These found objects may be the earliest art, in the sense of inanimate objects that appear to have been chosen and modified, not for use but in order to signify. Much later, the found element in art all but disappeared: the admired skill of the specialist maker – **the artist** – lay in his or her ability to shape raw material so that it became eloquent. Another characteristic of artistic skill was that it could be employed to make any object special, no matter how ordinary or functional.

The aura of the relic pervades twentieth-century art's enthusiastic adoption of found objects, in which the most ordinary things, including fragments and rubbish, acquire new meaning when selected and configured by the artist. In this type of production, what the English Romantic poet William Wordsworth called 'creative agency' resides in the recognition of 'affinities/ In objects where no brotherhood exists/ To common minds'. For the poet, the act of recognition leaves the object itself untouched; in the visual artist's case, however, objects such as a bicycle wheel (Duchamp) or ruler (Haussmann, for both see p.127) have to be separated from the context in which

they are found and introduced into the sphere of art.

Found objects provided a rich seam of material for the Surrealists, demonstrating the strangeness of the everyday material world and its uncanny propensity to mirror the inner state of the observer. The Exposition Surréaliste d'Objets in Paris in 1936 was a modern version of the Renaissance *Kunstkammer*, bringing together recent works of art with found objects and non-Western cultural artefacts. The most striking found-object sculpture of this (or any) period is also one of the simplest: Picasso's *Head of a Bull* (1942, opposite), composed from the handlebars and leather seat of a bicycle. The artist's role in endowing found objects with fresh meaning introduces a strong conceptual element. Cristóvão Canhavato (who works under the name Kester) fashioned his *Throne of Weapons* (2001, above) from decommissioned guns collected following the end in 1992 of the long civil war in Mozambique. Their configuration in art transformed these killing tools into a symbol of peace and hope.

Following the example of Dada, and especially Kurt Schwitters's concept *Merz* (see p.127), found objects became indispensable in many types of art. Robert Rauschenberg's 1950s 'combines' fused photographs with miscellaneous junk such as stuffed animals; Italian *Arte Povera* ('Impoverished Art') artists

such as Michelangelo Pistoletto used found objects extensively in their attempt to resolve 'the dichotomy between art and life'. In the 1980s New British Sculpture was characterised by the reconfiguration of machine-made components, as in the work of Bill Woodrow (see p.202) and David Mach (see p.14) or Tony Cragg's map of plastic parts, *Britain Seen from the North* (1981). **Installation art,** as in Cornelia Parker's use of wood fragments in *Cold Dark Matter: An Exploded View* (1991), frequently co-opts vast quantities of found material. ■

Moving parts

KINETIC ART

Kinetic art – art that incorporates movement – disturbs the conventional balance between static artwork and motionless viewer. It also physically enacts pictorial metaphors such as 'exploring space' or 'balanced composition'. While retaining some of the age-old magic of mechanical artifice, modern kinetic art has sought to reflect psychological, social and scientific models of change and dynamism.

Stories of the wonder-working power of artistic skill and invention (the creations themselves either did not survive or had never actually existed) were part of the Classical legacy from which European Renaissance artists took their inspiration. Giorgio Vasari records how Leonardo da Vinci – almost as much in demand for such feats as for his uncannily lifelike paintings – constructed flying animals and a mechanical lion.

One expression of the relationship between arts and sciences in Enlightenment Europe was the vogue for extraordinarily intricate automata, such as the robotic *Flute Player* and *Digesting Duck* devised by Jacques de Vaucanson, who later transferred his skills to the revolutionary invention of the automated loom. In an age that pictured God as a divine watchmaker, constructing the universe from innumerable interrelated parts, such automata approached the nature of living things.

In the early twentieth-century doctrine of Constructivism formulated by Naum Gabo (who trained as an engineer), movement expressed an analogous concern with art's action in the wider social sphere, a realisation of Gabo's theory that all objects constitute 'entire worlds with their own rhythms'. His statement that 'Space and time are the only forms on which life is built and hence [from which] art must be constructed' is effectively a manifesto for kinetic art. Gabo rejected the 'bankruptcy' of the Impressionists and the 'new delusions' fostered by Cubism, affirming instead that 'kinetic rhythms [are] the basic forms of our perceptions of real time'. Gabo's *Kinetic Construction (Standing Wave)* (1919–20) consists of a single metal strip whose rapid oscillation creates a slender, illusory three-dimensional form. László Moholy-Nagy's *Light Room Modulator* (1922–30, right) functions more like a machine-age automaton, while Alexander Calder's 'mobiles' (main image), in which coloured shapes suspended from wires turn in currents of air, have a different source. Their trance-like, involuntary movements evoke the rhythms of dreams and reveries, projections of **the unconscious** that Surrealists held to be art's true field of action.

The kinetic element in these three examples represents distinct interpretations of the relationship between art and its surroundings. Taken together, they provided a rich source for later kinetic art. The mechanical sculptures by Jean Tinguely cavorting in the pool beside the Centre Pompidou in Paris combine Calder's surrealism with the robotic sorcery of Vaucanson's automata.

Liliane Lijn's *Cosmic Flares* (1965–66), on the other hand, have the spare, precise beauty of practical physics. 'It should be that in the discipline of a drawing,' she wrote, 'there is the same rhythm as that of cosmic forces.' ∎

LEFT: *When Lászlo Moholy-Nagy's,* Light Room Modulator *(1922–30, with later modifications) was set in motion, light passing through it projected an abstract shadow-play onto the surrounding walls. It was used for theatrical lighting and in a film by Moholy-Nagy.*

RIGHT: *'The idea of detached bodies floating in space ... seems to me the ideal source of form,' said Alexander Calder. Visits to Mondrian's studio and a planetarium influenced Calder's construction of mobiles such as* Gamma *(1947).*

Ordinary sights

IDEA № 75
SCENES OF DAILY LIFE

BOTTOM LEFT: *The lives of working women often feature in Edgar Degas' work, such as* Laundresses *(c.1874–76). To prevent his subjects posing self-consciously, Degas made rapid sketches on the spot, from which he painted in the studio.*

ABOVE: *In academic art theory, everyday scenes such as Velázquez'* Old Woman Cooking Eggs *(c.1620–22) were termed 'genre' subjects and considered a minor art form. Velázquez' genre scenes have the dignity and intensity conventionally associated with* **history painting**.

Although artists since the Renaissance have been exhorted to fill notebooks with sketches of ordinary sights, art isn't usually the place to look for an objective picture of daily life. Such scenes often turn out to be coloured by moral didacticism, elite fantasies and other subjective or conventional modes of interpretation.

Children at play, shopkeepers, farmers, the working day, the ordinary home or street – artists have introduced these subjects into different types of work of all periods. There are the cooks preparing food or the man giving alms to a disabled child in the margins of the fourteenth-century Luttrell Psalter, or the Japanese *ukiyo-e* artist Torii Kiyonaga's print of women and children in a bathhouse (1790s), or Pieter Bruegel's *Peasant Wedding* (c.1568). In such images, it feels as though art is temporarily setting aside its distorting conventions and showing daily life as it actually is. Realism isn't quite the right term – there is no emphasis on the brute facts of labour or poverty associated with industrial-era Realist art (see pp.118–19). Instead, the viewer senses an affec-

tionate but slightly distanced or amused observation, and feels a certain relief at not being put to the test by learned allusions. Art, for once, appears to be playing it straight.

The ability to create exactly this impression is an effective artistic means of disarming and engaging the viewer. Diego Velázquez' *Old Woman Cooking Eggs* (above) looks like a snapshot from a Seville street corner, except that the focal food-offering has a sacramental quality, which derives in part from the many New Testament stories featuring ordinary people sharing food. Where Caravaggio racked up the tension with extreme **chiaroscuro**, Velázquez used similar lighting but went in closer, so that the humblest objects and actions have – as in Gospel accounts of the Last Supper – a drama of their own.

There are plenty of peasant scenes in seventeenth- and eighteenth-century painting, but these usually evoke the poetic land of Arcadia, an ideal countryside untouched by hardship or social divisions. From ancient Greece onwards, elite classes cherished visions of a care-free rustic existence to which art gave substance: fantasising about the farm-worker's simple life while not actually experiencing it was one of the pleasures of being rich. The scenes of daily life that filled Impressionist paintings (see pp.124–25) in late nineteenth-century France, though more contemporary in

feel, are generally scenes of a bourgeois Arcadia of leisure and plenty on the fringes of modern industrial society. For Edgar Degas, however, painting tested its strength against the transience of utterly ordinary moments – laundresses yawning (left), women bathing, ballerinas unglamorously herded backstage.

It was **photography** that convinced people that daily life can be fully known, even experienced, through images. As photography became a ubiquitous activity in the twentieth century, some painters took a contra-Impressionist approach, emphasising the indefinite time a moment could be held rather than its fleetingness. Edward Hopper's bland, blank paintings of mid-twentieth-century American life (opposite) create a persuasive sense of alienation and suspended action within ordinary surroundings. ∎

ABOVE: The woman in Automat *(1927), alone under the lights of a fast-food café, is typical of Edward Hopper's isolated, introspective figures. Unlike Degas' hard-working laundresses, she seems half-absent, going through the motions of modern life.*

Step inside

IDEA №76

INSTALLATION

An installation can be any deliberate arrangement of an enclosed space, usually – though not always – an interior. In contrast to the idea of art as consisting of isolated special objects, installation requires the spectator to step inside the work and experience it as an environment. It is a type of participatory theatre without performance.

If installation means creating unified artificial environments, it has a continuous history from **cave art** to the present, encompassing Egyptian tombs, the Hall of Mirrors at Versailles and the **assemblages** to which Kurt Schwitters gave the name *Merzbau* (*Merz*-building, opposite and see 127). Usually, however, installation art means art that insists on its environmental dimension for other than mainly religious or social reasons. Its rationale is to stop the artwork becoming a saleable commodity and to compel the audience to enter the work on its own terms, literally so in the case of *SHE – a Cathedral* (1966), a multi-installation environment conceived by Niki de Saint Phalle. This took the form of

a giant recumbent woman, which visitors approached via a ramp between the figure's legs and entered through its vulva.

Modern installation art occupies two apparently contradictory positions. In late nineteenth-century Europe, the idea that the arts could stimulate 'higher' experiences by operating simultaneously on different senses informed several related endeavours. The composer Richard Wagner's concept of the all-encompassing musical, visual and dramatic opus (or *Gesamtkunstwerk*) gave intellectual weight to a cult of aestheticism exemplified by James Abbott McNeill Whistler's *Peacock Room* (1876–77), a decorative scheme in blue

and gold designed to create a setting 'alive with beauty' for his patron's collection of Chinese porcelain. Like the frescoed rooms of Renaissance despots, such installations were controlled microcosms from which the ugly or ordinary were excluded.

Installation art of the twentieth century overturned this pattern. It evolved, instead, as a means of importing ordinary, unsettling or provocative material into normally exclusive spaces reserved for art. In the 1960s and 1970s, installation became a gallery-based corollary of **performance art**, **land art** and other practices that had originally rejected the model of gallery display favoured by **dealers** and institutions. Walter De Maria's *New York Earth Room* (1977) comprised a room filled with soil; admittedly it could only be viewed through windows, from outside, but the principle of an immersive, artist-made space remained. During the following decades commercial and public galleries adopted the practice of turning spaces over to an artist to organise as they chose (see pp.200–01). In this way, radical installation art was partially assimilated to the *Peacock Room* principle, offering a contained experience of provocation or disquiet in place of a symphonic bath of beauty. Installation's theatrical impact as *mise-en-scène* can, however, be as powerful as it is difficult to convey in reproduction. Mona Hatoum's *Light Sentence* (1992, left), a structure of wire-mesh lockers lit by a single bulb, is at once meditative and menacing. ∎

Exaggeration and distortion

IDEA № 77
EXPRESSING INNER STATES

'Art does not reproduce the visible,' wrote Paul Klee in 1920; 'rather, it makes visible.' In early twentieth-century Europe, this conception of art's primary purpose – broadly termed Expressionism – seemed to require passionate partisanship. In other contexts, particularly religious ones, making the unseen manifest is simply what art is for.

ABOVE: In the distorted shapes and visceral colours of Chaim Soutine's The Village *(c.1923), the contours of a recognisable world of objects and people seem to buckle under the pressure of the artist's turbulent inner life.*

OPPOSITE: Painting someone's portrait, said Francis Bacon, involved 'trying to get near ... to the way they have affected you'. Bacon's sitter in this 1969 portrait was Henrietta Moraes.

BOTTOM LEFT: The limestone statuette known as the Willendorf Venus is though to be between 18,000 and 30,000 years old. Though it is not known why she was carved, her ample flesh and red-ochre colouring represent an almost Expressionistic distortion of the hunter-gatherer physique.

Klee's statement, from his *Creative Credo*, could be applied to all forms of sacred art. The faces of the Buddha or Christ or the masks and costumes worn by participants in African masquerade ceremonies are all manifestations of the invisible The idea that it was art's role to express unseen forces or the artist's inner vision took on a radical new dimension with the late eighteenth-century **Romantic** dissociation, or alienation, of **the artist** from wider society.

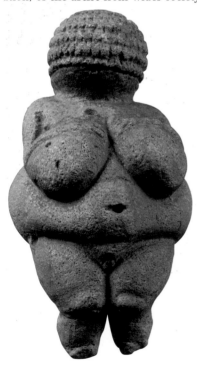

Isolated genius, rebel, bohemian, outcast – in such roles the artist no longer spoke for the mainstream. Instead artists came to see their social function as anticipatory, prophetic, expressing inner truths that society was not yet able to recognise because it had no images for them.

Again and again, early twentieth-century progressive artists articulated their work in such terms. 'Composition is the art of arranging ... the various elements at the painter's disposal for the expression of his feelings,' affirmed Henri Matisse, while Wassily Kandinsky explained: 'The form is the outer expression of the inner content.' The German artist Max Beckmann claimed to be 'seeking for the bridge which leads from the visible to the invisible'. His countryman Emil Nolde stated: 'A work becomes a work of art when one re-evaluates the values of nature and adds one's own spirituality.' If expression was to constitute art – a public activity, since the desire to make visible implies that someone will be looking – then it must communicate. Hence the stress placed by Expressionist artists on allowing colour and line to speak for themselves. Klee described drawing a line as a 'dynamic act'. Said Kandinsky: 'colour harmony must rest ultimately on purposive playing on the human soul.' The question we should ask of any given work was: 'Which of his inner desires has the artist expressed here?'

For the early twentieth-century Northern European artists known as Expressionists – notably the Dresden-based group *Die Brücke* (The Bridge) and the *Blaue Reiter* (Blue Rider) group in Munich – the idea that art should express inner states had a philosophical foundation. In the work of later painters such as Chaim Soutine (above), Marc Chagall or Beckmann, the expressive impulse coincides with a more autobiographical or social extension. Dreamlike subjects and emotive colour in Chagall evoke the artist's experience within a social and cultural frame. Expressionist art was targeted by the mind-control agenda of totalitarianism, most infamously in the exhibition *Entartete Kunst* (Degenerate Art) staged by the Nazis in 1937. Against the insistence on outward conformity, Expressionist art remains a political act, though often a highly self-conscious one as in the New Expressionist art of 1970s and 1980s Germany, exemplified by Georg Baselitz and his younger followers. ∎

Chemical wonders

IDEA № 78
PLASTICS

Plastic, meaning a substance that can be moulded, is the name given to a range of synthetic carbon-based polymers. Originally developed to replace or improve on natural materials in commercial and industrial production, plastics have found numerous applications in art, from Perspex sculpture to acrylic painting.

The first synthetic polymer, a type of celluloid, was made by the English inventor Alexander Parkes in 1855. By the 1890s, the Eastman Kodak Company was using celluloid to produce flexible photographic film, which revolutionised camera use, as bulky cameras loaded with solid photographic plates were replaced by small portable models. The snapshot – an image of contemporary life captured on the move with a portable camera – changed the way artists (among others) looked at the world. Braque and Picasso's shared passion for snapshots fed into their formulation of Cubism, with its **multiple-viewpoint** aesthetic (see pp.142–43).

Despite plastics' unparalleled potential for different applications, however, they were not seriously considered as artistic materials until Naum Gabo and his brother Antoine Pevsner began to experiment with them in the 1920s. 'Our century has been enriched by the invention of many new materials,' wrote Gabo in 1937; there should be 'no aesthetical prohibition against a sculptor using any kind of material'. Gabo's theorisation of space as a dynamic continuum, extending through every part of a sculpture and its surroundings, led him to experiment with thermoplastics (plastics that can be shaped by heat) such as sheets of cellulose acetate and Perspex, and nylon filament (opposite bottom). Light, trans-

parent and capable of being cut and moulded into any shape, plastics answered his desire for sculptural forms that did not feel ponderously static and solid. As industrial materials, plastics also expressed the Modernist ambition, shared by artists throughout Europe, of integrating their work with contemporary mass society.

Whereas Gabo favoured clear plastics, commercial production usually involved the addition of colour. From the mid-1940s, commercial acrylic paint (plastic resin thinned with solvent) was taken up by American painters such as Helen Frankenthaler and Morris Louis (opposite top) in preference to **oil paint**. Acrylic paint's fluidity and short drying time, in contrast to viscous, slow-drying oil paint, made it the medium of choice for several Abstract Expressionist painters, since it allowed the free flow of gestural brushmarks while fixing them as rapidly as ink on paper. The succeeding generation of **Pop** artists found acrylic paint effective for representing the opaque, flat colour of **commercial art** and the bright plastic surfaces that filled contemporary streets and interiors. Roy Lichtenstein used acrylics for his plus-sized versions of the comic-strip idiom, in paintings such as *Blam* (1962, see p.174). Andy Warhol's practice of screenprinting over flat acrylic grounds mimicked the finish of mechanically reproduced images.

While acrylic paint won rapid acceptance as a mainstream art material, artworks made with coloured plastic sheets, textiles or solid moulded forms still carry overtones of commercial, mass-market production. The sculpture of Claes Oldenburg (see p.19), followed by Jeff Koons' and others' cool-kitsch interpretations of Pop (see pp.174–75), plays against the prejudice that plastic goods cannot aspire to be art. By wrapping public buildings such as the Reichstag, Berlin, in plastic, Christo and Jeanne-Claude (above) affirmed that even the most august national institutions can be 'packaged'. ■

The silent shout

IDEA № 79
PROTEST

Where **satire** exposes hidden realities, such as corruption or hypocrisy, protest art is avowedly activist, seeking to achieve a tangible political impact by mobilising opinion against a powerful adversary. Protest art turns state **propaganda** on its head, creating a subversive counter to official iconography.

For protest art to exist, artists must see themselves as being in a position to take sides, even where they owe their livelihood to the institutions against which their protest is aimed. In other words, protest presupposes the artist as a free agent, a circumstance that only began to take shape in Renaissance Europe and had fully developed by the late eighteenth century. As a result, protest art has a shorter lineage than state propaganda, which historically has enjoyed considerable resources and control over official iconography.

Goya is the first great example of an artist whose work both stood within and was ranged against the circles of power. In its lurid tableau of butchery following

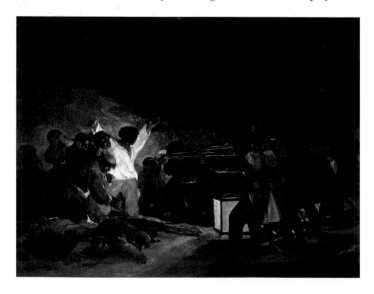

the Spanish resistance to the French assault on Madrid, his painting *The Third of May 1808* (1814, below) effectively transforms the conventions of historical and religious **narrative** painting into an anti-war protest in which Spain's failure to protect its own people is as culpable as the French firing squad, shown hunched forwards like monstrous automata.

Picasso's *Guernica* (main image) commemorates a later atrocity on Spanish soil, the bombing of Basque civilians by Italian and German warplanes in April 1937. In a more deliberately political act than Goya's, Picasso put his art at the service of the Republican cause in the Spanish Civil War. *Guernica* was displayed as a monumental

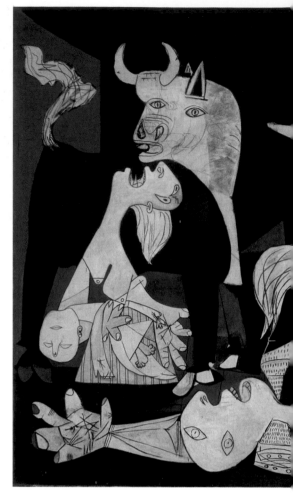

protest against fascist actions at the Republican Pavilion at the 1937 World's Fair in Paris. Its explosive political charge has outlasted the 1930s: in February 2003, the tapestry version of *Guernica* at the United Nations was covered over during a press conference presenting the Bush administration's case for bombing Iraq.

In the politically polarised climate of 1930s Europe, in which artists and writers still believed that they could help to halt the rise of fascism, progressive artists tended to align themselves explicitly with the Left. Surrealists, in particular, had close ties with international Communism. In John Heartfield's photomontage *A Pan-German* (opposite) there is no satirical invitation to 'smile at folly': this is a statement of Surrealism's dream (or nightmare) world turned into a daily political reality that must be opposed at all costs, a graphic protest against what the philosopher and critic Walter Benjamin characterised as Fascism's 'aestheticisation of politics'. Since the 1960s, the interac-

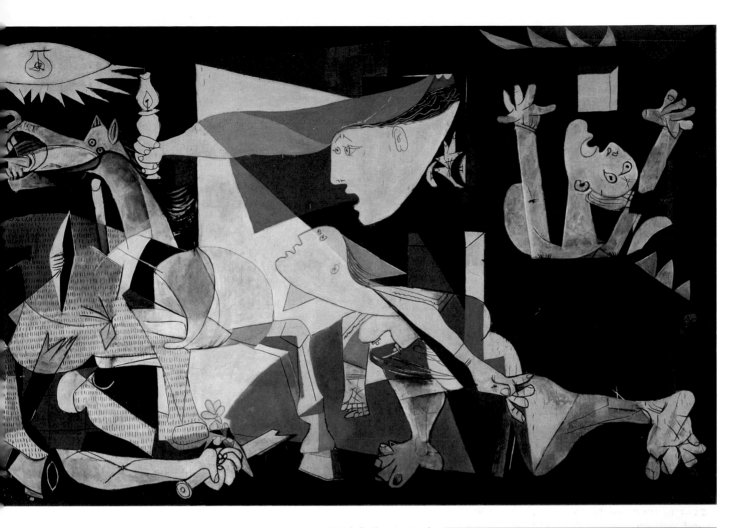

OPPOSITE: *Painted after the restoration of the Spanish monarchy in 1814, Goya's* The Third of May 1808 *reaches beyond patriotic mythologising to protest against whatever it is in human nature that allows such things to happen.*

ABOVE: *The Spanish Republican government commissioned a public work from Picasso some months before the atrocity at Guernica provided the catalyst. Without historical knowledge of the massacre, however, would Picasso's protest painting read more like a personal myth?*

RIGHT: *In the early 1930s John Heartfield (born Helmut Herzfelde) created political photomontages for the left-wing publication AIZ (Workers' Illustrated Newspaper). A Pan-German (November 1933) expresses the need for extreme urgency in opposing Nazism after Hitler's appointment as chancellor.*

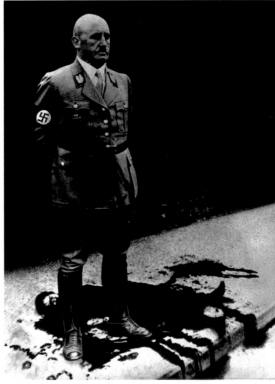

tion between art and mass culture has seen artists working in all the main political, and therefore protest, media – posters, advertisements, films, flyers and texts. Feminist campaigners in the 1970s took on art institutions on their own terms, as in the Guerrilla Girls' 1989 poster campaign 'Do Women Have to Be Naked to Get into the Met. Museum?'. A wider understanding of what constitutes a political act potentially makes **documentary** or **memorial** art, such as Doris Salcedo's *Casa Viuda* (see p.118), a form of protest too. ∎

A form of witness

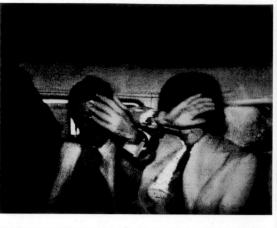

IDEA № 80
DOCUMENTARY

Art has often served a documentary function, purporting to provide an objective visual record of facts and events. Yet the essential documentary statement 'This happened' is a form of witness from which art, either intentionally or incidentally, derives an imaginative impact that is anything but neutral.

TOP: *In Richard Hamilton's* Swingeing London, 67 II *(1968), Jagger and Fraser raise handcuffed hands to deflect the intrusive flash of press photography. Outside its newspaper context, the meaning of the sensational moment becomes increasingly ambiguous.*

ABOVE: *Mary Kelly's* Post-Partum Document *(1973–79) combines an objective record of child development (such as the faecal stains and feeding chart shown here) with 'an effort to articulate the mother's ... stake in that project called "motherhood".*

Although documents of all kinds are often treated as factual evidence, the information they convey is never neutral, especially when encoded in images. This is true of even the most straightforward documentary art, produced to serve scientific enquiry and the spread of knowledge. Illustrations from travel narratives, paintings of battlefield injuries for medical reference or minutely detailed botanical and natural history prints have an imaginative resonance beyond their function as vehicles for information. The manuscript known as the Codex Mendoza (begun c.1540) was compiled by an indigenous scribe after the Spanish conquest of Mexico as a dossier for the new European rulers. Its combination of Aztec imagery and Spanish text has, like many works originally produced for documentary purposes, come to be viewed more in terms of the complex ambiguities of art, an irreducibly multivocal witness statement. The persuasive power of the witness statement (real or factitious) was harnessed by Jan van Eyck in the *Arnolfini Wedding*, in which his signature takes the form of a graffito, 'Jan van Eyck was here 1434'.

'The creative treatment of actuality' was how British film-maker John Grierson described the documentaries he made in the 1930s for the GPO Film Unit. This is the primary sense of documentary in twentieth-century art – the first century whose visual culture was dominated by **photography** and film, when artists were officially co-opted for their 'creative treatment' of reportage, usually in connection with some wider programme of social or political activity. In the two world wars, artists were often employed to document the conflict. Paintings of trench warfare by Christopher Nevison and Paul Nash are less objective than they seem: they certainly do not convey the utter degradation captured by photographs from the Western Front; where the artist stood as witness, the camera put viewers themselves in this uncomfortable position. Henry Moore's drawings made in the London Underground (opposite), where many people sheltered from nocturnal bombing raids during the Blitz, were instantly recognisable as a first-hand record. But they also endowed the scene with a monumental, timeless quality.

As newspapers became more heavily illustrated and television the dominant medium for image-viewing, actuality itself came to be defined through its creative treatment by photographers and cameramen. News stories were treated like facts, to which artists' response was to ask, 'What is *really* happening here?' Richard Hamilton's series of works based on a news photograph of rock star Mick Jagger and art dealer Robert Fraser being arrested for cannabis possession opens out the documented fact to reveal themes of authority and rebellion, privacy and stardom, crime and glamour. In conceptual artist Mary Kelly's *Post-Partum Document* (1973–79, above), a contrary process takes place in which the least newsworthy of events is painstakingly charted in the development of the artist's child through infancy. ∎

Documenting the use of London
Underground stations as bomb
shelters in 1941 appealed to Henry
Moore partly because it reflected
his existing artistic concerns:
'I saw hundreds of Henry Moore
Reclining Figures stretched

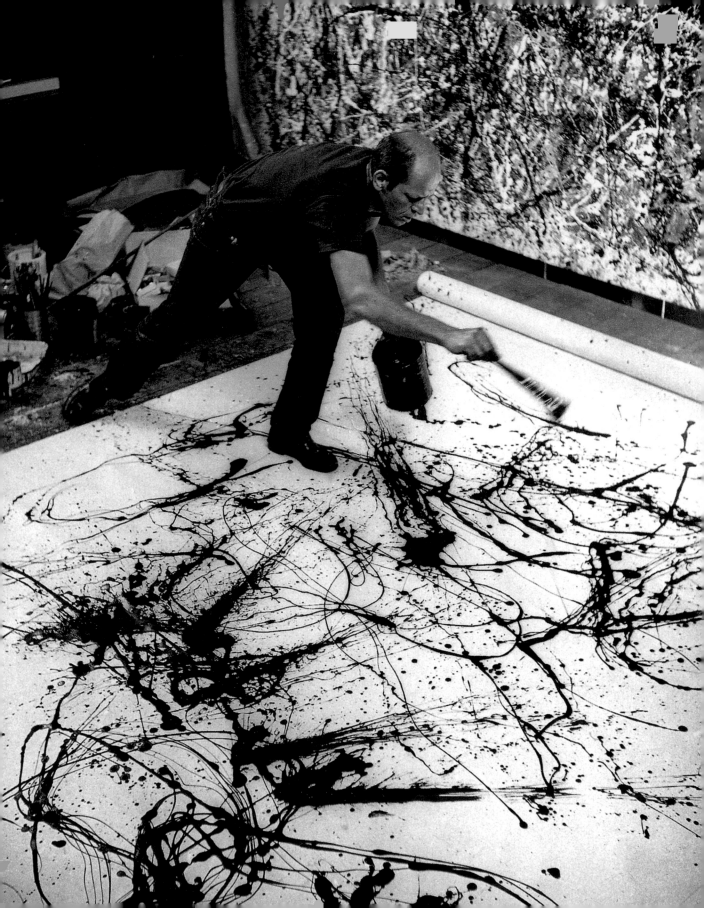

Relinquishing conscious control

IDEA № 81

CHANCE

For artists to relinquish conscious control when creating their works may seem to contradict their authorial role. Yet in the early twentieth century disillusion with cultural conventions and a new psychoanalytic understanding of the mind opened the way to artistic practices in which the outcome was, in theory, determined by chance rather than intention.

'Everything happens in a completely idiotic way,' announced Tristan Tzara in his 1922 'Lecture on Dada'. Art had always involved unpredictable factors: painted colour changes as it dries, wood and stone reveal unforeseen qualities of grain to which the sculptor must adapt. Pre-twentieth-century European artists, however, had striven to curb the impact of accidents on their work. Their task was to make the visible world intelligible, according to Christian theology, Greek proportion or some other school of thought. The war of 1914–18 threw such certainties into question. To the Romanian artist-poet Tzara and his expatriate associates in neutral Zurich, it seemed that centuries of Western cultural, scientific and political development had culminated in a self-perpetuating state of chaos characterised by the meaningless mechanical slaughter of their generation.

As his fellow Dadaist Hans Arp (left below) wrote, 'Since the cave age, man has glorified himself ... and with his monstrous vanity provoked human catastrophes. Art has been the collaborator of man's false development.' Dada – a nonsense word suggestive of baby-talk – was the name the Zurich group gave their shared enterprise. In place of order and rationality, Dada embraced chance and the irrational. Their anarchic performances at the Cabaret Voltaire in Zurich were the embodiment of Dada, 'the voluntary destruction of the bourgeois world of ideas'.

Contemporary psychoanalytic theory supported such practice: if artists could bypass conscious rationality to gain direct access to **the unconscious**, the art that emerged would be marvellously, if shockingly, truthful, unlike the meretricious products of convention. As conceived by Dada polemicist André Breton and a growing circle of artists including Max Ernst, Salvador Dalí and Man Ray in the 1920s, Surrealism espoused 'pure psychic automatism ... the absence of all control exercised by reason'. Automatism entailed suppressing conscious control in drawing, painting or writing and discovering meaning in the action of chance, for example in the shape of ink blots or patterns produced by frottage (rubbing a crayon over paper placed on a textured surface).

Automatism had a second flowering in America and Europe in the 1940s and 1950s through the practice of what the critic Harold Rosenberg termed 'action painting'. The rhetoric of action painting stressed the performative interaction between the artist's unconscious and his material. 'When I am in my painting,' said Jackson Pollock (opposite), 'I'm not aware of what I'm doing ... the painting has a life of its own..' ∎

OPPOSITE: *Jackson Pollock, 1950, photograph by Hans Namuth. In Namuth's photo-shoot of Pollock creating a 'drip painting', the artist dances shamanistically about a canvas spread on the floor, using a stick to spatter and trail paint straight from the can.*

BOTTOM LEFT: *In place of order and rationality, Dada embraced chance and the irrational. Dada artists devised 'anti-art' that explicitly repudiated artistic tradition, such as Hans Arp's* Collage Arranged According to the Laws of Chance *(1916–17).*

ABOVE: *Niki de Saint-Phalle's* Shooting Picture *(1961) is one of several works the French artist made by encasing pots of paint in plaster on a wooden board, then shooting at the work with a rifle.*

The transgressive spirit

SHOCK

ABOVE: *Defending Manet's* Déjeuner sur l'herbe *(1863) from accusations of 'obscene intent', the novelist Emile Zola took the scandalised public to task for being preoccupied with subject matter and ignoring the painting's qualities as art.*

OPPOSITE: *Joke or provocation?* La Nona Ora *(The Ninth Hour, 1999) typifies the way Italian conceptual artist Maurizio Cattelan tests moral and social boundaries. Public outrage at his work has raised its value in the art world.*

Shock-factor art has a long history. Medieval images of hell, for example, were meant to shock the believer into good behaviour. But the idea that art should set out to shock its audience – that public outrage was a register of serious intent – changed the game for artists from the mid-nineteenth century onwards.

Shock, in the artistic sense, is never simple. For a start, it takes a sustained effort of imagination (a mental process incompatible with shock) and a knowledge of historical context to regain anything like a vivid sense of what it can have felt like to be scandalised by a nude woman picnicking with two clothed men (Edouard Manet), a face with two eyes on the same side (Pablo Picasso) or an inscribed porcelain urinal lying on its back (Marcel Duchamp). Today all three artists have their established place in art history, based on an understanding of how their work shocked people by breaking the conventions of its time.

This transgressive spirit was a feature that distinguished modern art from the art of previous eras. But shock is a game that takes two to play: it relates far less to what goes on in the studio than to the artist's public, social role as a member of the avant-garde or vanguard. The military origins of this concept are apparent in the rhetoric of modern art movements such as Futurism: there could be 'No masterpiece without the stamp of aggressiveness' announced Marinetti in 1909. Earlier **Romantic** rhetoric had stressed the complete indifference to public reception that was the prerogative of genius. 'No one had any business to like the picture,' growled J.M.W. Turner in response to an attempt to interpret his 1842 *Snow Storm*. In mid-nineteenth-century Paris, however, where the Salon exhibitions of officially approved art were significant events in the social calendar, artists engaged more pointedly and consistently with their public. Few visitors to the Salon des Refusés (for artists rejected by the Salon), where Manet exhibited *Déjeuner sur l'herbe* (above) in 1863, can have grasped the painting's art-historical allusions to Renaissance pastoral scenes. What shocked them was the juxtaposition of a nude woman with men in contemporary dress, who made her nudity frankly sexual rather than hypocritically Classical.

If the bourgeois audience was disturbed by work that at the same time forced it to confront its own prejudices, then art was performing the corrective social function claimed for it by the French socialist thinker Pierre-Joseph Proud'hon. Shock, in effect, was a moral medicine that became part of the cultural economy. And audiences came to expect it: by the early twentieth century, when Paris was the centre for a succession of self-aware avant-garde movements such as Fauvism, Cubism and Surrealism, shock had become chic. A Picasso on the wall, like a puma in the drawing room, was dangerous, exotic, exclusive.

Shock remained part of the progressive artist's pact with audiences throughout the twentieth century, though its sphere of action became more general and diffuse. The experience of mass warfare, global communications and the liberalisation of Western visual culture made it progressively harder to find genuinely shockable audiences or to distinguish between shock with moral intent and the frisson of horrified fascination.

In general, the closer in time, the more effectively art that aims to shock retains its currency. A dummy of the pope knocked senseless by a meteorite (Maurizio Cattelan, opposite) or a huge full-face portrait of a convicted child-killer made from a child's handprints (Marcus Harvey) retain their transgressive impact for many viewers – though decreasingly, as references become less topical and public attitudes change. ■

Sculpture goes industrial

IDEA № 83
WELDING

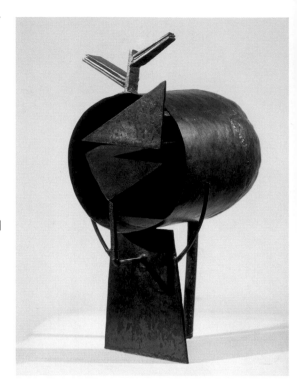

Welding is a method of heating the edges of metal sheets until they bond. This long-established metalwork process had little direct influence on art until the early twentieth century, when the development of welding at very high temperatures using an oxyacetylene blowtorch transformed the possibilities for large-scale metal sculpture.

Before the twentieth century, making large sculptures in metal involved casting in moulds taken from clay or wax models, a technique perfected in ancient Greece and practised to striking effect in African and Renaissance European sculpture (see pp.32–33). Advances in industrial welding technology during the nineteenth century led to the discovery that a mixture of pure oxygen and acetylene could raise the temperature of the flame to 3500ºC, making it possible to weld massive pieces of metal. The use of a blowtorch to deliver that flame meant welding could be done outdoors or in an ordinary workshop. As a result of armaments production during World War I, welding kit and expertise became routine. The technique entered the repertory of modern European art via Julio González, whose metalworking skills, learnt from his father, provided useful income for the young Spanish painter in Paris in the early twentieth century.

In González' experiments in metal sculpture (above right) the welded joints between metal sheets and strips replicated the glued wood and cardboard forms of the Cubist constructions produced by Picasso and Georges Braque. By allowing the transference of Cubist principles into durable sculptural form, welding provided the technological basis for the development of a new art form: constructed (rather than carved or modelled) sculpture. At the same time, welding answered the Surrealist quest for striking conjunctions of disparate forms as well as the desire, shared by artists of different affiliations, that art should reflect the nature of modern life and mass society. Constructivist welded sculpture, such as László Moholy-Nagy's elegant *Nickel Construction* (1921), reflects Naum Gabo's insistence that no material should be excluded from the production of art.

The double impact of Cubism and welding profoundly affected mid-twentieth-century sculpture. The American

ABOVE: Head called 'The Tunnel' (1933–34) is one of Julio González' pioneering works in welded iron sculpture, which grew out of his collaboration on constructed metal pieces with Pablo Picasso in the late 1920s.

LEFT: Anthony Caro described his massive welded steel sculpture Tundra (1975) as a response to the changing times, leaving behind the 'hopeful '60s' for a world that seemed 'more earthy … more rooted in our problems'.

artist David Smith began making sculpture after encountering Gonzalez' work. From early assemblage-type pieces, such as *Home of the Welder* (1945), he developed industrial-scale constructed sculptures that drew on both the Cubist legacy and his affinities with Abstract Expressionist painting. For his younger British contemporary Anthony Caro, it was Picasso who 'unfolded' sculpture by treating it as a form of **collage**, 'taking parts and putting them together'. Caro designed sculptures from standard-size steel sheets and girders, welded into abstract configurations (opposite below). In works such as *Early One Morning* (1962), the minimal, open arrangement of metal parts and the addition of colour impart a deceptive lightness and lyricism to these industrial materials. More recently, in works such Roxy Paine's *Conjoined* (2007, right), welded metal sculpture has moved away from Cubist-inspired construction and macho, industrial forms. ■

Young, sexy – and Big Business

POP

Pop was the critical label given to a new kind of iconography and approach in art that took its cue from commercial and advertising design. Though artists often disliked the designation 'Pop', their shared determination to embrace popular visual culture as opposed to 'high' culture changed Western art in the 1950s and 1960s.

ABOVE: *Roy Lichtenstein's* Blam *(1962) scales up a comic-strip frame to the dimensions of a painting. Lichtenstein's appropriation of popular culture cuts two ways: while the comic-strip image seems overblown, the painter acknowledges its enviable impact.*

OPPOSITE: *Jeff Koons's* Pink Panther *(1988) made headlines in 2011 when it sold at auction for £10.1 million. Koons both parodies and endorses the cult of celebrity by transforming figures from popular culture into costly or monumental objects.*

In the decade or so following World War II, it became obvious to many observers that Western visual culture was being transformed. As Europe finally pulled through a period of economic austerity in the late 1950s, American consumer goods, advertising and cinema set the tone for the emerging consumer society. Bright, appealing colours, streamlined designs and lively, upbeat images spoke what seemed like a universal language of confidence, class-lessness and possibility.

This moment coincided with New York's rise to dominance of the international art market, which also increasingly behaved like the fashion industry. The first of a succession of postwar art-world fashion moments was the rapid eclipse of Abstract Expressionism by Pop around 1960. In its direct derivation from a comic-book panel, Roy Lichtenstein's *Blam* (1962, above right) upends the preoccupations of the preceding half-century of Western avant-garde art, in which abstraction had been advanced time and again as a vehicle for universal truths. If this was so, ran the rationale behind Pop, why did most people outside a minority of artists and intellectuals find **abstract art** incomprehensible? Moreover, if art aimed to reflect reality, shouldn't it reflect the contemporary reality of comic books, cars, screen idols and – in Jasper Johns's bronze sculpture of two beer cans or David Hockney's painting of a Typhoo tea packet – the products ranged on supermarket shelves?

Unlike the twentieth-century art movements that preceded it, from Cubism to Constructivism to Abstract Expressionism, Pop seemed genuinely popular. Andy Warhol in the US and Hockney in Britain became household names in a way that had seldom happened with earlier modern artists. It was easy to ignore Pop art's more complex intellectual foundations. When, in 1957, Richard Hamilton, an artist member of the London-based Independent Group of cultural theoreticians, defined the new Pop art as 'popular, transient, expendable, low-cost, mass-produced, young, witty, sexy, gimmicky, glamorous, and Big Business', little art that explicitly embodied these values had actually been produced. Hamilton's 1956 photomontage *Just What Is It That Makes Today's Homes So Different, So Appealing?* is a satirical take on American consumer culture rather than an endorsement of its creative vitality. British artists associated with Pop had a more oblique relation to contemporary commercial iconography than Lichtenstein or Warhol. Peter Blake, for example, drew on the Victorian popular culture of fairground lettering and book illustration.

Much Pop art of the 1960s was still produced using traditional studio techniques; by 1970, however, the survival of easel painting in any form as a contemporary art medium was being questioned. **Conceptual, performance**, video and **land art** – among other developments – took the argument away from a straightforward stand-off between 'high' and 'low' art. Salient features of Pop art re-emerged in the 1990s in the work of Jeff Koons (opposite) and others. ∎

Austere riches

BELOW: The 'empty' distance in the landscape painted by Hasegawa Tohaku on a six-panel folding screen (c.1600) seems full of an invisible forest, while the trees in the foreground seem about to melt into invisibility.

OPPOSITE: Mark Rothko's Black on Maroon (1958) echoes his joint statement with Adolph Gottlieb in 1943: 'We favour the simple expression of the complex thought. We are for the large shape because it has the impact of the unequivocal.'

IDEA № 85
LESS IS MORE

The desire to make art using 'the minimum of operating means' has been repeatedly voiced, but in practice it is never a straightforward matter. Whether in terms of the Japanese aesthetic of *wabi* ('austere natural beauty') or of Minimalist sculpture, it challenges the artist to endow voids, absences or limitations with significance.

A common theme in both Eastern and Western mystical traditions is losing in order to find, letting go in order to attain. The argument for retaining an analogous austerity and simplicity in visual art was lost, in the West at least, with the outcome in the ninth century of the Iconoclastic Controversy, when permission was given to use religious images as aids to devotion; by an inevitable process of association, these became objects of veneration in their own right. Spiritual riches seemed to require an answering opulence in visual art.

If Eastern art seemed, to its nineteenth-century European aficionados, so much more 'mystical' than their own, it was partly as a result of a Buddhist-inspired aesthetic in which emptiness, poverty, silence and stillness conveyed a paradoxical plenitude. The Japanese concept of *wabi* connotes a beauty born of simple, natural, austere qualities on which the attention can settle without distraction, which calm rather than excite. A **landscape** perceived through mist, hauntingly painted on a folding screen by Hasegawa Tohaku (*c.*1600, below), achieved effects outside the scope of contemporary Western painting, with its concern to fill the whole **frame** with incident.

The catchphrase 'less is more', associated with the Modernist architect Ludwig Mies van der Rohe's rejection of ornament, accords with the early twentieth-century Constructivist idea that art should embody the underlying structures of material reality, rather than reproduce appearances. A formal rhetoric based on geometric shapes and absence of ornament resurfaced in art and architecture after World War II.

Formulated by the American sculptor Donald Judd in his 1965 article 'Specific Objects', this rhetoric combined a debt to prewar Modernism with a new **conceptual** emphasis ('A work can be as powerful as it can be thought to be').

Judd's sets of metal box-forms, whose interior voids were often brightly coloured, fit his definition of 'specific objects' that were neither sculptures nor paintings. In these cases, as in other 1960s and 1970s Minimalist art, the effect also depends on the provision of uncluttered space and sympathetic lighting by the exhibiting gallery. The poetic tendency in Minimalism – its sensitivity to structural and spatial rhythms – connects it to other types of studied simplicity in art. It is ironic that an art form that rejected specious illusionism should have become, as a result of the furore over Carl Andre's installation of firebricks at London's Tate Gallery in 1976, a byword for public scepticism about the integrity of modern art. ∎

Mind games

IDEA № 86
OPTICALITY

Optical art exploits the workings of perception to create a virtual reality in the viewer's mind. Static lines appear to vibrate, colours pulse or change hue, shapes switch constantly between negative and positive. Such effects, usually carefully engineered by the artist, trigger strong sensations in spectators' minds.

BOTTOM LEFT: Georges Seurat's Pointillist method can be clearly seen in his oil sketch Women on the River Bank *(c.1884–85). At a distance the dabs of colour fuse into lucid, atmospheric effects, like a landscape viewed through a heat haze.*

ABOVE: The shifting, illusory three-dimensionality of Vasarely's large painting Torony–MC *(1970) creates an optical sensation of movement. In the 'geometric, polychromatic' city of the future, wrote Vasarely, the arts would be 'kinetic, multi-dimensional and collective ... inseparable from science'.*

The ability to persuade someone to grasp at objects that were not actually there had been a measure of a painter's skill since antiquity. In the fifteenth century, **linear perspective** opened deep vistas of illusory space in flat picture surfaces, but still this seemed, like the fabled **trompe-l'oeil** of Zeuxis and Parrhasios, a form of artistic magic rather than a function of the viewer's mind. From the sixteenth century, however, as the scientific understanding of light and human perception increased, artists acquired the tools to experiment with optical effects. In the optical scenario, the eye is not a blank screen receiving **the artist's** creation but, through the psychophysiological process of perception, an active element in the making of art.

In the 1880s, the young Georges Seurat was deeply influenced by the colour theory of the French chemist Michel-Eugène Chevreul, who had observed the operation of 'simultaneous contrast', in which juxtaposed colours alter the perception of each different tone. Seurat then devised the Pointillist method in which he composed paintings from thousands of small, distinct dabs of colour (below). Seurat's Pointillism and the colour theory on which it was based (termed Divisionism) were adapted by other artists, such as Camille Pissarro and Vincent van Gogh.

Few of Seurat's contemporaries shared his rigorous approach; the next wave of optical art had to wait until the mid-1960s, when the term Op Art became current. By this time there was

greater acceptance that art was by its nature interactive – a question of the spectator's response as well as the artist's intention – coupled with a more general awareness of the psychophysiology of perception. Victor Vasarely based his *Planetary Folklore* **series** of the early 1960s on a 'plastic alphabet' of simple coloured shapes, which he organised in grid-based configurations to create pulsing or shimmering optical effects. Vasarely's opticality developed from his experience as a graphic designer and his commitment to the geometric **abstract art** of the 1920s and 1930s pioneered by Piet Mondrian and the Bauhaus artists. This had a utopian social aspect, in which art aspired to change society for the better by creating new ways of seeing.

Around the same time, the English painter Bridget Riley's study of Seurat's **landscapes** led her to re-create his heat-haze vibration effects in a pattern-based idiom that sometimes resembles scaled-up optical illusions of the traditional parlour-game kind (opposite). In Riley's work, however, there is little sense of painterly touch, since her designs were often executed by assistants. ∎

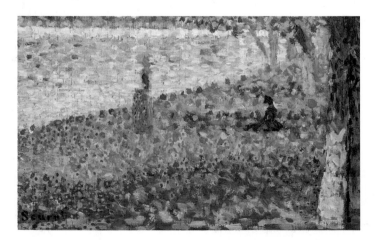

In Bridget Riley's Fission *(1963) the painting functions as a perceptual machine: the pattern of dots apparently lies on two curved planes that slide down into, or upwards from, an optical fissure.*

'Riley's study of Seurat's landscapes led her to re-create his heat-haze vibration effects in a pattern-based idiom.'

Liberating perception

IDEA № 87
HALLUCINOGENS

The social history of hallucinogens embraces their widespread use by artists. Psychoactive drugs can seem to give access to the heightened or alternative realities that much art seeks to represent. Western artists have found such substances effective for countering the tendency for artistic convention to shape the way we see.

OPPOSITE: *Bryan Wynter admired Aldous Huxley's writings, including* The Doors of Perception. Mars Ascends *(1956) is one of a series of large abstract paintings that Wynter – previously a figurative painter – made after his first experiences with mescaline.*

ABOVE: *With its swirling patterns and acid colour, Bonnie MacLean's poster for a rock concert at Fillmore Auditorium, San Francisco, in July 1967, is typical of 1960s psychedelic art, which briefly became a universal countercultural language.*

BOTTOM LEFT: *The practice of chewing coca leaves was widespread in early Andean cultures and often represented in their arts. A Moche stirrup-spout pot (second–fifth centuries) shows the jar of lime for releasing the alkaloid cocaine in the leaves.*

The ritual use of plant-based hallucinogens – drugs that give rise to hallucinations – is documented in Precolumbian Mesoamerican and modern Native American art: for example, the paintings of Stephen Mopope and other artists associated with the Peyote religion. The densely scrolled, interlocking vegetal and bodily forms of Aztec relief sculpture echo the hallucinatory visual effects described by users of mescaline (the psychoactive agent in peyote cactus), in which surfaces separate into slowly pulsating layers or plant forms assume a heraldic grandeur.

In European art, the use of psychoactive drugs as an artistic tool recurs from the mid-nineteenth century onwards.

Introduced to France by Napoleon's troops returning from Egypt, cannabis became the focus of scientific and artistic investigation. In Paris in the 1840s, writers and artists such as Théophile Gautier, Charles Baudelaire and Eugène Delacroix congregated at the Hashish Club. Baudelaire (probably an infrequent user) described how hashish – or cannabis – gave colours an 'unusual energy', causing them to penetrate the mind with 'victorious intensity', as well as triggering synaesthetic effects in which sounds were perceived as colours and vice versa.

Cannabis and opium, both freely available throughout the nineteenth century, were staple features of the Romantic bohemian lifestyle, seeming to provide a direct route to the visionary isolation and heightened perceptions that were the mark of creative genius. The more deliberate, programmatic use of drugs for artistic purposes belongs to the twentieth century, however. It has been suggested that mescaline use by Braque and Picasso contributed to the planar fragmentation and strangely detached visual instability of Cubist art. In *The Doors of Perception* (1953), Aldous Huxley recorded how, during his first, scientifically observed mescaline trip, 'Table, chair and desk came together in a composition that was like something by Braque or Juan Gris.' Huxley concluded that the drug was not so much creating hallucinations as removing the obstacles placed by the rational mind to true seeing: 'What the rest of us see only under the influence of mescaline, the artist is congenitally equipped to see all the time.'

It was the capacity of drugs to 'liberate' perception, in both an aesthetic and a political sense, that most engaged artists after World War II. In the 1950s, the French painter and poet Henri Michaux and the British artist Bryan Wynter (opposite) separately embarked on **series** of mescaline-influenced abstract works as a development of previous Surrealist experiments with automatist techniques. In their case, hallucinogens were a means to an end – the freeing of the unconscious from repressive consciousness. In the 1960s, the visual distortions induced by LSD were formalised in graphic design. As the emphasis in art shifted from the perceptual to the conceptual, however, hallucinogens seemed a less reliable creative route to revelation. ∎

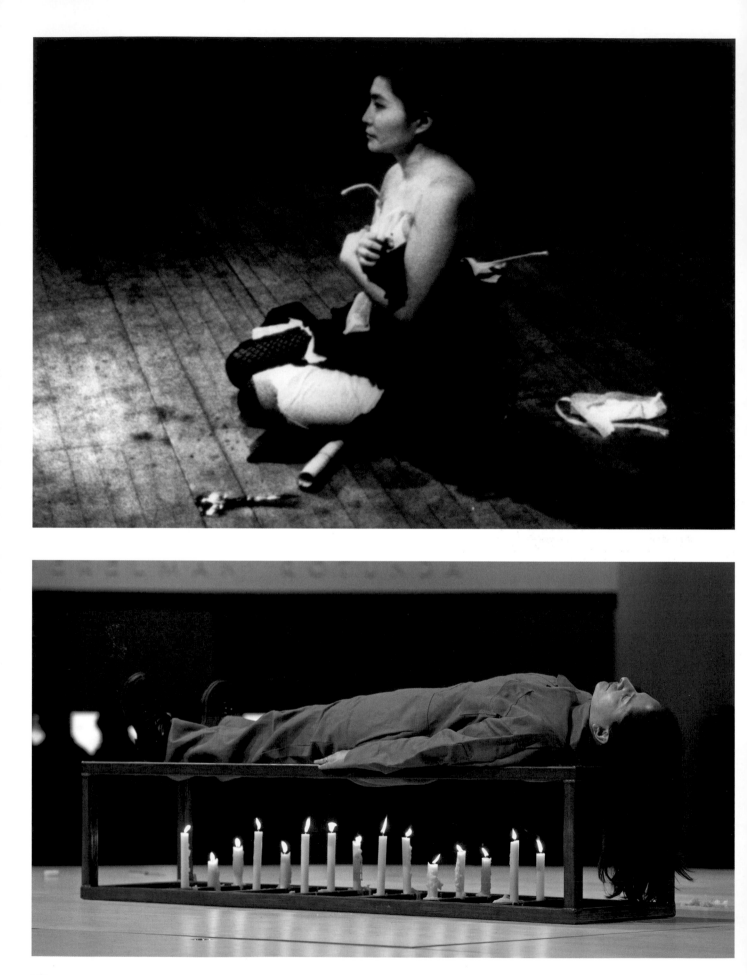

Got to be there

IDEA № 88
PERFORMANCE ART

Performance art typically consists of a live performance involving the artist, which is presented to an audience, who may be invited to participate. Although performance emerged as an avowed art form in the West only in the later twentieth century, the idea of performance in art has much deeper roots.

OPPOSITE TOP: *Yoko Ono sits in Carnegie Recital Hall, NYC, in 1965, during her performance* Cut Piece *in which members of the audience cut off pieces of her clothing. On the floor beside her lies a scroll from which she read during the performance.*

OPPOSITE BOTTOM: *In 2005 performance artist Marina Abramovic re-enacted* The Conditioning, *a notorious 1973 piece by Gina Pane, which entailed lying for 30 minutes on a metal bed above burning candles. Pane's performances often involved 'unaesthetic' self-inflicted suffering.*

ABOVE: *The Dogon people of Mali are known for their arts of masquerade. The masks and costumes worn in masquerade are inseparable from the ritual enactments that transform the people who wear them and those who watch.*

Historically, performance is associated with ritual and entertainment. Art, on the other hand, is associated with special categories of inanimate objects. With the atrophy of ritual life and the commodification of art in the modern industrialised West, however, the idea of performance art was developed as a vehicle for artists' efforts to transform people's perceptions and the very structure of society. Through public performances, artists could connect personally and directly with audiences, like actors. From the riotous Futurist Evening in Trieste in 1910 to Russian agit-prop performances of the following decade and the Dada group's anarchic soirées at the Cabaret Voltaire in Zurich during World War I, such events offered a discordant synthesis of images, music, poetry and theatre, intended to be politically as well as artistically provocative. Dada artists, for example, aligned with the political left in announcing that 'the enlightenment of the proletariat' was their primary aim.

Of course, more broadly artists can be said always to have performed actions that change materials into art; their work also performs particular functions for the people who view or use it. Even in the setting of a public museum, moreover, the audience 'performs' in certain ways, moving around passively or interacting with the art they encounter. In its more specialised sense,

as an action set apart from daily life, such as a religious ritual or theatrical drama, performance generates art. Much of the art from Africa presented in static displays in Western ethnographic museums is hard to comprehend when divorced from its original performative context. In the Western tradition, too, artists have traditionally been co-opted to make sure that performances have their desired ritual effect. In the sixteenth and seventeenth centuries artists such as Caravaggio and Rubens directed pageants and masques that conveyed through performance the splendour of temporal power.

In the 1950s the idea of the painting – and by extension all art – as an 'event', the material residue of a performance by the artist, took root through Hans Namuth's photographs of Jackson Pollock enacting his legendary drip-painting technique (see p.168). In the 1960s and 1970s, performance art in its earlier, political mode was refined by a number of artists such as Joseph Beuys and Carolee Schneemann in solo performance pieces. A more anarchic sub-genre, the happening (a term coined by Allan Kaprow in 1959), centred on group actions in public outdoor settings. The artist Al Hansen defined it as a 'form of theater in which one puts parts together in the manner of making a **collage**'. In many performance pieces, spectators were invited to become participants.

Although, unlike Dada cabaret, these events could seem slow-paced to uninitiated audiences, they were conceived as public demonstrations, making political and artistic points. Although performance art had limited impact outside the commodity-based art world it aimed to circumvent, it helped to consolidate the early twenty-first-century view of **the artist** as someone who is interesting for what they do, as much as (or more than) the objects that may result from their actions. ∎

Goodbye to the Great White Male

PERSONAL IS POLITICAL

The phrase 'the personal is political' gained wide currency in the 1970s feminist movement. Its reinterpretation of the relationship between individual experience and institutionalised power informed a broader development of art that explicitly reflects minority or marginalised viewpoints.

BOTTOM LEFT: Carolee Schneemann explained that her audiovisual work Fresh Blood: A Dream Morphology *(1981–87) confronts 'our most taboo viscerality'. It was based on a menstrual dream featuring a red umbrella and dried flowers stuffed with dolls.*

ABOVE: Cindy Sherman's extensive series of photographic self-portraits represents her in the guise of archetypal female figures such as the movie star (Marilyn Monroe) or, in Untitled *(1989), the (breastfeeding) Madonna of Italian Renaissance art.*

The original context for the phrase was a 1969 essay by Carol Hanisch, one of the pioneers of the Women's Liberation Movement, in which she observed that the problems described by women seeking therapy generally had more to do with their social condition as women than with their personal psychology. Any solution must therefore lie in the political sphere rather than in individual psychotherapy. Hanisch suggested that women had common cause with other oppressed groups: 'Can you imagine what would happen if women, blacks, and workers ... would stop blaming ourselves for our sad situations?' Feminist activism in the cultural sphere confronted the de facto exclusion of women from both art history

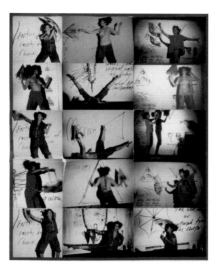

and the gallery scene. 'Why have there been no great women artists?' asked the American art historian Linda Nochlin in her influential 1971 essay. Put simply, men had traditionally both defined the category 'great' and ensured that women were effectively barred from entry.

The response from feminist artists included appropriating previously male-dominated genres, such as the 'Last Supper' painting referenced by Judy Chicago's *The Dinner Party* (1974–79, opposite). Women's 'greatness', sexuality, spirituality and nurturing role come together here in a synthesis that is part celebration, part protest. Chicago and Miriam Schapiro had earlier set up the Feminist Art Program at the California Institute of the Arts, where students and artists created the collaborative project *Womanhouse* (1971) within a derelict building. **Installations** such as the *Menstruation Bathroom* gave expression to aspects of women's experience that had hitherto been ignored by art.

Sporadic alliances between artistic and political avant-garde movements throughout the twentieth century had coexisted with the contrary notion that art was primarily concerned with expressing the artist's personal experience. The feminist conflation of the personal and the political denied any such separation. Feminist art represented an activist version of academic critical theory, which – in very broad terms – interpreted art, literature and

other cultural products as a way of generating meaning within wider systems (social, political, linguistic) rather than as expressions of their creators' individuality.

Feminist art practice and theory, and actions by feminist groups such as the Guerrilla Girls, founded in 1985, brought significant changes to the art world. More women began to be included in exhibitions, to sustain professional artistic careers and to be accorded public commissions and accolades. For the first time, the full range of women's experience became accepted material for art. Western feminism did not always translate into other cultural contexts, but it did establish a model for giving artistic centre stage to minority or marginalised perspectives, whether to do with gender, ethnicity or social class. In 1996, Renée Cox was still able to outrage New York's male civic and Catholic establishment by placing a nude black woman (a self-portrait) at the centre of the Eucharistic table in her photograph *Yo Mama's Last Supper*. ∎

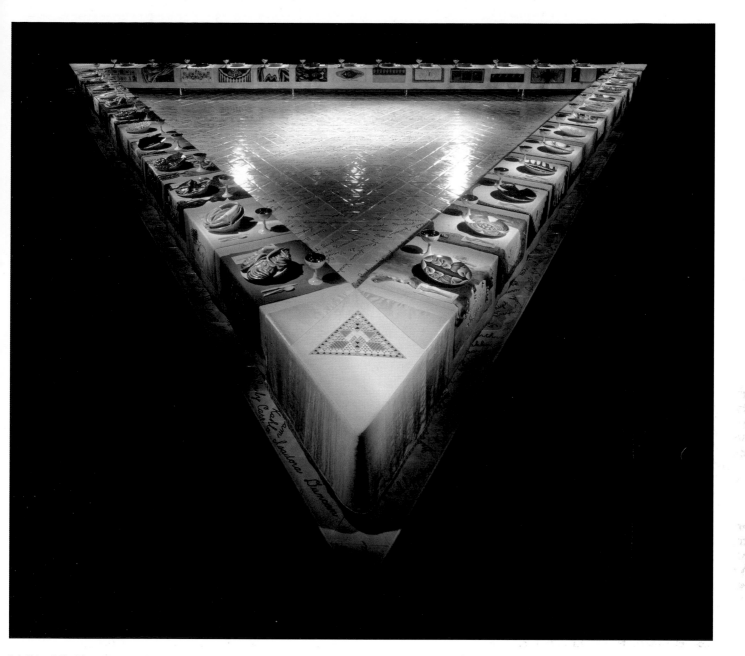

Judy Chicago's The Dinner Party
*(1974–79) is an installation consisting
of a three-sided dining table on
which each of the 39 place settings
commemorates an eminent woman
with a decorative ceramic setting
resembling female genitalia.*

The mechanical ballet

IDEA № 90
MOVING IMAGES

ABOVE: *Fernand Léger's* Ballet Mécanique *(1924), co-directed by American director Dudley Murphy to a score by George Antheil, is a fast-moving 'ballet' of kaleidoscopic frames that give animated form to Léger's pictorial 'machine aesthetic'.*

After the development of motion pictures in the early twentieth century, artists began to experiment with the new temporal dimension that film introduced into image-making. From the 1960s, the social and technological phenomenon of television opened the way to the development of video as the medium of choice for many artists.

The nature of **artificial light** before the introduction of electricity made the illusion of movement a common experience in viewing pictures. It is possible that Palaeolithic cave painters deliberately exploited the conditions created by lamp flames in the pitch dark, in whose unstable light the animal images on the uneven rock walls seemed to move. By the late nineteenth century, European artists were preoccupied by the paradoxical stasis of the painted or photographic image that sought to convey the rhythm of modern life. Impressionism, Cubism, Vorticism, Futurism – each of these movements evolved distinctive visual formulae to represent time. **Kinetic art** was one outgrowth of this preoccupation, but cinema offered a more attractive medium, being both closer to the painter's view, with its mechanics concealed behind visual effects, and more evidently in step with the social moment (another ambition of art since Gustave Courbet).

Unlike painting and sculpture, film didn't need to be reinvented for the modern age: it was both a product of that age and, as it seemed, the perfect medium for seizing its spirit of rapid change. Artist-made films during the 1920s and 1930s tended to be occasional excursions, but they demonstrate an extraordinary range of experimental effects. Fernand Léger described his *Ballet Mécanique* (1924, above) as the 'first film

without a scenario' – a format that was to define artists' films and later video art in contrast to mass entertainment.

Marcel Duchamp's *Anaemic Cinema* (1925) is a more conceptual conflation of word and image, consisting of alternating frames of spiralling circles and Dadaesque nonsense poems. In Salvador Dalí and Luis Buñuel's collaboration on *Un Chien andalou* (1928), film revealed itself as the Surrealist medium *par excellence* – a dream experienced while fully awake. In 1935, Len Lye produced *A Colour Box* for the British GPO Film Unit by painting directly on film; his abstract colour-poem ends by advertising postage prices, bizarrely highlighting the inbuilt connection between film, mass culture and commerce. Andy Warhol's *Sleep* (1963), a single-take film of a friend sleeping for almost five-and-a-half hours, eschewed the artificiality by which cinema constructs its cut-and-edited version of reality. Filming events in real time with minimal editing became a distinguishing feature of art (as opposed to commercial) film and video work.

Television added a new dimension to the art of moving images by inserting a portable image-producing device into the heart of domestic consumer life. Although broadcast television generally remained distinct from artists' work with electronic images, both shared the standard television set as a viewing

medium. From the mid-1960s, Nam June Paik experimented with video recordings and introduced television sets into works such as *TV Bra for Living Sculpture* (1969) and *TV Garden* (1974–78). In the 1970s, video emerged as a primary medium for **conceptual art**, used either to record **performance** pieces, as by Bruce Nauman (see p.28), or in the lyrical, choreographic manner of Bill Viola, registering processes of flow and transformation in a way that would not be possible without moving images (opposite). From the 1990s, **digital technology** made moving images almost as ubiquitous as snapshots. Artists now regularly return to the older technology of film spooling through a projector, whose audible whirring emphasises the 'mechanical ballet' of the moving image. ■

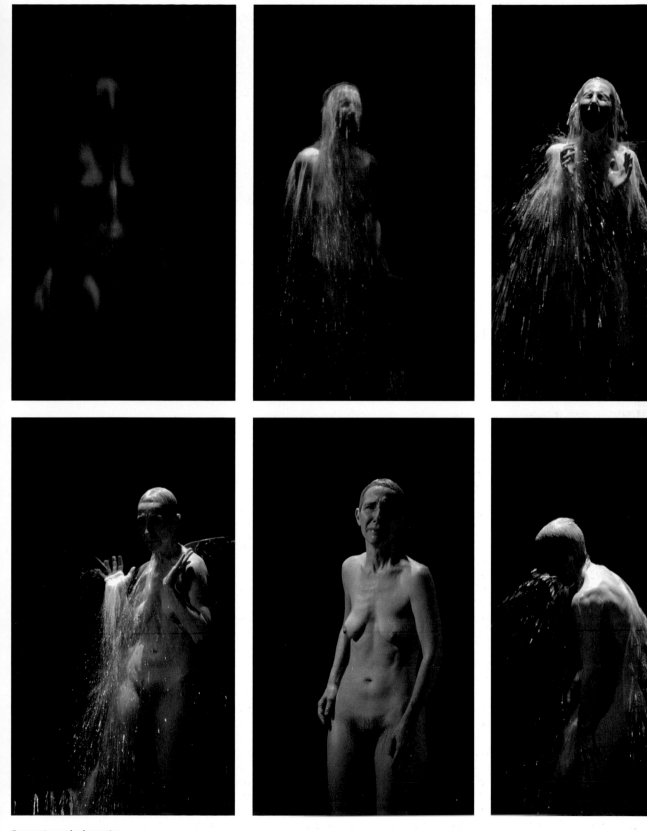

Commenting on the slow-motion
water sequences in video works such
as Acceptance (2008), Bill Viola said,
'Often I've used water as a metaphor,
the surface both reflecting the outer
world and acting as a barrier to the
other world.'

It's the thought that counts

CONCEPTUAL ART

The idea that artists are primarily concerned with realising concepts rather than fabricating objects has been current since the Renaissance. It was taken to its logical conclusion in twentieth-century conceptual art. By making objects subordinate to ideas, conceptualism countered art's seemingly unavoidable commodification in modern capitalist economies.

Although it is difficult to know how ancient artists saw their vocation, the artists of the Italian Renaissance, who aspired to be their successors, stressed art's conceptual side as much as its skilful execution. 'A man paints with his brains, not his hands,' according to Michelangelo. For Nicolas Poussin in the seventeenth century, art's foundation was emphatically conceptual: 'Able men must work with their intellects, that is, they must conceive beforehand what they want to do.' Painters who just imitated appearances were relying on mere instinct, 'like that of animals'. Poussin's **allegory** of the four seasons *A Dance to the Music of Time* (*c*.1634–36, below) embodies such precepts: a personified concept (Time) employs the most abstract of the arts (music) to generate bodily actions (dance).

In his insistence on concept as primary, Poussin stands at the head of two centuries of European academic art. By the nineteenth century, however, the rules that governed **academic** training seemed irrelevant to many artists. The backlash could be savage: to Joshua Reynolds's assertion that the 'disposition to abstractions ... is the great glory of the human mind', William Blake retorted, 'To Generalize is to be an Idiot.' For **Romantic** artists, art was an expression or revelation of truths that were inaccessible to the intellect alone. The contemplation of art, in John Keats's 'Ode on a Grecian Urn', 'doth tease us out of thought'.

In the Romantic tradition, art is heuristic – it leads you towards a discovery rather than beginning with an idea. As Mark Rothko and Adolph Gottlieb wrote in 1943, 'Art is an adventure into an unknown world.' To

OPPOSITE: *In Nicolas Poussin's* A Dance to the Music of Time *(c.1634–36), the colour transitions from earthy brown through roseate flesh to celestial blue echo the way in which dancing gives bodily form to the idea of time.*

ABOVE: *Christian Boltanski's* The Reserve of the Dead Swiss *(1990) tests our responses to the death of strangers. The enlarged portrait photographs are not, as they may seem at first, Holocaust victims but mugshots from newspaper obituary pages.*

characterise art as an 'adventure', rather than an expensive cultural product, could, however, seem disingenuous. In art-market terms, wasn't adventure simply being used here as a concept to market paintings? It was more honest, surely, to distinguish between the commodity object and the meanings attached to it. This distinction is the basis for the concentration on concept as opposed to object that characterises much art since the 1960s. It informs not only rigorously conceptual pieces, such as Robert Morris's *Document* (1963), for which he drew up a legal denial of 'all esthetic quality', or Joseph Kosuth's *Titled (Art as Idea)* (1966–67), which comprised photographs of dictionary definitions, but also the more hybrid types of **installation art**, in which objects' physical qualities express an overarching **narrative** or concept.

In the late twentieth century, conceptual art was widely favoured as a contemporary medium by publicly funded museums and galleries. Since these institutions communicate to visitors through marketing and educational programmes, a common audience experience is one of arriving conceptually primed. Prior understanding of the work's conceptual content is then modified through first-hand encounter. ■

What's it all about?

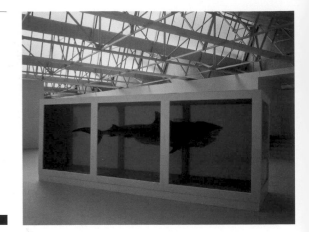

IDEA Nº 92
TITLES

Naming and knowing are so closely associated that titles can seem essential to understanding art, even though the modern titles of many early works were not given by the artists themselves. More recently, titling has become integral to the way artists confer meaning on their work, in the interplay between words and image.

In terms of the production of art, across the whole chronological and global span, formal titles are largely irrelevant. Except in later Western and modern art, works tended to be titled descriptively according to their maker, subject, owner or location. Famous titles such as the *Venus de Milo*, the *Mona Lisa* (below) or *Las Meninas* ('The Maids of Honour', originally inventoried as *La Familia*, 'The Family', see p.92) became canonical only when the work entered critical or historical discourse. In museum and gallery displays, titles can be a significant distraction; visitors have been found to spend longer consulting labels than looking at the works they refer to.

Although it is difficult to be certain in individual cases, artists probably began to think of words or phrases as an integral part of their work when, during the Renaissance, literary subject matter became fashionable. In Guercino's *Et in Arcadia ego* ('I too am in Arcadia', 1618–22), the words are an essential element of the picture's meaning: contemplating a skull beneath which these words are inscribed, two shepherds learn that, even in the ideal pastoral world, death is present. **History paintings** needed titles to identify their subjects or to function as a stirring strapline, as with Jacques-Louis David's *Oath of the Horatii* (1784, see p.104) or Théodore Géricault's *The Raft of the 'Medusa'* (1819). As the printed word increasingly became art-world currency during the nineteenth century, in the form of lists of works for sale or critics' reviews, titles tended to become fixed, like those of books, bringing scope for interaction between title and image. By giving an apparently Realist painting of a London street the title *Work* (1852–65), for instance, the Pre-Raphaelite painter Ford Madox Brown insisted it be read as a parable.

The twentieth century was a great age for the title. Artists used titles to suggest associations for non-figurative works, such as Wassily Kandinsky's 'Fugue' paintings or Henri Matisse's

Snail or, in Surrealist art, to arrest, unsettle, amuse or provoke. Acknowledging the influence of contemporary writers on his work, Marcel Duchamp reflected: 'perhaps I was less attracted by Laforgue's poetry than his titles.' Like Laforgue's titles ('Five-minute Watercolour', 'Macabre Excuse') Duchamp's can have the enigmatic poetry of mistranslations or crossword clues: *In Advance of the Broken Arm, The Bride Stripped Bare by her Bachelors, Even*. The use of riddling titles to engage the audience is typical of conceptual and installation art, as in Rebecca Horn's *Ballet of the Woodpeckers* or Damien Hirst's *The Physical Impossibility of Death in the Mind of Someone Living* (above). Titles have become a universal expectation; the artist can play the game or opt for *Untitled*, which can seem either a principled statement of the irreducibility of the visual or a lazy way out. ∎

Many of Willem de Kooning's
paintings are on the border between
abstract and representational. In
Untitled XIX (1977) the gestural
brushmarks could equally suggest
landscape or human forms.
'Untitled' lets the viewer make
their own interpretation.

Timeless immediacy

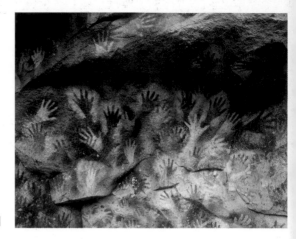

IDEA № 93
BODY AS MEDIUM

Skin, hair, bones, blood, fingernails, faeces – materials provided by the human body have frequently been used to make works of art. Alongside the emergence of **performance art** in the 1960s, Western artists turned with new attention to the human body's potential as both tool and material for making art.

BOTTOM LEFT: Richard Long's A Line Made by Walking *(1967) is a monochrome photograph of a path trodden through a Wiltshire field. The visual record distils the ghostly track of the artist's boots, as a drawing registers hand movements.*

ABOVE: Between 13,000 and 9,500 years ago, ancestors of the Tehuelche people of Patagonia painted the Cave of the Hands with handprints coloured with mineral pigments such as iron oxides (red and purple) and kaolin (white).

OPPOSITE: Marc Quinn's self-portrait head Self *(1991) consists of 4.5 litres of the artist's frozen blood. Quinn described his desire 'to push portraiture to an extreme, a representation which ... is actually made from the sitter's flesh'.*

The positive and negative handprints found in **cave-art** sites (right above) are not there because their makers had nothing better to paint or stencil with. Whatever their intended function, the immediacy with which they connote human presence does not significantly weaken with time. Unlike other types of mark-making – the Pointillist dab or the Abstract Expressionist splash – they convey a strong sense of the moment of their making without placing it in any kind of stylistic or historical frame. Artists can exploit this timeless immediacy as consciously as they can exploit any other quality – it is there, for example, in Richard Long's recent site-specific mud paintings.

From Egyptian funerary arts to medieval shrines and Renaissance

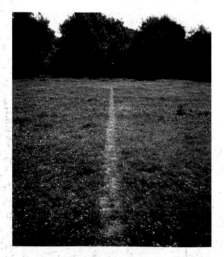

tombs, the dead body lies at the heart of vast artistic programmes. Though it is less often encountered as matter for making art, this does occur. Heads consisting of skulls encased in plaster, made in Jericho around 8,000 to 9,000 years ago, may have been portraits or effigies. A staring mask fashioned from a skull comes from Mexico around the time of the Spanish Conquest. Adorned with turquoise, obsidian and gold pyrites mosaic, it was probably part of a ritual costume representing the creator god Tezcatlipoca.

In Western art bodily materials started to feature alongside conventional media such as stone or paint only in the later twentieth century, at which point traditional taboos against making or displaying such work had all but disappeared. Sometimes, as in Joseph Beuys's incorporation of nail clippings into his work, the context is both quasi-ritualistic and autobiographical: **the artist**, like the medieval saint, is a special being whose every trace may be (ironically or otherwise) offered for veneration. At the same time, since the artist expresses shared experience, the body – which everyone has, no matter how different their thoughts – is a universal medium.

The use of body matter is a realisation of the familiar trope that art 'springs from' the artist, who 'gives birth' to his or her work. Piero Manzoni's notorious, self-explanatory *Artist's Shit* (an edition of 90 labelled cans, see p.113) began a now well-established tradition, most recently exemplified by Marc Quinn's 'Self' **series** of refrigerated self-portrait heads (opposite), cast every five years from 4.5 litres of the artist's own blood. Artworks made from body matter are often effectively a precipitation of **performance art**, in which the action's transient conceptualism becomes a solid object with market value. The risks in both performance and object-based work are comparable, as moving appeals to common humanity risk crossing the border into sensationalism or exhibitionism. ∎

Keith Haring drawing in the New York subway in 1982. A sometime collaborator with Basquiat, Haring turned graffiti-style imagery into a highly successful form of personal logo, opening the Pop Shop in New York in 1986.

Urban interventions

IDEA № 94
STREET ART

Urban streets provide unlimited surfaces to which designs and texts can be applied. The concept of street art embraces the anonymous, often illegal decoration of publicly visible surfaces and the art market's commodification of graffiti, beginning with the works of Jean-Michel Basquiat in 1980s New York.

BOTTOM LEFT: In 2007 redevelopment in New York's SoHo district revealed a graffiti-covered wall. Art critics were convinced it was Basquiat's work. 'A piece of SoHo's artistic history is built right into our structure,' enthused the project's architect.

ABOVE: Graffiti by Banksy on a wall in Toronto, photographed 11 May 2010. From the early 1990s, Banksy's whimsically satirical freehand and spray-stencilled graffiti in his home town of Bristol and elsewhere made him an international celebrity.

There are examples of words and images scratched, drawn or painted on urban walls from the ancient world onwards, but this type of mark-making didn't attract much interest from artists before the twentieth century. The modern idea of the city as an infinitely complex accumulation of signs, which led the philosopher Walter Benjamin to anatomise capitalist society in terms of the nineteenth-century Parisian streetscape, was matched by the camera's unprecedented ability to frame every detail of its surface texture. Today, there is a sense in which being culturally literate means being able to interpret the wider visual culture of the urban environment, not only those aspects traditionally categorised as art.

In the 1900s Eugène Atget's photographs of Paris dwelt lovingly on poster-covered walls. To Aaron Siskind's eye in 1950s Chicago, the scrawled slogan 'I want a raise in work' had the look of an avant-garde painting with a socialist message. How was this anonymously inscribed surface different from Cy Twombly's contemporary exercises in automatic writing? It was also around this time that aerosol-spray technology made the transition from military to commercial production, bringing a new, combined paint medium and application method to the market. From the 1970s, spray paints transformed urban graffiti, allowing vast surfaces to be covered with clandestine speed. The chunky cursive script and multicoloured spray-painted patterns of New York subway graffiti became a universal street-art style – or vandalistic genre, depending on the critical perspective.

The emergence of gallery-based **Pop** art in the 1960s was supported by an intellectual endeavour to bridge the divide between 'high' and 'mass' culture. British critic Lawrence Alloway insisted that the future belonged to 'mass art' and that 'mass art is urban and democratic'. Once Andy Warhol had persuaded the art market that such products and their production processes could be seen as art, the way was clear for artists to embrace other, actually more democratic elements of urban popular culture.

In the late 1970s, the New York graffiti style was adapted by young artists working outside mainstream cultural institutions and markets. Jean-Michel Basquiat (left) and fellow student and graffiti artist Al Diaz devised the mock-cult figure SAMO© ('same old shit'), whose cryptic slogans began to appear throughout New York. Through Basquiat's subsequent introduction to elite artistic society, his move to easel painting and his friendship with Andy Warhol, graffiti art and black iconography found an enthusiastic welcome in the art market. The apparently contradictory relationship between covert, illicit urban art and mainstream popular and gallery culture in the early twenty-first century is exemplified by the pseudonymous celebrity British artist Banksy (above). ∎

Art without frontiers

IDEA № 95
GLOBALISATION

The term globalisation became current in the 1990s to describe the apparently unprecedented irrelevance of national boundaries. Whether culturally or economically defined, the concept of globalisation has taken root in the art world with the proliferation of biennales and international curators as well as in individual artists' practice.

The nation state, with its clear geographical boundaries, is a modern political entity. In much of the world before the colonial era, territorial definitions of identity were more fluid. The diffusion of what we call Greek art crossed political, cultural and religious boundaries. Roman emperors, for example, adapted it for their iconography of power and propaganda. But although 'Greek' art could be produced almost anywhere to serve any purpose, its visual identity remained as strong as a modern commercial brand.

Globalisation as understood in the late twentieth and early twenty-first centuries shows some of these ancient

elements of boundary-free trade and cultural movement. In the speed with which it is substituting a new geopolitical model in place of the nation state, however, it represents a quantum shift. The activities of multinational corporations, the movement of migrant labour and the spread of real-time global communications are powerful but often invisible agents of change, operating below the radar of news coverage. Art is one means of giving tangible form to the globalisation process.

In the late twentieth century, the art world evolved its own global mode of operation in the proliferation of biennales. These are large-scale, often themed, multi-site exhibitions of international contemporary art that are designed to enhance the prestige of the host city and, among other benefits, to increase its attractiveness to investors. Biennales are typically organised by itinerant 'super-curators' and feature headline international artists alongside local ones. In addition to the long-established events in Venice and São Paulo, the 1990s saw the inception of biennales in Berlin, Dakar, Johannesburg, Liverpool, Shanghai and Sharjah, among other cities. Okwui Enwezor's approach as chief curator of the second Johannesburg Biennale (1997), titled *Trade Routes: History and Geography*, has been seen as a textbook example of art addressing globalisation. Enwezor and his multi-

national team of co-curators set out 'to look at issues related to border crossings, but not ... in the classic sense of a celebration of hybridity'. They wanted to explore 'the situation ... of being a citizen in the particular context of shifting political landscapes'.

British-born Nigerian artist Yinka Shonibare expresses the history and geography of globalisation in material form. His figure sculptures based on eighteenth- and nineteenth-century portraits of Europeans (opposite) are clothed in what appear to be African fabrics, which actually represent the Indonesian products of Dutch colonial textile manufacture. In Enwezor's phrase: 'Something as seemingly innocent as fabric, comes loaded with political, social, historical and cultural metaphors.' ■

Modelling data

IDEA № 96
DIGITAL TECHNOLOGY

Digital technology is a system for encoding information rather than a medium, such as drawing or **photography,** that captures an imprint. The absence of physical limitations in the storage, manipulation and presentation of digitised visual information brings vast creative potential but challenges the very notion of art by dissolving its media-based foundations.

The antecedents of modern digital technology can be traced to the marriage of Enlightenment science and artifice represented by the punch-card operating system devised by Jacques de Vaucanson for his extraordinarily elaborate automata. With rapid advances in computer technology after 1945, digital programs with binary codes consisting of a series of 0s and 1s became the standard method for storing information captured electronically from a wide range of sources. It has proved possible to digitise not only mathematical but also visual, auditory and other kinds of data.

Computers allow any user to manipulate digital data; this high degree of interactivity has changed the nature of image-making. Whereas what are termed analogue media carry the physical imprint of an originating event – whether a sculptor carving a stone block or a cathode ray bathing a television screen with electrons – digital technology translates every stimulus into neutral numbers. There is no original work of art resulting from an artist's actions, only an increment of the digital database. Analogue photography records the physical changes effected by reflected light on a photosensitive medium; digital photography registers and records light intensity as data, but the medium itself is not changed in the process. When data from different sources, such as several digital images, is combined, the result is simply a new digital image, neither more nor less 'original' than its sources and equally available for further processing. Although computer users, including artists and audiences, have access to an unprecedented range of visual cultural material, a salient feature of the digital information revolution is that most of this material is experienced passively most of the time, via the small rectangular frame of the computer screen.

Artists have harnessed both the potential and the limitations of digital technology in several ways. Some, like Wade Guyton, exploit the parasitism of digital information on physical media, machines and visual conventions, without which it cannot enter human experience. Guyton uses inkjet printers as 'tools to make works that act like drawings, paintings, even sculptures', in other words reversing the process of digitisation by transforming data back into physical objects. Working with computer programmers, Joseph Nechvatal developed what he termed viractual art (opposite) – a conflation of physical processes with the virtual world constructed from digitised information – in such works as computer-assisted paintings on canvas. The conventions of computer gaming – a hugely successful entertainment genre that owes its

existence to digital technology – have been adapted by Chinese artist Feng Mengbo, who introduces an unaccustomed autobiographical and ethical dimension through a variety of interactive strategies. ■

OPPOSITE: *Richard Hamilton's inkjet print* Shock and Awe *(2010) commemorates British leader Tony Blair's support for the US bombing of Baghdad in 2003. A 'real' digital photograph of Blair actually in cowboy clothes would be indistinguishable from this one.*

TOP: *Wade Guyton created* Untitled *(2008) by dragging linen through an inkjet printer. On office paper the digital file should print as a black rectangle; linen clogs up the inkjet heads, producing white lines.*

ABOVE: *Joseph Nechvatal created his diptych* Orgiastic abattOir : flawless ignudiO *(2003) through a process he termed viractual. In this practice, he explained, 'we find the emerging of the computed (the virtual) with the uncomputed corporeal (the actual)'.*

Past and present

IDEA Nº 97
MUSEUM

ABOVE: In Mining the Museum (1992–93), Fred Wilson reorganised Maryland Historical Society's collection to express the histories of Native American and African people in Maryland. For Wilson, museums provide 'a constructed kind of design space ... an installation environment'.

OPPOSITE: Visitors to Olafur Eliasson's The Weather Project at Tate Modern (2003) lay on the floor, basking in the hazy glow of a sun that seemed to hang above them, conjuring the grand scale of land art into the gallery.

Since the foundation of the *mouseion* ('temple of the Muses') in third-century BC Alexandria, art has featured in museums. Art's place in Western society, in particular, is linked to the cultural values museums represent. In the twentieth century, artists began to exploit the museum's complex nature as an object store and place of learning that is also a social arena.

Historically the people who founded and ran museums generally had clearly defined reasons for collecting and preserving objects, and making the **collections** available for study. Though the emphasis shifted according to period and context, museums have always been sensitive barometers of cultural, social and political change. The spirit of the seventeenth-century scientific revolution is mirrored in the founding principle of the Ashmolean Museum, Oxford (1683): to promote 'the knowledge of Nature [which] is very necessarie to humaine life, health, & the conveniences thereof'. The Napoleonic transformation of the Louvre in Paris from royal palace to people's museum and the rapid development of nineteenth-century American museums as cultural counterparts to economic might register comparably profound historical shifts.

For most of this time span, however, contemporary art had a limited role in museums, beyond the hours spent by art students copying the approved achievements of earlier ages. This relationship altered in the early twentieth century with the widespread realisation that the rapid pace of change, seen by Karl Marx as a defining feature of capitalist society, made the present age different in kind from any preceding era. Modern art presented itself as a tool that could avail modern society in its quest for self-awareness. It was in this spirit that the Museum of Modern Art, New York, was founded in 1929; its mission statement in 2011 continues to envision the museum as an agent of creativity rather than a storehouse of objects, 'a place that ignites minds, and provides inspiration'. The twentieth-century proliferation of large public museums dedicated to collecting and displaying contemporary art, from Paris (1961) to Bilbao (1997) and London (2000), consolidated the process by which art became news – information by which we make sense of the wider world on a day-to-day basis. As an object lesson in the here and now, contemporary art provided perfect material for the modern, socially engaged museum.

Museum curators saw opportunities for revitalising their collections and appealing to new audiences. One strand, pioneered by **installation** artist Fred Wilson in the 1980s, is to have an artist 'intervene' in a museum collection by reorganising the traditional categorisation of objects. In the exhibition *Mining the Museum* in Baltimore in 1992–93 (above), Wilson re-energised the drab curatorial category 'US Metalwork 1723–1880' by including slave irons among the showpiece silver goblets. It has become common practice for artists to turn institutional spaces into installations, as in Anish Kapoor's exhibition at the Royal Academy, London, in 2010, which included a cannon that assaulted the gallery walls with canisters of red wax. Such acts of authorised iconoclasm are characteristic of museums' relationship with contemporary art. Several modern and contemporary art museums occupy former industrial buildings, in which art symbolically replaces heavy machinery as an economic and social driving force. At Tate Modern, London, the turbine hall of the former power station provides a vast arena in which contemporary art can blossom as colossal spectacle, for example, in Olafur Eliasson's *Weather Project* (2003, opposite). ∎

What lies between

NEGATIVE SPACE

ABOVE: *Bill Woodrow's* Car Door, Ironing Board and Twin-Tub with North American Indian Head-Dress *(1981) enacts a reversal of both spaces and values, as a colourless consumer object provides material for flamboyant regalia.*

BOTTOM LEFT: *Bronze statuettes of the Hindu god Shiva traditionally show him as Nataraja (Lord of the Dance). Interaction between positive and negative forms within the cosmic ring of flame give the figure a strong sense of animation.*

OPPOSITE: *Rachel Whiteread has constructed an entire oeuvre out of negative space. Much of her sculpture is cast from domestic voids, to which it gives concrete form, as in her 1993 project* House *in London's East End (demolished the following year).*

Negative space is the space around two- and three-dimensional forms. It is the space within or against which positive forms are defined – the white page around a silhouette or the gap between the arms and torso of a statue. Artists often exploit perceptual ambiguities in the distinction between negative and positive space.

Our ability to read visual images depends on being able to distinguish between figure and ground. An oval black blob on a white page will look like a hole (negative), whereas if it has lumps on one side suggesting a forehead, nose and chin it will resemble a head (positive) surrounded by empty (negative) space. The clear distinction between figure and ground can be deliberately destabilised; this is the basis for simple optical illusions in which shapes continually shift between negative and positive.

Negative space is an active element in carving, in which forms are defined by cutting away. In ancient Egyptian sunk **reliefs**, for example, the figures

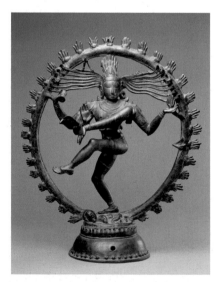

formed by cutting into the stone are interpreted as physically present, the uncut surroundings as empty. In three-dimensional carving, the sculpture takes shape through a process of removing the material around it. When, in the early twentieth century, Modernist sculptors such as Constantin Brancusi, Henry Moore and Barbara Hepworth revived the practice of stone and wood carving, they adopted negative space as an important aspect of their formal rhetoric. The outdoor spaces against which the rhythmic indentations of Brancusi's 'Endless Columns' (1920s–30s) are defined are an essential element in these works. Both Moore, in his reclining figures, and Hepworth, in her pierced abstract carvings, used negative space to relate sculpture to its environment, often a **landscape** that can be viewed through the gaps and holes in the works.

Some production methods require artists to reverse negative and positive space. Intaglio **printmaking** involves cutting away areas on the printing plate that will hold the ink, from which the positive image is created. In decorative arts generally, in which flat patterns are applied to three-dimensional surfaces, the interplay between figure and ground is often subtly orchestrated. The chemical transformation of negative to positive is the basis for producing photographic prints from film: without this

reversal, the action of light on photographic film would produce pallid absences in place of what we know to have been substantial.

Negative–positive reversal has been exploited to witty and moving effect by contemporary sculptors such as Bill Woodrow and Rachel Whiteread. In Woodrow's *Car Door, Ironing Board and Twin-Tub with North American Indian Head-Dress* (1981, above), a deeply indented ribbon of metal cut from a washing machine becomes a Native American feather headdress. In the Holocaust Memorial, Vienna, Whiteread used casts taken from library shelves in which negative space commemorates a population and culture transformed to ash and air. ∎

Everything to everyone

IDEA № 99

THE INTERNET

The internet is a global system of interconnected computer networks that enables users to communicate and share information irrespective of their location or distance from one another. As communications technology, the internet has changed the relationship between art and audiences; as a tool for making art, its use has proved more problematic.

The internet began in the 1960s as a project designed to link US military computers at different sites in a secure network. Over the following two decades, as more sites became connected, it was adapted for non-military communications too. In 1989, British scientist Tim Berners-Lee invented the World Wide Web, an internet-based service that enabled any computer user with an internet connection to access material on their screen via hypertext links. The web opened the way to an explosion in internet use, becoming a global forum for all kinds of information-seeking and sharing, from academic research to shopping, pornography and social networking. Culturally, it offered the realisation of the interconnected 'global village' envisaged by Canadian thinker Marshall McLuhan in 1962.

As the artist Robert Adrian pointed out, global real-time connectivity 'challenges the concept of art-making as a more or less solitary and product-producing activity'. While pre-internet art-making had in fact rarely been strictly solitary (at least, when compared to computer users alone in front of their screen), the concurrent development of **digital technology** means that highly sophisticated art, in terms of complexity and finish, can potentially be distributed among an online community of millions, in contrast to the limited reach of galleries, publications or analogue broadcast media. One problem facing artists on the internet, however, is that, without institutional endorsement in such forms as gallery exhibitions or newspaper reviews, their products (art) are not readily perceived as qualitatively different from any other web content, whether goods for sale or personal photo albums. Web users, moreover, tend to expect content to be free (with website income coming from advertisements), so that artists making internet art have to fund their work from other sources. And websites have proved in practice to be more ephemeral than conventional media, requiring constant maintenance and updating if they are to function long term.

Despite these issues, the internet has brought new capabilities for art in terms of dealing with global social and political questions. It has changed the concept 'world' from a compartmentalised map to a conceptual network of multiple, changing connections – a shift registered by Tobias Rehberger in his internet-based installation *Seven Ends of the World* (2003, left). In such work, data that could equally be presented as lists or diagrams was given aesthetic expression. Other artists have used the internet to heighten the element of interactivity in **conceptual** work. Claude Closky's 'Links' project (2001–02) presents an encylopaedia-style list of famous names; clicking on any particular name takes you to an eponymous business website, highlighting the artificial distinction maintained between fame and brand recognition. In the early twenty-first century it has become a common practice for artists and art students to share and critique work over the internet. ■

IDEA Nº 100
EPHEMERALITY

BOTTOM LEFT: *Earthquake damage to Giotto's fresco* St Francis Preaching to the Birds *(c.1297–99) in the Basilica of Saint Francis, Assisi, was photographed seconds before a subsequent, more powerful earthquake struck on 26 September 1997.*

OPPOSITE TOP: *On 15 September 2003, Cai Guo-Qiang's Light Cycle briefly illuminated the night sky above Central Park, New York. In the wake of 9/11, the elaborate display demonstrated that pyrotechnics can also be 'constructive, beautiful, and healing'.*

OPPOSITE BOTTOM: *A cloud of dust fills the Basilica of St Francis, Assisi after the ceiling collapsed in the 1997 earthquakes, destroying famous frescoes by Giotto and Cimabue. Ten people died and about 3,000 were made homeless in the disaster.*

Ephemerality – the quality of lasting only a short time – conflicts with the notion that art should endure. Yet the idea of ephemerality has often been a powerful element in art, from seventeenth-century vanitas **still lifes** to the sense of fleetingness that defined Impressionism and **performance art's** insistence on what's happening here and now.

Of all human activities and productions, art has a particularly complex relationship with time. Consideration of every aspect of art – its making, its existence as objects, the meanings ascribed to it, its social context and the ways in which it is experienced – entails awareness of time. This awareness may be what distinguishes art from entertainment, which suspends our sense of time. But it is hard to be sure. Wonder-provoking, beautiful, memorable, ephemeral – is a firework display entertainment or art?

Art, we feel, should embody timeless values and survive long after its makers are dead. We rely on the art of earlier times to understand how our lives are

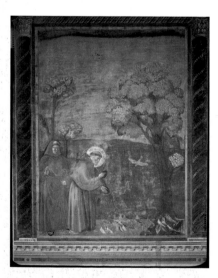

both different from and similar to what went before. Some artists address this constant battle with ephemerality head-on. Dutch **still-life** paintings, for example, encoded time's passing on every level: their wilting flowers and rotting fruit took time to paint and the works were meant to last, like their buyers' other prized possessions, while paradoxically conveying the message that everything decays. The twentieth-century French thinker Roland Barthes used the term *punctum* to describe how the moment preserved in such lifelike form by a photograph 'pierces' us with the knowledge that it can never be recovered.

By denying any expectation that it will last, ephemeral art deliberately changes the relationship between art and audience. In twentieth-century avant-garde art, ephemerality was strategically enlisted to undermine the material sense of artworks as objects whose value may grow over time (investments) or endorse elite social settings by their presence. Cubist **collages** and Surrealist **found objects**, made from ordinary perishable materials but now regarded as historic art, challenge museum conservators' efforts to endow these ephemeral products with a sense of permanence.

Ephemerality was a central tenet of auto-destructive art, developed by Gustav Metzger in the 1950s, but also of avant-garde practice in general. If modern art justifies its existence as an agent of change, then it must disavow lastingness, since durable objects have the opposite effect, becoming symbols of the status quo. It was in this spirit that Jean Tinguely made his junk sculpture *Homage to New York* (1960) self-combust outside the Museum of Modern Art.

Unlike the religious and social taboo-breaking that once seemed to validate the avant-garde project, the idea of art's ephemerality remains disturbing – perhaps more than ever, since the desire to fix a life's entire tapestry in digital images is now just routine. For all our familiarity with images of catastrophe – mass destruction and loss of life – the dust cloud (opposite bottom) containing pulverised Giottos captured on CCTV during the 1997 earthquakes at Assisi surges towards the viewer with the force of a moral realisation. ■

Glossary

The following is a selection of art-historical and other terms used in the book that may be unfamiliar to some readers.

Abstract Expressionism
Manner of abstract painting, also called action painting, in which paint is applied in expansive, unpremeditated gestures. Especially associated with 1940s–50s New York School artists such as Jackson Pollock and Mark Rothko.

Arts and Crafts
Influential late nineteenth-century movement in the visual arts that aimed to revive vernacular, often medieval, forms and methods in reaction against industrial mass production.

automatism
Approach developed by **Surrealists** around 1920, intended to bypass conscious artistic control and release deeper (unconscious) mental processes by embracing the results of chance and irrational impulse.

avant-garde
French military term meaning vanguard, adopted by socialist thinkers in the mid-19th century to describe the **progressive** elements in society. Later used to mean assertively new or progressive art.

Baroque
A dramatic, dynamic style associated with the Catholic Counter-Reformation of the seventeenth century, also the period as a whole.

Bauhaus
Influential German school of modern architecture, art and design founded in Weimar in 1919, moved to Dessau in 1925 and closed by the Nazis in 1933.

Byzantine
Of the Eastern Roman Empire (after its capital Byzantium, modern Istanbul) from 330 to 1453. For most of this period, the classically inspired and hieratic forms of Byzantine art were Christianity's primary artistic expression.

calligraphy
The art of 'beautiful writing', in which the artistic qualities of the handwriting are as important as its textual meaning, often more so.

Classical
Form of cultural expression that reflects the style of ancient Greek and Rome.

commodification
Karl Marx defined a commodity as an object that has both use value and exchange value. Art is said to be 'commodified' when it is traded like any product of industrial capitalism.

Constructivism
Early twentieth-century Russian art movement based on the idea that art should be 'constructed' from geometric elements and modern materials rather than imitating appearances.

Cubism
Art movement that began in Paris around 1907 with Braque and Picasso's dismantling of traditional rules of perspective and composition in painting.

cuneiform
Form of 'wedge-shaped' script used in Mesopotamia between the third and first millennia BC based on angular characters derived from an earlier pictographic script.

Dada
Movement founded in Zurich in 1915, espousing anarchy, irony and chance as means of opposing the political and cultural establishment.

Enlightenment
Phase in European history roughly corresponding to the eighteenth century, when intellectuals widely believed that human experience, knowledge and society had (or should have) a purely rational basis.

en plein air
French: 'in the open air', the practice of painting out of doors.

Expressionism
Early twentieth-century German art movement. More widely, any art that emphasises the expression of the artist's feelings.

Fauvism
From French *Fauves*: 'wild animals', name given by the critic Louis Vauxcelles to painting by Matisse, Derain and others around 1905 that used non-naturalistic strong colours.

figurative
Art concerned with recognisable objects and figures (also called **representational art**), often defined in opposition to abstract (or non-representational) art.

fresco
Italian: 'fresh', technique for painting on wet plaster applied to walls, though the term is also used for paintings on dry wall coatings.

frieze
A horizontal band running around a building (originally a Greek temple) between the roof and the supporting walls or columns, which provides a long, narrow field for decoration.

Futurism
Italian art movement founded by Filippo Tommaso Marinetti in 1909. Futurism rejected historical art and architecture and glorified machines, speed and war.

Gothic
European style of architecture and art of the twelfth to fifteenth centuries. The nineteenth-century revival of Gothic features, such as pointed arches and expanses of stained glass, is termed Neo-Gothic or Gothic Revival.

glyph
Element in a carved script, for example the pictographic script on Pre-Columbian Maya buildings.

humanism
Intellectual movement in fifteenth- and sixteenth-century Europe, characterised by renewed interest in ancient Greek and Roman literary and artistic culture and a desire to develop its secular modern equivalent.

illusionism
Using artificial means to create the effect of real experiences, such as flat painted objects that appear three-dimensional.

inkjet
Type of printer that translates digital information from a computer into jets of ink that produce text or images.

jeu d'esprit
French term meaning 'game of wit'.

kitsch
German: 'trash' or 'trashy'. Used of art that deliberately combines references to popular culture with the language of 'high' (elite) art, or assertively courts the accusation of bad taste.

life drawing
Drawing from a nude model.

Mannerism
Style of Italian art from the 1520s to about 1600. Vasari praised the *maniera* ('style') of his contemporaries, but Mannerism later became a pejorative term for affectation and distortion.

Minimalism
Movement in European and American sculpture and painting of the 1950s and 1960s that subsumed the artist's personal engagement in the work and emphasised the integrity of rational configurations of geometric shapes.

Modernism
Broad term for tendencies in early twentieth-century art and culture that broke with conventions of the preceding era, it includes abstract and **Surrealist** art.

motif
Artists who depict what is in front of them are said to work 'from the motif' (French: *sur le motif*, 'in front of the object').

naturalism
The attempt to represent things as they actually appear. Naturalism is found in many different types of art: for example, holy figures in **Renaissance** religious paintings may have naturalistic clothing or features.

Neoclassical
Art of the eighteenth and early nineteenth century reflecting the renewed interest in ancient Greek and Roman culture, also influenced by antiquities discovered following Napoleon's invasion of Egypt.

Neo-Expressionism
European and North American art movement of the 1970s–80s, characterised by large paintings executed in a raw, **expressionistic** manner and sombre subject-matter.

Palaeolithic
Archaeological era beginning with the earliest traces of human activity and lasting until about 10,000 years ago. The earliest known European Palaeolithic art dates from around 40,000 years ago.

picture plane
Plane defined by the physical surface of a picture, in relation to which the various elements in the picture may appear to be either farther away or closer to the viewer.

pointillism
Term describing Georges Seurat's method of applying paint in small brushmarks of pure colour, so that colours interact in the viewer's perception rather than being mixed together by the artist.

progressive
Art that aims to do something new, often in terms of a wider vision of social progress (see also **avant-garde**).

ready-made
An ordinary object taken out of its context and exhibited with little or no modification as art. The ready-made was pioneered by Marcel Duchamp in such works as *Fountain* (1917), a signed porcelain urinal.

Realism
Art movement in mid-nineteenth-century France associated with Gustave Courbet's paintings of provincial working-class life and socialist aspirations for art. Realism is also used for other types of art that represent the harsher aspects of life.

reliquary
Container for a sacred relic.

Renaissance
Term meaning 'rebirth' adopted by the French historian Jules Michelet (1855) and subsequently applied to the flowering of arts and intellectual culture, inspired by **Classical** precedents, in fourteenth- to sixteenth-century Italy and, slightly later, in other regions of Europe.

reportage
Reporting current events in the manner of news journalism.

representational art
See **figurative**.

Rococo
Style of art and architecture associated with eighteenth-century aristocratic culture in which **Baroque** grandeur and drama were replaced by lighter, more graceful and decorative forms.

Sublime
Aesthetic concept developed by eighteenth-century thinkers such as Edmund Burke central to the spirit of Romanticism. In contrast to beauty's calming effect, the Sublime inspired awe and even terror. Mountains, cataclysms and momentous events could all embody the Sublime.

Suprematism
Movement in Russian art developed by Kazimir Malevich around 1915, based on the idea that non-representational geometric forms could 'unmask' life's spiritual foundations.

Surrealism
Term coined by the French poet Guillaume Apollinaire in 1917 and formulated as a movement by André Breton in his *Surrealist Manifesto* (1924). Surrealists sought a reality beyond conventional appearances, using new methods such as **automatism**.

Vorticism
Short-lived British art movement founded in 1914 by Percy Wyndham Lewis and characterised by an emphatically angular, machine-inspired style.

woodblock
A type of print made by cutting away areas from a block of wood, which is then inked and pressed onto paper so that the uncut areas form an image.

Index

Page numbers in **bold** refer to picture captions

A

'action painting' 169
Aboriginal art 8, **8**
Abramtsevo, Russia 134
Abramovic, Marina: *Conditioning, The* **183**
Abstract Expressionism 30, 110, 149, 163, 173, 174
abstract painting 30, **55**, 65, **65**, 101, **106**, 117, 128, 131, **131**, 145, 148-9, **149**, 174, 178
Abu Ma'shar 61
Académie Royale de Peinture et Sculpture, Paris 108, **109**
academies of art 97, 105, **105**, **106**, 108, **109**, 114, 137
acrylic paints 131, 163, **163**
Adrian, Robert 205
advertising 128, **128**, 138, 174
Aesthetic Movement **49**, 159
African art 183
 masks 140, 160, 183
 sculpture 33, **33**, 140
Ain Sakhri Lovers 52
Al Diaz 195
Albers, Joseph 72
 Variation in Red and Orange around Pink, Ochre, Plus Two Reds **72**
Alberti, Leon Battista 65, 68, **68**, 105, 114
 De Pictura (On Painting) 68, 105
Alexander Mosaic, House of the Faun, Pompeii 56
Alexander Sarcophagus 23, **23**
Alexander the Great 23, **23**, 56, 97
Alexandria 200
allegory 75, 82, **82**, 132, 188, **189**
Alloway, Lawrence 195
Altamira caves, Spain 8
Altar of Zeus, Pergamon 23
altarpieces 45, 58, **58**, 72, 93
Alÿs, Francis: *Fabiola* 47
American Revolution 110
anatomy 86, **86**, 108
Andre, Carl 176, **197**
Anglo-Saxons 23, **23**, 49
Arabic language 41, **41**, 55
architectural sculpture 23, 38, **38**, **39**
Arezzo, church of San Francesco 100
Aristotle 66, 94, 138
Arles, France 134
Arp, Hans 169
 Collage Arranged According to the Laws of Chance **169**
art colonies 131, 134
art market 100, 101, 123, 174, 189, 195
Art Nouveau 146
Art of This Century Gallery, New York 123
Arte Povera 153
artificial light 137, **137**, 159, **159**, **178**, 186
artist, the 78, 110, 124, 128, 160, 164
Arts and Crafts movement 42, 128
 see also craftsmanship
Ashmolean Museum, Oxford 200
Asmat bis poles, New Guinea 37, **37**
assemblage 126, 127, **127**, 159
 see also found objects
Assisi, Basilica of Saint Francis **206**
Atget, Eugène 195
auctions 123
Auerbach, Frank: *Head of E. O. W.* I **62**
Augustus, House of, Rome 50, **50**
authenticity **112**, 113, **113**
auto-destructive art 206
'automatic writing' 55
Autogena, Lise: *Black Shoals Stock Market Planetarium* (with Joshua Portway): **205**
automata 154, 198
automatism 55, 169, 181
Autun Cathedral, France 38, **39**, 52
Aztec art **10**, 11, 181

B

Bacon, Francis 52, 91, 137
 Henrietta Moraes (Laughing) **160**

Balla, Giacomo: *Streetlight* 137, **137**
Bamayan, Afghanistan: Colossal Buddhas 19
Bandinelli, Baccio **108**
Banksy 195, **195**
Banner, Fiona 55
Baroque sculpture 106
Barthes, Roland 206
Bartholdi, Frédéric-Auguste: Statue of Liberty, New York 14, 75
Baselitz, Georg 160
Bastien-Lepage, Jules 131
Baudelaire, Charles 110, 181
Bauhaus 108, 128, 178
Beardsley, Aubrey: *The Yellow Book* 49, **49**
Becher, Bernd and Hilla: *Gas Tanks* **146**
Beckmann, Max 118, 160
Bellini, Giovanni: *Madonna of the Meadow* **72**
Benin, Kingdom of 106
Benjamin, Walter 75, 195
Bernini, Gianlorenzo: *Ecstasy of St Theresa* 106
Beuys, Joseph 34, 55, 110, 114, 183, 192
 Bathroom of Circe **145**
bibles 49 *see also* Christian iconography
biennales 197
Bignou, Etienne **123**
Black Mountain College, North Carolina 108
Blake, Peter 174
 Sgt Peppers Lonely Hearts Club Band (album cover) 128, **128**
Blake, William 67, 108, 110, 117, 188
 Songs of Innocence and Experience **110**
Blaue Reiter, Die 160
Blow, Sandra 145
body art 24, **24**, **25**
Bohuslän, Sweden 8, **8**
Boltanski, Christian: *Reserve of the Dead Swiss* **189**
Bonalumi, Agostino 113
Bonnard, Pierre: *Mirror in the Bathroom* **81**
Bony, Paul 42
book production 34, 49, **49**, 100
 see also printing
Bosch, Hieronymus: *The Garden of Earthly Delights* 50, **51**
Botticelli, Sandro: *Primavera* **74**, 75
Boucher, Alfred 134
Boucher, François: *Hercules and Omphale* 52
Bourgeois, Louise 102
 Spider Couple 33, **33**
Bouts, Dieric 62:
 Madonna and Child **62**
Brancacci Chapel, Santa Maria del Carmine, Florence 20, **21**
Brancusi, Constantin **106**, 140, 202
 Bird in Space 33
 Danaïde **140**
 'Endless Columns' **202**
Braque, Georges 34, 42, 89, 142, 145, 163, 172, 181
 Le Courrier **144**
 Le Portugais 142
Brecht, Bertolt 150
Breton, André 138, 169
Brittany, France 134, **134**
Broadcasting House, London 23, 38
bronze sculpture 11, **15**, 33, **33**, 91, **126**, **202**
Bronzino, Agnolo: *Eleanora of Toledo and son Giovanni* **76**
Brown, Ford Madox: *Work* 190
Brücke, Die 160
Bruegel, Pieter: *Peasant Wedding* 156
Bruggen, Coosje van *see* Oldenburg, Claes
Brunelleschi, Filippo 68
Buddhism 34, 97, 98, 176
Buddhist art 19, 160, 176, **197**
Buñuel, Luis: *Un Chien andalou* (with Salvador Dalí) 186
Burri, Alberto 145
Byzantine art 56, **56**

C

Cabinets of Curiosities 102, **102**, 153
Calder, Alexander 154
 Gamma **155**

calligraphy 34, **35**, **41**, 55, **55**
Cambiaso, Luca: *Holy Family with St John the Baptist* 137
camera obscura 94, **94**, **95**
Campin, Robert 62
Canaletto 94
candlelight 137, **137**
Canhavato, Cristóvão *see* Kester
Canova, Antonio
 Cupid Awakening Psyche 75
 Three Graces, The 106, **106**
Canterbury Cathedral, England 42
canvas 42, 93, **93**, 131
capitalism 89, 120, 128, 200
Caravaggio 137, 156, 183
 Basket of Fruit 89
 Calling of St Matthew **84**
 Concert of Youth 75
 Entombment 85
 Supper at Emmaus 85
Caravaggio, Polidoro da **79**
caricature 50, 150
Carnac, Brittany, France 13
Caro, Anthony 172, 173
 Early One Morning 173
 Tundra **172**
Carroll, Lewis: *Alice in Wonderland* 49
carving *see* relief carving; sculpture
caryatids 38
Castagnary, Jules-Antoine 124
casting 33, 42
cast-iron construction 38
Çatal Hüyük, Turkey 10-11
cathedrals 38, 42, 45
Catholicism 30, 106
Cattelan, Maurizio: *La Nona Ora (The Ninth Hour)* 170, **170**
cave art 8, 45, 68, 76, 78, 137, 186, 192, **192**
Cave of the Hands, Patagonia **192**
ceramics 10, 56, 185
Cerveteri, terracotta sarcophagus from 37, **37**
Cézanne, Paul 142
 Montagne Sainte-Victoire **142**
Chagall, Marc 42, 160
Chardin, Jean-Siméon: *Soap Bubbles* 124, **124**
Chartres Cathedral 42, **42**
Chauvet caves, France 8, **8**
Chesneau, Ernest 124, **124**
Chevreul, Michel-Eugène 72, 178
chiaroscuro **84**, 85, **85**, 108, 156
Chicago, Judy: *Dinner Party, The* 184, **185**
China
 calligraphy 55
 painting 16, 33, 58, 98, **98**, 116
 and papermaking 34, **35**, 82
chi-rho 10
Chirico, Giorgio de: *Mystery and Melancholy of a Street, The* 68, **68**
Christian iconography 28, 38, **39**, 45, **45**, **46**, 47, **47**, 49, 56, **56**, 58, **58**, 75, 91, 97, 160 *see also* icons; Madonna and Child, depictions of
Christianity 42, 47, 49, 52, 72, 97, 106
Christo and Jean-Claude 19, 163
 Gates, The **163**
cicatrization 24
cinema 20, 50, 174, 186
Claesz. Heda, Willem: *Still Life with a Lobster* **88**
Classical style
 art 26, **26**, 50, 66, 97, 106, 120
 sculpture 14, **15**, 26, **26**, 28, **28**, 33
 see also Neoclassicism
Claude Lorrain 78, 99, 116
 Landscape with the Marriage of Isaac and Rebecca 98, **98**
Close, Chuck 118
CoBrA group 140
Codex Mendoza 166
collage **26**, 34, 127, 132-3, **144**, 145, **145**, 173
collections 55, **91**, 101, 102, 108, 123
 see also museums
Colossi of Memnon, Egypt 19
colour 42, 49, 56, 62, 72, **72**, 106, **106**, 110, 116, 131, 142, 145, 148, 160, 169, 181

colour theory 72, 178 *see also* Divisionism
Communism 30, **31**
computers 65, 82, 198-9
 see also digital technology
Concarneau, Brittany, France 134
conceptual art 34, 55, 78, **170**, 174, 186, 188, **189**, 190
Constable, John
 Stonehenge **117**
 study of clouds over Hampstead Heath, London **124**
Constructivism 106, 154, 172, 176
consumerism 127, 128, 146, 174, 186, **202**
contrapposto 28, **28**
copies, making 28, **28**, 82, 90, 91, **91**, 108, 123, 200
Córdoba, Great Mosque 56
Courbet, Gustave 52, **90**, 91, 118, 134
 Burial at Ornan, A 118
 Peasants at Flagey Returning from the Fair 118
 Studio of the Painter, The 114, **114**, 132
Cox, Renée: *Yo Mama's Last Supper* 184
Cozens, John 117
craftsmanship 42, 114, **114**, 120, 128
Cragg, Tony: *Britain Seen from the North* 153
creation myths 8, 10
Creed, Martin: *Work No. 88* 34
Cubism 67, 93, 124, 142, **142**, **144**, 154, 163, 170, 174, 181, 186
 and collage 145, **145**, 206
 and sculpture 172, 173
 and still life 45, 89
cuneiform script 41
Cuyp, Aelbert 98-9
Cyclades, Greece 140

D

Dada 127, 132, 146, 153, 169, **169**, 183
Dalí, Salvador 169
 Great Paranoiac, The **138**
 Un Chien andalou (with Luis Buñuel) 186
Danby, Francis 117
Daumier, Honoré 150
David, Jacques-Louis 30, 97
 Oath of Horatii, The **104**, 105, 190
Daw, Alex: *Pamela* **145**
de Kooning, Willem: *Untitled XIX* **191**
De Stijl 128
decalcomania 34
Degas, Edgar 28, 123, 124, 132
 Cotton Market at New Orleans 145
 Laundresses 156, **156**
 Little Dancer Aged Fourteen **126**, 127
Degenerate Art exhibition (1937) 160
Deir el Bahri, Egypt 91
Delacroix, Eugène 78, 106, 110, 181
 Liberty Leading the People 75, **75**, 110
della Porta, Giambattista 94
Delphi, Sanctuary of Apollo 33
Denis, Maurice 145
Denoyers, Fernand 118
digital technology 82, 186, 198-9, **199**, 205
diptychs 58
Divisionism 142, 178
Dix, Otto 118
 War 58, **58**
Doesburg, Theo van 128
Dolní Vestonice, Venus of 10
Donatello 33
 St George, Orsanmichele 91
 St Mark 28
Dong, Song: *Broken Mirror* 81
drawing 8, 34, 68, 76, 76, 78, **78**, **79**, 86, **86**, 94, **94**, 108, **150** *see also* sketching
dreams 138, **138**
drugs 181, **181**
Drury, Chris: *Sky Mountain Chamber* **94**
Dubuffet, Jean 62, 127, 140
Ducal Palace, Mantua 70, **71**
Duchamp, Marcel 124, 137, 170, 190
 Anaemic Cinema 186
 Bicycle Wheel **127**, 153
 In Advance of the Broken Arm, The Bride Stripped Bare by her Bachelors, Even 190

Durand-Ruel, Paul 123
Dürer, Albrecht 37, 116, 123, 131
 Apocalypse (series) 100-1
 Saint Michael Fighting the Dragon 50
 Night, Death and Devil 82, **82**
Dutch painting (seventeenth century) 89, 94, **95**, 98, 106, **124**, 206

E
Eagle Warrior (Aztec) 10, 11
education 33, 78, 86, 91, 102, 108, 128, 200 *see also* academies
Egyptian art 10, 14, **14**, 19, 72, 76, 78, **78**, 86, 91, 116, 200
 in tombs 10, 16, 89, 159, 192
 relief carvings 23, **30**, 202
El Lissitzky: *Beat the Whites with the Red Wedge* 30, **31**
electricity 137, **137**, 186
Eliasson, Olafur: *Weather Project, The* **200**, 200
Engels, Friedrich 146
engraving 8, 82, **82**
Enlightenment, the 98, 102, 110, 140, 154, 198
environment, human relationship with 10, 13 *see also* land art
Enwezor, Okwui 197
ephemerality 205, 206
Epstein, Jacob: *Rock Drill, The* **146**
Erechtheion, Acropolis, Athens 38, **39**
Ernst, Max 34, 169
erotic art 52, **52**
d'Este, Alfonso
Etruscan art 16, **17**, 37, **37**
everyday scenes 156, **156**, **157**
exhibitions 108, 124, **126**, 153, 160, 170, 197
Expressionism 110, 160, **160**
Eyck, Jan van 62, 65, 70
 Annunciation diptych **44**, 45
 Arnolfini Marriage 81, 166
 Virgin and Child with Chancellor Rolin **64**, 65

F
Factory, The (Warhol) **114**
Falconet, Etienne-Maurice: *Bronze Horseman, St Petersburg* 14
Fauvism 110, 170
Fei, Cao: *RMB City (Second Life)* **205**
feminism 52, 165, 184
Feminist Art Program: *Womanhouse* 184
Fibonacci sequence 66, 67
film (photographic) 163, 202
film-making **155**, 166, 186 *see also* cinema; video art
Finlay, Ian Hamilton 97
 Belvedere Muses, The **97**
Flavin, Dan: *Untitled* 137, **137**
Fontana, Lucio: *Spatial Concept 'Waiting'* 93, **93**
Forbes, Stanhope: *Newlyn* **134**
foreshortening 68
found objects **102**, 127, **127**, **144**, 153, **153**, 206
Fra Angelico: *Annunciation* (fresco), San Marco, Florence 16, **16**
frames **44**, 45
Frankenthaler, Helen 117, 163
Franks casket 23, **23**
frescoes 16, **16**, 20, **21**, 30, 75, **75**, 93
Freud, Lucian 76
 Benefits Supervisor Sleeping 26
 John Deakin **76**
Freud, Sigmund 41, 50, **50**, 52, 55, 138
Friedrich, Caspar David 110
 Moonrise Over the Sea **110**
 Morning in the Riesengebirge 66
Frink, Elizabeth: *Four Heads* **101**
Fry, Roger 140
Fuseli, Henry 138
 Nightmare, The **138**
Futurism 124, 137, **137**, 146, 170, 183, 186
Futurist Manifesto (Marinetti) **137**, 146, 170

G
Gabo, Naum 154, 163, 172-3
 Kinetic Construction No. 1 **163**
Gandhara **197**
Gaudí, Antoni: Parc Güell, Barcelona 56, **56**

Gauguin, Paul: *Bonjour Monsieur Gauguin* 134, **134**
Gautier, Théophile **118**, 181
Gehry, Frank
 Chiat/Day building, Los Angeles 38, **38**
 Guggenheim, Bilbao 38
Gentileschi, Artemisia 85
George Nevill 76, **76**
Géricault, Théodore: *Raft of the 'Medusa', The* 190
Gilbert, Alfred: *Eros*, Piccadilly, London 14
Gill, Eric
 relief at Broadcasting House, London 38
 Dancing Couple 23, **23**
Giorgione 114
 Sleeping Venus 26
Giotto 16, 206, **206**
 St Francis Preaching to the Birds, Basilica of Saint Francis, Assisi **206**
 Seven Vices and *Seven Virtues*, Scrovegni Chapel, Padua 75
Gislebertus: *Last Judgement*, Autun Cathedral 38, **39**, 52
glass 81 *see also* mosaics; stained glass
globalization 197
Goethe, Johann Wolfgang von 72
Gogh, Vincent van 72, 91, 134, 178
 Bedroom, The **72**
Golden House of Nero (Domus Aurea), Rome 50
Goldin, Nan: *Valerie and Bruno: bodyforms, Paris* 52, **53**
Goldsworthy, Andy 13
Gombrich, E. H. 91
Goncharova, Natal'ya: *Peasants* **140**
Gonzáles, Julio 172, 173
 Head called 'The Tunnel' **172**
Gorky, Arshile: *Garden of Wish Fulfilment* **138**
Gormley, Antony
 Angel of the North 19
 Field **10**, 11
Gothic revival 42, 12 *see also* medievalism
Gothic style 146
 architecture 42, 45, 120, **120**
 see also Gothic revival; stained glass
Gottlieb, Adolph 189
gouache **131**
Goya 137
 Los Caprichos 138, 150
 Third of May 1808, The 164, **165**
GPO Film Unit (Britain) 166, 186
graffiti **195** *see also* street art
Greek architecture 23, 38, **39**, 45, 56, 106
Greek art 38, 52, 68, 70, 75, 86, 89, 97, 123, 197, **197**
 bronzes 33, 91
 collections 55, 102
 mosaics 56
 red-figure painting 114
 relief carving 23, 38, 45, 106
 sculpture 14, 26, **26**, 28, **28**, 33, 45, 50, 86, 97, **97**, 106, 114, 172
 see also Classical style
Greenberg, Clement 45, 93, 148-9
Grierson, John 166
Gris, Juan 181
 Breakfast **142**
Gropius, Walter 128
Grosz, Georg 118
 Pillars of Society 150, **150**
'grotesque' 50, **50**, **51**
grottoes 50
Grünewald, Matthias: *Isenheim altarpiece* 58, **58**
Guercino: *Et in Arcadia ego* 190
Guerilla Girls 184
 'Do Women Have to be Naked to Get into the Met. Museum?' 165
Guggenheim, Bilbao (Gehry) 38
Guggenheim, Peggy 123
Gursky, Andreas: *99 Cent* 133, **133**
Guyton, Wade 198, **199**

H
Hagens, Gunter von: Plastinations 86
hallucinogens 181, **181**

Hamilton, Richard
 Just What Is It That Makes Today's Homes So Different, So Appealing? 174
 Shock and Awe **199**
 Swingeing London, 67 II 166, **166**
handwriting 55, **55**
Hanisch, Carol 184
Hansen, Al 183
Hanson, Duane: *Supermarket Shopper* **150**
Haring, Keith **194**
Harvey, Marcus 170
Hatoum, Mona
 Corps étranger 86
 Light Sentence 159, **159**
Hausmann, Raoul 127
 Mechanical Head (Spirit of Our Time) **127**, 153
Haworth, Jann 128
Hayter, Stanley 82
Hepworth, Barbara 99, 202
Heartfield, John: *Pan-German, A* 164, **165**
Henner, Jean-Jacques 47
Herculaneum, House of Stags 89
Heron, Patrick: *2 July: 1995* **131**
Herschel, John 132
hieroglyphs 91
Hilliard, Nicholas: *Self-portrait* **61**
Hindu art 26, 52, **52**, 202
Hiroshige, Ando 65, **65**
Hirst, Damien 114
 Physical Impossibility of Death in the Mind of Someone Living, The 190, **190**
history painting **104**, 105, 118, **156**, 190
Höch, Hannah 127, 146
Hockney, David 94, 142, 174
 Celia's Children, Albert & George Clark 142
 Tea Painting 89
Hodgkin, Howard 45, **45**
Hogarth, William 150
 Rake's Progress, A 100, **101**
Hokusai, Katsushika: *Great Wave at Kanagawa, from Thirty-Six Views of Mount Fuji* 82, **82**
Holbein the Younger, Hans: portrait of George Nevill 76, **76**
Hooch, Pieter de 68
Hopper, Edward: *Automat* 156, **157**
Horn, Rebecca: *Ballet of the Woodpeckers* 190
Houses of Parliament, London (Pugin) 120
human body, use in art 113, **113**, 192, **192**
human figure, studies of 8, 10-11, **10**, 28, **28**, 86, 76, **184** *see also* anatomy; nude, the
humanist philosophy 26
Hussein, Saddam (statue of) 14
Huxley, Aldous: *Doors of Perception, The* 181, **181**

I
Iconoclastic Controversy 41, 47, 176
icons 45, **45**, **46**, 47, **47**, 72, 91
idealism 26, **26**, 50, 66, **90**, 97, 98, 106, 114, 118, 120, **120**, 128, 156
Ife, Nigeria: bronze heads 33, **33**
illusionism *see* trompe l'oeil
illustrated books 49, **49**, 82
impasto 62, **62**
Impressionism 62, 78, 123, 124, **126**, 127, 131, 132, 154, 156, 186, 206
Indian art 23, 52, **52**
indirect lost-wax casting 33
industrialization 42, 120, 128, 146, 163
Ingres, Jean-Auguste-Dominique 97
 Jupiter and Thetis **97**
inkjet prints 82, **199**
installation art **10**, 11, **16**, 102, 153, 159, **159**, 184, 189, 190, 200, **200**
internet art 45, 205, **205**
Islamic architecture 56
Islamic art 41, **41**
 calligraphy 55, **55**
istoria see history painting

J
Japan 24, **25**, 34, 55, 82
 landscape painting 176, **176**
 multi-panel painted screens 58, 176, **176**
 woodblock prints 58, 65, 82, **82**, 128

Jaar, Alfredo: *One Million Finnish Passports* **197**
Jericho, plaster heads 192
Johannesburg Biennale 197
Johns, Jasper 174
Judd, Donald 176

K
Kahnweiler, Daniel-Henry **102**
Kandinsky, Wassily 72, 148, 149, 160, 190
 Study for Composition VII **149**
Kanō school 58
Kant, Immanuel 66
Kapoor, Anish 200
 Sky Mirror, Rockefeller Center, New York 81, **81**
Kapova, Russia 8
Kaprow, Allan 183
Karnak, Egypt 30
Kells, Book of 49
Kelly, Ellsworth: *Window, Museum of Modern Art, Paris* 65, **65**
Kelly, Mary: *Post-Partum Document* 166, **166**
Kester: *Throne of Weapons, The* 153, **153**
Khajuraho, Madhya Pradesh, India: Lakshmana Temple sculptures 52, **52**
Kiefer, Anselm 105, 138
 Volkszählung (Census) 49, **49**
Kimberley region, Australia 8
kinetic art 154, **155**, 186
Kiyonaga, Torii 156
Klee, Paul 117, 160
 The Fish in the Harbour **117**
Klimt, Gustav 52
Kline, Franz 149
Koons, Jeff 19, 163
 Pink Panther 174, **174**
Koraïchi, Rachid: *Les Priants* 41, **41**
Koran, the 55, **55**
Kosuth, Joseph: *Titled (Art as Idea)* 189
Kritios Boy 26, **26**
Kuan, Fan: *Travellers Among Mountains and Streams* 98, **98**
Kufic script 55
Kunstkammer see Cabinet of Curiosities
kylix 114

L
La Tour, Georges de 85
 St Joseph Carpenter 137, **137**
land art 13, **13**, 45, 159, 174
landscape painting 34, 98-9, 116-17
 Impressionist 124, 131
 Japanese 58, 176, **176**
 Romantic 98, **110**, **112**, 117, 131
 see also plein-air painting; Sublime, the
Landy, Michael: *Break Down* 102
Lange, Dorothea 118
language, use in visual arts 40, 41, **41**
Laocoön **109**
lapis lazuli 49
Larsson, Carl: *Open-Air Painter* **131**
Lascaux caves, France 8
Lautréamont, Comte de 127
Le Nain, Mathieu **109**
Léger, Fernand 146
 Ballet Mécanique 186, **186**
 Propellers, The **146**
lenses 94
Leonardo da Vinci 66, 68, 72, 81, 85, 86, 94, 114, 154
 Architectural Perspective, for the Adoration of the Magi (drawing) **69**
 Mona Lisa 24, 98, 190, **190**
 Portrait of a Lady with an Ermine (Cecilia Gallerani) 85
 Vitruvian Man 66
LeWitt, Sol:
 installation, Andover, MA 16, **16**
 Two Open Modular Cubes 106
Lichtenstein, Roy
 Blam 163, **174**
light 42, 56, 84, 85, **85**, 137, **137**, 159, 178 *see also* chiaroscuro; photography
Lijn, Liliane: *Cosmic Flares* 154
Lin, Maya: Vietnam Veterans' Memorial 37, **37**

Index

linear perspective 45, 68, **68**, **69**, **71**, 142, 178
Lingyun, Xie 98
Literati Painters, Song Dynasty, China 34
lithography 128
Long, Richard 113, 192
 Line Made by Walking, A **192**
Lorrain, Claude *see* Claude Lorrain
lost-wax casting 33, **33**, 172
Louis, Morris 163
 Beta Lamda **163**
Louvre, Paris 102, 200
Ludwig II, King of Bavaria 120, **120**
Luttrell Psalter 156
Lye, Len: *Colour Box, A* 186

M
Macclesfield Psalter **49**
Mach, David 153
 Silver Back **14**
machine aesthetic 146, **146**
MacLean, Bonnie 181
Madonna and Child, depictions of **45**, 62, 64, **72**, 113, **184**
Magritte, René 68
 L'Appel des cimes 70, **70**
 Treachery of Images **40**, 41
Malevich, Kasimir 30, 148
 Black Square 148
 Black Trapezium and Red Square **149**
Man Ray 169
Manet, Edouard 123
 Bar at the Folies-Bergère 81
 Déjeuner sur l'herbe **91**, 170, **170**
Mantegna, Andrea
 Ducal Palace, Mantua (ceiling oculus) 70, **71**
 Cybele 23
manuscripts, illuminated 61, **61**, 116, 166
Manzoni, Piero: *Artist's Shit* 113, **113**, 192
Maori people, New Zealand 24
Mapplethorpe, Robert: *Desmond* 85, **85**
Marcus Aurelius, equestrian statue of **15**, 105
Maria, Walter de: *New York Earth Room* 159
Marinetti, Filippo Tommaso **137**, 146, 170
Martin, Kenneth 67
Masaccio 68
 Tribute Money 20, **21**
 Trinity 68, 70
Masson, André 55
mass-production 128, **128**, 146, 163
mathematics 66, 66-7, 68, 86, 97, 108, 114
Matisse, Henri 28, 102, **123**, 145, 160
 Chapelle de la Rosaire, Vence 42, **42**
 Jazz 49
 Large Reclining Nude 26, **27**
 Snail **190**
Mayan glyphs 41, **40**
Medici, Lorenzo de' 76, 102, 108
medieval art 26, 28, **39**, 45, 61, 75, 91, 120, 170 *see also* cathedrals; Gothic style; stained glass
medievalism 120, **120**
Meissonier, Ernest: *Barricade, Rue de la Mortellerie, June 1848, The* **118**
Memling, Hans: *Donne Triptych* 65
memorials 37, **37** *see also* tomb art; war memorials
Mengbo, Feng 199
menhirs 13
Merritt, Anna Lea: *Love Locked Out* 75
Merz, Mario **66**, 67
Mesoamerican art **10**, 11, 23, **40**, 41, 181, 181 *see also* Olmec culture; Tenochtitlán, Mexico
Mesopotamian civilisation 14, 23, 41, 56, 81
metalwork 172 *see also* bronze sculpture; casting
Metzger, Gustav 206
Mexico City *see* Tenochtitlán, Mexico
Michaux, Henri 55, 181
Michelangelo Buonarroti 23, 86, 97, 102, 140, 188
 David 14, 97, **97**
 Pope Julius II tomb 28, 30

Rebellious Captive 28
Sistine Chapel frescoes 16, 30
Mies van der Rohe, Ludwig 176
Mikhailov, Grigory: *Antiquities Gallery of the Academy of Fine Arts, The* 102
Millais, John Everett: *Mariana* **120**
Millet, Jean-François 131
miniatures 61, **61**
Minimalism 106, 176, **176**
Mirabeau, Octave **123**
Miró, Joan **82**
mirrors 80, 81, **81** *see also* camera obscura
Miyake, Issey 24
 Poem of Cloth and Stone, A 128
Moche culture 181
Modernism 106, **106**, 120, 128, 163, 176, 202
Modernist architecture 38, 42, 120, 128, 176
Moholy-Nagy, Lázló
 Light Prop for an Electric Stage 154, **155**
 Nickel Construction 172
Moldovita Monastery, Romania 47, **47**
Mondrian, Piet 106, **106**, 128, 148, **155**, 178
Monet, Claude 124
 Boulevard des Capucines 124, **124**
 Impression: Sunrise 124
 Poplars along the River Epte **131**
 Saint-Lazare railway station (sketch) **78**
monotypes 82
Moore, Henry 202
 London Underground drawings 166, **167**
Mopope, Stephen 181
Morisot, Berthe 124
Morris, Robert
 Document 189
 Slab 106
Morris, William 42, 128
mosaics 42, 45, 47, 56, **56**, 70, **70**
Mother Goddess 10-11
Mozart, *Don Giovanni* 14
Mueck, Ron: *Dead Dad* 26
multi-panel painting 58, **58**, **176**
multiple viewpoints 20, 142, **142**
Murray, Charles Fairfax 91
Museum of Modern Art, New York 200, 206
music 14, 26, 66, **106**, 110, **120**, **128**, 148, 149, 159, 183, 188
myths/mythology 8, **8**, 10, 16, 30, 114, 116
 Greek 23, 26, 38, **39**, 52, **52**, 75, 97, 102, **140**

N
Namuth, Hans **168**, 183
Napoleonic era 30, 105, 110, 181, 200
narrative 8, 20-21, **21**, 58, 85, 100, 105
Nash, Paul 166
Nataraja (Lord of the Dance) **202**
National Gallery, London 113, **113**
Native American art 181
natural light 62, 72, 124, 131
Nauman, Bruce 28, **28**, 186
Nazca lines, Peru 13
Nazism **105**, 118, 138, 150, 160, **165**
Nechvatal, Joseph 198
 Orgiastic abattOir: flawless ignudiO **199**
negative space 178, 192, 202, **202**
Neoclassicism 97, **104**, 106, **106**, 106
Neoplasticism 148
Neo-primitivism **140**
Neri, Giancarlo: *The Writer* 19
Neudecker, Marielle: *I Don't Know How I Resisted the Urge to Run* 110, **110**
Neue Sachlichkeit (New Objectivity) 118
Neuschwanstein Castle, Bavaria 120, **120**
Nevelson, Louise: *Sky Cathedral* 127
Nevison, Christopher 166
New Objectivity *see* Neue Sachlichkeit
Newlyn, Cornwall, England 134, **134**
Newman, Barnett
 Stations of the Cross (series) 101
 18 Cantos (series) 101
newspapers 34, 145, 166, **166**
Newton, Isaac 72
Nicholson, Ben 106, **106**, 140
Niépce, Nicéphore 94
Nike of Samothrace 75

Nochlin, Linda 184
Nolde, Emil 160
Nuba people, Sudan 24
nude, the 26, **26**

O
O'Gorman, Juan: Central Library, Mexico City 56
objets trouvés *see* found objects
Oceanic art 140, **141**
oil paint 62, 78, 85, 93, 116, 117, 131, **131**, 163
 see also tube packaging (oil paints)
Oldenburg, Claes (with van Bruggen) 163
 Binoculars, Chiat/Day building, Venice, California 38, **38**
 Spoonbridge and Cherry 19, **19**
Olmec colossal heads 19, **19**
Ono, Yoko: *Cut Piece* **183**
optical art 178, **178**, **179**
optics 85, 114
Orlan 24
ostraca 78, 91

P
packaging 34, 116, 128, 131 *see also* tube packaging (oil paints)
Paik, Nam June
 TV Bra for Living Sculpture 186
 TV Garden 186
Paine, Roxy: *Conjoined* 173, **173**
painting 34, 62, 145, **168**
 early forms of 8, **8**
 oil 62, 85, 116, 117, 131
 on canvas **92**, 93, **93**, 131
 see also abstract painting; body art; frescoes; miniatures; spray paints; wall paintings; watercolour painting
Palaeolithic art 8, **8**, 10, 52, 68, 76, 137, 186
Palenque, Mexico **40**, 41
Pane, Gina **183**
Paolozzi, Eduardo 146
paper 26, 34, **35**, 116, 145
papermaking 34, **35**, 82
papyrus 34, **150**
Parker, Cornelia: *Cold Dark Matter: An Exploded View* 153
Parkes, Alexander 163
Parmigianino: *Self-portrait in a Convex Mirror* 80, **81**
Parr, Martin: *Basel Art Fair* **123**
Parrhasios *see* Zeuxis
Parthenon, Acropolis, Athens 23, 38
patronage 30, 68, 78, 82, 93, 100, 102, 108, 123
Pazyryk, Russia 24
performance art 45, 159, 169, 174, 183, **183**, 192, 206
perspective 66, 68, 70, 94
 see also linear perspective
Perspex 163, **163**
Peto, John F. 70
Pevsner, Antoine 163
Pheidias 26, 33, 38, **91**, 114
Philip IV, King of Spain 92
philosophy 66, 70, 97, **97**, 106, 114, 138, 148, 160
 ancient Greek 66, 97
 humanist 26
photography 34, 61, 70, 85, 94, **123**, 132-3, **133**, 142, **146**, 156, 163, 166, **166**
 and collage 127, 145, 153
 digital 198
 Polaroid **142**
 and portraiture 76, 118, 142, **184**
photomontage 127, 128, **128**, 132-3, 146, 164, **165**, 174
Picasso, Pablo 34, 62, 89, 97, 102, **102**, 142, 145, 163, 170, 172, **172**, 173, 181
 Desmoiselles d'Avignon, Les 140, **141**
 Guernica 138, 164, **165**
 Head of a Bull 153, **153**
 Las Meninas 91, **91**
 Still Life with Chair Caning 145
Piero della Francesca 66

Flagellation, The **66**
Ideal City **68**
Legend of the True Cross, The (series) 100
pigments 8, 61, 131, **192**
Piles, Roger de 98
Pissarro, Camille 123, 124, 178
Pistoletto, Michelangelo 153
plastics 163
Plato's academy, Athens 97, 108
plein-air painting 62, 116, 131, **131**, 134
Pliny the Elder 55, 70, 89, 93, 102, 105
Pointillism 178, **178**
Polaroid photographs 142
Pollock, Jackson 55, 123, 149, **168**, 169
Polykleitos 114
 Doryphoros 28, **28**
polyptychs 58
Pompidou Centre, Paris 154
Pont-Aven, Brittany, France 134
Pop art 47, 89, 163, 174, **174**, 195
Portinari, Tommaso 58
portraiture 30, 37, **37**, 61, 76, **76**, 91, 118, **160**
 see also royal portraiture; self-portraiture
posters 128, **128**, 146, 165, **181**
postmodernism 38, 110
Poussin, Nicolas: *Dance to the Music of Time, A* 188, **189**
Praxiteles 26
prehistoric earthworks 13, 45
Pre-Raphaelite Brotherhood 120
'primitive' 134, 140, **141**, 156
printing 49, 82, 100
printmaking 34, 82, **82**, **83**, 100, **101**, 123, 128, 198, **199**, 202
product design 128, **128**
propaganda 30, **30**, **31**, 82, 118, 150, 164
proportion 42
protest art 164-5, **165**
Protestant Reformation 47, 72, **76**, 82, 113
Protestantism 89, 93, 106
Proud'hon, Pierre-Joseph 118, 170
Proust, Marcel: *À la recherche du temps perdu* 124
psychedelic art 181
public art 14, **15**, 16, 19, **19**, 26, 30, 56 *see also* architectural sculpture; memorials
Pugin, A. W. N. 42, 120

Q
Quinn, Marc: *Self* 192, **192**

R
Rand, John G. 131
Raphael 50, 120
 Madonna of the Pinks, The 112, **113**
Rauschenberg, Robert 145, 153
Ravenna, basilica of Sant'Apollinare 56
Read, Herbert 163
Realism **90**, 118, 127, 131, 156
Rehberger, Tobias: *Seven Ends of the World* 205, **205**
Rejlander, Oscar: *Infant photography gives the painter an additional brush* 132, **133**
relief carving 20, **21**, 23, **23**, 30, 38, **39**, 40, 200, 202
reliquaries 45, 58
Rembrandt van Rijn 62, 85, **85**, 123, 133, 137
 Dr Tulp's Anatomy Lesson 86, **86**
 Self-portrait **90**
Renaissance, the 37, 62, 65, 76, **80**, 81, 114, 140, 188, 190
 frescoes 16, 20, **21**, 93
 and Classical art 26, 28, 97, 105, 120, 154
 and perspective 68, **69**, 94
 and science 85, 86
 sculpture 11, 14, 28
 see also under individual artists
Renoir, Pierre-Auguste 52, 123, 124
reportage 166, **166**, **167**
Reynolds, Sir Joshua 30, 62, 108, 110, 188
Riace Bronzes 33
Richter, Gerhard 133
 Uncle Rudi 105, **105**
Riefenstahl, Leni 24
Rietvald, Gerrit: *Red-Blue chair* 128, **128**
Riley, Bridget 23, 178

Fission **179**
Rilke, Rainer Maria 98
Robert, Hubert 102
rock art 8, **8**
Rodin, Auguste
 Age of Bronze 28
 Kiss, The 106
Roman architecture 50, 56, 66, 70
Roman art 26, 47, 89, 97
 collections **91**, 102, 123
 copies of Greek sculptures 28, **28**, 91, **91**, 97, 102, 123
 frescoes 75, **75**
 mosaics 45, 56, 70, **70**
 relief carving 20, **21**, 23
 sculpture **15**, 33, 50, 91, **91**, 105
 wall paintings 45, 50, **50**, 75, **89**
Romanticism 66-7, 78, 91, 110, 113, 120, **120**, 138, 170, 188-9
 emphasis on emotion and experience of the individual 113, 114, 120, 124, 128, 138, 160, 181
 and landscape painting 98, 110, **110**, **112**, 117, 131
 see also Neoclassicism
Romulus and Remus 23, **23**
Rothko, Mark 72, 189
 Black on Maroon **176**
Rouault, Georges 42
Rousseau, Henri 140
Rousseaux, Jacques des **85**
Royal Academy, London 108, **109**, **117**
royal portraiture 19, 30, **30**, 33, **33**, 76, **92**
Rubens, Peter Paul 30, 78, 123, 183
Rublev, Andrei 46
Ruche, La, Paris, France 134
rulers, depictions of 14, **14**, **15**, 19, **19**, **30**, 33, **33**, **42**, 76, 97, 197
 see also royal portraiture
Ruskin, John 91, 98, 146

S

Saenredam, Pieter 106
Saint-Denis, Paris 42
Sainte-Chapelle, Paris 42
Saint-Phalle, Niki de
 Shooting Picture **169**
 SHE – a Cathedral 159
Salcedo, Doris
 La Casa Viuda VI **118**, 165
Salon des Refusés 170
San Lorenzo Tenochtitlán, Mexico 19, **19**
San Marco, Florence 16, **16**
Sander, August: *People of the Twentieth Century* 118
Sanraku, Kano: *Autumn Millet* 58
satire 100, 127, 150, **150**, 164, 174
scale 19, **19**
Schapiro, Miriam 184
Schiele, Egon 52
Schinkel, Karl Friedrich: *Medieval City on a River, A* 120, **120**
Schlegel, Friedrich 110
Schneeman, Carolee 183
 Fresh Blood: A Dream Morphology **184**
Schwitters, Kurt 127, 153
 Merzbau 159, **159**
science 85, 86, 94, 102, 154, 178, 198
screenprinting 114
Scrovegni Chapel, Padua, Italy 75
sculpture **10**, 10-11, **15**, 19, **19**, 28, **28**, 33, 91, 163, 172, **172**, **173**
 African 33, **33**, 140
 Baroque 106
 Buddhist 19, **197**
 ancient Greek 14, 26, **26**, 28, **28**, 33, 86, 97, **97**, 106
 ancient Roman **15**, 28, **28**, 91, 123
 see also architectural sculpture; bronze sculpture; assemblage; found objects; relief carving; statues
Searle, Berni: *Snow White* 24
self-portraiture 24, **24**, **61**, 80, 81, 114, **114**, 137, 184, **184**, 192, **192**
 see also artist, the

Selinus, Temple C: Labours of Herakles (frieze) 38
series of works 100-1, **101**, 178
Serpent Mound, Ohio 13
Seurat, Georges 142, 178
 Women on the River Bank **178**
sexual imagery 52, **52**
sfumato 85
Shah Mosque, Isfahan 41
shawabti 10
Shelley, Percy Bysshe 67
Sherman, Cindy: *Untitled* **183**
shock, ability to 170, **170**
Shonibare, Yinka: *Reverend on Ice* 197, **197**
Singleton, Henry: *Royal Academicians in the General Assembly, The* **109**
Siskind, Aaron 195
Sisley, Alfred 124
Sistine Chapel, Rome 16, 30
sketching 78, **78**, **79**, 124, **178**
 see also plein-air painting
Smith, David 146
 Home of the Welder 173
Smithson, Robert: *Spiral Jetty* 13, **13**
South Kensington Museum, London 128
Soutine, Chaim 160
 Village, The **160**
Spanish Civil War **82**, 164, **165**
spray paints 195
St Catherine's Monastery, Sinai 47
St Ives, Cornwall, England 134
Santa Maria Novella, Florence 68, 70
stained glass 42, **42**, 47, 72, 120
standing stones 13
Statue of Liberty, New York (Bartholdi) 14, 75
statues 14, **15**, 19, 33, 97
Stella, Frank: *Lunna Wola II* 93, **93**
stencilling 8
still life 45, **88**, 89, 94, 124, 206
stone 11, 14, 23, 23, 33, 39, **40**, 91
storytelling *see* narrative
street art **194**, 195, **195**
Stubbs, George **86**
studiolo 102
Sublime, the 66-7, 99, 114
Suger, Abbot 42, **42**
Süleyman II **55**
Suprematism 30, **31**, 67, **149**
Surrealism 34, **40**, 41, **70**, **82**, **86**, 123, 127, 138, 164
 exhibitions 153
 and film 186
 found objects 153, 206
 and photomontage 128, 132
 see also automatism
Surrealist Manifesto (Breton) 138
Surréaliste d'Objets exhibition, Paris, 1936 153
Symbolism 106, **106**

T

tapestry 93
Tàpies, Antoni 62
Tate Gallery, London 176
Tate Modern, London 200, **200**
tattoos 24, **25**
Taylor-Wood, Sam: *Still Life* 89, **89**
Tehuelche people, Patagonia **192**
television 20, 166, 186
tempera 62
Temple of Inscriptions, Palenque, Mexico **40**, 41
tenebrism 85
Tenniel, John 49
Tenochtitlán, Mexico 11
terracotta 11, 37, **37**
textiles 34, 82, 93
Theophilus, *De diversis artibus* 42
Tinguely, Jean 154
 Homage to New York 206
Titian 62, 114
 Bacchus and Ariadne 102
 Sacred and Profane Love 75
 Venus of Urbino 26, **26**
titles (of artworks) 190, **191**

Tohaku, Hasegawa 176, **176**
tomb art
 ancient Egyptian 10, 16, 89, 159, 192
 Etruscan 16, **17**, 37, **37**
 Renaissance 28, 192
Torrentius, Johannes 94
Toulouse-Lautrec, Henri de: *Moulin Rouge: La Goulue* poster 128, **128**
Toyokuni, Utagawa: *Inside a Kabuki Theatre* 58
Trajan's Column, Rome 20, **21**
Tribe, Kerry 21
Triclinium, Tomb of the, Tarquinia 16, **17**
triptychs 58
Trois Frères caves, France 8
trompe-l'oeil **44**, 70, **70**, **71**, 89, **89**, 145, 178
tube packaging (oil paints) 116, 131, **131**
Turner, J. M. W. 78, 99, 117
 Snowstorm: Hannibal and Army Crossing the Alps 66-7
 Snow Storm – Steam-Boat off a Harbour's Mouth **112**, 113, 170
Twombly, Cy 195
 Four Seasons: Autumn **55**
Tzara, Tristan 169

U

Uccello, Paolo: *Battle of San Romano* **104**, 105
Uffington Horse, Oxfordshire, England 13, **13**
ukiyo-e 58, 65, 156
unconscious, the 138, **138**, 169
Unswept Floor, the (mosaic), Aventine Hill, Rome 70, **70**
urban art *see* street art
Uruk, Mesopotamia 56

V

van der Goes, Hugo: *Adoration of the Shepherds, The* 58
vanitas paintings 89, **124**, 206
Varo, Remedios: *Anatomy Lesson, The* 86
Vasarely, Victor: *Planetary Folklore* series 178
 Torony-MC **178**
Vasari, Giorgio 68, 97, **97**, 102, 154, **190**
 Lives 91, 140
Vaucanson, Jacques de 154, 198
Velàzquez, Diego 94
 Las Meninas **91**, **92**, 93, 190
 Toilet of Venus 75
 The Cook (An old woman fries eggs) 156, **156**
vellum **55**, 61, 116
Vence, France: Chapelle de la Rosaire (Matisse) 42, **42**
Venice Biennale 197
'Venus' figurines 10, 52, **160**
Vermeer, Johannes 94
 Officer and Laughing Girl 94, **95**
Verrocchio, Andrea del
 Giuliano de' Medici (portrait bust) 11
 Lorenzo de' Medici (portrait bust) 76
Vesalius: *De humani corporis fabrica* 86
Vico, Enea 137
Victoria & Albert Museum, London *see* South Kensington Museum, London
video art 20-21, 24, 28, **28**, 81, 86, 174, 186
Viola, Bill 186, **186**
Vitruvius 66
Vollard, Ambroise **123**
Vorticism 186

W

wabi 176
Wagner, Richard 159
 Gesamtkunstwerk, concept of 159
 Lohengrin 120
wall paintings 16, **16**, **17**, 45, 47, 50, 68, 75, **75**, 89, 116
Wallis, Alfred 140
wallpaper 34, **144**
war memorials 37, **37**, 202
Warhol, Andy 47, 89, **114**, 163, 174, 195
 Sleep 186
watercolour painting 116-17, **116**, **117**, **118**, 131
welding 172-3, **172**, **173**
Westminster Cathedral, London 23

Weyden, Rogier van der 65
Whistler, James Abbott McNeill
 Peacock Room 159
 Symphony in White 106, **106**
Whiteread, Rachel
 Holocaust memorial, Vienna 37, 202
 House **202**
Wilke, Hannah: S.O.S: Starification Object Series 24, **24**
Willendorf, Venus of **160**
Wilson, Fred: *Mining the Museum* 200, **200**
Winckelmann, Johann Joachim 97, **97**, 106
windows, notion of paintings as 65, **65**
Wodaabe tribe, Sahara desert 24, **24**
woodblock prints 58, 65, **82**, 128
Woodrow, Bill 153
 Car Door, Ironing Board and Twin-Tub with North American Indian Head-Dress 127, 202, **202**
Wordsworth, William 153
World War I **58**, 120, 138, **150**, 166, 169, 172, 183
World War II 118, 127, 138, 140, 146, 166, **167**
World Wide Web 205
Worm, Olaf **102**
Worpswede, Germany 134
Wright of Derby, Joseph: *Academy by Lamplight, An* 108
writing systems **40**, 41
 see also handwriting
Wynter, Bryan 181
 Mars Ascends **181**

Y

Yellow Book, The 49, **49**
York Minster, England 42
Yoruba sculptors 33
Young British Artists (YBAs) 128

Z

Zen calligraphy 55
Zeus of Artemision, the 33
Zeuxis and Parrhasios, story of 70, 89, 178
Zhao Mengfu 35
Zola, Émile 170
Zurbaràn, Francisco de 85

Picture credits

Laurence King Publishing Ltd, the author and the picture researcher wish to thank the institutions and individuals who have kindly provided photographic material for use in this book. Numbers below are page numbers. While every effort has been made to trace the present copyright holders we apologise in advance for any unintentional omission or error and will be pleased to insert the appropriate acknowledgement in any subsequent edition.

KEY AA: Art Archive; BAL: Bridgeman Art Library; KHM: Kunsthistorisches Museum, Vienna; MoMA: The Museum of Modern Art, New York; NGL: The National Gallery, London; QF: © Quattrone, Florence; SF: Scala, Florence; TGL: The Tate Gallery London; WFA: Werner Forman, London Archive

2 Museo del Prado, Madrid. 8 WFA. 9t Panel of the Horses, Chauvet Cave, Vallon-Pont-d'Arc, Ardèche Gorge, France. Ministère de la Culture et de la Communication, Direction régionale des affaires culturelles de Rhône-Alpes, Service régional de l'archéologie. 9b WFA/Tim and Ros Bowden. 10 Antony Gormley, Field for the British Isles, 1993, terracotta, dimensions variable: approx. 40,000 figures, figures 8–26cm (3–10¼in) high, installation view, Tate Gallery, Liverpool. Courtesy White Cube. © Antony Gormley. 11 Museo del Templo Mayor, Mexico City, Mexico/AZA INAH. BAL/Michel Zabé. 12 Robert Smithson, Spiral Jetty, Great Salt Lake, Utah, 1970, c. 457m (1,500ft) long, 4.6m (15ft) wide. Contact Press Images/Gianfranco Gorgoni. © Estate of Robert Smithson/DACS, London/VAGA, New York 2012. 13 Alamy/Skyscan Photolibrary. 14bl SF. 14tr David Mach, Silver Back, 2007–08 Assembled wire coathangers, 200 x 125 x 290cm (6ft 6¾in x 4ft 1¼in x 9ft 6⅛in). Courtesy Galerie Jérôme de Noirmont, Paris. © David Mach. 15 Museo Capitolino, Rome. Canali Photobank. 16t Sol LeWitt, Wall Drawing No 652, on Three Walls, Continuous Forms with Color Washes Superimposed, 1990. Colour-ink wash on wall, approx 9.1 x 18.3m (30 x 60in). Shown here as temporarily installed at the Addison Gallery, Andover, MA, 1993. Now in the Indianapolis Museum of Art, Gift of the Dudley Sutphin Family, Robert Cheek, Belmont, MA. Courtesy the Addison Gallery, Andover. © ARS, NY and DACS, London 2012. 16c QF. 17 SF – courtesy of the Ministero Beni e Att. Culturali. 18 Anthropology Museum, Veracruz University, Jalapa. WFA. 19 Claes Oldenburg and Coosje van Bruggen, Spoonbridge and Cherry, 1988, Stainless steel and aluminium painted with polyurethane enamel, 9 x 15.7 x 4.1m (29ft 6in x 51ft 6in x 13ft 6in). Collection Minneapolis Sculpture Garden, Walker Art Center, Minneapolis. Photo courtesy the Oldenburg van Bruggen Studio. © 1988 Claes Oldenburg and Coosje van Bruggen. 20b © Vincenzo Pirozzi, Rome fotopirozzi@inwind.it. 20–21 QF. 22t Archaeological Museum, Istanbul. © Hadiye Cangökçe. 22b © Trustees of the British Museum. 23 Private Collection. © Peter Nahum at The Leicester Galleries, London/BAL. 24bl Hannah Wilke, S.O.S. Starification Object Series, 1974, one of 35 b/w photographs, each 5 x 7 inches in "Mastication Box". Courtesy Donald and Helen Goddard and Ronald Feldman Fine Arts, New York/www.feldmangallery.com. Photo Les Wollam. © Marsie, Emanuelle, Damon and Andrew Scharlatt/ DACS, London / VAGA, New York 2012. 24tr Getty Images/Stone/Jason Dewey. 25 photo © RMN (Musée Guimet, Paris)/Droits réservés. © Craig & Marie Mauzy, Athens mauzy@ otenet.gr. 27t Galleria degli Uffizi, Florence/QF. 27b Henri Matisse, Large Reclining Nude, 1935, oil on canvas, 66 x 92.7cm (26 x 36½in). The Balitimore Museum of Art: The Cone Collection, formed by Dr. Claribel Cone and Miss Etta Cone of Baltimore, Maryland, BMA

1950.258. Photo Mitro Hood. © Succession H. Matisse / DACS 2012. 28 Bruce Nauman, Walking in an Exaggerated Manner Around the Perimeter of a Square, 1967–68, 16mm film, black and white, silent 400 feet. approx. 10 min. Distributed by Electronic Arts Intermix (EAI) Courtesy Sperone Westwater, New York. © ARS, NY and DACS, London 2012. 29 Museo Nazionale Archeologico, Naples. © Fotografica Foglia, Naples. 30t akg-images/Andrea Jemolo. 30c Musée du Louvre, Paris. © Photo Josse, Paris. 31 Tretyakov State Gallery, Moscow. SF. 32 © Trustees of the British Museum. 33 Louise Bourgeois, Spider Couple Untitled, 2003, bronze, silver nitrate patina, 228.6 x 360.6 x 365.7cm (7ft 6in x 11ft 10in x 12ft). Courtesy Cheim & Read, Galerie Karsten Greve, and Hauser & Wirth. Photo Christopher Burke. © Louise Bourgeois Trust/ DACS, London / VAGA, New York 2012. 34b Christo, Surface d'empaquetage, 1959, paper, paint, sand and lacquer, 64 x 48.5cm (25¼ x 19⅛in). Photo Eeva-Inkeri. © Christo 1950. 34–35 Zhao Mengfu, Sheep and Goat, detail from a horizontal scroll, Yuan dynasty c.1300, ink on paper, 26.8 x 26.5cm (10½ x 10⅜in). Freer Gallery of Art, Smithsonian Institution, Washington DC. /SF. 36 Photolibrary.com/ National Geographic Society. 37bl Jewer, Terepos and Faripdas (carvers), Ancestor poles, Asmat tribe, Irian Jaya, New Guinea, 1900s. The Metropolitan Museum of Art, New York. The Michael C. Rockefeller Memorial Collection. Gift of Nelson A. Rockefeller and Mrs Mary C. Rockefeller, 1965 1978.412.1248, 1249, and 1250. Image © The Metropolitan Museum of Art/Art Resource/SF. 37tr Museo Nazionale di Villa Giulia, Rome. © Araldo De Luca, Rome. 38 Claes Oldenburg and Coosje van Bruggen, Binoculars, 1991, Steel frame; exterior: concrete and cement plaster painted with elastomeric paint; interior: gypsum plaster 13.72 x 13.41 x 5.49m (45 x 44 x 18ft). Collection Central component of Chiat/Day Inc. building designed by Frank O. Gehry & Associates, Inc., 340 Main Street, Venice, California ©Photo Attilio Maranzano, courtesy the Oldenburg van Bruggen Studio. © 1991 Claes Oldenburg and Coosje van Bruggen. 39t © Paul M.R. Maeyaert 39b © René Mattes/Hemis/Corbis 40t René Magritte, La trahison des images (Ceci n'est pas une pipe), 1929. Los Angeles County Museum of Art. Purchased with funds provided by the Mr. and Mrs. William Preston Harrison Collection (78.7). Digital Image Museum Associates/LACMA/Art Resource NY/ SF. © ADAGP, Paris and DACS, London 2012. 40b AA/Gianni Dagli Orti. 41 Rachid Koraichi, sculpture from Les Priants series, 2008, steel, 98cm x 49cm x 14cm (3ft 2¾in x 1ft 7¼in x 5½in). Courtesy October Gallery. © ADAGP, Paris and DACS, London 2012. 42 SF. 43 BAL. © Succession H. Matisse / DACS 2012. 44 Thyssen-Bornemisza Collection, Madrid. akg-images. 45bl Howard Hodgkin, Chez Max, 1996–97, oil on wood, dia 176.53cm (69½in). Courtesy Gagosian Gallery, London. © Howard Hodgkin. 45tr Kremlin Museums, Moscow. BAL. 46 Tretyakov State Gallery, Moscow. /SF. 47bl Saint Catherine's Monastery, Sinai. 47tr akg-images/ De Agostini Picture Library. 48t Fitzwilliam Museum, University of Cambridge. BAL. 48b Private Collection. The Stapleton Collection/ BAL. 49 Anselm Kiefer, Census, 1990, steel, lead, photographs, 4.15 x 5.7 x 8m (13ft 7¾in x 18ft 8⅜in x 26ft 3in). Nationalgalerie im Hamburger Bahnhof, Staatliche Museen zu Berlin. SF/BPK, Berlin/Werner Zellin. © Anselm Kiefer. 50bl Freud Museum, London. BAL. 50tr BAL. 51 Museo del Prado, Madrid/ Photo SF. 52 Pushkin Museum, Moscow. /SF. 53t Photolibrary.com/Age fotostock/Jose Fuste Raga. 53b Nan Goldin, Valerie and Bruno: bodyforms, Paris, 2001, Cibachrome, 76 x 102cm (30 x 40in) Courtesy Matthew Marks Gallery, New York. © Nan Goldin. 54 Yamato Bunkakan, Nara. 55bl The Trustees of the Chester Beatty Library, Dublin. BAL. 55tr Cy

Twombly, from Quattro Stagioni (A Painting in Four Parts) Quattro Stagioni: Autunno 1993–95, acrylic, oil, crayon and pencil on canvas, 3.136 x 2.15m (10ft 3½in x 7ft⅜in). Photo © TGL 2011. © Cy Twombly Foundation. 56 bl BAL/Ken Welsh. 56 tr AA/Collection Dagli Orti. 57 © CAMERAPHOTO Arte, Venice. 58 The Temple Gallery, London. 59t Musée Unterlinden, Colmar. Art Archive. 59b Otto Dix, War Triptych, 1929–32. akg-images/De Agostini Picture Library. © DACS 2012. 60 akg-images/Erich Lessing. 61bl Bibliothèque Nationale, Paris. BAL. 61tr Victoria & Albert Museum, London. BAL/The Stapleton Collection. 62 SF. 63 Frank Auerbach, Head of E.O.W. I, 1960, oil on wood panel, 43.3 x 35.5cm (17 x 13⅞in). Photo © TGL 2011. © Frank Auerbach, Courtesy Marlborough Fine Art, London. 64 Musée du Louvre, Paris. © Photo Josse, Paris. 65bl State Hermitage Museum, St Petersburg. akg-images. 65tr Ellsworth Kelly, Window, Museum of Modern Art, 1949. Oil on wood and canvas, two joined panels, 128.3 x 49.5cm (50½ x 19⅜in), Collection of the artist. © Ellsworth Kelly. Photo Jerry L. Thompson, courtesy the artist. 66bl Mario Merz, Progressione di Fibonacci, 1975, chalk, tempera, snail's shell and clay on cardboard, 73 x 103cm (28¾ x 40½in). Private Collection, Courtesy Archivio Merz. © Mario Merz/SIAE/DACS, London 2012. 66–67t SF – courtesy of the Ministero Beni e Att. Culturali. 68 Giorgio De Chirico, The Mystery and Melancholy of a Street, 1914, oil on canvas, 87 x 71.4cm (34¼ x 28⅛in). Private Collection. © DACS 2012. 68–69t SF – courtesy of the Ministero Beni e Att. Culturali. 69b QF. 70bl SF. 70tr René Magritte, L'appel des cimes, 1943. SF/BI, ADAGP, Paris. © ADAGP, Paris and DACS, London 2012. 71 QF. 72bl BAL. 73t Digital image © NGL/SF. 73b Josef Albers, Variation in Red and Orange around Pink, Ochre, Plus Two Reds, 1948. Private Collection. BAL. © The Josef and Anni Albers Foundation/VG Bild-Kunst, Bonn and DACS, London 2012. 74 QF. 75bl AA/ Alfredo Dagli Orti. 75tr © Photo Josse, Paris. 76bl Lucien Freud, John Deakin, 1963/64, oil on canvas, 11⅞ x 9¾in (30.2 x 24.8cm). Private Collection. BAL. © The Lucien Freud Archive. 76tr BAL. 77 Photo SF – courtesy of the Ministero Beni e Att. Culturali. 78bl WFA. 78tr BAL/Giraudon. 79 Polidoro da Caravaggio, Study of a Man with Various Sketches, c.1535, red chalk, recently reassembled after having been cut into an irregular shape, 20.6 x 18.4cm (8⅛ x 7¼in). The J. Paul Getty Museum, Los Angeles. 80 akg-images/Erich Lessing. 81bl Anish Kapoor, Sky Mirror, 2006, stainless steel dia. 10m (32ft 9⅜in). Installed at Rockefeller Centre, 2006. Photo Seong Kwon. Courtesy the artist and Public Art Fund. 81tr Pierre Bonnard, The Mirror in the Bathroom, 1908. Pushkin Museum, Moscow. SF. © ADAGP, Paris and DACS, London 2012. 82t Hokusai, The Great Wave at Kanagawa, (from a Series of Thirty-six Views of Mount Fuji), Edo period c.1830–32, colour woodblock print, ink and colour on paper, 25.7 x 37.9 cm (10⅛ x 14¹³⁄₁₆in). Metropolitan Museum of Art, New York. H. O. Havemeyer Collection, Bequest of Mrs. H. O. Havemeyer, 1929. Acc.n.: JP1847. Image © The Metropolitan Museum of Art/Art Resource/SF. 82c Joan Miró, Galerie Maeght poster, Peintures, Murales, Miró, 1961, lithograph, 66.7 x 48.5cm (26¼ x 19⅛in). Museum of Modern Art, New York, Anonymous gift. Photo Successió Miró, Palma de Mallorca. © Succession Miro/ADAGP, Paris and DACS, London 2012. 83 akg-images. 84 QF 85bl Robert Mapplethorpe, Desmond, 1983, silver gelatin print, 20 x 16in. © The Robert Mapplethorpe Foundation. Courtesy Art + Commerce. 85tr BAL/Noortman Master Paintings, Amsterdam. 86bl BAL. 86tr Varo Remedios (aka), Varo Maria delos Remedios, The Anatomy Lesson, 1935. Musée National d'Art Moderne, Centre Pompidou, Paris. © Collection Centre Pompidou, Dist. RMN/ Philippe Migeat. © Remedios Varo, DACS/ VEGAP, 2012. 87 SF. 88 © NGL/SF. 89bl AA/

Gianni Dagli Orti. 89tr (3 frames) Sam Taylor-Wood, Still Life, 2001, Edition of six 35mm Film/DVD, duration 3 minutes 44 seconds. Courtesy White Cube. © Sam Taylor-Wood. 90r BAL/Lauros Giraudon. 90l akg-images/Erich Lessing. 91bl SF/Luciano Romano. 91tr Pablo Picasso, Las Meninas (after Velazquez' 1656 portrait of family of Philip IV of Spain), 1957. Museo Picasso Barcelona. AA/Gianni Dagli Orti. © Succession Picasso/DACS, London 2012. 92 Museo del Prado, Madrid. 93bl Frank Stella, Lunna Wola II (Polish Village #29), 1973. The Archive of Frank Stella, New York. Art Resource/© ARS, NY and DACS, London 2012. 93tr Lucio Fontana, Spatial Concept 'Waiting' (Concetto spaziale 'Attesa'), 1960. © TGL 2011. © Lucio Fontana/SIAE/DACS, London 2012. 94bl akg-images/IAM. 94tr Chris Drury, Inside Sky Mountain Chamber, Arte Sella, Italy, 2010 © Christ Drury. Photo Giacomo Bianci. 94c Chris Drury, Sky Mountain Chamber, Arte Sella, Italy, 2010, 150 tons of limestone © Christ Drury. Photo Giacomo Bianci. 95 Corbis. 96 SF/White Images. 97bl QF. 97tr Ian Hamilton Finlay, The Belvedere Muses, 2006. Courtesy Wild Hawthorn Press/ Peter Coates © estate of Ian Hamilton Finlay. 98bl National Palace Museum, Taipei. 98–99t © NGL/SF. 100–01b Private Collection. 101t Elisabeth Frink, Four Heads. Private Collection. BAL/Mark Fiennes. © Estate of Elisabeth Frink. All Rights Reserved, DACS 2012. 102–03t BAL. 103bl Private Collection. 103br akg-images/Imagno. 104t Musée du Louvre, Paris. © Photo Josse, Paris. 104b © NGL/SF. 105 Gerhard Richter, Onkel Rudi, 1965, oil on canvas, 87 x 50cm (34¼ x 19¾in). Courtesy the artist and Marian Goodman Gallery, New York/Paris. 106 AA. 107t Ben Nicholson, 1934 (relief – version 1), 1934, oil on carved board, 20.3 x 30.5cm (8 x 12in). Private Collection. BAL/James Austin. © Angela Verren Taunt 2012. All rights reserved, DACS. 107b BAL. 108 BAL/The Stapleton Collection. 109t © Royal Academy of Arts, London. 109b Musée du Louvre, Paris, France / Giraudon /BAL 110 Yale Center for British Art, Paul Mellon Collection. 111t Nationalgalerie, Staatliche Museen zu Berlin. /SF/BPK, Berlin/Joerg P. Anders. 111b Mariele Neudecker, I Don't Know How I Resisted the Urge to Run, 1998, glass tank, water, food dye, acrylic medium, salt fibre-glass, plastic, 61 x 75 x 90cm (24 x 29½ x 35⅜in) plus plinth. Courtesy Private Collection, Cologne. © Mariele Neudecker. 112 © TGL 2011. 113bl Piero Manzoni, Artist's Shit (Merda d'artista) 1961, tin can with paper wrapping with unidentified contents. © TGL 2011. © DACS 2012. 113tr NGL/ SF. 114bl Antiken-sammlung, Staatliche Museen zu Berlin. SF/BPK, Berlin/Ingrid Geske. 114tr © Corbis/Lynn Goldsmith. 115 Musée d'Orsay, Paris. © Photo Josse, Paris. 116bl AA/ Sally Chappell. 116–17t BAL/Christie's Images. 118 Doris Salcedo, La Casa Viuda VI, 1995, wood, bone and metal, Part I: 190.2 x 99.1 x 47cm (74⅞ x 39 x 18½in); Part II: 159.7 x 199.3 x 55.8 cm (62⅞ x 78⅜ x 21¹³⁄₁₆in); Part III: 158.7 x 96.5 x 46.9cm (62½ x 38 x 18⅜in) Courtesy White Cube. © Doris Salcedo. 119 Musée du Louvre. AA/Dagli Orti. 120l Nationalgalerie, Staatliche Museen zu Berlin. SF/BPK, Berlin/ Joerg P. Anders. 120tr AA/Dagli Orti (A). 121 BAL.122 © Samuel Courtauld Trust, The Courtauld Gallery, London. BAL. 123bl Getty Images/Hulton Archive. 123tr © Magnum Photos/Martin Parr. 124 bl Los Angeles County Museum of Art. akg-images/Erich Lessing. 124tr Yale Center for British Art, Paul Mellon Collection.125 Nelson-Atkins Museum of Art, Kansas City. BAL/Boltin Picture Library. 126 Sterling & Francine Clark Art Institute, Williamstown. BAL. 127bl Marcel Duchamp, Bicycle Wheel, 1963. Private Collection. BAL/ Cameraphoto Arte Venice. © Succession Marcel Duchamp/ADAGP, Paris and DACS, London 2012. 127tr Raoul Hausmann, The Spirit of Our Time, (Der Geist unserer Zeit (Mechanischer Kopf)), 1919. Musée National d'Art Moderne, Centre Pompidou, Paris. © Collection Centre